SHOT FROM ABOVE

STEVEN BRINDLE WITH DAMIAN GRADY

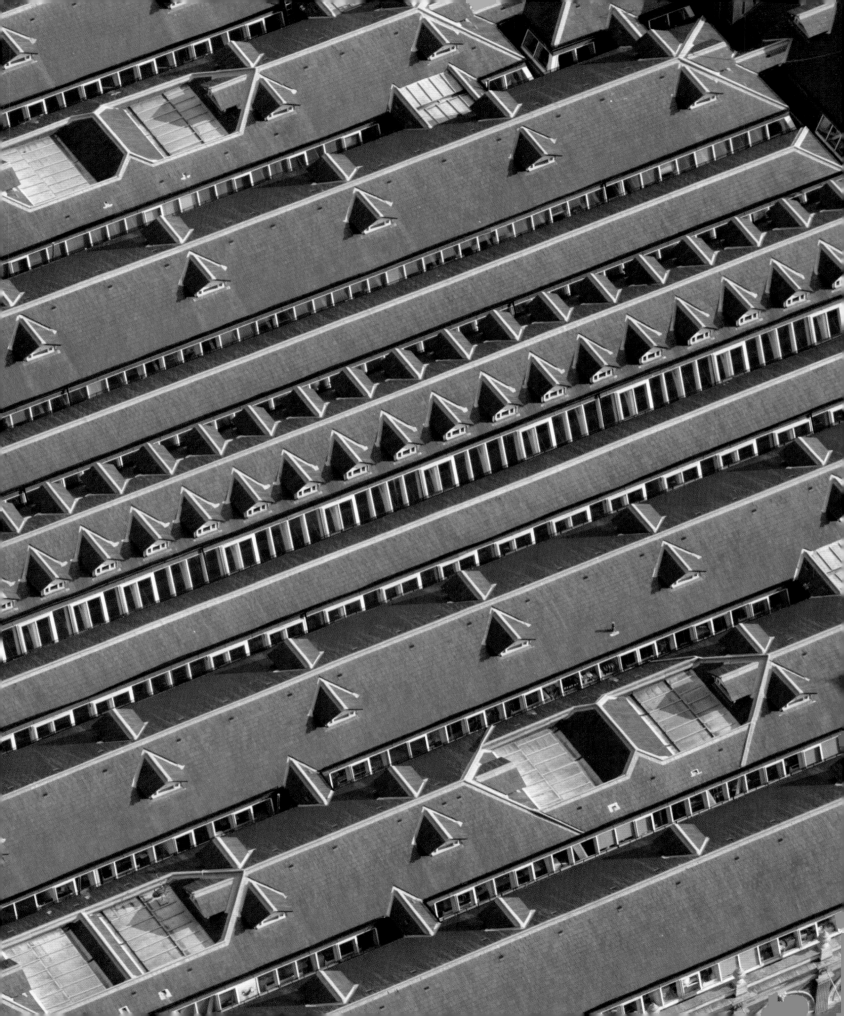

SHOT FROM ABOVE

STEVEN BRINDLE WITH DAMIAN GRADY

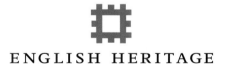

ENGLISH HERITAGE

Published by English Heritage, Isambard House, Kemble Drive, Swindon SN2 2GZ
www.english-heritage.org.uk

English Heritage is the Government's statutory advisor on all aspects of the historic environment.

The text of this book reflects the personal views of the author and does not necessarily reflect the corporate view of English Heritage.

The reference numbers for the images are noted in square brackets in the captions. RAeS Library images are from the Royal Aeronautical Society Library; R H Windsor Collection images are English Heritage.NMR; RAF images are English Heritage (NMR) RAF Photography; NMR images taken before 1 April 1999 are © Crown copyright.NMR and NMR images taken on or after 1 April 1999 are © English Heritage.NMR. Every effort has been made to trace copyright holders and we apologise in advance for any unintentional omissions, which we would be pleased to correct in any subsequent edition of the book.

The extract from Sir John Betjeman's poem *Harrow-on-the-Hill* on p 197 is © John Betjeman by kind permission of the estate of John Betjeman.

The reference numbers for the frontispiece and left-hand opening images to chapters 1–6 are as follows: frontispiece (Smithfield Market, NMR 24423/017), p 20 (Nat West Tower, NMR 24448/037), p 54 (Westminster Abbey, NMR 24414/032), p 126 (Rayners Lane, Harrow, NMR 24389/034), p 166 (Wembley Stadium, NMR 24391/025), p 202 (Trains at Stratford, NMR 24394/016) and p 262 (London Eye, NMR 24415/008).

First published 2007

10 9 8 7 6 5 4 3 2 1

ISBN 978 1 905624 05 8

Product code 51219

British Library Cataloguing in Publication Data
A CIP catalogue record for this book is available from the British Library.

Edited and brought to publication by René Rodgers, English Heritage Publishing
Design by Michael McMann
Index by Alan Rutter
Printed in England by Butler and Tanner

CONTENTS

High over the City of London (to the left) and Southwark (to the right) with St Paul's Cathedral in the foreground, c 1930s
[R H Windsor Collection, TQ 3781/13]

INFINITE CITY

In the beginning there was a name, a name in the unwritten Celtic language of ancient Britain. Quite what the name was and what it meant, no one can say for sure. For the historian Richard Burton, writing in 1684, it was either 'Llwndain', meaning a fenced town, or 'Lough Dinan', meaning a town of ships. More recently it has been interpreted as 'Lynn-don' meaning a hill or fort by a lake, or 'Lain-don', the long hill, or 'Londos-don', meaning the hill or fort of the fierce man. Recent scholarship has added 'Plowonida' from the Celtic roots 'plew' and 'nejd', which would mean something like 'the flowing place' – and the idea of London as a watery, flowing element is an appealing one. At any rate, there was a name. What sort of settlement – if any – it signified, we do not know. All we know is that very soon after the Emperor Claudius' invasion of Britain in AD 43, Roman traders moored their boats here and began to build huts, heard the name that the locals spoke and Latinized it as Londinium. And so far as the foundation of the city is concerned, that is more or less all we have: London's birth is lost in the mists of time in a satisfyingly open-ended way.

It is normal for the grander kind of historic city to have a founding myth and a more or less mythic founder. Thus Athens was dedicated to Athena, Rome was founded by Romulus and Remus, Alexandria was founded by Alexander the Great, New York was possibly founded by Pieter Stuyvesant and St Petersburg was definitely founded by Peter the Great. However, no individual – whether real, mythic or something in between – has ever set his or her mark on London in this way. Instead, just as its name has several possible etymologies, London also has a number of founding myths. For Geoffrey of Monmouth, writing in the 12th century, the city was founded by the Trojan Brutus, great-grandson of Aeneas. Brutus came to Britain (or Albion, the white land) and founded New Troy or Troia Nova, later corrupted to Troynovant or Trinovant. Later, he tells us, King Lud built walls around the city, naming it Caer Lud or Caer Lundein. Early folklore also named the giants Gog and Magog as the city's ancient protectors. By the 17th century historians were looking for classical roots again: for Michael Drayton in his *PolyOlbion* (1619), the city was named for Llan Dien, the temple of Diana, which he placed on the site of St Paul's. Shakespeare, in his *Richard III*, repeated another myth: that the Tower of London was founded by Julius Caesar. The myths, in their opaque way, are rather satisfying. If you try and tie the city down to actual facts, you are landed back in AD 43 (or soon after) with those anonymous Roman merchants and the even more obscure Britons whom they first heard say the magic name that sounded something like 'London'. The entertaining truth seems to be that the first named individual in London's history is none other than Queen Boudicca, whose sole contribution to its progress was to burn the whole place down in AD 61.

Despite these uncertainties, the name of London is so famous that a good majority of humanity must have heard it. But, as with its origins, ambiguity and complexity swiftly take over when it comes to describing the city – London is too diverse, shifting and enigmatic to admit of anything so banal as easy definitions. What makes London special is the kaleidoscopic range of its history and character. It is ancient, but it is also the world's greatest financial centre. It is one of the world's three or four greatest centres of television and modern media, and it has another, mythic life as the setting for books and plays, more so than any other city in the world. It has more live theatre than anywhere else on the planet and in the 16th century it was the birthplace of the Elizabethan theatre of Shakespeare and Marlowe. Britain's imperial triumphs, to which London made such a vast contribution, spread the English language round the world; yet paradoxically, another result of them is that over 300 languages are spoken in London today. It is probably the most cosmopolitan city in the world – New York is probably the only real competitor in this regard.

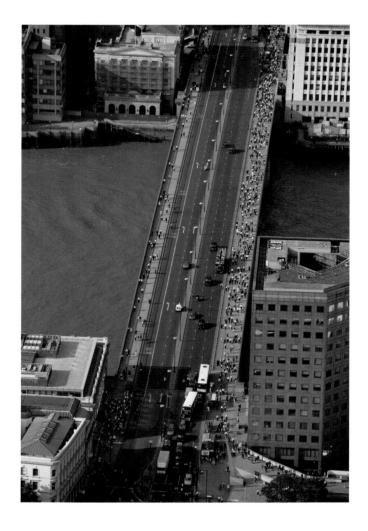

London Bridge from the south, August 2006 [NMR 24424/019]

This book, a celebration of London from the air, has been developed from the remarkable and previously unpublished holdings of aerial photographs in the National Monuments Record (the public archive of historic buildings and monuments held by English Heritage) and also in the library of the Royal Aeronautical Society. When seen (or shot) from above, all manner of new light is shed on the city, on its topography and buildings, its history and character. What must be borne in mind is that the book's shape has to a large degree been guided by what we happen to have early pictures of.

We start where the Roman city overlooks the river. The 'Don' of the name would seem to have been the low heights of the City: a pair of hills divided by the Walbrook Valley, one now occupied by St Paul's Cathedral and the other due north of London Bridge. The streetscape, from the air, shows how far the actual City is still defined by the Roman and medieval streets and boundaries, including the main streets like Ludgate Hill, Great Tower Street, Aldersgate or Cheapside, and other streets like Minories, Bevis Marks and London Wall, which represent the line of the city walls. This ancient framework is the ghost in the machine of the modern city, but very little Roman fabric survives. There is surprisingly little medieval fabric either – only the Tower, the Guildhall, a handful of churches and one of the City's Livery Halls (the Merchant Taylors') retain any, and not a single medieval house remains. Medieval and Tudor London were destroyed in the Great Fire of 1666 and the City that rose from the ashes was always more about business than pleasure or show, with plain brick houses rising from the narrow medieval streets and alleys. And being a place for business, the houses tended to get rebuilt and replaced. It is also obvious from these views that the City is not a grand royal capital: the packed, narrow streets and the absence of a single decent-sized public space (except for the garden of Finsbury Circus) again speak of a

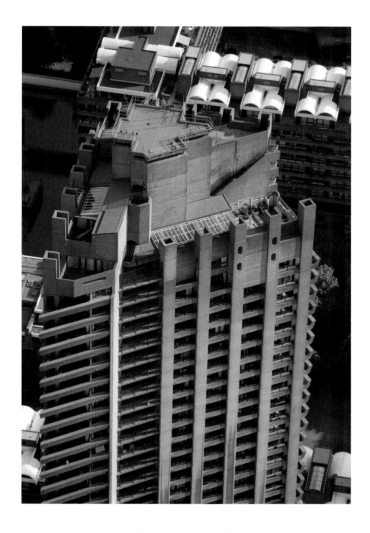

One of the Barbican Towers, City of London, August 2006 [NMR 24425/014]

place dedicated almost entirely to business, rather than to ceremony. Today what remains of the Georgian City is a matter of isolated fragments, with occasional noble monuments like the Wren churches; instead, the City as it appears in the early 20th-century views is overwhelmingly a Victorian place, albeit one built on ancient foundations.

In the older views of the City one also senses how, up to and after the Second World War, it was still a place of overlapping communities: from the wharfingers and warehousemen on the river, to the money-men then clustered in the East Central area, to the national press in Fleet Street, to the book trade north of St Paul's, the butchers of Smithfield, the doctors of St Bartholomew's Hospital and the lawyers in the Temple. This was still a community with a broadly based economy, albeit an economy of specialists. The waterfront, to modern eyes, is particularly startling, with its warehouses still in use and the barges lined up on the foreshore.

Move to the modern photographs of the City and the contrast is abrupt. The wartime bomb damage was followed by a wave of reconstruction in the 1950s and 1960s, but this is put in the shade by the scale of the rebuilding since 1980. The medieval street plan remains there, but in much simplified form, with many of the little alleys and courts built over as the City has needed ever-larger buildings. Today, the Victorian character seen in the early photographs is confined to specific areas and the City, from being a broadly based community, has become home to a monoculture, the greatest concentration of the financial industry in the world. There is little or nothing here to support the idea that London is a city frozen by conservation and deference to the past: it isn't true now and it never has been. The skyline formed by Wren's cathedral dome and his church spires, painted by Canaletto and legible until the Second World War, has been

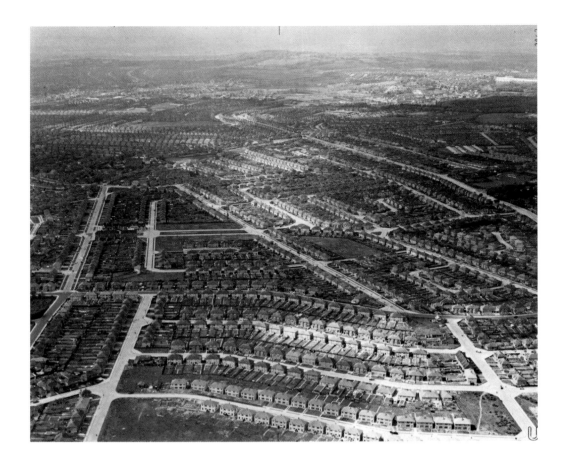

Suburban housing in Crayford, south-east London, 29 April 1949 [RAF/30350/PFFO/0212]

overwhelmed by the vast new buildings. The impact of the modern age – on the City's physical environment as on its human culture – has been tremendous and is accelerating.

If the City as seen in the historic views is mainly Victorian in character on a medieval street plan, then the essential character of the West End is Georgian. There are important Victorian additions and interruptions, but in its scale and street plan, the leafy squares and the even rows of terraced houses, the West End is seen from the air to be the biggest Georgian city of all. Another thing one notices about the West End is how lacking in any real centre it is – its streets are a network with many parallel centres. The official and royal city of Whitehall, Westminster and Buckingham Palace seem isolated from the rest of the West End by the spaces of St James's Park, the Mall and Trafalgar Square. Any sense of direction and pattern, which the great boulevards give to St Petersburg, Berlin, Paris or Vienna, the sense that all roads lead to the great government buildings and palaces, is lacking. The one great equivalent we have, the Mall and the ceremonial spaces around Buckingham Palace, is a brilliant piece of design, but it wasn't created until the 20th century. If you looked at these aerial views of the West End as a stranger and wondered where the 'centre' was, what would you conclude?

This sense of many centres existing in parallel, of a tension between planning and randomness, goes back to the origins of the West End in the Georgian age, when many dozens of builder-developers leased plots from an array of landowners and ran up rows of terraced houses, virtually without planning controls. They were outside the City and all this expansion was governed only by a number of parish vestries. The Georgian West End 'just growed' and, as such, it reflected the energetic and remarkably free (that is to say, unregulated) society which created it.

After the chapter on the West End, the book is structured in four chapters which travel around the outer city. Almost everywhere, the photographs give one the sense that London is an accidental metropolis, a network of towns and villages which have grown together with remarkably little central direction or planning. The Danish architect and writer Steen Eiler Rasmussen sensed this – in his book *London – the Unique City* (1934), he conveyed a vision of the city's civilised and

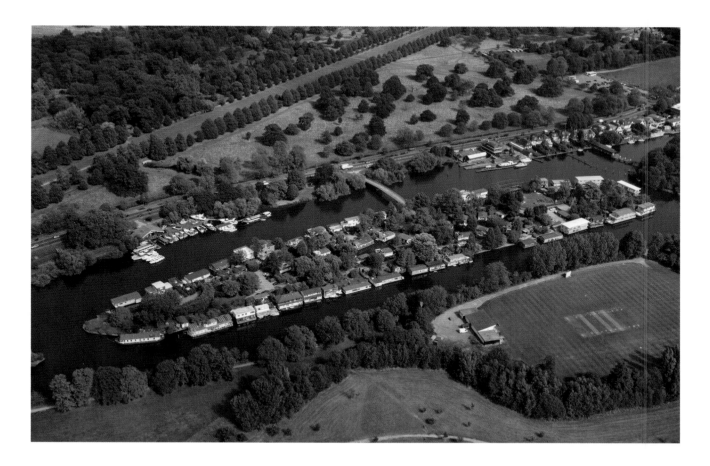

Fagg's Island, Hampton, September 2006 [NMR 24437/017]

humane quality, owed ultimately to its resistance to absolutism, the lack of control by any central authority, the 'low-rise' ethos of the terraced house and the degree to which local character and the sense of neighbourhood had been preserved around its suburbs. In the historic images, the old village centres such as Highgate, Hampstead and Wimbledon are clearly legible from above, the Victorian suburbs wrapped neatly around the medieval centres. Go further out, and medieval town centres such as Uxbridge and Erith read even more clearly. At first sight, Uxbridge might be any market town in the south-east of England. Here, the modern equivalents tell a grimmer story, of the hollowing-out of London's medieval town centres and their takeover by often mediocre office developments.

This book not only traces the geographical structure of London, but it also explores a variety of themes central to the development of the city. Look at the views in detail and one of the great underlying themes is the ubiquity of the terraced house, from the slums of the East End to the squares of Belgravia. This is one of the distinctive English contributions to architectural history, the means whereby the Georgians sought to maintain the values of private life within a vast and teeming city, wholly unlike the more apartment-based models of great continental cities. This legacy, enthusiastically embraced and multiplied by the Victorians, governs much of London's character and the style of life in the city to this day.

Another of the great themes of London's history and identity, which appears time and time again through the views, of course, is that of its greenness, of the English love of nature and determination to remain in touch with it. The great sequence of parks in the West End is unmatched in any comparable historic city. Yet even this is overshadowed by the enormous number of parks and open spaces in outer London. Some, like Richmond Great Park, are the happy legacies of the ancient power of the Crown. Some, like the spacious Baroque landscapes of Hampton Court or Kensington Gardens, bear comparison with the grand formal spaces of Paris. Others, like Clapham Common, Hampstead Heath and Wimbledon Common, have a much more democratic quality, as common lands dating back to Saxon times, whose survival testifies to the determination of their communities to defend them from the greed of owners and developers.

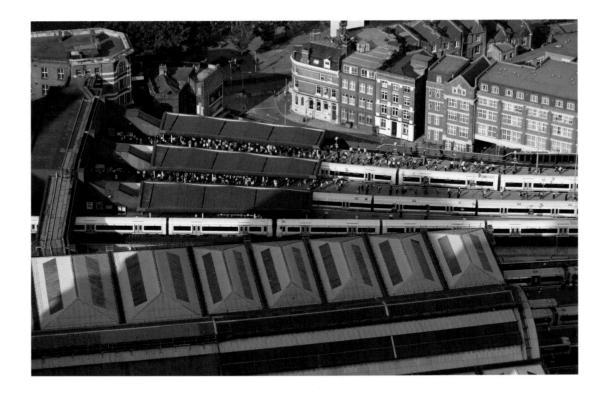

Commuters at London Bridge Station, August 2006 [NMR 24424/018]

 Underneath suburban London, we can fathom an earlier landscape of medieval towns, villages and common lands. Underneath this, there is a more ancient past and this makes sporadic appearances throughout the book: Caesar's Camp, an Iron Age hillfort, appears as a ghostly circular shape in the middle of Wimbledon Common; a Saxon barrow cemetery appears as a series of bumps in Greenwich Park; a prehistoric forest appears in the Thames foreshore at low tide below Erith. Yet these are isolated incidents. The common unifying character of suburban London as it appears in these views, again and again, is Victorian. Victorian terraces hem in the ancient common at Clapham. Victorian houses have colonised the streets of medieval villages such as Hampstead and Highgate. The hilltop of Harrow is dominated by the fine Victorian buildings of the school. Victorian industry transformed places further east like Crayford. Victorian pursuits and sports define the character of many London suburbs and remind us of the immense range of their interests and achievements: cricket at the Oval in Kennington, lawn tennis at Wimbledon, racing at Kempton Park, association football at Stamford Bridge, the Royal Botanic Gardens at Kew. Pleasure domes and entertainment complexes – at Alexandra Palace, the Crystal Palace, White City and Wembley – further testify to Victorian creativity and prosperity.
 The railways – built by the Victorians and the defining institution of their age – have also been a major influence on London's development. In some places their impact was devastating, drawing a tight noose around Southwark Cathedral, destroying Hungerford Market to make way for the Charing Cross Bridge or demolishing half of the poor suburb of Somers Town to clear a way for the new terminus of St Pancras. More generally, though, the impact of the railways was convulsively creative, turning the green fields of Middlesex, Kent, Surrey and Essex into rows and rows of neat streets of brick houses, the endless suburbs where 6 million people (or so) live. Below the level of the towns like Uxbridge and Richmond and the villages like West Drayton or West Ham, the suburban flood submerged hundreds of hamlets and farms – places which were hardly places at all suddenly had thousands of inhabitants, schools, churches and shops, and their builders had to find names for them, whether from the rural past or their own imaginations. London's suburbs have great shoals of names, more than anyone except a very well-informed taxi-driver could ever know. A simple demonstration of this for Londoners: take a copy of the London A to Z and open it randomly three times; the likelihood is that by the third opening, you will have found at least one park, one railway station and a whole suburb that you have never heard of before.

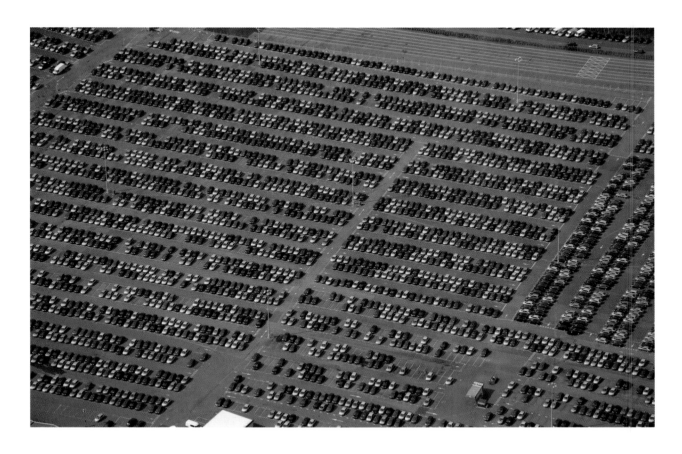

Cars parked at Dagenham, August 2006 [NMR 24400/029]

However, the river was the city's original *raison d'être,* and its biggest influence. In the 19th century London was the greatest port in the world, the point of origin of the British Empire. The archive views throughout this book show the Thames still full of shipping and moored barges. By the 19th century the waterfront itself was no longer adequate to serve London's growing global trade and the construction of enclosed docks began on the Isle of Dogs, in Wapping and in the Surrey Docks. The aerial views convey the complexity and tremendous scale of these docks – when the Port of London Authority handed over its property to the London Docklands Development Corporation in 1980, the area assigned to the LDDC was larger than the twin cities of London and Westminster put together. In other great cities, the largest designed landscapes are boulevards or squares, like the Champs-Élysées in Paris or the Ringstrasse in Vienna; in London, the largest designed landscapes are the docks.

As the historic aerial views show, the docks were surrounded by industry on a huge scale. Traditional interpretations of British history tend to present London as a commercial and financial centre, in contrast to the industrial cities of the Midlands and the north. The aerial views show a very different reality. In the dark and crowded cityscapes of the Lea Valley and the docks, great numbers of small workshops, factories and warehouses jostled with the terraces of little houses. There were huge establishments as well, such as the Royal Arsenal at Woolwich, the largest arms factory in Britain; the Ford plant in Dagenham, at the time it was built the largest single factory in Europe; the East London Gas Light and Coke Company's works at Beckton, when it opened in 1870 the largest gasworks in the world. Silvertown – south of the Royal Docks and London's grimmest industrial suburb – has a skyline straight out of the Black Country. Further afield, we see the sites of Britain's first large public power station at Deptford and one of the first aircraft factories at Hendon.

So London was a great industrial city. It was also a martial place, capital of the greatest power in the world, and this theme, too, emerges time and time again from the views. The Arsenal at Woolwich was the Georgian and Victorian empire's greatest munitions factory and up the hill at Woolwich Common we see the immensely impressive Royal Artillery Barracks and the old Royal Military Academy. At Greenwich, the old Royal Hospital was turned in 1873 into the Royal Naval College, where the navy trained its officer cadets.

The Thames estuary (north is to the right), 29 April 1949 [RAF/30350/SFFO/0241]

In the 1940s, when many of these photographs were taken, the whole city was of course at war, not just the soldiers and sailors. London's greatest historical trial was in 1940–1 and also its historic apotheosis, as the citadel of freedom and the prime seat of resistance to the evil of Nazism. The signs of this can be seen in many images, from the bomb-nets above the Treasury to protect the Cabinet War Rooms, to the anti-glider defences dug in the city's parks and open spaces when the threat of invasion was at its height. Key buildings, such as the Fairey aircraft factory in Harlington and the Stonebridge Park Power Station, are seen painted with camouflage to protect them from the bombers. Britain's plight can also be seen in the large areas of park and common land which have been dug up for allotments: London was digging for victory. London was also suffering in 1940–1 from the heaviest bombing that any city had yet experienced. The results of this, too, can be seen in many of the pictures. We see the City of London with whole blocks of buildings gone, and the superb Baroque churches of St James, Piccadilly, and St John, Smith Square, bombed and burnt out.

London was the centre of Britain's fight for national survival in 1940 in more ways than one. During the Battle of Britain, four of Fighter Command's airfields were within the modern boundaries of Greater London: Northolt in the west, Kenley and Biggin Hill in the south, and Hornchurch in the east. All are represented in the book, and in these views they bear the visible scars of that great struggle. The trials of the war, above all, can be seen in the empty spaces of the bombed city in 1944 and in the great holes torn in the fabric of the East End as photographed in 1947–8, where whole streets of houses are missing.

Compare the historic views to the modern ones and we also see that of all these great commercial, military and industrial places, few seem to survive in their original uses other than the railways and the waterworks. The Arsenal at Woolwich, the Ford factory at Dagenham, Battersea Power Station, the docks themselves – all have closed and moved on. Even the Royal Artillery are due, at the time of writing, to leave Woolwich soon. London does not stand still and even when the physical fabric survives, its function and meaning changes.

Perhaps the biggest single change, however, is in the city's relationship to the Thames. The river gave birth to the city and its trade was the ultimate basis of London's economic life for a thousand years. In the modern views the river is almost empty: the city seems to have turned its back on the Thames. The resurgence of Docklands since the 1980s might seem to say otherwise, but the patterns of use are now radically different. The docks have been tamed, reduced in scale, turned

Footballers on Hackney Marshes, October 2006 [NMR 24394/047]

into marinas and, in many cases, filled in altogether. Fine paths have been developed along great stretches of the Thames – the riverfront is now for pleasure, for looking at, no longer for business. When the West India Docks were built in 1797–1806, the scale of the achievement was heroic: these were the largest excavated docks in the world. Today Canary Wharf rises out of them; this is still a pre-eminent home of international trade, but this has migrated from the tangible – the sacks of sugar, pepper and tobacco – to the intangibles of foreign exchange, banking and derivatives. The short-haul aircraft of the City Airport – situated where the cargo ships used to tie up – now take businessmen to the continent. The docks have gone from being the world's greatest port to being Britain's largest water features.

The river may seem to have been marginalised, even trivialised by all this, but the city starts and finishes with its geology and the river will probably be there when London, at whatever immensely distant date, is no more. One modern view shows the prehistoric stumps of oak, yew and alder trees revealed by extreme low water on the foreshore at Erith – 4,000 years ago there was a dense forest growing there. Another shows the huge area flooded by the river in 1953. London stands on a gradually sinking coast. The Thames Barrier, arguably the most important single structure in the city, was built as a direct response to the disaster of 1953. The Thames Barrier has now been raised at least 100 times since its construction and is raised once a month for testing purposes. Its design life runs until 2050; the Environment Agency is already planning its replacement.

On the political front, London has also been through several transformations. The City has been governed by its mayors and aldermen since the medieval period, but their writ only ran within its ancient boundaries. The city's fluid boundaries reflect its fluid identity. In the 16th-century maps of Agas, or Braun & Hogenberg, we see a city still contained and rendered legible by its medieval walls and gates – though already, ribbons of development were extending along the main roads out of it. By the late 17th century London was expanding beyond its walls – they had become an irrelevance and were progressively destroyed. On the continent, in contrast, walls continued to define most major cities well into the 18th and even the 19th century, remaining massive features in their topography. By the mid-18th century London was growing so fast that there was a good deal of ambiguity about where it began or ended. The great cartographer John Rocque, making his map of London of 1746, could no longer centre it on the City and had to take in the West End as well; and for good measure he published a second great map of 'ten miles round London' as if to acknowledge the wider metropolitan area.

It seems paradoxical, when one thinks about it, that during the 18th century and well into the 19th, Westminster, Whitehall and the West End could house the royal court, the government of a great empire, most of its main cultural institutions, the cream of British society and a huge population, but in formal, institutional terms they hardly existed as a place at all: they weren't even a town, merely a series of neighbouring parishes in the old county of Middlesex. Westminster was incorporated as a City in 1900. By then, in a rather nicely British touch, the name had already been adopted as a title by the aristocratic Grosvenor family, who happened to be the area's largest private landowner, as marquesses (1831) and dukes (1874) of Westminster.

Georgian and early Victorian Britain was the most liberal economy in the world and to many people this laissez-faire approach to urban government probably seemed natural enough. They paid their parish rates and the parish vestries were responsible for more or less the whole range of public services: they paved and lit the streets, ran sewer commissions and turnpike trusts, organised the 'watch' (the police of the day), ran primary schools after a fashion and provided relief for the poor, up to a point. The services could be fairly scanty, but there was no one else to provide them. This is not to say, though, that the metropolis lacked problems: there were legions of them. As London grew and the problems escalated, the national government was forced to intervene. London's endemic criminality was running out of control and in 1829 the Home Secretary, Sir Robert Peel, instituted the Metropolitan Police. By the 1840s the city's streets were filthy and choked with traffic, its appalling water supply was threatening to poison everyone, its sewers and cesspits were overflowing and the Thames was full of human and other sewage. In 1852 Parliament forced the water companies to clean up their act and in 1855 it formed the Metropolitan Board of Works and turned the main 28 parish vestries into proper elected bodies. In 1875 the Metropolitan Board of Works' chief engineer, Joseph Bazalgette, completed the heroic task of creating the main sewers, which serve London to this day. So finally Londoners got proper drains and cleaner water. And from 1870 the School Board of London set to work to do something about the state of young Londoners' minds too – it had built 469 new schools (and counting) by 1904.

The spirit of improvement accelerated markedly from 1889, when the Metropolitan Board of Works metamorphosed into the London County Council (LCC). Then in 1900 the old parish vestries turned into proper metropolitan boroughs, with town halls and real powers of their own. The name 'City of London' was already taken, as it were, and maybe there was also a sense that the metropolis had simply grown too big to be designated as a 'city' in any case. So a new county of London was carved out of the historic counties of Middlesex and Surrey, and at last London got a unitary authority that was really up to the task of running it and bringing order and civilisation to the lives of all its inhabitants. A little later, work began on County Hall (1909–33), and at long last the city had a great emblematic building to represent itself, the old Guildhall having, for all practical purposes, been left behind centuries ago.

So by the early 20th century, London seemed at last to have acquired a metropolitan identity and its localities had a growing sense of local identity thanks to the metropolitan boroughs. Victorian improvement was gradually tackling the huge legacies of Georgian neglect. In 1965 the LCC was replaced by a beefed-up and greatly enlarged successor, the Greater London Council (GLC). Middlesex disappeared in the upheaval and further great tracts of Kent, Surrey and Essex were annexed. The capital was reinvented, growing from 117 square miles to 610, with its population rising to over 7 million. The little late Victorian boroughs were merged into 30 big new ones (in addition to the old cities of London and Westminster), each with the population of a large town. London now seemed to exist as a metropolis at every level and as a topographical county covering most of the built-up area, with a mammoth county bureaucracy sitting above a tier of local authorities and a platoon of statutory bodies to deal with education, fire, civil defence, water supply, gas supply, the drains, electricity and anything else one cared to mention.

So far, so good – but nothing is forever and certainly not where London is concerned. The abolition of the GLC by the Conservative government in 1986 should have seemed like the end of civilisation: the council's powers were scattered to the boroughs and any number of other bodies, with nothing and no one to coordinate them, yet in the event the city seemed to shrug the change off almost carelessly. London was, in fact, poised for its greatest burst of economic growth and prosperity since Victorian times, which has continued with one interruption to the present day and has by now made the city the unofficial financial capital of the world. One consequence of the abolition was that there was no central planning body in the 1980s and 1990s to arbitrate between the old City's claims to monopolise the financial industry and the rise of new areas, in particular Canary Wharf in the east. The creation of the London Docklands Development Corporation, with a brief to regenerate the vast, derelict estate of the old Port of London by selling the land cheap and drastically reducing planning controls, could be seen, in hindsight, as a reversion to a Darwinian-competitive approach to urban planning, a positively Georgian way of doing things.

Since then the political pendulum has swung back somewhat with the creation of the Greater London Authority. The GLA is a far cry from the mighty and ubiquitous GLC: so far, it has impinged on Londoners' consciousness primarily through its running of the city's transport networks – in particular by imposing the congestion charge for road vehicles in central

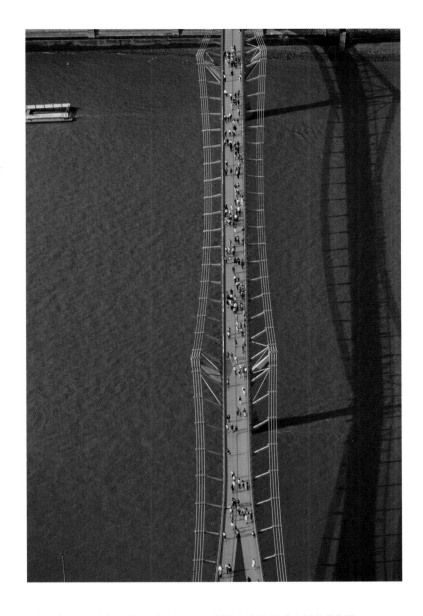

The Millennium Bridge between the City and Southwark, August 2006 [NMR 24422/020]

London – and through its surprisingly small headquarters building opposite the Tower of London. London's contemporary icons are characteristically odd. The GLA building, which one would think ought, institutionally, to have the role, is little admired and is overshadowed in the public eye by the Canary Wharf Tower, the Swiss Re Tower and the London Eye, all of which are private developments. The Millennium Dome, the last great attempt by central government to act as patron of the arts in central London, was widely reviled and stood empty for many years. The London Eye, a symbol of modern leisure, fills the views across the river from Westminster. It looms over County Hall, the building which once symbolised the city's long struggle to achieve rational and ordered government, but is now a luxury hotel with a giant aquarium attached. And to take a few more symbols: you haven't been able to walk past the door of 10 Downing Street for 20 years; the Routemaster bus is no more; you hardly ever see a bowler hat in public; red telephone boxes are on their way out as no one uses public telephones any more; more people drink coffee in the daytime than tea nowadays; and even the Cockney sparrow is said to be in danger of extinction. One might regret any and all of these developments, but London just seems to absorb them and move on: the city is bigger than any of its symbols. It is not a sentimental place.

London has no one founder. It has no one dominant myth or symbol, but a shifting kaleidoscope of them, depending on who you are. It has no centre, and no really solid boundaries. It has exported the English language around the world, but it now has 300 languages. It is a modern Babel, mecca for ethnic communities from around the world, essential stopping-off point for jet-setters and a home from home for the super-rich of Russia, the Gulf, India, the Far East and the United States. In its fantastic progress towards international status, the city has become somewhat detached from the rest of England, so that in many ways it feels more like a city-state and an international enclave than a national capital. There is a sense in which London, like the English language, has been taken from the English and given to (taken by?) the rest of the world. Thus the English people's imperial triumphs, at long last and in paradoxical form, have rebounded upon them. Two things that for many other nations are among the principal repositories of their national identity and culture – their language and their great city – have been globalised. The city, in its international reputation, is now bigger than the country. This, surely, has something to do with the difficulty that is sometimes remarked on in defining English or British culture. It is not something to fear; it is a measure of success. This is London. Deal with it.

In all the shifts and complexities of London's history, the name is its centre, the one still point, and even that is mysterious: we have counted several different interpretations of its origin. No one could write the city's history definitively, any more than you could write a definitive history of humanity. The world in 610 square miles. Mirror of humanity. Infinite London.

A note on the photographs and aerial photography

This book arose from a desire to explore London's development as seen 'shot from above'. By comparing the older archive images from the 1900s to the 1950s with the modern aerials, London's transformation becomes apparent. The early Royal Aeronautical Society (RAeS) photographs chosen for this book were taken from balloons, reflecting the enthusiasm for the sport in the Edwardian period. A small group of enthusiasts, the most notable individual being the engineer Charles Stuart Rolls, bought hot-air balloons, filled them with gas from London's gasworks, enjoyed champagne picnics at 5,000ft and started taking glass-plate negatives with the cumbersome box cameras of the age as mementos. They founded the RAeS, whose archive houses the one large collection of these images.

The majority of the photographs in this book – including the images from the R H Windsor Collection, taken in the 1930s – are selections from the National Monuments Record (NMR), the public archive of English Heritage. The R H Windsor views, like the balloonists', tend to concentrate on well-known sights and places in London and the south-east, though there are some startling exceptions. The R H Windsor Collection was formed with private resources and is on a relatively limited scale with 174 prints held by the NMR. The bulk of the NMR collection of archive aerial photographs consists of images taken by the RAF from the 1940s onwards. During the Second World War the Allies made extensive use of aerial photography to gather intelligence. Photographic Reconnaissance and Photographic Interpretation evolved into a remarkably efficient operation. The Photographic Reconnaissance Unit undertook the flying coordinated by its headquarters at RAF Benson while the interpretation was undertaken by the Central Interpretation Unit (CIU), which had its headquarters at Danesfield House, Medmenham, in Buckinghamshire from 1941. The 'M' section at RAF Medmenham was responsible for British aerial imagery and it is this photography that forms the bulk of the wartime images in this book. In the early part of the war the photography was done for training purposes, to assess wartime defences, to check the effectiveness of camouflage on strategically important buildings such as the Fairey aircraft factory at Harlington and to assess the damage caused by German air raids. The photography was a mixture of vertical photographs (photographs taken from cameras looking straight down from several thousand feet) and oblique photographs (taken at an angle forming a more familiar viewpoint and usually taken at much lower altitudes).

From 1943 an important reason for taking the photographs was to assist civilian planners in rebuilding the country. After the war, in the absence of any civilian aerial reconnaissance capability, the Ministry of Housing and Local Government and then the Ordnance Survey coordinated the RAF's photography of Britain. Between 1944 and 1949 the RAF photographed most of the country and continued this survey through to 1954. The surviving films and prints of England, together with later photography, are now held at the NMR. The physical condition of the prints and negatives varies greatly. The processing of vast numbers of prints was not for long-term usage; therefore some of the prints in this book show signs of decay, including browning, fading, surface contamination and curling. (The prints are now stored in the archive of the NMR where conditions will extend their life and delay the onset of decay.)

Several personnel with photographic reconnaissance experience during the war went on to play an important role in developing aerial photography for archaeology. Aerial reconnaissance and photo interpretation are still used today to discover new archaeological sites and to record and monitor the condition of the historic landscape. The modern photographs in the book have been taken by English Heritage's Aerial Survey and Investigation team as companions to the archive images, either reproducing the older view as closely as possible or drawing out interesting details and changes related to the paired archive image. The modern views are also archived by the NMR. To date the NMR holds about 700,000 obliques and over 2 million vertical photographs, about 70,000 of which cover Greater London.

The NMR collection may be consulted at English Heritage's office in Swindon. Telephone 01793 414600, email nmrinfo@english-heritage.org.uk or visit our online gallery www.english-heritage.org.uk/viewfinder. If you would like copies of the NMR photographs in this book please call enquiries on 01793 414600, quoting the reference numbers at the end of the image captions.

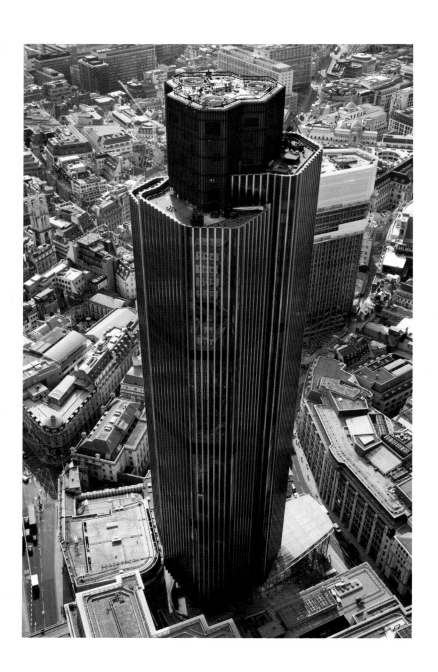

< THE CITY >

①

The City from high up, Liverpool Street Station at the centre, c 1930s

The Square Mile: bright sunlight falls on the heart of the City in this view, which captures almost the whole of Roman Londinium, from St Paul's in the west to the Tower of London in the east. London Bridge, at bottom centre, marks the place of the Roman bridge, built on the most easterly viable crossing-place over the river where an island rose out of the mudbanks in what is now Southwark. This determined the site of their city and everything that has followed since. The dramatic impact of the railways in the 19th century is conveyed by the bulk of London Bridge Station (at the bottom of the image), where the city's first terminus (that of the London & Greenwich Railway) opened in 1836, much extended by the two rivals – the London, Chatham & Dover and the South Eastern Railway – which shared it. [R H Windsor Collection, TQ 3381/1]

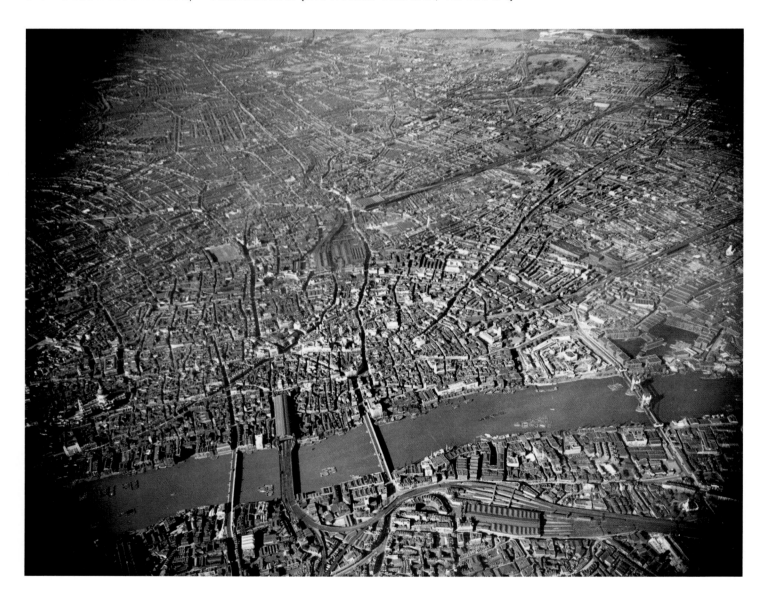

The City from Southwark looking north, August 2006

The Eastern City is the heart of Europe's greatest financial centre: from this lower viewpoint, its boundaries are roughly conveyed by the towers and high-rise buildings. The surviving medieval monuments – Southwark Cathedral at lower left and the Tower off to the right – are dwarfed in comparison. The tower of Guy's Hospital (Watkins Grey Woodgate International, 1963–75), one of the tallest medical buildings in the world, looms brutally above the orderly courtyards of the Georgian hospital (1721–77) to its left and over the confused and confusing townscape around London Bridge Station. [NMR 24424/016]

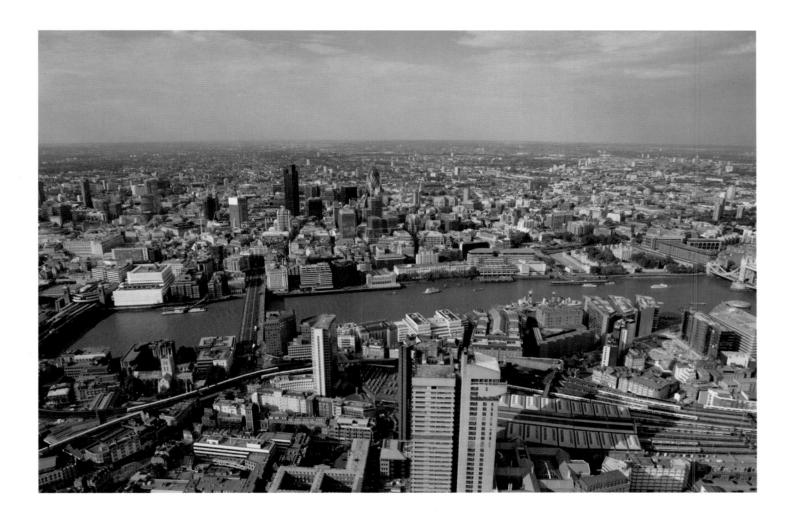

The Thames with Southwark Bridge, Cannon Street Station and London Bridge, c 1930s

The City's waterfront, still a working area of warehouses and wharves, is punctuated by the bars of Southwark Bridge (Mott, Hay & Anderson, 1912–21), Cannon Street Railway Bridge (Sir John Hawkshaw, 1861–5) and the second London Bridge (John Rennie Junior, 1823–31). The plight of Southwark Cathedral, originally the Priory Church of St Mary Overie, imprisoned between warehouses and the South Eastern Railway's viaduct at Borough Market, conveys the 19th century's laissez-faire disregard for organised town planning. [R H Windsor Collection, TQ 3280/3]

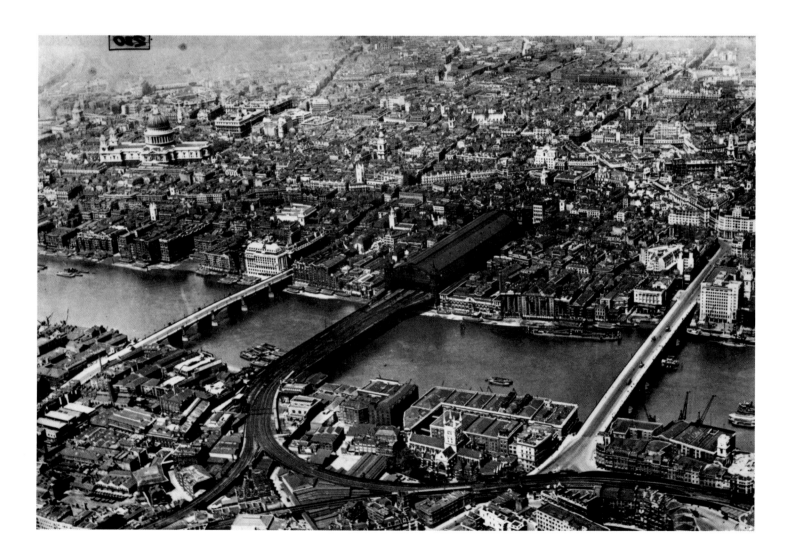

Looking downriver from the Blackfriars bridges towards Tower Bridge, August 2006

Until the 18th century, London Bridge was the only fixed crossing over the Thames below Kingston. The present proliferation of bridges can be seen in this view, from the bottom of the image upwards: Blackfriars Bridge (road) and Blackfriars Railway Bridge (see pp 28 and 29); the Millennium Bridge (see p 27); Southwark Bridge; the Cannon Street Railway Bridge; London Bridge; and Tower Bridge (see p 49). The present London Bridge is the seventh or eighth on the site; like the song says it has indeed fallen down on more than one occasion. The first was a Roman timber bridge of the 1st century AD, which may have been maintained right through Saxon times; more probably it was rebuilt during the Saxon period though we do not know when. The bridge was burnt by Viking invaders in 1014 and rebuilt, destroyed by a gale in 1091 and rebuilt, and burnt in 1136 and rebuilt again. All of these manifestations of London Bridge were timber, probably reusing earlier piles to some extent. The first masonry bridge – the famous London Bridge with 19 arches – was begun in 1176 and finished around 1209, one of the great feats of medieval engineering. The old bridge survived until its removal and replacement with a noble 5-arched structure by John Rennie Junior in 1823–31. Because its foundations were being weakened by tidal scour, Rennie's bridge was removed and re-erected in Lake Havasu City, Arizona, USA. The present bridge, an undemonstrative concrete structure, dates from 1967–72 (Mott, Hay & Anderson). [NMR 24433/013]

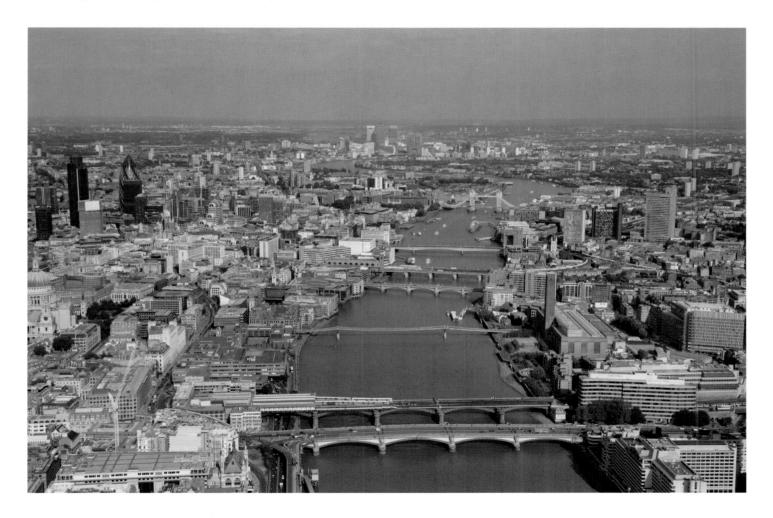

St Paul's Cathedral from the south, c 1930s

A coronal cluster of steeples tall … and high over all, the Cross and the Ball, on the riding redoubtable Dome of St Paul.

(A New Song on the Bishop of London, J C Squire, 1930s)

Sir Christopher Wren's sublime masterpiece appears here surrounded by his attendant spires of (clockwise from upper right), St Vedast, Foster Lane; St Augustine, Watling Street (just visible close to the east end of the cathedral); St Nicholas Cole Abbey (the square tower, its grey spire hardly visible, just below); St Mary Somerset with its tall finials (the bulk of the church had gone in 1869); St Benet, Paul's Wharf (hard to see, directly below the cathedral's west towers); St Andrew-by-the-Wardrobe (just left of the aggressive white bulk of the telephone exchange); St Martin, Ludgate Hill (white tower and dark spire, left centre); and Christ Church Greyfriars, Newgate Street (the spire appearing just above the cathedral nave). The wonderful views of the cathedral surrounded by Wren's towers and spires survived until just after the Second World War. [R H Windsor Collection, TQ 3281/2]

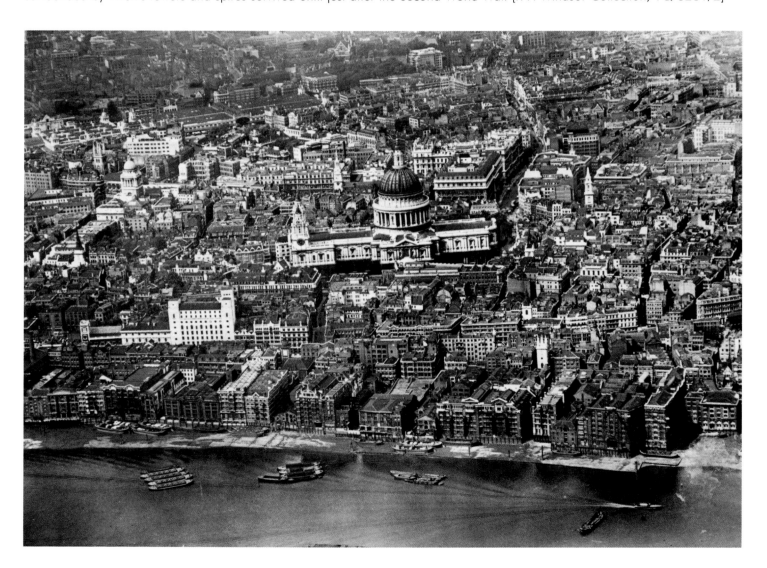

Looking north over Tate Modern towards St Paul's Cathedral, August 2006

The western half of the City doesn't rise nearly so high as the eastern, thanks to planning policies designed to protect the setting of St Paul's. Even so, the scale of the buildings has increased and the surviving Wren churches are now difficult to pick out. There has been a more or less clean sweep of the Victorian riverfront on the north bank of the Thames, from the Blackfriars bridges on the left to Southwark Bridge on the right; the modern replacements are a mediocre bunch, which in no way live up to their magnificent riverfront site. The south bank is far more rewarding, dominated by the heroic bulk of Sir Giles Gilbert Scott's Bankside Power Station (1957–60), triumphantly reborn as Tate Modern (Herzog & de Meuron, 1996–2000), and the delightful reconstruction of Shakespeare's Globe (opened 1997, Theo Crosby with Jon Greenfield), just to its right. The Millennium Bridge (Arup Associates with Foster Associates, 1999–2000), at the centre, for all its initial difficulties, can justly be described as a triumph of engineering artistry. [NMR 24422/016]

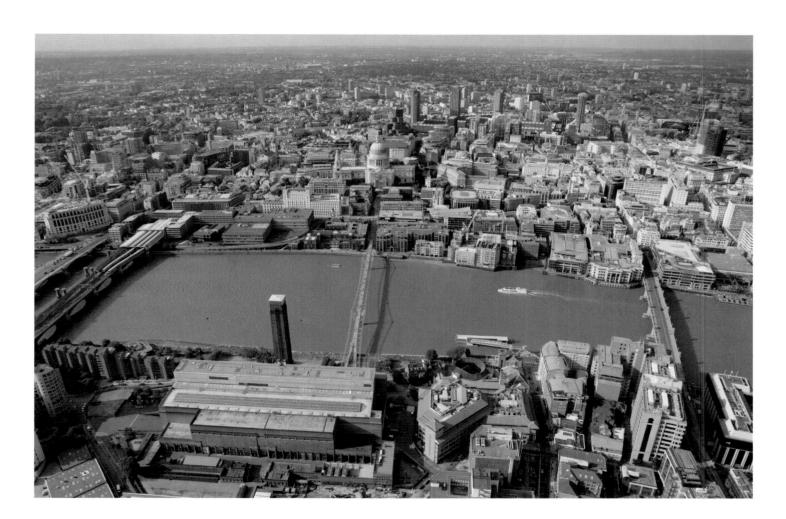

Blackfriars Bridge and railway bridges, c 1930s

The district of Blackfriars was named for London's Dominican friary, midway between the railway lines and St Paul's in this picture. The first Blackfriars Bridge, built for road and foot traffic, was designed by the engineer Robert Mylne in 1760–9. It was paid for, somewhat bizarrely, from the fines exacted from rich Londoners refusing the time-consuming and onerous office of sheriff. Joseph Cubitt built its handsome Gothic Revival replacement, with a certain chronological symmetry, in 1860–9. The imposing classical bulk of Unilever House (J Lomax Simpson with Burnet, Tait & Partners, 1930–2) would have been very new when this picture was taken, hence its dazzling whiteness; the spire of Wren's St Bride, Fleet Street, rises behind it.
[R H Windsor Collection, TQ 3180/1]

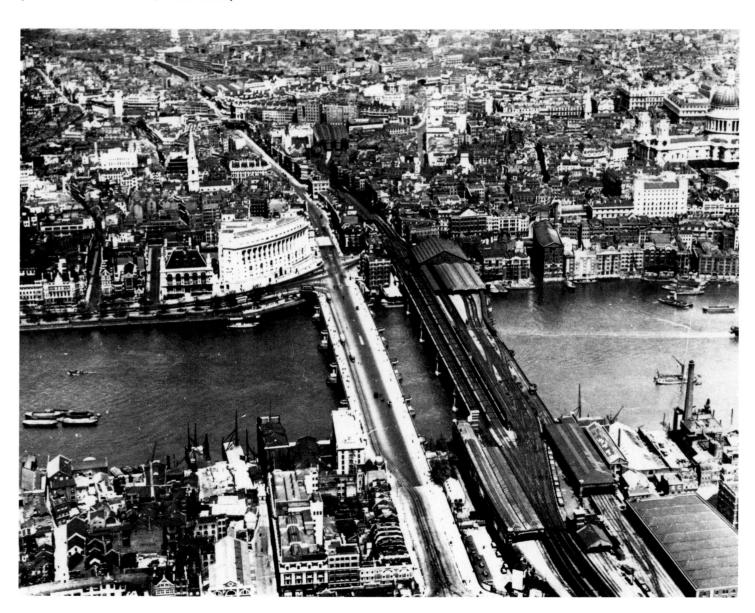

Looking north-east over the Blackfriars bridges towards the City, August 2006

The first Blackfriars Railway Bridge – the remaining columns to the left of the railway bridge in this picture – was built for the London, Chatham & Dover Railway to give them a station on the north bank of the Thames connecting with the Metropolitan Railway. It was designed by Joseph Cubitt and F T Turner in 1862–4. The second bridge – again called the Blackfriars Railway Bridge (John Wolfe Barry and Henry Marc Brunel, 1884–6) – was added by the allied Holborn Viaduct Station Company. The magnificent cast-iron columns of the first railway bridge now stand disused and isolated, and recent proposals for a new 'living bridge' here have so far come to nothing. [NMR 24422/010]

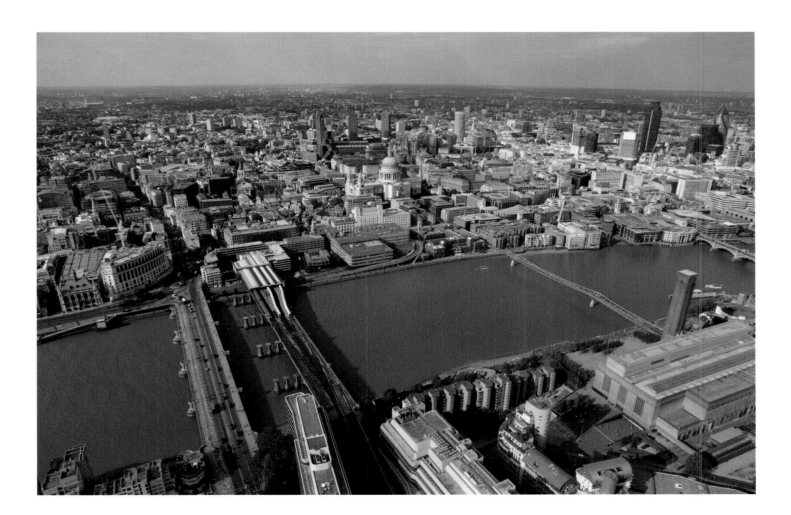

Fleet Street and the Law Courts from the west, c 1930s

The eastern end of the Strand: as its name suggests, this was originally the river foreshore. Just beyond the Law Courts, at the centre of the picture, is the site of Temple Bar, the City gate which was removed in 1878; this is where the road enters the City of London and turns into Fleet Street. To the right is the picturesque townscape of the Inner and Middle Temple. The Knights Templar established their church and house here in the 1160s; when they were dissolved in 1312 the estate passed to the Knights of St John, the rival crusading order, and by the end of the 14th century, the first lawyers and students were moving in as their tenants. This has been the heart of legal London ever since. However, to attend court the lawyers always had to travel to Westminster, until the construction of the magnificent Gothic Revival Law Courts (George Edmund Street, 1874–82), one of London's great Victorian masterpieces. [R H Windsor Collection, TQ 3181/2]

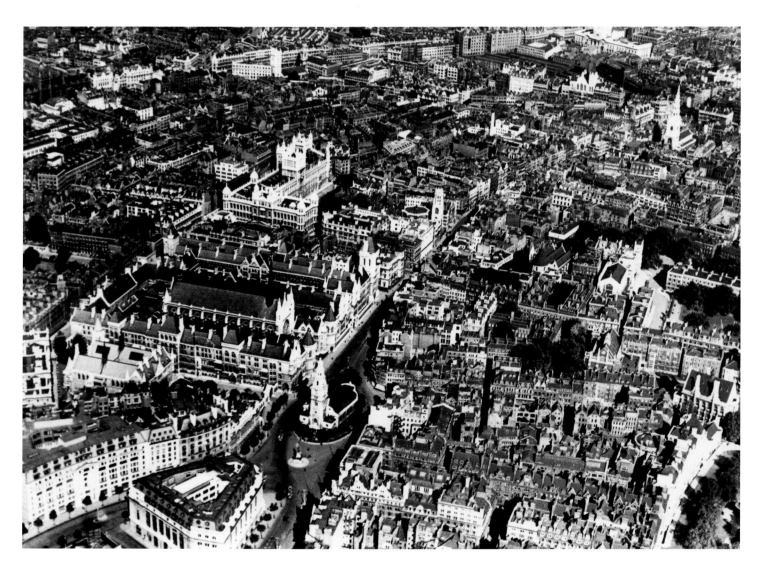

Looking east over the Temple area with Fleet Street to the left, August 2006

The trees, historic streetscape and the domestic scale of the Temple buildings appear as a welcome oasis in comparison with the arid concrete blocks of the City rising beyond. The gabled roof of Middle Temple Hall of c 1573 can clearly be seen at the lower centre of the picture; Shakespeare's *Twelfth Night* was premiered here on 2 February 1601. Immediately above is the rectangular block of the Inner Temple Hall; its Victorian Gothic predecessor, seen in the historic picture, was devastated in the Blitz and rebuilt in a simple classical style by Sir Hubert Worthington in 1955. The Temple Church, with its rotunda and its rectangular nave beyond, was built by the Knights Templar early in the 13th century in imitation of the Church of the Holy Sepulchre in Jerusalem. [NMR 24421/027]

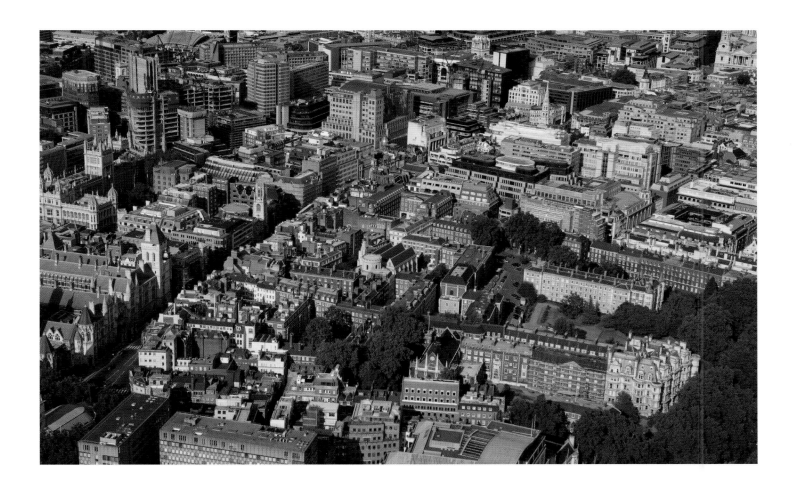

The Law Courts and Chancery Lane from the south, c 1930s

The contrast between the domestic scale of the late 17th- and 18th-century houses of the Temple quarter and the giant scale of the grand Victorian institutional architecture animates this view of the 1930s. George Edmund Street's Law Courts are complemented by the more rectilinear bulk of the Public Record Office on Chancery Lane by James Pennethorne, built in stages between 1851 and 1896. Victorian self-confidence demolished the medieval Inner Temple Hall in 1865 and replaced it with the larger, pinnacled building seen in the lower right-hand corner. [R H Windsor Collection, TQ 3181/5]

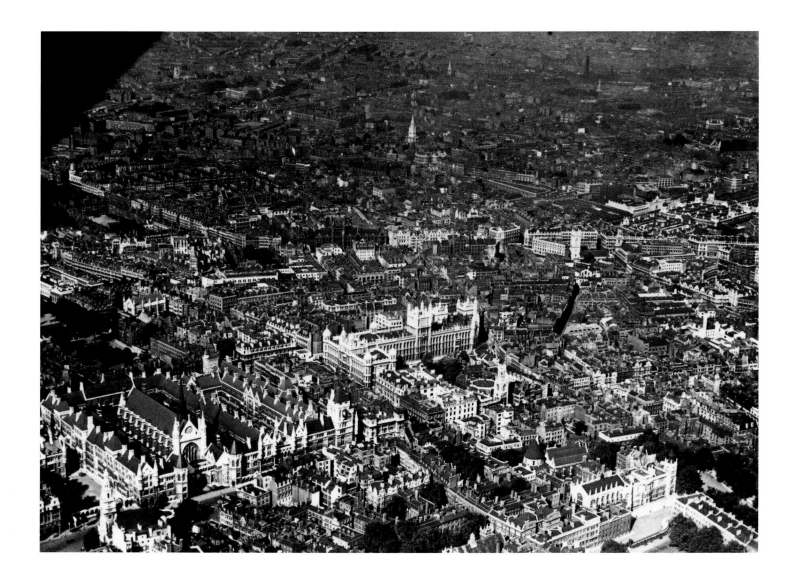

The Law Courts, August 2006

Until 1882, Britain's highest courts of law had always been grouped around Westminster Hall in the Palace of Westminster. By the mid-19th century they were so crowded and inconvenient as to oblige the Crown and the legal profession to think again; therefore, at huge cost, a site on the Strand was purchased so as to be close to the Inns of Court and the Temple, which had long been the homes of the legal profession. An architectural competition was held, which proved to be one of the great highlights of the Gothic Revival, with numerous spectacular designs being entered. The church architect George Edmund Street won and spent the rest of his life embroiled in the struggle to realise his design. The foundations were laid in 1871, but building the huge complex was horribly complicated by delays, changes to the brief, labour problems, the inadequacy of the main contractor and the parsimony and interference of Gladstone's 1868–74 government, above all from the Secretary to the Office of Works, a pestilential micro-managing bully called Acton Smee Ayrton. Queen Victoria opened the building in 1882, but Street had died of a stroke the previous December. He had created one of the great Victorian public buildings of Britain, but many believed it had been at the cost of his life. The vaulted central hall, which he had battled to defend and build and which appears prominently in this view, is one of the great interiors of London. [NMR 24433/008]

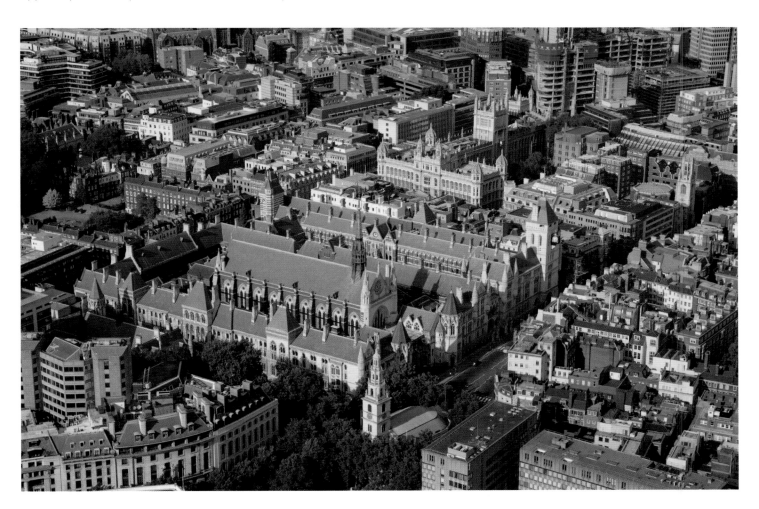

Blackfriars and St Paul's Cathedral from the south-west, c 1930s

St Paul's and the western City from above the river. The strangest thing to modern eyes about this image is perhaps the warehouses and the Thames at low water, with the empty barges beached – at the time this was still a working waterfront. The dense, medieval street plan of the City is clearly legible, cut through by New Bridge Street (to the left), built in 1764 as an approach to the new Blackfriars Bridge, and Queen Victoria Street (heading diagonally up to the right below St Paul's), cut through in 1867–71 to link the new Embankment with the heart of the City. The narrow and intricate lanes around Paternoster Row, just above and left of the cathedral, were for centuries the heart of the book trade; they burnt especially fiercely in the Blitz. [R H Windsor Collection, TQ 3281/3]

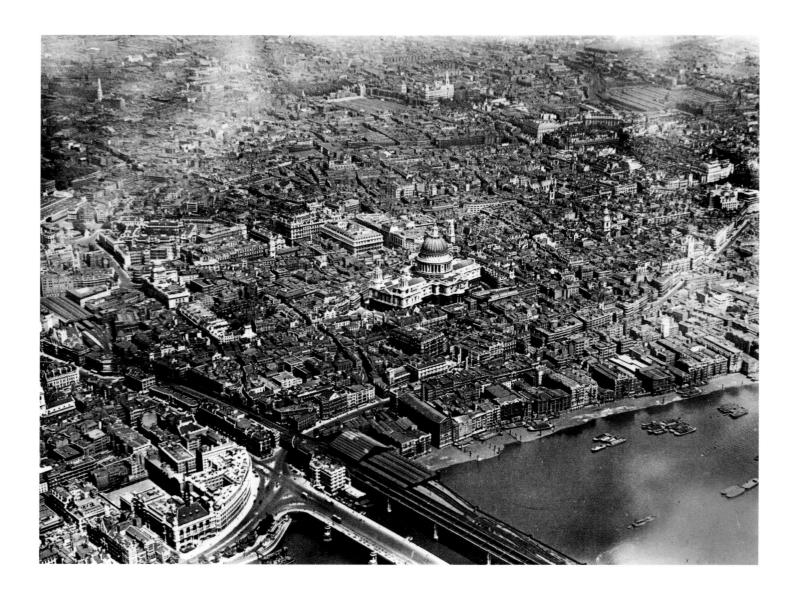

St Paul's Cathedral from the south-west, August 2006

St Paul's appears as if afloat in a sea of post-war reconstruction. The quickening pace of urban redevelopment has meant that the Paternoster Row area, devastated during the Second World War, has been completely redeveloped twice. In the 1960s the medieval street plan was completely wiped out and a huge development with a new elevated square surrounded by big grey blocks was built – it was much admired in the architectural press (Sir Nikolaus Pevsner described it as 'outstandingly well conceived'). In a pattern seen in many other places, the 1960s Paternoster Square became obsolete and reviled in record time and has itself been completely replaced by something equally large in scale, but somewhat more varied and humane in design. The curved, brick-faced block immediately to the right of the cathedral – the New Change Buildings (Victor Heal, 1953–60) – is likely to go the same way fairly soon. The pace of architectural change has never been so fast. [NMR 24433/018]

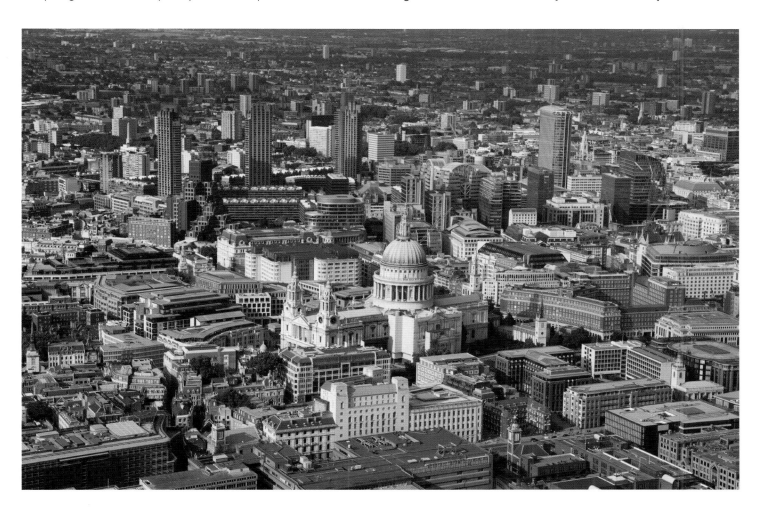

St Paul's Cathedral at the centre of a vortex, c 1930s

Stunt-flying in the 1930s: this view of the dome of St Paul's was taken from an aircraft in a spin. [RAeS Library APh 302]

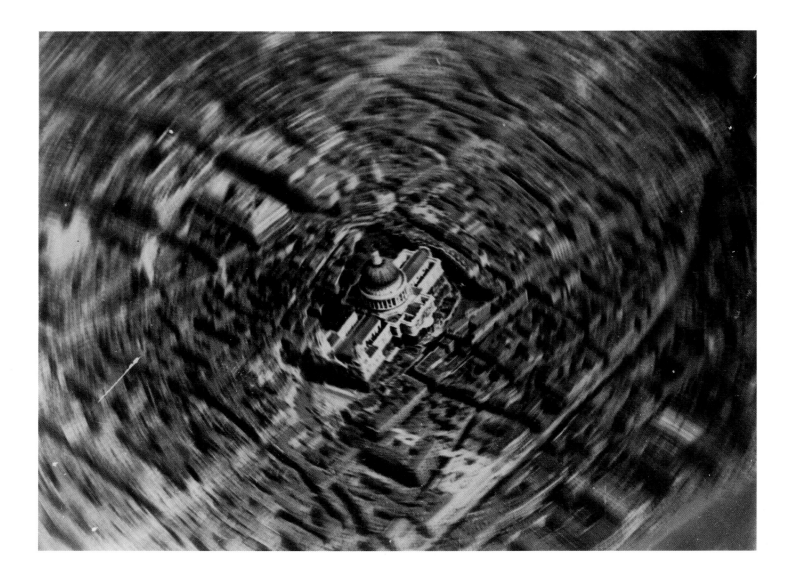

St Paul's Cathedral, August 2002

Sir Christopher Wren's great masterpiece, in a view that shows the voids between the upper part of the nave and the outer façades, and also conveys the 'tide-mark' of pollution up to the first entablature, since cleaned off. The photograph was taken in 2002, during construction of the new Paternoster Square, immediately to the north (left). [NMR 21761/03]

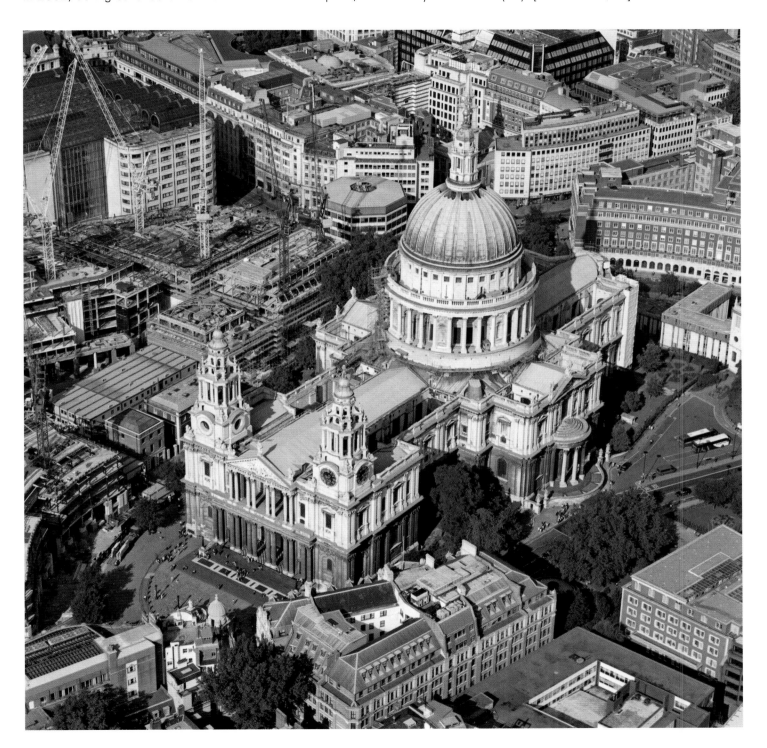

Smithfield, St Bartholomew's Hospital and the Old Bailey, c 1930s

Doctors, lawyers, postmen and butchers: a throng of great institutions crowd the north-western edge of the City in this view over Smithfield. A prebendary priest of St Paul's named Rahere founded a new Augustinian priory dedicated to St Bartholomew, with a hospital to care for the poor, through the backing of a group of wealthy City men in 1106. Rahere's church of St Bartholomew-the-Great still stands, or at any rate its eastern arm does, seen to the right of centre at the foot of the picture. The central quadrangle of St Bartholomew's Hospital, with its fine buildings by James Gibbs (1730–68), is the square space with four large trees at the centre of this photograph. The spirit of Victorian improvement is embodied in the grand Edwardian Baroque buildings of the Old Bailey (E W Mountford, 1900–7), whose dome is seen towards the top of this photograph, and the King Edward VII Post Office (Sir Henry Tanner, 1907–11) with its formal classical façade, which can be seen further up the street from the long crescent-shaped building to the left of St Bartholomew's quadrangle. The big rectangular block extending behind the post office is the Sorting Office (1907–11), of interest as one of the first really large reinforced concrete buildings in Britain; it has now been replaced. [R H Windsor Collection, TQ 3181/3]

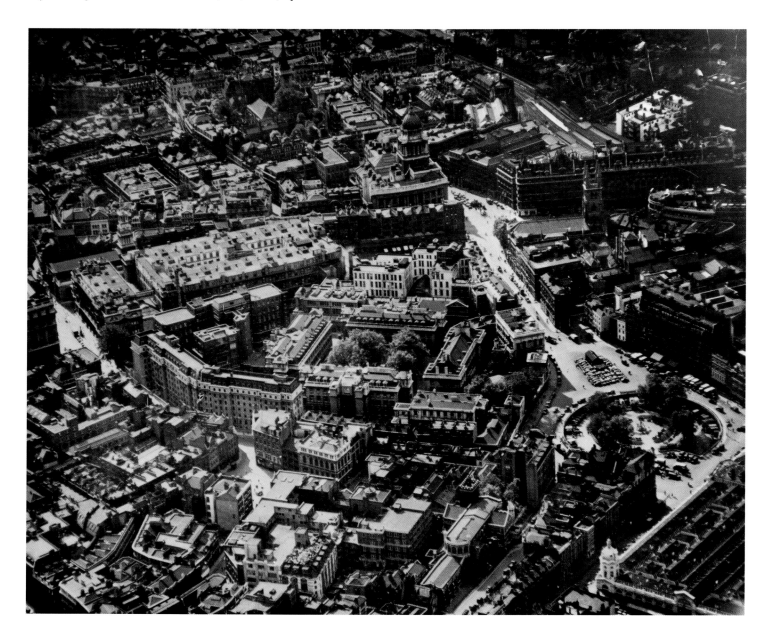

Looking south-west over Smithfield and the western City, August 2006

The long roofs of Smithfield Market, still the chief meat market for London, stretch across the foreground of this view. From medieval times into the 19th century, drovers brought live cattle here for sale, regularly causing chaos when stampedes broke out and cattle got into neighbouring properties (which probably gave rise to the expression 'a bull in a china shop'). In 1852 the live cattle market was moved to the Caledonian Market at Islington (see p 176), while Sir Horace Jones, surveyor to the Corporation of London, built these magnificent buildings for the market in butchered meat between 1851 and 1875. [NMR 24423/010]

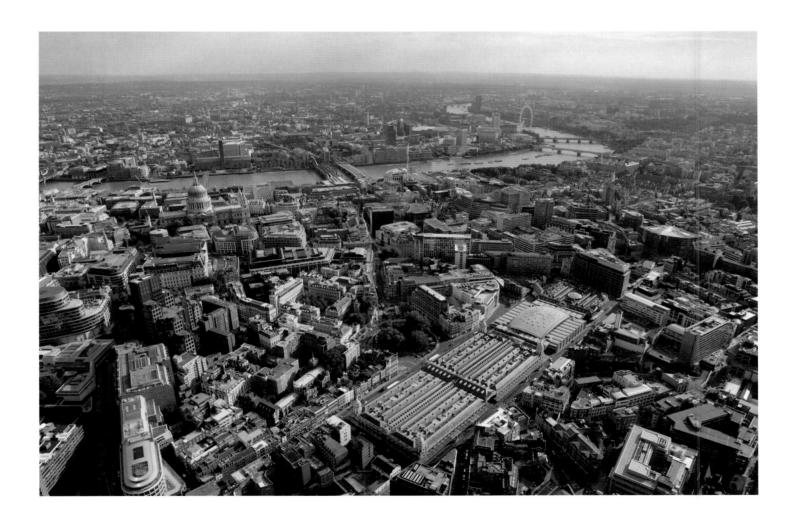

The City and Guildhall to St Paul's, c 1930s

This photograph shows the City, looking west, with the steep pitched roof of Guildhall in centre foreground. The two prominent blocks in line together to the right of St Paul's are the main Post Office buildings on St Martin's le Grand, one of the great institutions that once defined the City but have since largely disappeared from it. The small scale of the Victorian City, with its street plan of medieval alleys, is made clear in this view. [R H Windsor Collection, TQ 3281/5]

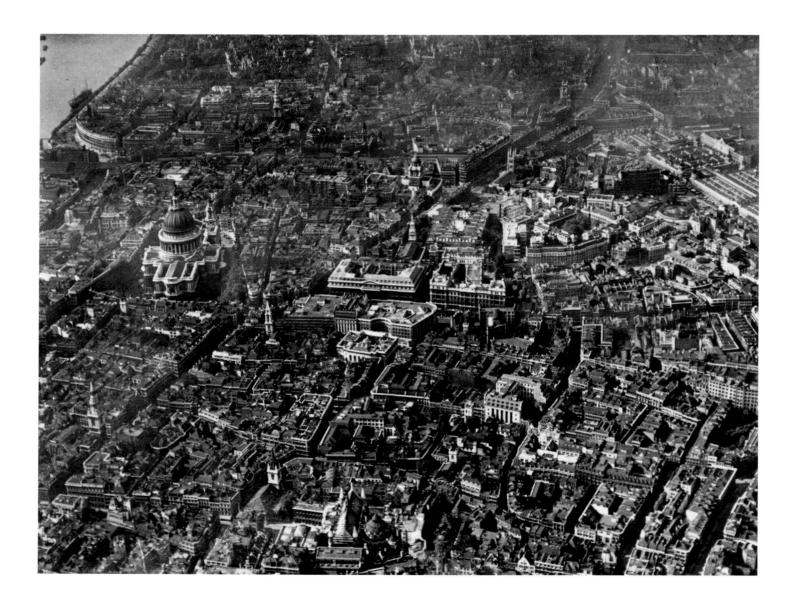

Guildhall from the south-west, September 2006

There was a guildhall here, home to the mayor and aldermen of London, from the 12th century if not earlier. The present hall dates from the early 15th century; it was burnt out in the Great Fire of 1666, rebuilt, then re-gothicised and rebuilt with a steep roof in 1864–8 by Sir Horace Jones. After it was gutted during the Blitz, it was reconstructed again in 1953–4 by Sir Giles Gilbert Scott, with great stone arches spanning the hall to carry the roof. The Scott family were also responsible for the modern buildings to either side of the square: the Brutalist block housing offices and the library to the left and the strange neo-Gothic building on the right, housing the City's Art Gallery. During construction of the latter, remains of a Roman amphitheatre were found, part of which is on display in the gallery's basement; Guildhall Square represents the area of the amphitheatre's arena. [NMR 24448/006]

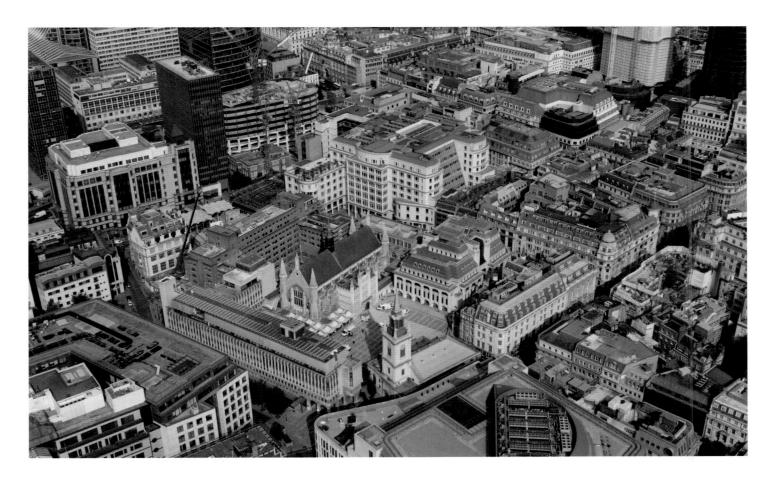

The heart of the City looking south, c 1930s

The bright afternoon sunlight throws the Roman and medieval street plan into sharp relief. Near the foot of the picture is Finsbury Circus (laid out in 1815, rebuilt at larger scale c 1900–25), then to the left, Broad Street Station and Liverpool Street Station. Cutler's Gardens (c 1769–1820), the vast warehouses originally built by the East India Company, can be seen halfway up the left-hand edge of the photograph. The picture can be roughly dated by the fact that the Bank of England is halfway through the protracted reconstruction of 1925–39 by Sir Herbert Baker (you can locate the Bank by drawing a line from the centre of Finsbury Circus to the shed of Cannon Street Station at upper right: this line passes through the middle of the Bank building site). The approximate course of the Roman city walls, first built c AD 200, can be read in the streetscape in this photograph. From the Tower (top left) the line of the walls and ditch system proceeds down Minories to the double streets of Houndsditch and Bevis Marks, crossing Bishopsgate just above Liverpool Street Station; it then followed London Wall, the first street up from Finsbury Circus, crossing Moorgate and heading west on the same alignment. [R H Windsor Collection, TQ 3281/4]

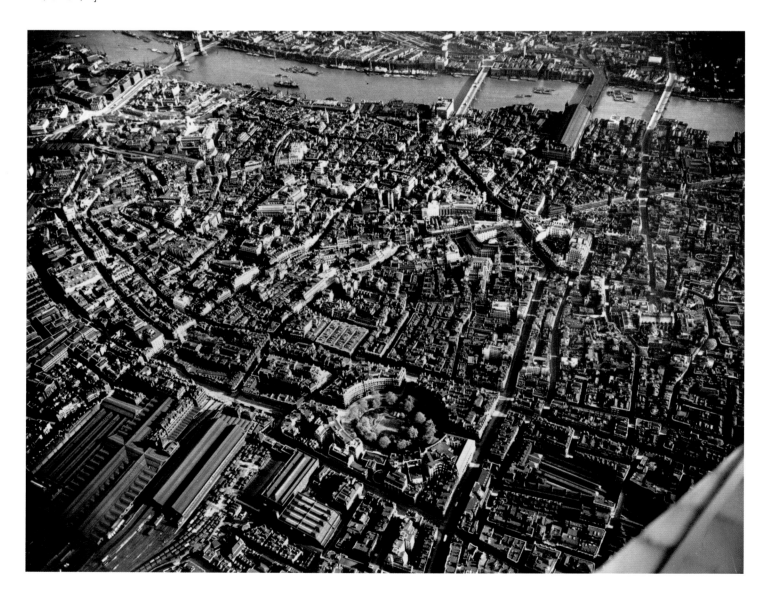

Finsbury Circus, September 2006

The City is singularly lacking in green space, so Finsbury Circus, laid out in 1815 to designs by the City Surveyor, George Dance the Younger, comes as a welcome oasis. None of the original terraced houses survive, of course, the Circus having succumbed to late Victorian redevelopment. Its most distinguished building by far is Britannic House, seen at the lower left of the Circus. Built by Sir Edwin Lutyens as the headquarters of the Anglo-Iranian Oil Company in 1924–7, it is still occupied by their successors, British Petroleum, having been thoroughly refurbished in the 1990s with the introduction of open-plan floors and an internal atrium, whose roof light is clearly visible. [NMR 24449/011]

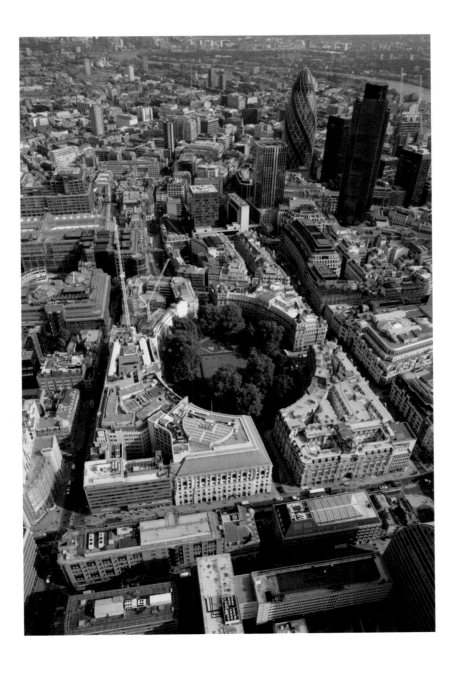

The Bank of England, c 1905

This hand-coloured glass slide from the O E Simmonds Collection, now in the Royal Aeronautical Society's archive, shows the Bank of England. The view, taken from a balloon, shows the Bank largely as it was left by Sir John Soane in his great rebuilding of 1792–1827. The Bank of England is a phenomenon: founded in 1694 by a group of City men in response to William III's need to finance his wars against Louis XIV, it swiftly became the principal means by which the Georgian state funded its wars against France – wars in which the British Empire was built, the English language spread around the world, the French Crown was bankrupted and brought to revolution, and modern public debt finance and financial markets were invented. This unique 300-year-old institution, one of the most decisively influential organisations in the history of the world, continues to play a central role in the modern City. [RAeS Library, Lantern slide 6910]

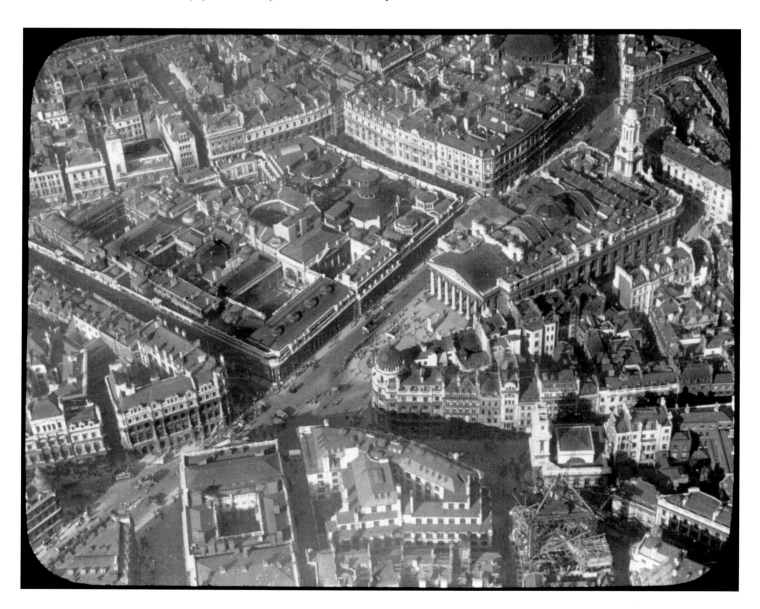

The Bank of England and the Royal Exchange looking east, September 2006

The Bank of England is on the left, transformed by the construction of the great block designed by Sir Herbert Baker in 1925–39, rising out of Soane's exterior walls and destroying the original top-lit banking halls. At the centre is the magnificent portico of Sir William Tite's Royal Exchange (1841–4), successor to Sir Thomas Gresham's original 16th-century building. Threadneedle Street is to its left, Cornhill to its right and Lombard Street to the right of that. The open space in front of the Bank is so well known that it comes as a surprise to realise that it was only made on the construction of the Royal Exchange in the 1840s to provide it with a proper setting; the City, oddly enough, has never had a proper public square or market place. The Stock Exchange Tower of 1964–72 (Llewellyn Davies, Weeks, Forestier-Walker & Bor with others), at left background, is seen being refurbished and reclad. [NMR 24448/026]

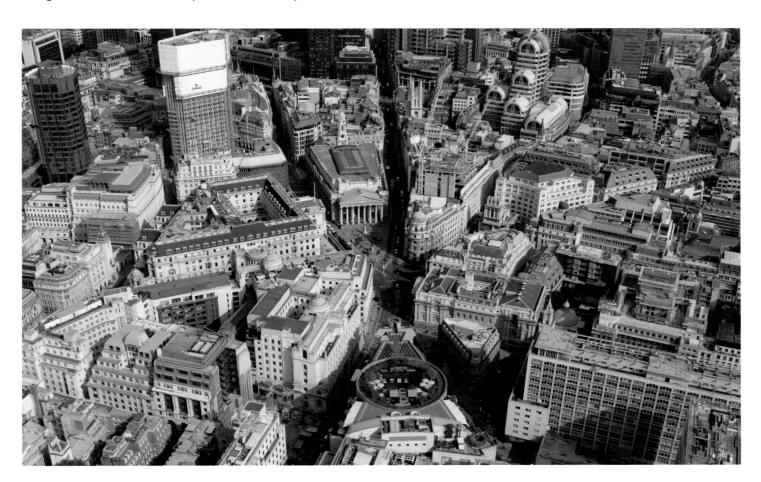

Finsbury Circus and Liverpool Street Station, c 1930s

The northern fringes of the City: the devastating impact of the railways on the small-scale streetscape is conveyed by the sprawling roofs of Liverpool Street and Broad Street stations. Older City institutions are called to mind by the open spaces at the centre of the picture: the large area of mown grass is the Artillery Ground on Moorfields, property of the Honourable Artillery Company since the 16th century. The Company, in effect the City's principal volunteer militia, played an important role in keeping the peace in the 17th, 18th and 19th centuries. Bunhill Fields, the wooded space above the Artillery Ground, represents death in the City: this originated as the bone-hill, where cartloads of bones from the charnel house of St Paul's Cathedral were taken in the 16th century. [R H Windsor Collection, TQ 3282/1]

Liverpool Street Station from the south, September 2006

This view shows the double-naved roofs of Liverpool Street Station, designed by Edward Wilson as engineer to the Great Eastern Railway and opened in 1875. The station never had an impressive façade; instead, there is the red terracotta bulk of the Great Eastern Hotel (Charles Barry Junior, 1880–4). The rest of the station is now surrounded by the Broadgate development (Arup Associates and Skidmore, Owings & Merrill for Greycoat PLC, 1982–91), the most ambitious exercise in air-rights development (that is, using the air rights above the railway lands and part of the station) yet undertaken in London. Broad Street Station formerly occupied the left-hand part of this picture, its site now taken by Broadgate Square with its circular arena. This was the terminus of the North London Railway, opened in 1865; around 1900 it was the third busiest station in London (after Liverpool Street and Victoria), on the strength of City commuter traffic. [NMR 24449/018]

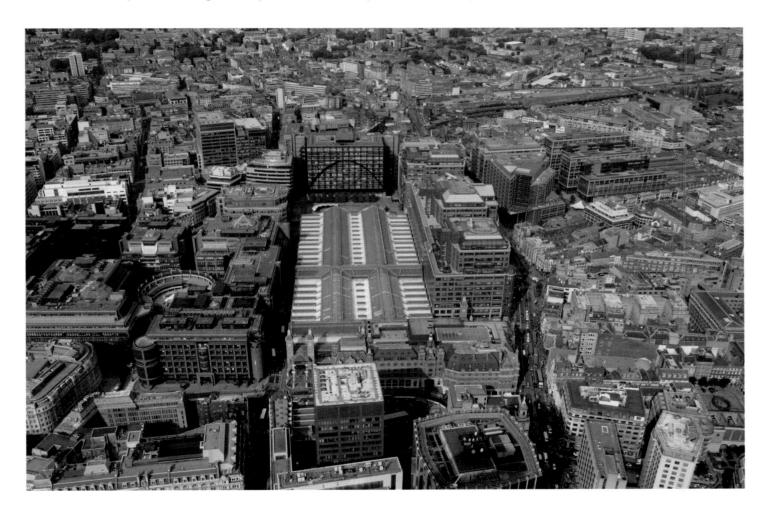

Eastern fringe of the City, c 1930s

The eastern side of the City in the 1930s – its fringes have been through as many generational changes as the City itself. The line of Minories, the street with the sharp shadow line running up the picture from bottom right, goes from Tower Hill towards St Botolph's Church, Aldgate. This represents the ditch outside the Roman and medieval city walls, rather than the wall itself. In Roman times there was a large cemetery here, while the name commemorates the Franciscan nuns or 'minoresses' whose convent was founded there in 1293, one of a ring of monastic houses surrounding the medieval city. In more modern times the area was colonised by commerce, as represented by the railway warehouses seen in the block to the right of Minories or the complex roofs of the East India Company warehouses at Cutler's Gardens, further up and to the right of Liverpool Street Station. [R H Windsor Collection, TQ 3381/3]

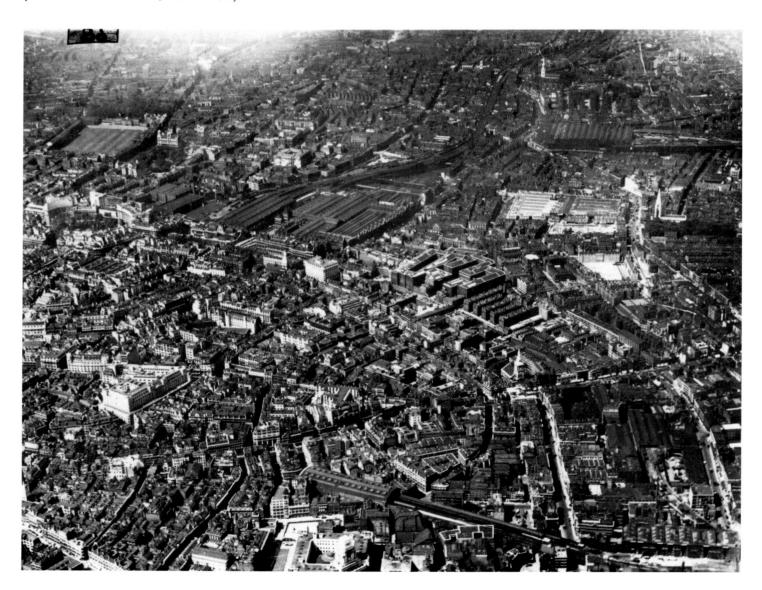

Tower Bridge and the City from the south-east, August 2006

Since the Second World War, the Eastern City, in order to remain the heart of the financial markets and financial services industry, has seen ever larger buildings squeezed into the medieval street plan. These range from the 6- to 10-storey blocks of the 1950s and 1960s to the first high-rises of the 1960s and 1970s, and the new generation of big buildings typified by the distinctively shaped 'Gherkin' at centre view (Foster Associates, 2001–3). To the left of the view on the other side of the river, the new Greater London Authority building (Foster Associates, 1998–2002) represents the continuing revival of the south bank. It is a little sad that the City itself largely turns its back on the Pool of London, which of course is where everything started. [NMR 24434/016]

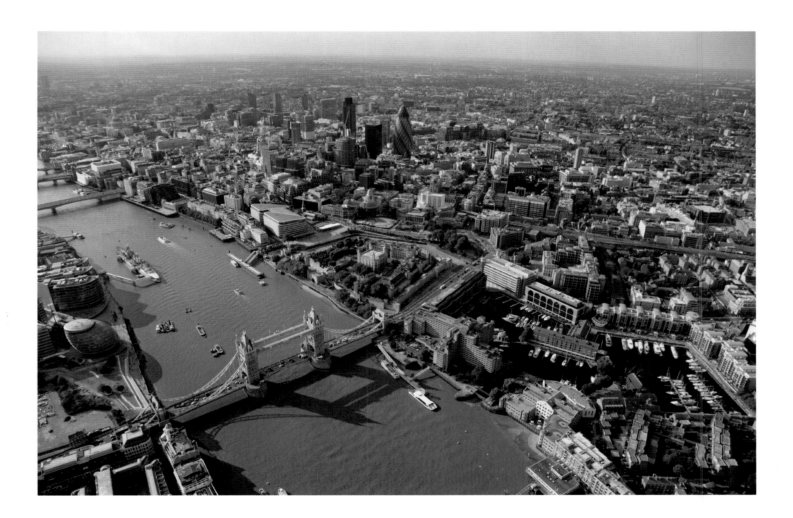

The Tower of London looking north-west to the City, c 1930s

William the Conqueror seized and cleared an area at the eastern end of the City, enclosed it within a relatively small bailey and built a palace-keep – the White Tower – to overawe and control London's 'vast and fierce populace'. The Tower grew in successive stages of enlargement and as it grew, its site and immediate surroundings were removed from the legal boundaries of the City. The 'Liberties of the Tower' were created, a Crown enclave under the jurisdiction of its Constable; each year the Governor of the Tower, accompanied by the Yeomen Warders and the choirboys of the church of St Peter ad Vincula, still 'beat the bounds' of the Tower Liberties to mark its independence. The complex roofs at lower right are those of the warehouses of St Katharine's Dock (built by the engineer Thomas Telford and the architect Philip Hardwick, 1825–9), masterpieces of industrial architecture comparable to the Albert Dock in Liverpool. [R H Windsor Collection, TQ 3380/4]

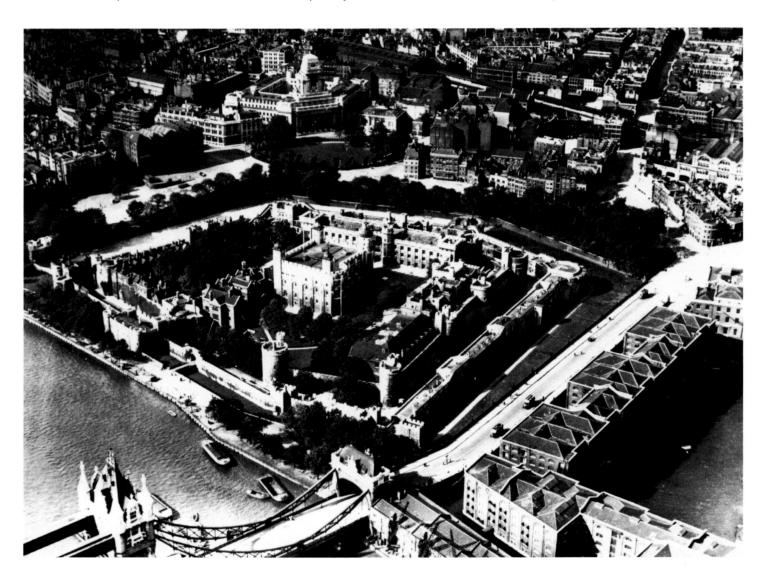

The White Tower, September 2003

The White Tower, the heart of the Tower of London, was begun soon after 1077 and probably finished by 1100; the man in charge of the work, who also might have designed it, was Gundulf, Bishop of Rochester. Unusually, in this instance the earliest example of a building form – the Anglo-Norman palace-keep – is also the largest and grandest. The White Tower was certainly conceived as a palatial residence, as well as an arsenal and fortress, though it is doubtful that it was ever occupied in this way. [NMR 23255/24]

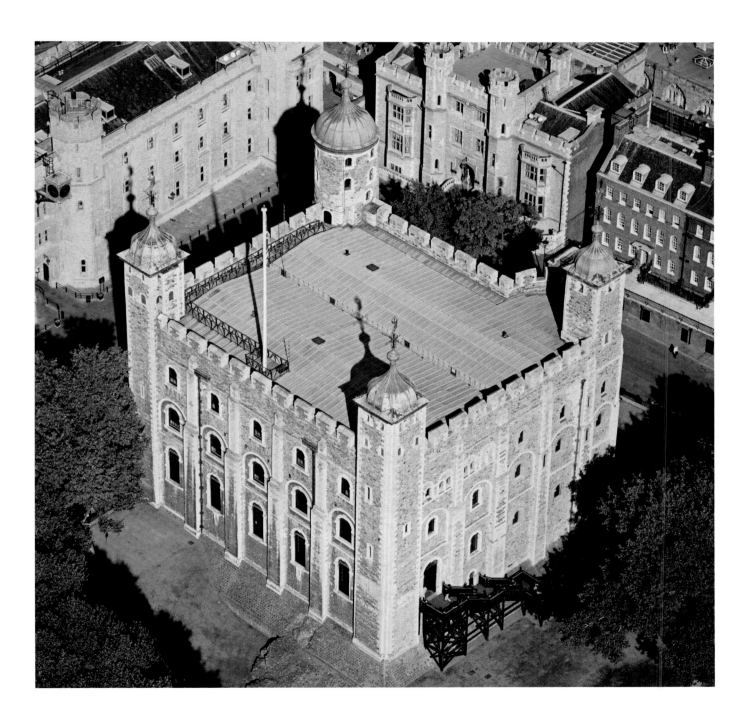

Looking downriver over Southwark Bridge, Cannon Street Railway Bridge, London Bridge and Tower Bridge, c 1930s

The river's character as a working waterway appears clearly in this view, looking over the bridges at Blackfriars (see pp 28 and 29). The relationship between the City on the left and Southwark on the right arises from the topography – the Romans founded the city on the higher and drier north side, while the south bank at that date was mudflats and islets. Southwark, as the City's original suburb, has fulfilled almost every kind of subordinate role, from housing grand suburban residences and religious establishments (in the Middle Ages), furnishing more or less respectable types of entertainment (in the 16th and 17th centuries), providing warehouses and noxious industries and trades (17th to the 20th century) and housing the poor. In this view, the warehouses and industry are clearly to the fore and the ancient past is represented only by Southwark Cathedral.
[RAeS Library, Lantern Slide 5477]

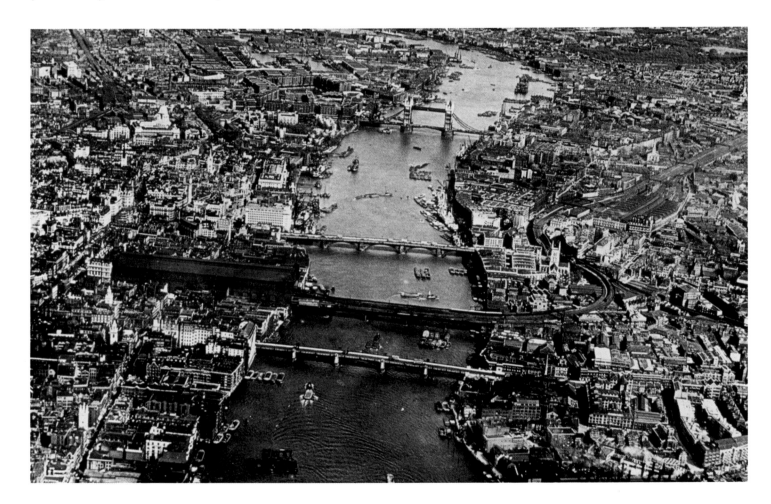

The Tower and the Pool of London looking west, August 2006

This view shows the Tower, Tower Bridge and the Pool of London with the moored *HMS Belfast*. The tiny number of craft on the river would surprise any Londoner from any historical period up to the 1960s. It is pleasant, though, to note the evidence of the rising prosperity of the south bank, such as the new Greater London Authority building, or Tate Modern in the distance. After many centuries as the City's backyard, the Southwark waterfront is coming into its own. [NMR 24434/021]

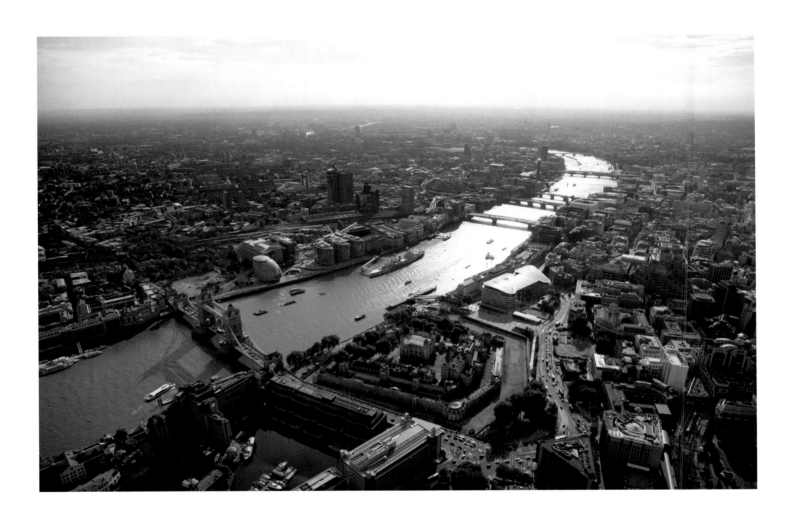

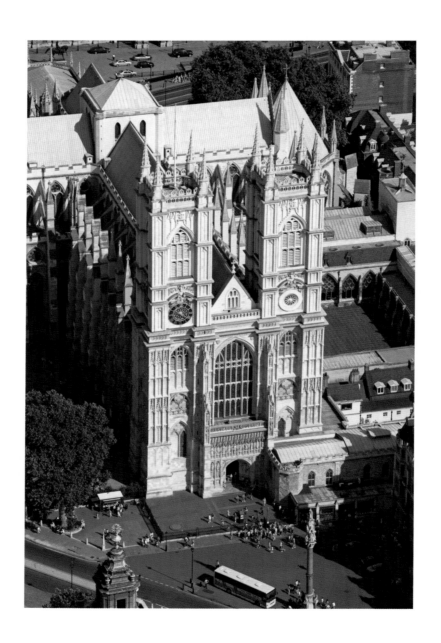

②

< THE WEST END >

Buckingham Palace, Westminster and Pimlico (north roughly to top right-hand corner), 7 August 1944

Low water in the river and the broad mudbanks are a reminder that 2,000 years ago the Thames had a very different configuration with a broader channel and numerous islets. Thorney Island, site of the abbey and palace at Westminster, was one of the largest and driest of these, while other areas are built on the silt of the infilled channels between them: Whitehall is a house built on sand. Rows of timber stakes – recently found in the river foreshore at the extreme bottom left corner of this photograph and dated to the Bronze Age – may represent the remains of a causeway out to one of these islets. Five years of war have made little visible difference to the ceremonial heart of the country in this view, save for the square outline of the visibly burnt out St John's, Smith Square, directly above the roundabout above the third bridge from the left. [RAF/106G/LA/29/3240]

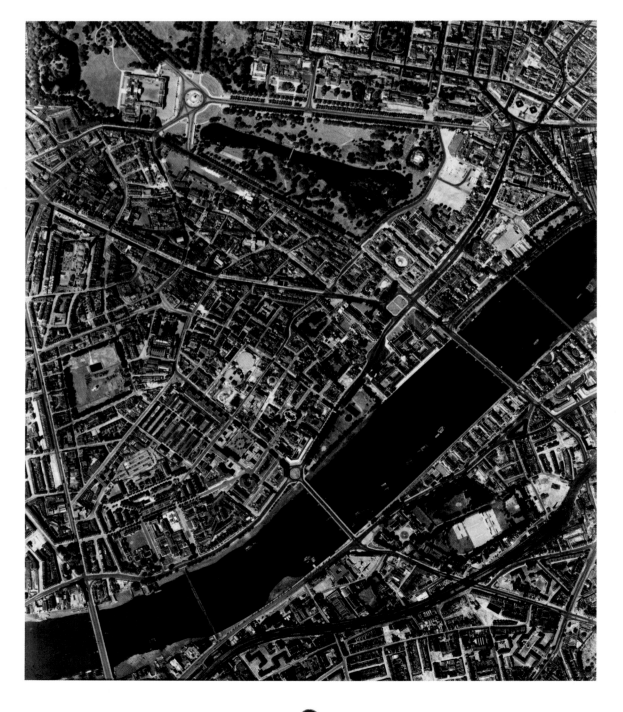

Thorney Island with the Palace of Westminster and the Abbey, August 2006

There was a Benedictine monastery dedicated to St Peter on Thorney Island, an area of dry ground rising out of the swampy riverbank, from the 7th century. In the mid-11th century Edward the Confessor rebuilt the abbey and also established a palace here; William the Conqueror was later crowned in the abbey church on Christmas Day in 1066. Together the abbey and palace formed the heart of the medieval kingdom of England, our equivalent to the Île de la Cité in Paris, Wawel Hill in Kraków, Hradcany Hill in Prague or the Kremlin in Moscow. This has been the ceremonial and political heart of the English and British state ever since. [NMR 24414/021]

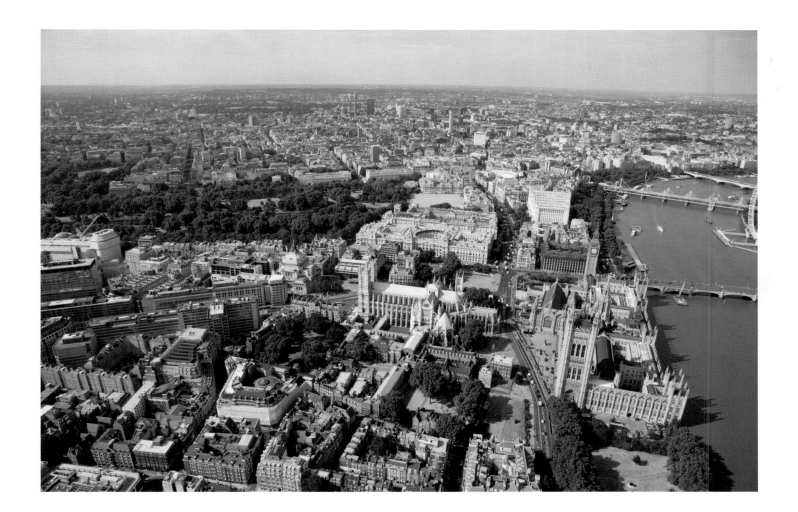

Millbank with Thames House in the foreground, 9 September 1946

Horseferry Road emerges onto Millbank opposite Lambeth Bridge, with Westminster Abbey in the middle distance in this view. The first mention of a horse-ferry here is from 1513; its history was not without its share of mishaps, for the ferry sank under the weight of Archbishop Laud's household goods when he was moving into Lambeth Palace in 1633. Oliver Cromwell lost his coach and horses in the same way in 1656. The ferry closed in the mid-18th century, put out of business by Westminster Bridge further up the river. A bridge was built here in the 1860s and replaced with the present Lambeth Bridge in 1929–32; the architect Sir Reginald Blomfield provided its architectural treatment, with the handsome pairs of obelisks at either end, complementing the massive classical architecture of Thames House (the two blocks linked by an arch) and Imperial Chemical Industries House, just further along. [RAF, TQ 3078/15]

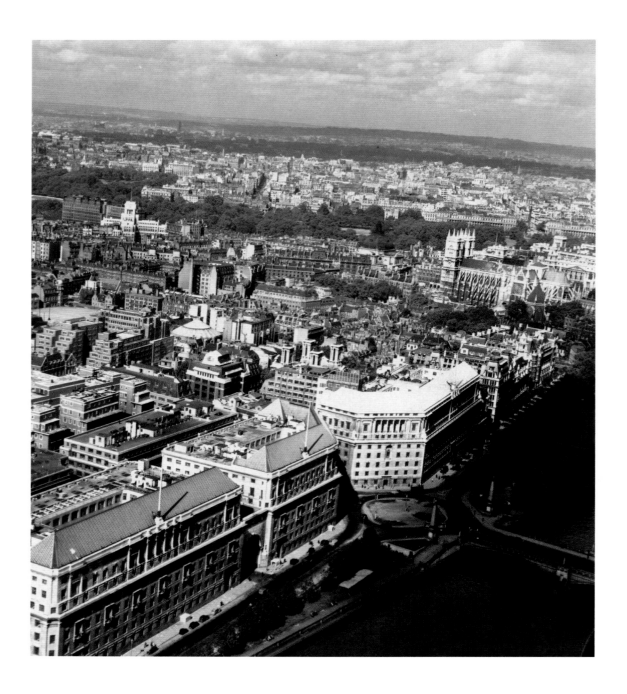

The Westminster reach of the Thames, August 2006

In this view the palace and abbey are surrounded by a constellation of alternative power bases. At centre right is Lambeth Palace, official residence of the Archbishop of Canterbury, representing the established church, a formidable political player up to the late 17th century but a largely acquiescent part of the Establishment thereafter. County Hall, the dark roof just right of the London Eye, was built to house the city's metropolitan authority; during the 1980s it represented left-wing local government's defiance of the Conservative central government until the abolition of the Greater London Council in 1986. Twentieth-century industry and the coming of the big multinational firms is represented by ICI House on Millbank and the Shell Centre, the big white blocks to the right of the London Eye. Millbank Tower, built as the headquarters of Vickers Ltd, a major engineering firm and defence contractor, represents a later generation of industrial revival, the 'white heat of the technological revolution' of the 1960s. [NMR 24429/018]

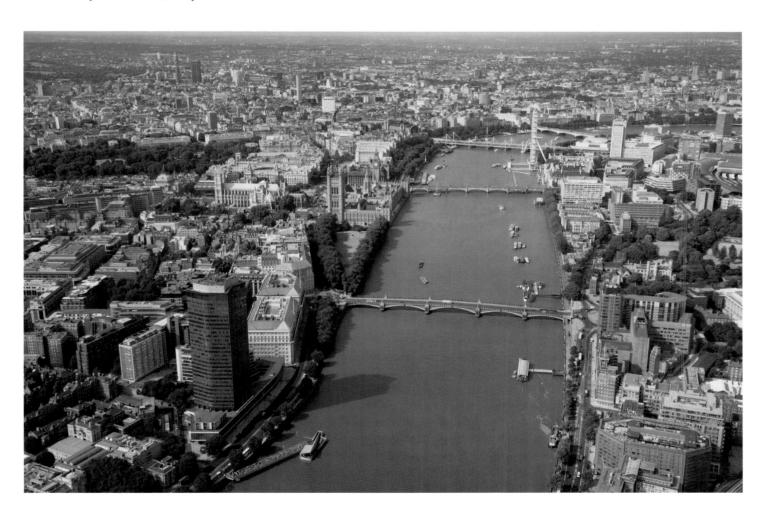

Looking east down Victoria Street with the Palace of Westminster in the distance, c 1930s

The long canyon of Victoria Street dominates this view of Westminster: first projected in 1844, the street was cut through a large area of slums west of the abbey in 1852–71. It filled up rather slowly, its buildings only completed in the 1880s. Unusually for London, it was lined with blocks of apartments and mansion flats, impressively uniform in their height, if not in the quality of their architecture. The cupola of Frank Matcham's Victoria Palace Theatre (1911) appears at the lower left-hand corner; in the 1930s it was enjoying great success as a venue for musical revues and comedies, culminating in L Arthur Rose and Douglas Furber's *Me and My Girl*, which featured the 'Lambeth Walk' and ran from 1937 until after the outbreak of the Second World War. [R H Windsor Collection, TQ 2979/1]

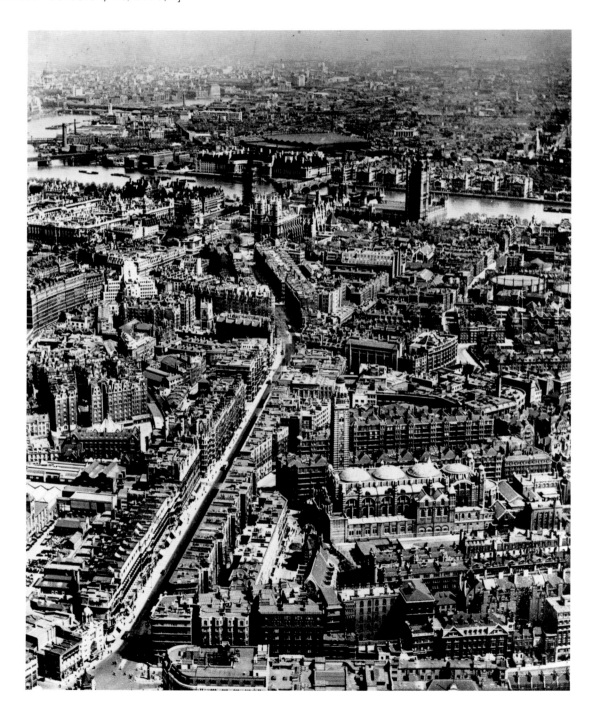

Victoria Street with Westminster Cathedral looking east, August 2006

Victoria Street is one of the few main arteries in central London whose character has been completely changed – few of the Victorian blocks remain, though their replacements are hardly much more appealing. It is somehow rather characteristic of London that the area's great monument, the gargantuan Byzantine-style bulk of John Francis Bentley's Westminster Cathedral (1892–1903), should have been demurely tucked away behind a block of mansion flats. At least now there is a view of it from the street. [NMR 24432/034]

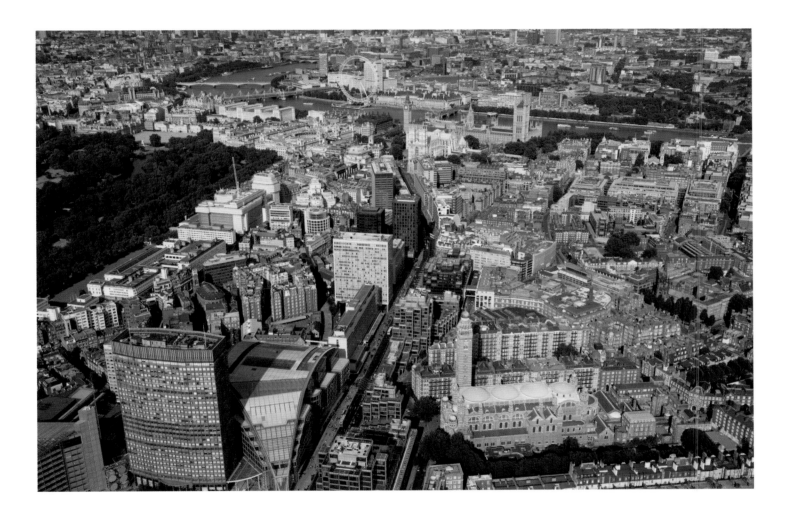

Looking over the Thames from Vauxhall to the Tate Gallery, 9 September 1946

Millbank, named for Westminster Abbey's watermill at the corner of Great College Street (out of the picture to the right), was an open marshy area into the 19th century, when this site was occupied by the Millbank Penitentiary, a gigantic prison in the shape of a six-pointed star. With its demolition in 1903, the site was cleared for the Tate Gallery, benefaction of Sir Henry Tate, the Liverpudlian sugar refiner who commissioned this and several public libraries from favoured architect, the otherwise forgotten Sidney R J Smith. Just before the Second World War the notorious art dealer Lord Duveen of Millbank paid for new sculpture galleries and the high roof with its lunette windows covering these galleries rises from the central axis of the building. To the left are the brick-and-stone buildings of the former Royal Army Medical College, moved here from Netley in Hampshire in 1907. [RAF, TQ 3078/57]

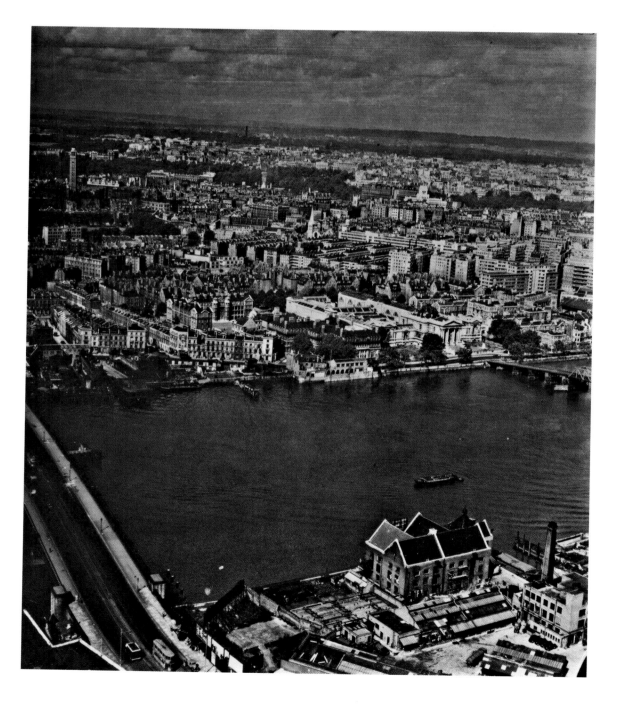

Vauxhall Bridge and the Thames looking north towards Millbank, August 2006

Sixty years on and wealth has spread to the south bank at Vauxhall in the shape of a series of big blocks along the Albert Embankment – generally more impressive than beautiful – culminating in the Art Deco-inspired bulk of Vauxhall Cross (Terry Farrell & Partners, 1991–3), now famous as the home of MI6. [NMR 24413/003]

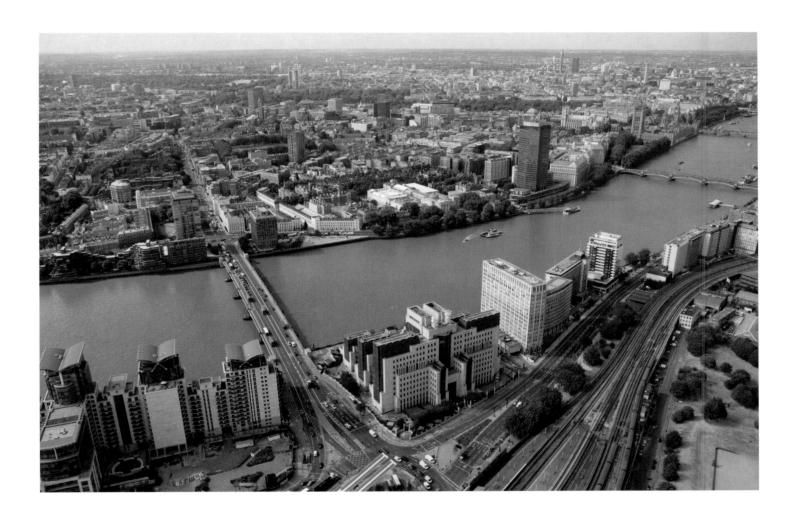

Westminster with St John's, Smith Square, in the foreground, 9 September 1946

The chaotic roofscape of the area south of Westminster Abbey, with the trees of St James's Park and the hills of Hampstead and Highgate in the distance. In the foreground are the distinctive towers of St John's, Smith Square, designed by Thomas Archer and built in 1713–28. It is one of the masterpieces of English Baroque architecture and one of the very few English buildings to have been directly inspired by the Roman High Baroque of Bernini and Borromini. It had been burnt out after a direct hit by a bomb and was not restored for many years. The conical roof to the left is that of Sir Herbert Baker's rather dour Ninth Church of Christ Scientist on Marsham Street (1926–30), built of a gloomy red-brown brick in an early Christian style (is it uncharitable to wish that the bomb had fallen this way instead?). [RAF, TQ 2979/18]

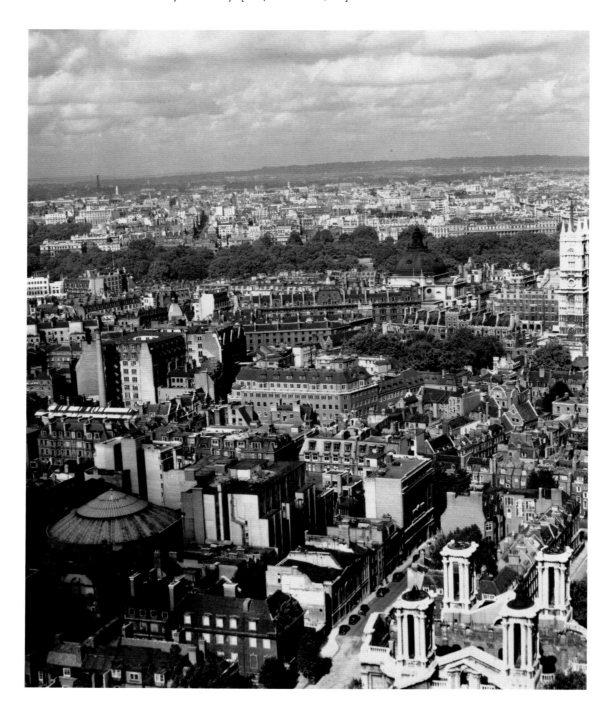

Pimlico looking north-east towards Smith Square, August 2006

St John's, Smith Square, sits more or less in the centre of this view, with Millbank, the river and the Palace of Westminster beyond, and the U-shaped blocks of the Grosvenor Estate of public housing of 1929–35 in the foreground (not to be confused with the Grosvenor Estate, the London property of the Grosvenor family, Dukes of Westminster). The estate was designed by Sir Edwin Lutyens, an architect more associated with country houses and grand public buildings. This is the closest that he ever came to modernism: the sash windows are linked diagonally by similarly sized oblongs of white render, making a distinctive chequerboard pattern with the pale-grey brick. [NMR 24414/004]

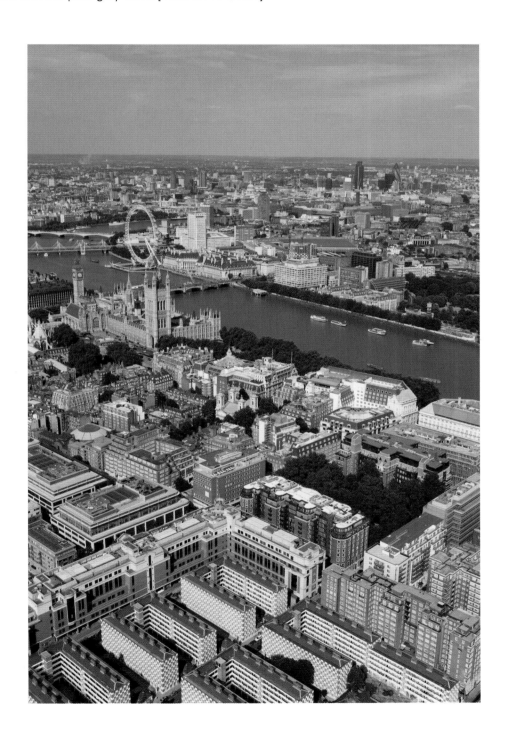

St James's Park with Queen Anne's Mansions and the London Regional Transport headquarters in the foreground, 9 September 1946

This RAF view looks over Petty France towards St James's Park. To the right is Charles Holden's subtly modelled cruciform tower for London Regional Transport (1927–9). To the left, in dire contrast, is the grim brown cliff-face of Queen Anne's Mansions, an immense block of flats of 1876–8. Sir Nikolaus Pevsner called it 'that irredeemable horror' and it stood as a stark reminder of what could happen in a city as free from planning controls as Victorian London. The mystery is that it should have been designed by E R Robson, fondly remembered as the architect of dozens of Board Schools for the London County Council where – in sharp contrast to this – he managed to create attractive and individual buildings despite very limited budgets. His memory has been well served by its demolition. [RAF, TQ 2979/24]

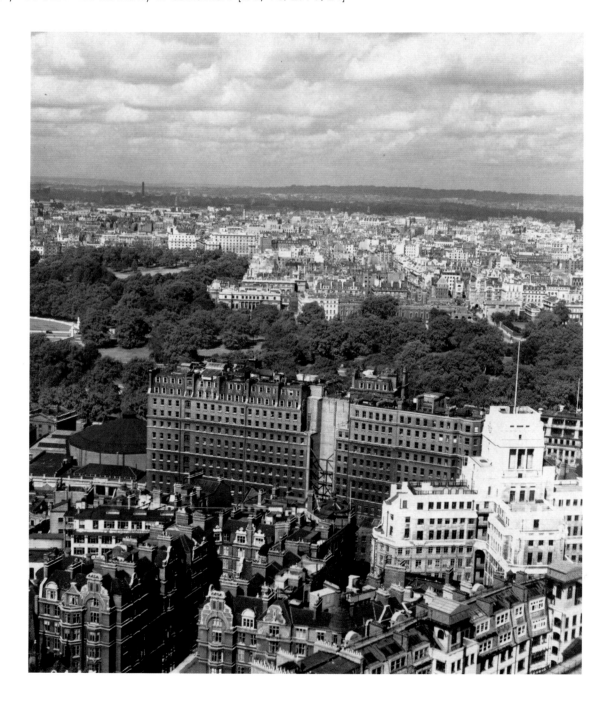

55 Broadway, headquarters of London Regional Transport, September 2006

London Underground Limited still occupy their magnificent Portland-stone faced citadel; the architect, Charles Holden, also designed a superb series of stations on the Northern and Piccadilly lines. For the headquarters he was allowed to make generous provision for art and commissioned a bold series of sculptures by the best sculptors of the age – including Jacob Epstein, Eric Gill and Henry Moore – to adorn the exterior of the building. The huge bulk of the former Home Office building (Sir Basil Spence with Fitzroy Robinson & Partners, 1972–6) can also be seen, wrapped during refurbishment – it is to house the new Ministry of Justice. [NMR 24445/008]

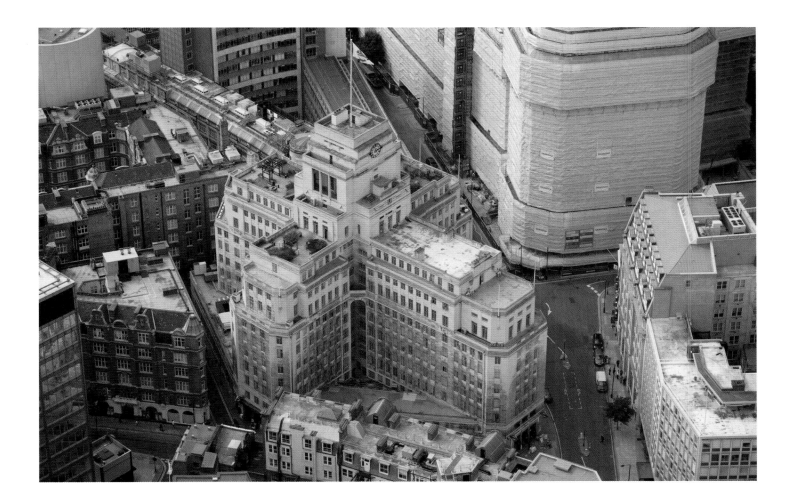

Westminster Abbey, the Treasury and St James's Park, 9 September 1946

Westminster Abbey, one of the greatest repositories of our national identity and memory, is seen here in a view that dramatically expresses its buttressed construction. This is the one place where English medieval masons directly sought to emulate both the style and the height of the great French cathedrals of the 13th century, though the design in detail is very much an English version of a French idea. Beyond, as if to remind us that culture has to be paid for, is the impressive Baroque bulk of the Treasury Building (built as offices for several government departments) by J M Brydon, c 1898–1912. The Cabinet War Rooms, where Churchill directed the wartime government, are under the left-hand half of the building, hence the framework visible over one of its courtyards, presumably for catching bombs. [RAF, TQ 3079/173]

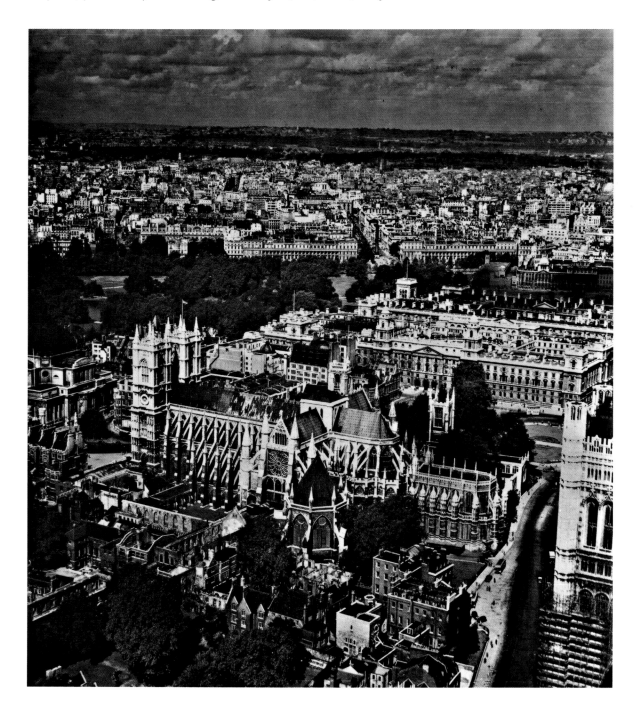

Westminster Abbey, August 2006

The original abbey, built before the Norman conquest by Edward the Confessor, was rebuilt by Henry III starting around 1240. Here, almost uniquely, a medieval monarch bore the entire cost of a cathedral-sized church (and one of especial richness). At over £40,000 it severely strained his finances, but this was the greatest single act of royal patronage of the arts in English history – and one of the greatest in European history – and we owe Henry III a debt of gratitude for his vision and determination. As shrine to Edward the Confessor, coronation church, burial place of kings and place of burial and memorial for our greatest compatriots, Westminster Abbey has an incomparable place in English history and culture. [NMR 24414/026]

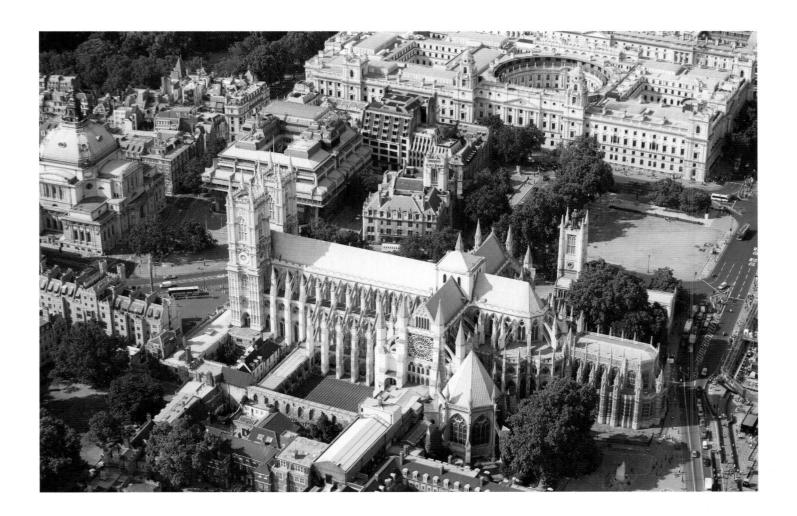

The Palace of Westminster, 22 May 1908

The 19th-century Palace of Westminster, photographed by a high-flying balloonist: it must have been early in the morning for the streets to be so quiet. The Houses of Parliament are, formally speaking, the premier palace of the English Crown. Nothing is known of the appearance of Edward the Confessor's mid-11th-century palace so its history effectively begins with the construction of Westminster Hall by William II Rufus in the 1090s. Off to the left the New Public Offices (now the Treasury Building) are seen incomplete, their circular courtyard unfinished; the last phase of the building only went up in 1910–12. Among the houses which were about to be demolished was Isambard Kingdom Brunel's home and office at 17–18 Duke Street, which can readily be identified at the west or lower end of King Charles Street (the one dividing the Treasury from the Foreign Office, the big block to its left): Brunel's house was immediately to the right, where the Clive Steps are today. [RAeS Library Aph 322]

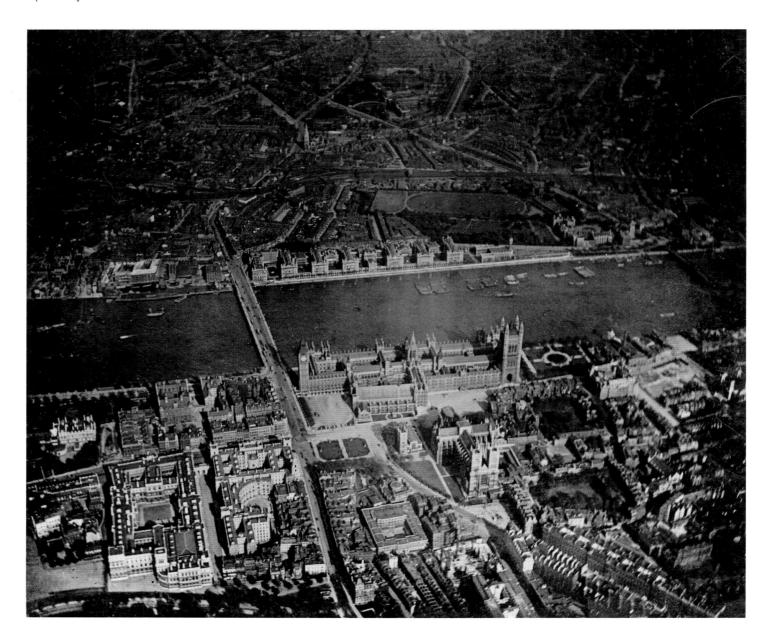

Westminster from the west, August 2006

The medieval palace on the site of the present-day Houses of Parliament burnt down in October 1834, with the exception of Westminster Hall, whose broad, buttressed roof can be seen in this view. In the subsequent architectural competition, entrants were directed to use the Gothic or Elizabethan styles, indicating that the palace was to be seen explicitly as a national symbol. Sir Charles Barry's New Palace rose between 1841 and 1861 at a cost of over £2½ million, which was then considered to be outrageous, but now seems rather a bargain. Barry had a genius for planning and overall design, which was complemented by his collaborator Augustus Welby Northmore Pugin's genius for decoration, and the result is one of the supreme masterpieces of 19th-century architecture in the world, a building which has imbued parliamentary democracy in Britain with its Gothic, club-like character ever since. It is often said that the whole nature of our party political system grew out of the narrow, rectangular shape of the House of Commons – in the nearer half of the building. [NMR 24414/031]

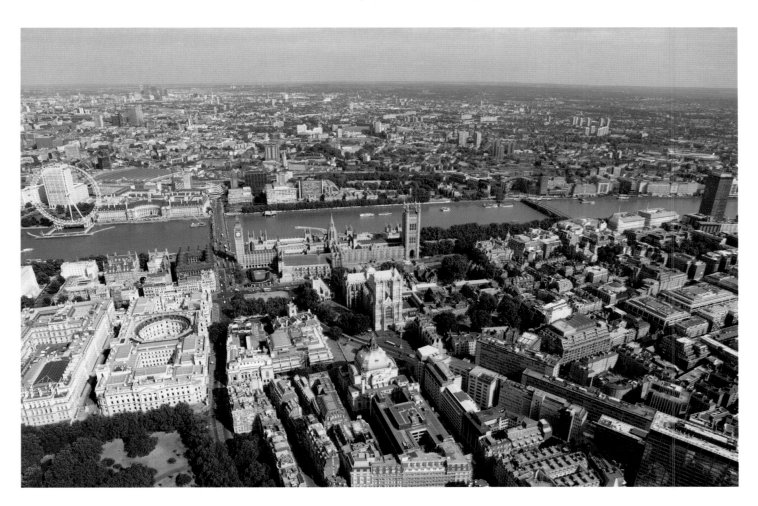

Looking north over the site of the future Ministry of Defence with the Old War Office behind, 9 September 1946

This is the site of Whitehall Palace, seat of the English court from 1529 until 1698, when the heart of the palace was destroyed by fire. Inigo Jones's great Banqueting House, built in 1618 for James I, is readily identifiable just to the left of centre. After the fire, the site of the palace was sold off and redeveloped in the piecemeal fashion typical of Georgian England. In the 20th century several of the Georgian houses were cleared to provide a site for a massive new government building, but the coming of the Second World War delayed matters and when this picture was taken work had just started again. The oblong block with a dark roof, immediately below and to the left of the bus, is 'Henry VIII's Wine Cellar' – part of Whitehall Palace – though actually built for Cardinal Wolsey around 1515. It had survived, built into an 18th-century house, and had been carefully preserved. When this view was taken it was about to be underpinned, put on rollers and slid to the left, while a massive basement was dug around it; it was then rolled back onto a steel framework sitting in its original position and lowered on screw-jacks by 30ft (9.1m) into the new basement. [RAF, TQ 3080/3]

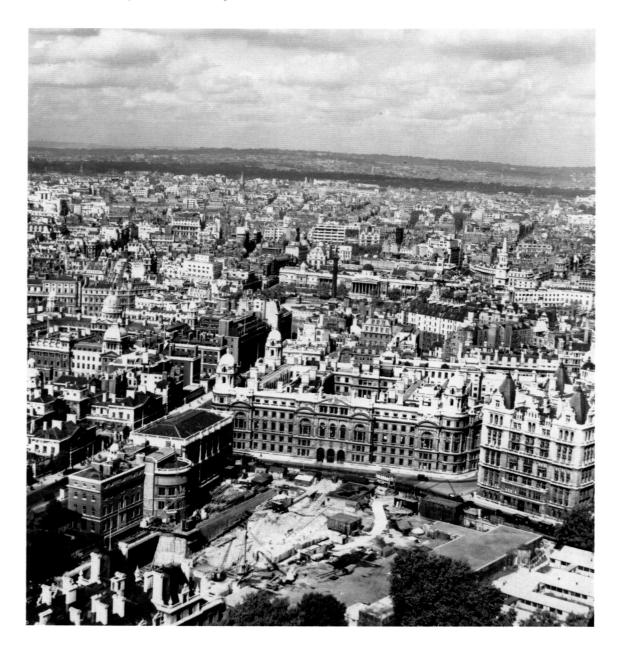

The Ministry of Defence, August 2006

The young architect Emmanuel Vincent Harris won the original competition for a building for the Board of Trade on this site in 1913. Construction was delayed by the First World War and Harris was ordered to redesign it in 1934 – he got the site cleared and then saw the project delayed again by the Second World War. The gigantic, severely classical block was only completed in 1959 and thus spanned the whole of Harris's career. Since then, this has become the Ministry of Defence Building; major recent refurbishment, which included the roofing of the three courtyards, has given it a new lease of life in this function. Wolsey's wine cellar still exists in its specially constructed basement – visiting its vaulted Tudor interior is a somewhat surreal experience, though inevitably in view of the building's function, there is no regular public access to it. [NMR 24415/012]

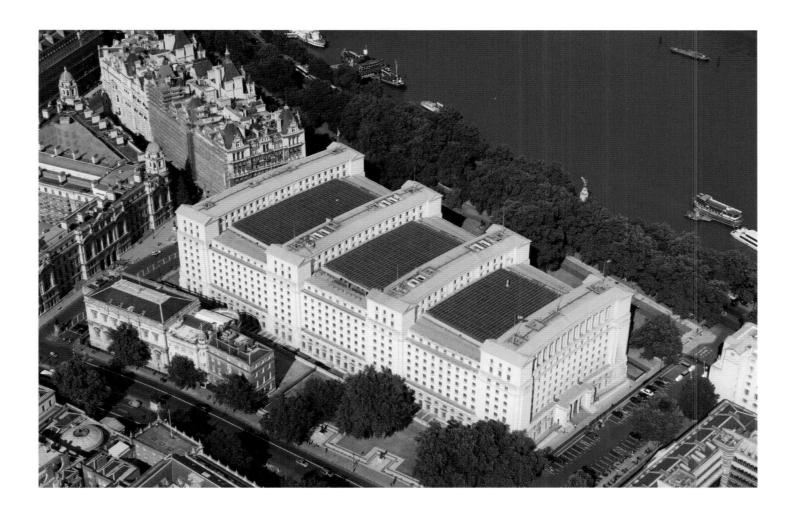

The Embankment with Shell-Mex House and the Savoy Hotel, c 1930s

The three great blocks of the Adelphi, Shell-Mex House and the Savoy Hotel, lining the south side of the Strand: the history of their sites recalls its earlier character as a street of great palaces overlooking the river. The Adelphi, to the left, was the site of Durham House, town house of the Prince-Bishops; in 1768 the enterprising Scottish architects John, James and Robert Adam leased the site, which had become a network of slums, and redeveloped it with smart terraces of houses to their own design, sitting above a huge network of vaults. They named the development the Adelphi, from the Greek for 'brothers', but were nearly ruined by the speculation. In 1864–70 the Victoria Embankment was built, colonising the river foreshore in front and providing a grand new road, a route for the Metropolitan Railway underneath, the principal sewer for London north of the Thames and, in due course, a site for Cleopatra's Needle in 1878, seen here on the river bank. This 60ft (18.3m) obelisk, weighing 186 tons, actually bears the name of the pharaoh Tuthmoses III. [R H Windsor Collection, TQ 3080/1]

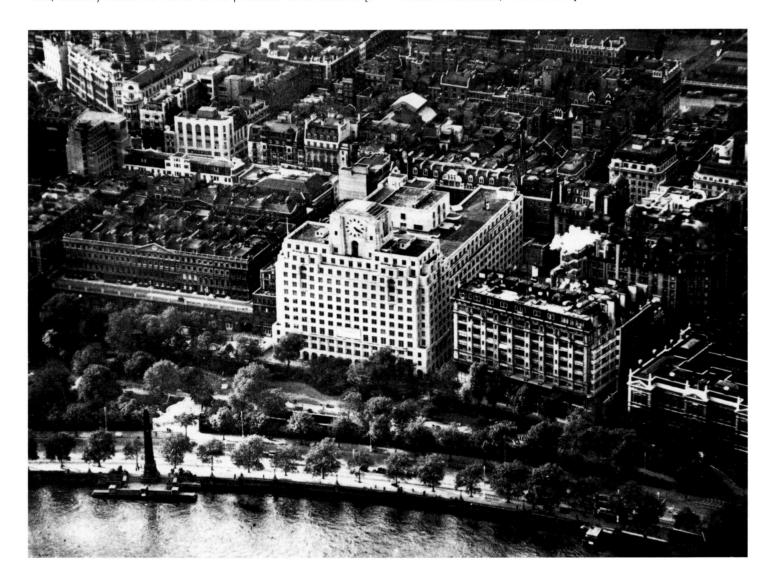

The Embankment, September 2006

The same scene today. The demolition of the main block of the Adelphi in the 1930s was one of the first great causes célèbres of architectural conservation in Britain, inspiring the foundation of the Georgian Group in 1936. The central block was replaced by the lumpy Art Deco building by Collcutt & Hamp in 1936–8, which rather cheekily assumed the name 'Adelphi'. The Adam brothers' flanking terraces survive on John Street and Adam Street. The equally lumpy Shell-Mex House (Ernest Joseph, 1930–1), here shrouded in scaffolding, occupies the site of the 600-bedroom Hotel Cecil, the largest in London when it opened in 1886; it was a sad loss for Victorian architecture when it came down c 1929–30. The Savoy Hotel (T E Collcutt, 1884–9), however, seen immediately to the right, has survived and prospered. Opened by the entrepreneur Richard D'Oyly Carte in 1889, it set a new standard for luxury: the first manager was César Ritz and the first chef was Georges-Auguste Escoffier. [NMR 24446/009]

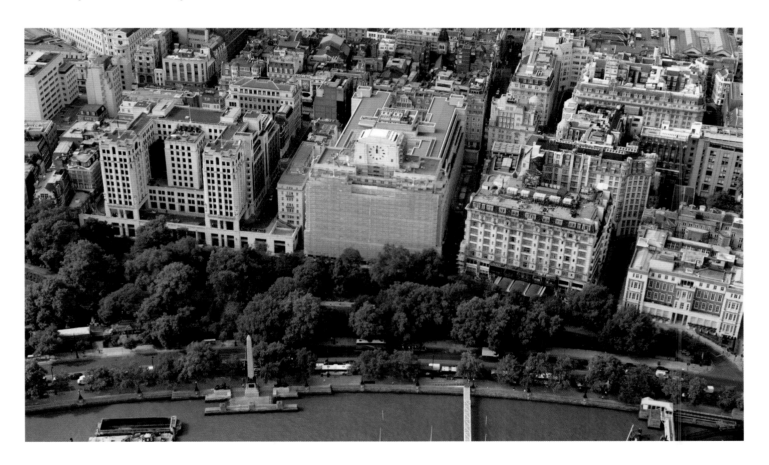

Aldwych from the south-east, c 1905–10

This coloured glass slide from the O E Simmonds Collection in the archive of the Royal Aeronautical Society shows Aldwych from the south-east. When the photograph was taken, the crescent of Aldwych and Kingsway leading north up to Holborn were very new, having been created by the London County Council, c 1900–5. Laurence Gomme, the historically minded clerk to the LCC, promoted the name 'Aldwych' to commemorate the Saxon settlement – the 'old wick' or 'Lundenwic' – that occupied the area roughly from Kingsway west to Covent Garden and the Charing Cross Road in the 6th and 7th centuries; it was abandoned on Alfred the Great's reoccupation of the Roman city. Many traces of 'Lundenwic' have been found in excavations during the 1980s and 1990s, in particular that for the expansion of the Royal Opera House. [RAeS Library, Lantern slide 6908]

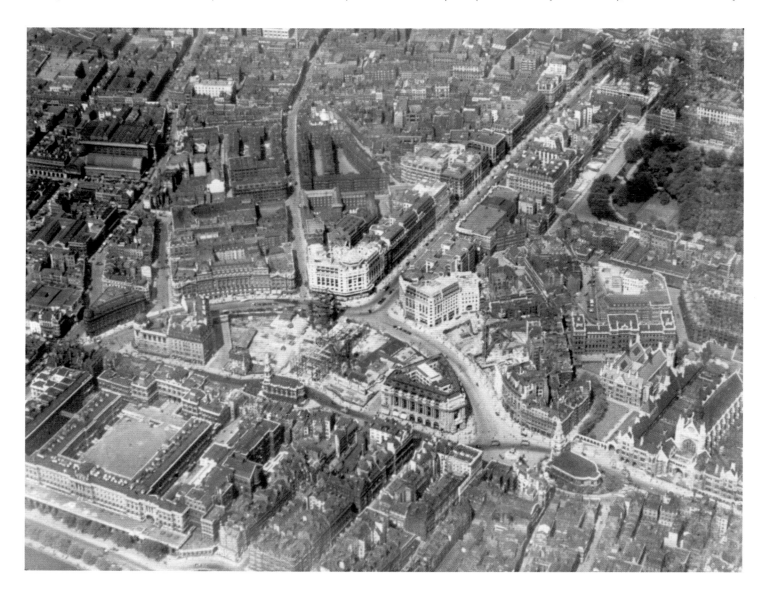

Aldwych today, August 2006

The crescent-shaped street was gradually lined with big, official-looking Portland-stone buildings centred on Bush House, still the home of the BBC World Service. St Mary-le-Strand, an elegant little Baroque church of 1714–17 designed by James Gibbs, preserves the smaller scale of the Georgian streetscape. To the right are the impressive classical ranges of Somerset House, the complex of government offices begun in 1776 to designs by Sir William Chambers; the opening of its great courtyard and terrace to the public was one of the most successful of the various initiatives to enhance London for the millennium.
[NMR 24421/009]

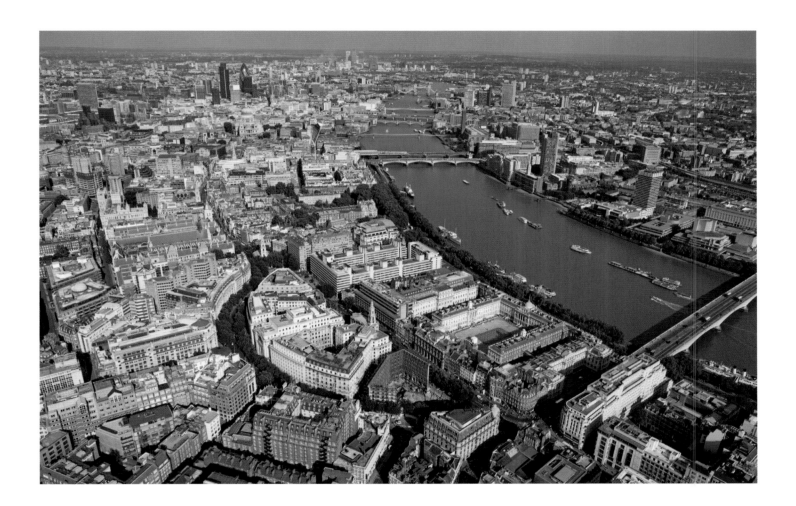

Trafalgar Square looking east towards Charing Cross Station, c 1939

Trafalgar Square is a relatively recent invention, representing the site of the Royal Mews, established here in the reign of Edward I initially to house falcons rather than horses. By the reign of Henry VII the principal royal stables were here and they remained here until c 1830, when they were moved to their present site in Buckingham Palace Road. The handsome early Georgian stables designed by William Kent were demolished and Trafalgar Square was laid out by Sir Charles Barry, architect of the Houses of Parliament. Nelson's Column was added in 1839–40, but its magnificent sculptural adornments were not completed until 1867 when the famous lions were installed. [RAeS Library APh 443]

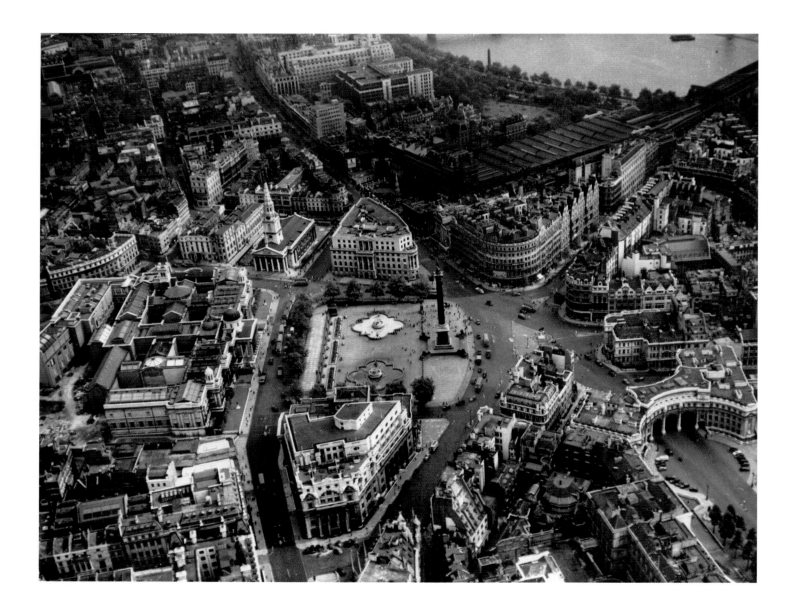

The National Gallery, August 2006

The National Gallery, one of the best-loved of all our national institutions, crowns the north side of Trafalgar Square – William Wilkins' façade of 1832–8 is dignified rather than powerful in design. Originally, the building was essentially one room deep and has been extended backwards over the rectangular site in several stages. Until recently, the gallery was cut off from the body of the square by swirling traffic – the pedestrianisation of the north side of the square and the creation of the grand new flight of steps at the centre of the terrace are an absolute success and a great benefit for the public. Though they are master strokes of simplicity and clarity it was inevitable, in the complex world of metropolitan planning, that it took years of planning and negotiation to make them happen. [NMR 24430/037]

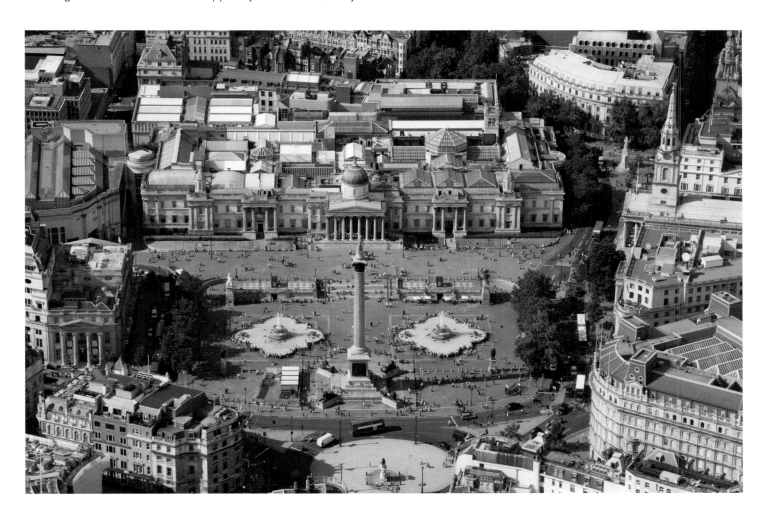

A Shackleton bomber above Charing Cross Station, 31 May 1956

This aerial view looks down on a Shackleton Mark II bomber of RAF Coastal Command as it passes over the Strand as part of a fly-by to celebrate Queen Elizabeth II's birthday. Charing Cross Station was designed by Sir John Hawkshaw and E M Barry for the South Eastern Railway and was built in 1860–5. The station roof seen here was constructed after the original roof, an iron-and-glass arch 164ft (50m) wide, collapsed with the loss of six lives in 1905 – Victorian self-confidence in engineering could, on occasion, be pushed too far. The 'Charing Cross' in the station forecourt was built by the South Eastern Railway Company to commemorate the last of the original Eleanor Crosses – the stone crosses raised by Edward I at all the sites where the funeral bier of his beloved wife, Eleanor of Castille, rested overnight. The real Charing Cross stood some distance away, on the site now occupied by the equestrian statue of Charles I. Whether one regards the Victorian replica as a nice commemoration or as a rather cheeky attempt to appropriate a romantic piece of English history by a railway company with image problems is perhaps a matter of personal taste (but the company has long gone and the Cross is still with us as a jolly piece of urban decoration). [RAF, TQ 3080/6]

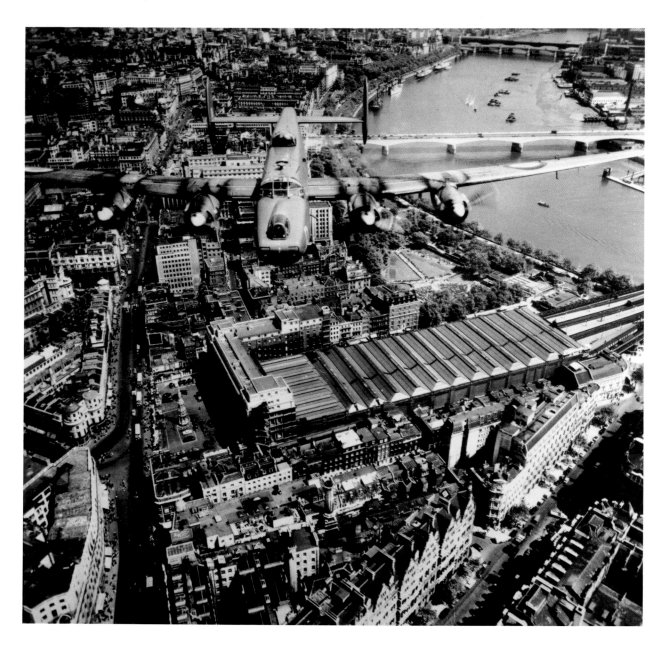

Charing Cross Station and the Strand looking east, August 2006

The 1980s boom introduced London to the concept of air-rights development on a large scale, notably Embankment Place above Charing Cross Station (Terry Farrell & Partners, 1987–90). In the Middle Ages this was the site of a great aristocratic dwelling called Hungerford House. In the late 17th century its site was occupied by a fruit and vegetable market, a rival to Covent Garden. In 1833 beautiful new market buildings designed by Charles Fowler were opened here and in 1845 an equally beautiful suspension bridge designed by Isambard Kingdom Brunel with a clear span of 670ft (204.2m) was opened leading from the market to the South Bank. In 1860 the market and bridge were both destroyed by the South Eastern Railway to make way for their station and railway bridge. So perhaps there is a kind of historical justice in their own building being decapitated and buried beneath someone else's commercial development. What will come next? [NMR 24415/035]

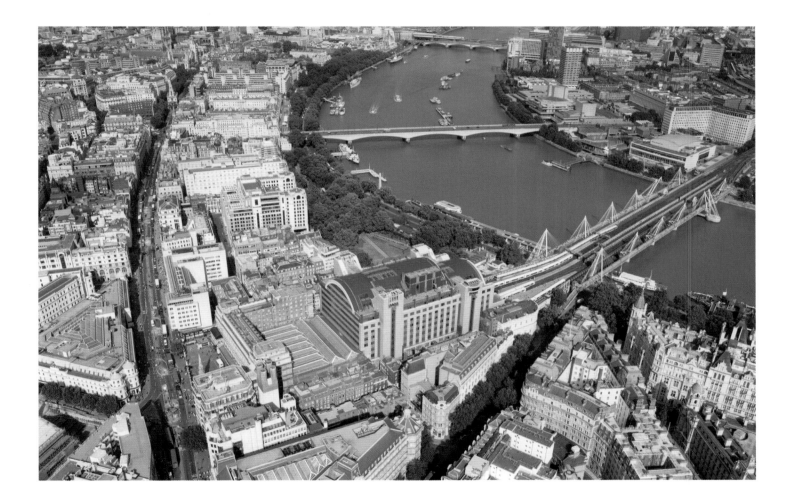

Looking west over St James's Park towards Buckingham Palace, c late 1930s

This magnificent panorama looks over St James's Park towards Buckingham Palace. The park was originally the grounds of Whitehall Palace, the lake originally a straight canal created as part of formal landscaping for Charles II in the 1660s. The Mall, likewise, was created as a double avenue of trees in the park, rather than as a route to anywhere – Buckingham House came later. [RAeS Library APh 446]

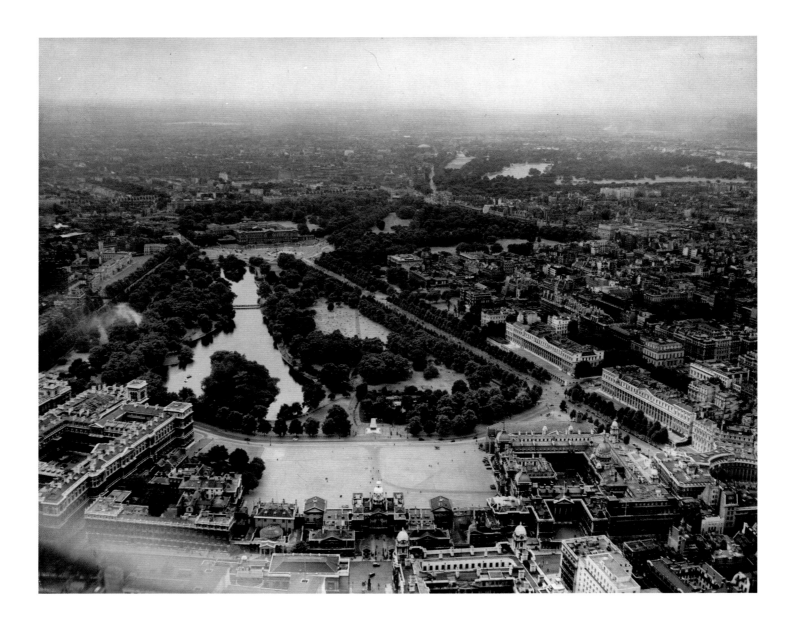

Whitehall, with the Ministry of Defence building, looking west over St James's Park, August 2006

Whitehall Palace has been replaced with the palatial citadels of government, whose grandeur and prominence is generally in inverse ratio to their age. The increase in scale really began with Sir George Gilbert Scott's government offices (1868–73, now the Foreign Office) at centre left, followed by William Young's Old War Office (1898–1907) at bottom right with the little white cupolas and J M Brydon's Treasury Building (1898–1912) at the far left, with Emmanuel Vincent Harris's giant Ministry of Defence Building (1946–59) at the centre, like the last of a race of architectural dinosaurs. Real executive power, of course, resides in the oldest buildings in this picture (albeit very much rebuilt), the relatively modest 10 and 11 Downing Street, just visible in the trees to the right of the Foreign Office. [NMR 24430/030]

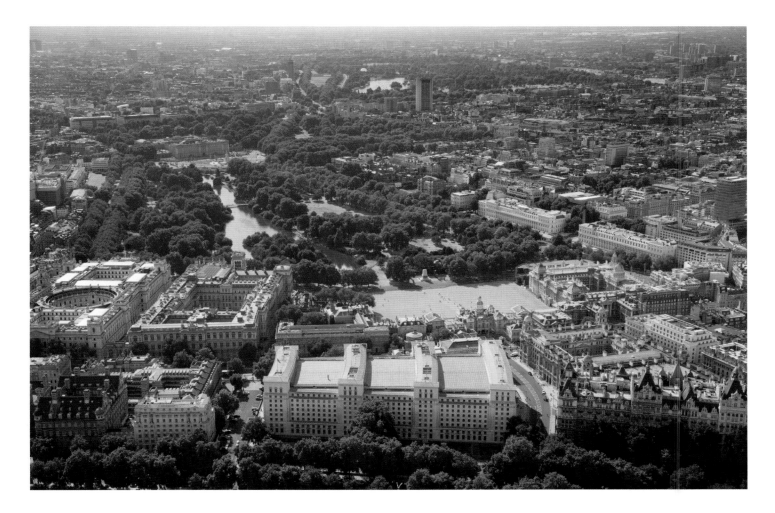

Looking north over Horse Guards Parade to Carlton House Terrace, 9 September 1946

A handful of vehicles are parked outside the New Admiralty and a new jet fighter attracts a small crowd of admirers. Horse Guards Parade was the tiltyard of Whitehall Palace, adjacent to the tennis courts and cockpit on the site of Downing Street – as at Greenwich, the royal entertainment complex stood between the palace and its park. Henry VIII held one of the last great tournaments here in 1540 and equestrian displays for Elizabeth I's birthday were also held here. The open space continued to be used for parades and ceremonies through the 17th century, a tradition maintained in the annual Trooping of the Colour for the Queen's Birthday. [RAF, TQ 2980/129]

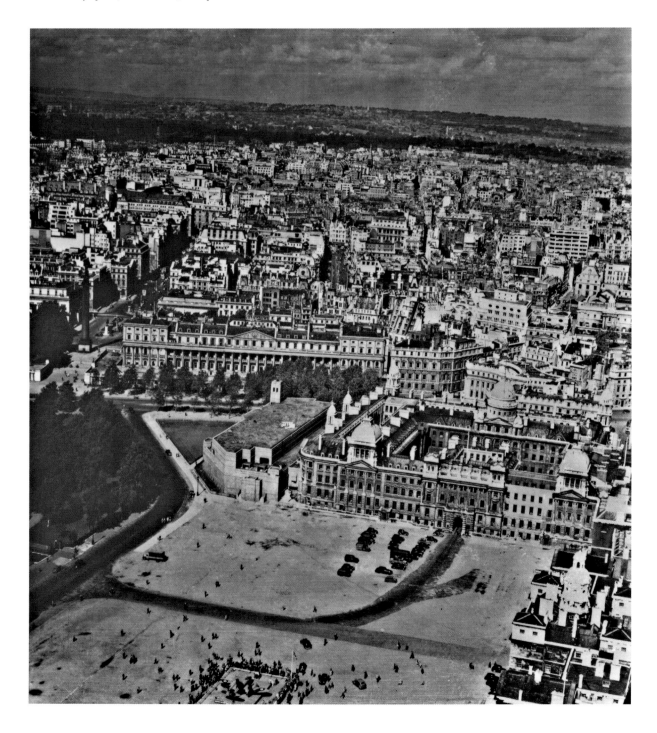

The New Admiralty, August 2006

The red-and-white bulk of the New Admiralty (Leeming & Leeming, 1894–5) looms over the north side of Horse Guards Parade. Such was the build-up in the Royal Navy at Britain's imperial height that in 10 years more space was needed and Admiralty Arch (Sir Aston Webb, 1906–9) was built adjoining, housing more offices and an official residence for the First Sea Lord; by luck and good planning it was possible to meet the Navy's needs while providing the desired grand new entrance to the Mall and Buckingham Palace at the same time. The grey bulk of the Citadel, covering over the park façade of the New Admiralty, speaks of a later generation of warfare – of the grim realities of air power and the imminent threat of bombing. [NMR 24430/021]

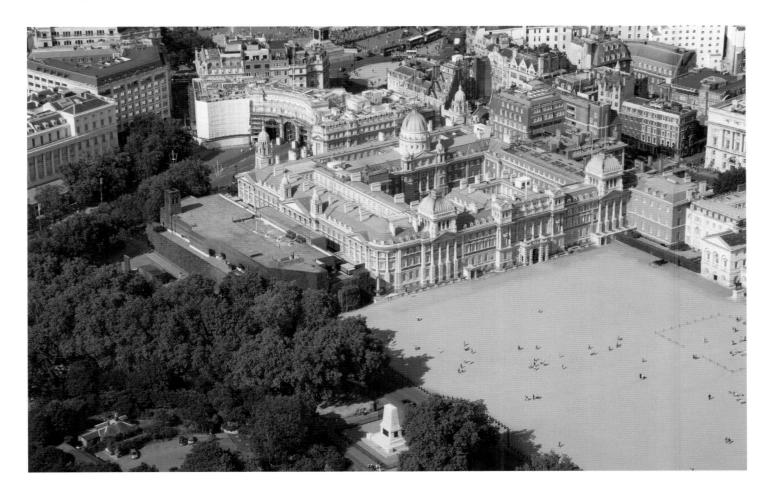

Looking north over St James's Park to St James's Palace, 9 September 1946

A stranger to London, asked to identify the palace in this picture, would probably point to the symmetrical Neoclassical façade of Lancaster House on the left. This was begun by Frederick, Duke of York, younger brother to the Prince Regent, but his debts obliged him to sell before the house was complete. York House, as it was then known, was bought by the millionaire Marquess of Stafford (later the Duke of Sutherland) and completed as Stafford House; it was so splendid that Queen Victoria, visiting her friend the Duchess of Sutherland, said 'I have come from my house to your palace.' The house was purchased by the philanthropic soap magnate Lord Leverhulme, who renamed it Lancaster House after his native county and left it to the nation. It was long open to the public, but is today given over to government entertaining and is inaccessible, which seems unlikely to be what Lord Leverhulme had in mind. The picturesque, battlemented mass of St James's Palace extends to the right, around several courtyards. Clarence House, the white four-storey block in between, is essentially a wing of St James's, added by the Duke of Clarence, the future William IV, in 1828–30. [RAF, TQ 2979/83]

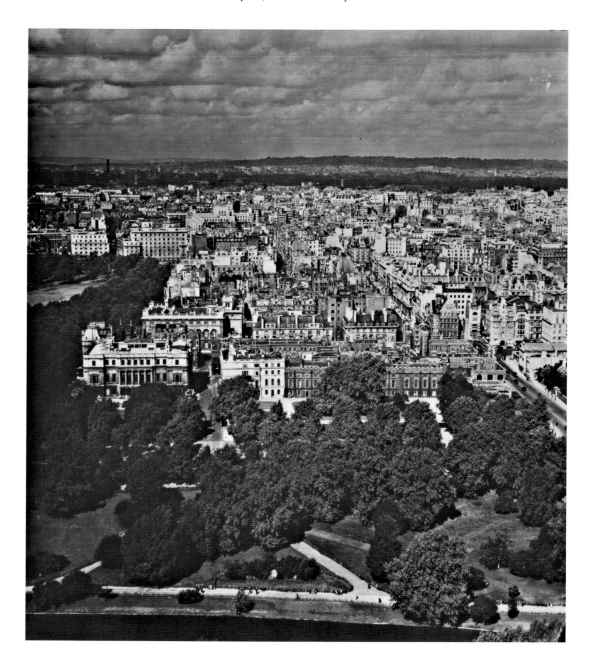

St James's Palace, August 2006

St James's Palace was built by Henry VIII on the site of a medieval leper hospital as an alternative residence to Whitehall Palace though it was relatively little used until the late 17th century. It was left as the principal metropolitan palace of the British Crown by default when Whitehall burnt down in 1698 and thus foreign ambassadors to this day are formally appointed to 'the court of St James'. Great or Colour Court appears in the centre of this view, with the Board of Green Cloth Court (named for the committee which used to run the royal household's finances) below. In the range between them is the 16th-century Chapel Royal. The pale stone building to the top right is the Queen's Chapel (1623–7), designed by the court architect Inigo Jones for Charles I's wife Henrietta Maria and her household, who remained Roman Catholics and thus needed their own place of worship. The palace has a suite of state rooms, regularly in use for official receptions, and it houses officials of the royal household; it has never been routinely open to the public. [NMR 24431/001]

Buckingham Palace, c 1930s

Buckingham Palace, the principal residence of the monarchy since the reign of Queen Victoria, is seen here in a view that nicely conveys its position between its own spacious gardens and the grand formal landscaping of the Mall. It retains a semi-private, suburban character in contrast to the urban palaces seen in continental capitals and this goes back to its origins when John Sheffield, 1st Duke of Buckingham, built a grand brick-and-stone mansion here in 1705. Buckingham House was bought by George III to serve as a private residence; he continued to hold his formal courts in the much older complex of St James's Palace, just visible beyond. The area in front of the palace, centred on the Victoria Memorial, was re-landscaped between 1901–14, creating the setting for royal ceremonial ever since. This view probably dates from the mid-1930s, but the double line of plane trees down the Mall, planted as part of the Memorial scheme around 1905, still seem quite small. [R H Windsor Collection, TQ 2879/1]

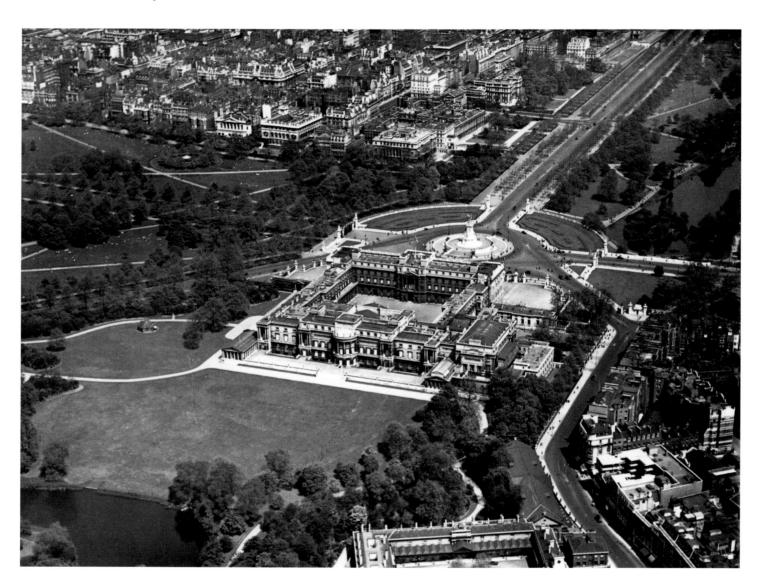

Buckingham Palace, August 2006

John Nash's transformation of the palace for George IV between 1825 and 1830 was one of the most controversial architectural projects of the 19th century, thanks to Nash's confused management and its spiralling costs. It was left to Victoria and Albert actually to use and occupy Pimlico Palace (as it was then nicknamed), closing the courtyard with the east range (on the far side of the palace courtyard) in 1845–50. It is only fair to Nash, though, to add that his State Rooms are of a splendour and beauty worthy of St Petersburg and that his garden front, though it has regrettably lost some of its statues and vases, is a singularly friendly and appealing piece of architecture. The Edwardian landscaping beyond has reached maturity, making the Mall and the open space around the Victoria Memorial one of the most popular public spaces in London. [NMR 24420/024]

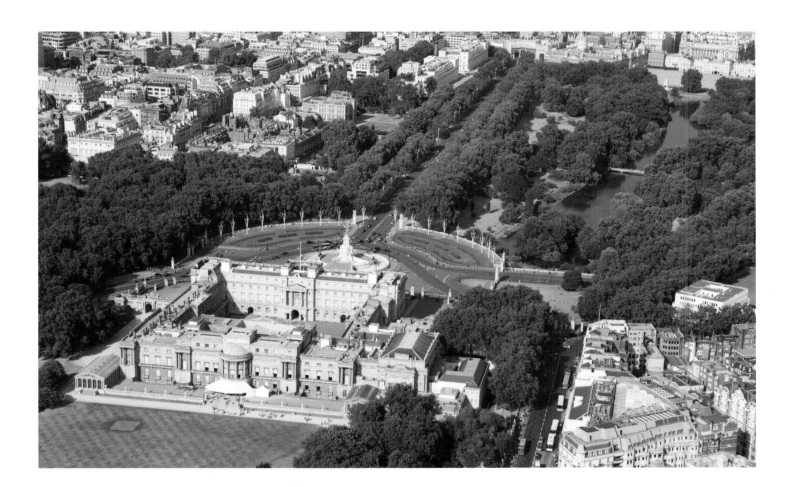

The Mall and West End looking north, 9 September 1946

The two long blocks of Carlton House Terrace in the foreground mark the site of Carlton House, residence of the Prince of Wales for most of the 18th century. In 1782 Carlton House was given to Prince George, just turned 21, the man who was later to be the Prince Regent and King George IV. He transformed it at vast expense into the most lavishly and superbly decorated palace in London. Sadly, by the time he ascended the throne, George IV had become bored with the creation of his youth – it was demolished in 1827 and effectively replaced by Buckingham Palace. Regent Street, another of his initiatives, has lasted better: in this view it reads surprisingly clearly, the central north–south axis of the West End leading all the way from the Mall to Regent's Park. [RAF, TQ 2980/133]

Vertical view of the West End, 7 August 1944

An aerial 'map' of the West End with Hyde Park at the lower left-hand corner and Regent's Park at the top. The West End grew, c 1680–1780, with an almost complete absence of overall planning – the only controlling authorities of any kind were the parish vestries of St James, Piccadilly; St George, Hanover Square; St Anne, Soho; and St Mary, Marylebone, who were responsible for the streets, the night-watch, law and order, the parish poorhouse and the parish school. It seems remarkable, in retrospect, that the resulting cityscape should be so eminently orderly and humane. The variations to the street grid (like the street names) reflect the different landowners – thus the area south of Piccadilly (at the bottom) represents the St James estate of Henry Jermyn, Earl of St Albans; the streets around and to the south of Berkeley Square, lower left, represent the estate of the Berkeley family; and the larger and more regular grid around oblong Grosvenor Square, centre left, represents the Mayfair estate of the Grosvenor family, headed by the Duke of Westminster. [RAF/106G/LA/29/3184]

Piccadilly Circus, c 1930s

Piccadilly Circus, the heart of the West End, only dates from c 1819 when it was formed at the intersection of John Nash's newly created Regent Street with Piccadilly. Nash designed a small and elegant circular place, immediately south of where his street turned left up the Quadrant. London's increasing traffic problems led to the Metropolitan Board of Works demolishing Nash's north-eastern block in the 1880s – its site is occupied by Eros on his traffic island in this view – to open up the way to the newly formed Shaftesbury Avenue and thus the Circus became the incoherently shaped space that it has been ever since. Its character was further altered by the erection of the first big illuminated signs c 1910 – the advertisement for Bovril, seen here, was one of the first. [R H Windsor Collection, TQ 2980/1]

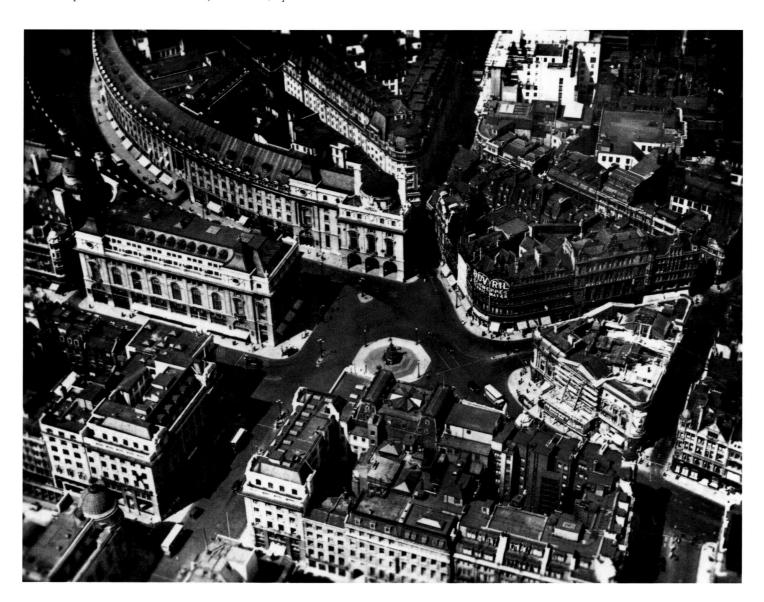

Piccadilly Circus, August 2006

Eros (1893) – Sir Alfred Gilbert's elegant aluminium figure of the god of love atop his elaborate bronze fountain base – has been moved south to allow the roads to be widened. The beautiful sculpture is one of the symbols of London, seen every day on the *Evening Standard's* masthead, but it is rarely remembered that this was built as the nation's memorial to a particularly sober Victorian philanthropist and reformer, the 9th Earl of Shaftesbury. [NMR 24430/042]

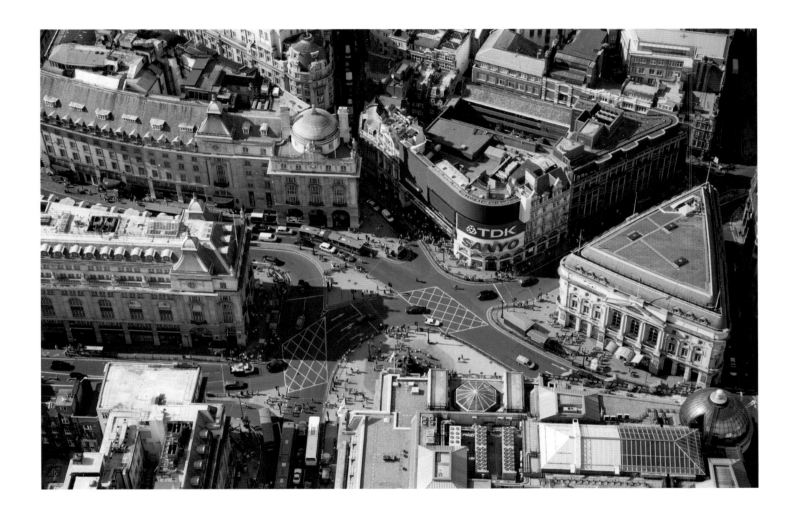

St James, Piccadilly, with Regent Street in the background, 9 September 1946

The church of St James, Piccadilly, was designed by Sir Christopher Wren and built in 1683–4 as part of the Earl of St Albans' development of the St James area, one of the first formative steps in planning the modern West End. Here, unlike most of the numerous City churches that Wren had been rebuilding after the Great Fire of 1666, he had a clear and spacious site and was able to design what he envisaged as an 'ideal' Anglican church, perfect in its restrained, sober elegance. The church is seen burnt out after a direct hit – at the risk of seeming frivolous, it does seem a malign act of fate that the bomb should have hit the one undoubted masterpiece in this picture. [RAF, TQ 2980/33]

St James's Square looking north over the West End, August 2006

Soon after the Restoration of 1660 Henry Jermyn, Earl of St Albans, obtained a lease of several fields close to St James's Palace from Charles II. He and a number of partners had streets laid out around a square – London's third after Lincoln's Inn Fields and Covent Garden – and lined them with plain brick houses. The St James development swiftly became the most fashionable quarter of London: this was the origin of the West End. The square remained aristocratic, divided between residences of the nobility and grand clubhouses, until the Second World War. Today commerce has taken over: there are precious few private houses remaining in the near or middle distance of this view. [NMR 24431/003]

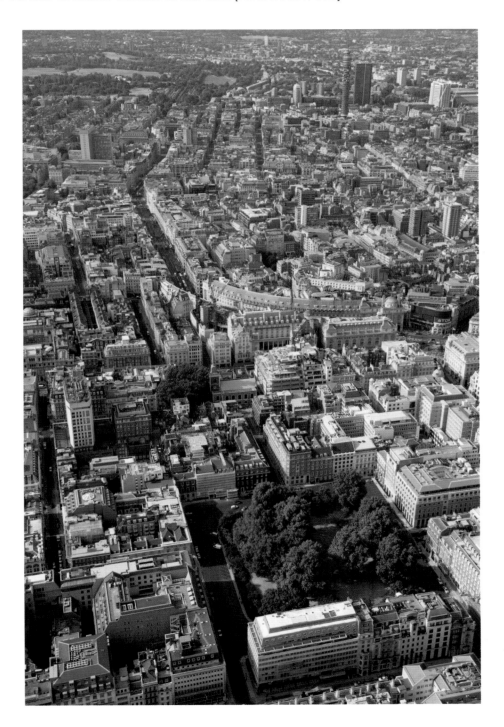

Lower Regent Street, 9 September 1946

The creation of Regent Street, c 1813–20, represents one of the few really ambitious pieces of grand city planning in London's history; John Nash acted as entrepreneur as well as architect and the Commission for the New Street got going with the enthusiastic backing of the Prince Regent, an Act of Parliament and a large government loan. Nash's admirable master plan envisaged the street's character changing as one travelled along it and Lower Regent Street, seen here, would be primarily lined with smart residences, including Nash's own house at Nos 14–16, sadly demolished in the late 19th century. The site of Nash's house is now occupied by the building with two storeys of dormer windows in its roof seen on the right-hand side of the street. The street terminates at Waterloo Place, still lined with the handsome stuccoed buildings of the Athenaeum Club (Decimus Burton, 1829–30) and the former United Services Institute (John Nash, 1827) on the right. [RAF, TQ 2980/13]

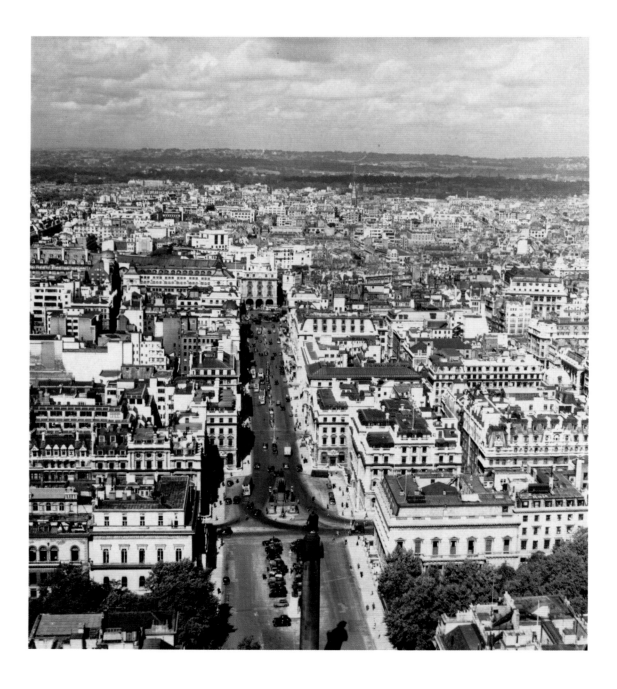

Waterloo Place, August 2006

Little has changed in the equivalent modern view. Waterloo Place, a handsome if little-used public space, represents some small compensation for the tragic loss of Carlton House, whose site occupied the middle ground of this view. The extravagant Prince Regent converted the house by stages from a relatively simple Georgian residence into a superbly decorated palace between 1782 and 1815. However, by the 1820s the prince had become bored with it and complained that it was too small to be a full royal residence; Carlton House was demolished in 1827 and replaced by the huge twin blocks of Carlton House Terrace in Nash's most grandly overblown manner. In between them are the Duke of York's steps and column (Benjamin Dean Wyatt, 1833–4), which were built of granite and commemorated George IV's younger brother Frederick. The duke was a popular commander-in-chief, even though his main (or at any rate, best known) contribution to the efficiency of our armed forces was to sell officers' commissions, with the kind assistance of his mistress, in order to relieve his pressing financial difficulties. [NMR 24416/008]

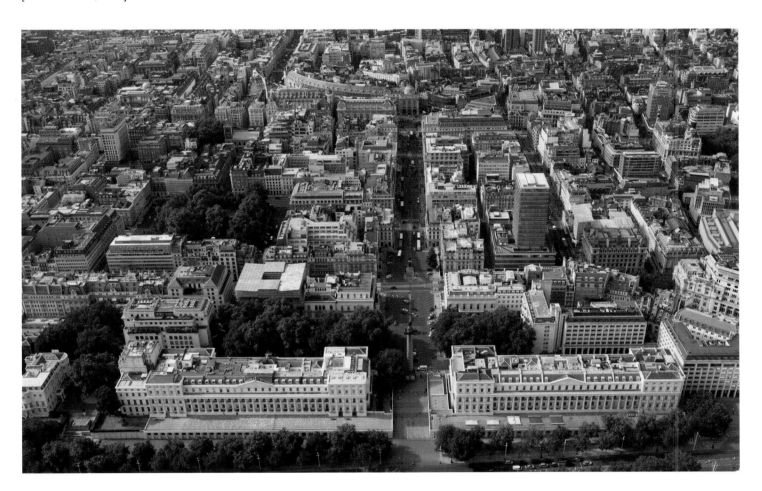

Regent Street, 9 September 1946

Britain was still in the iron grip of rationing, but the shop awnings are out and the pavements are carrying a tolerable crowd in this view of Regent Street. Back in 1813, John Nash had envisaged his street as giving a new sense of shape to the West End, making a grand processional way from Carlton House in the south to Regent's Park in the north – this long main tract was to be given over to fashionable shops. Where a continental architect might have lined such a grand boulevard with uniform blocks, Nash's imagination and sense of the picturesque rebelled against this kind of thing and instead he created a rich variety of stuccoed buildings within a broadly similar language of design. His new street, quite simply, was one of the most beautiful in Europe. By the 1920s, though, his buildings were not big and profitable enough for the liking of the Crown Estate Commissioners and down they all came. [RAF, TQ 2980/35]

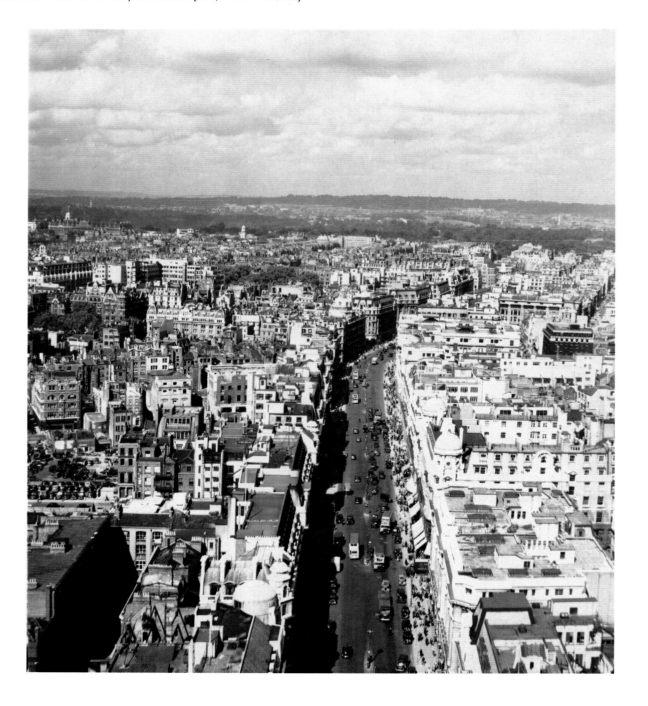

Regent Street, August 2006

Regent Street today, much as it looked in 1946. Nash's beautifully modulated terraces had been replaced in the 1920s by the sequence of oversized Portland stone-faced boxes seen here, many of them by the chief architect to the Office of Works, Sir Henry Tanner. A couple, such as the swaggering Roman façade of Liberty's, are memorable, but most of them are just dull. The destruction of Nash's Regent Street was one of the great artistic crimes of the 20th century. [NMR 24416/014]

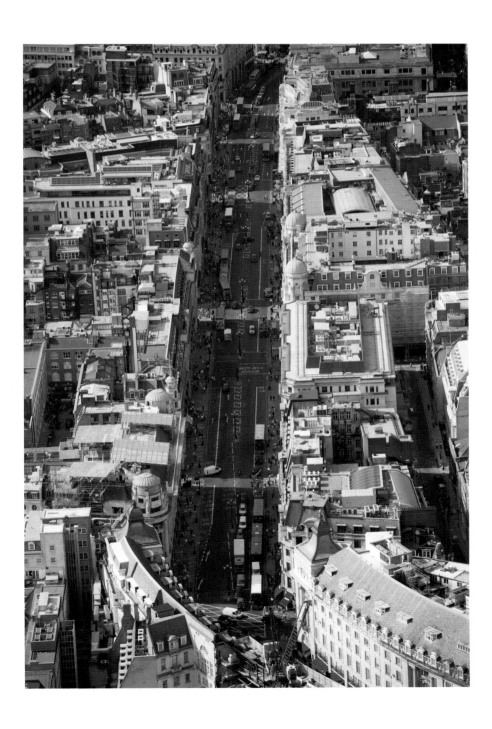

Broadcasting House and Langham Place, c 1930s

The Georgian West End was built, to a large degree, by speculative builders in collaboration with aristocratic property owners. Half of the manor of Marylebone was bought by John Holles, Duke of Newcastle, in 1708. His daughter Henrietta and her husband Edward Harley, Earl of Oxford, began by laying out Cavendish Square (just off this picture to the right) and the surrounding streets, including Harley Street (the row of houses visible at the bottom), from 1717 on. The estate passed via their daughter Lady Margaret Cavendish Harley to the dukes of Portland and passed by descent again to Lord Howard de Walden in 1879. The Marylebone estate, 100 acres or so of the most valuable property in the world, remains with the Howard de Walden family. The builders included the energetic Adam brothers, who laid out Portland Place (the street leading off to the left, just in front of Broadcasting House) as one of their most ambitious speculations, from 1773 on. This civilised Georgian streetscape was undoubtedly enhanced by John Nash's church of All Souls. Two massive intruders have disrupted the scale: the Langham Hotel (John Giles, completed 1865) and the Art Deco Broadcasting House of 1931. [R H Windsor Collection, TQ 2881/1]

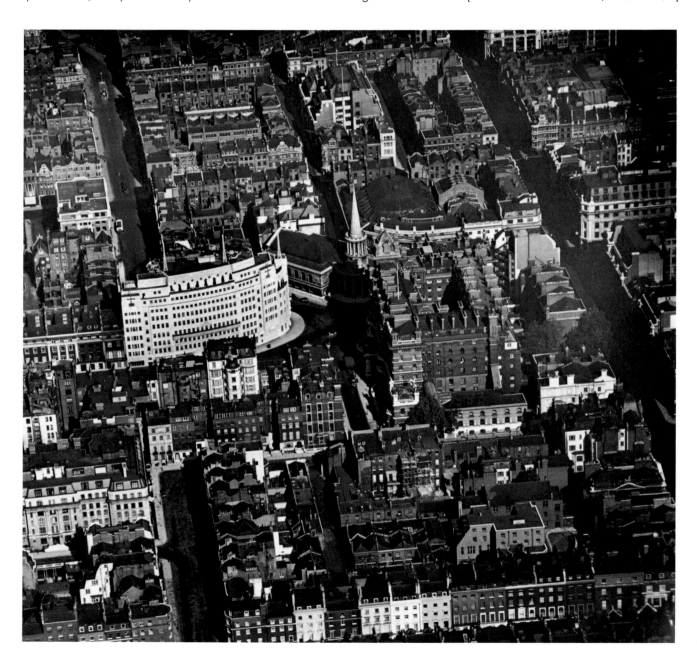

Broadcasting House from the south-west, August 2006

An intruder can be forgiven when it is of the architectural quality of Broadcasting House, whose Art Deco curves, faintly reminiscent of ocean liners, come as a tonic after the rather tired *beaux arts* classicism of Sir Henry Tanner's buildings lining Regent Street. The BBC had commenced radio broadcasts from Savoy Hill in 1922, but soon needed more space and purchased the Georgian house on this site in 1928. The architect G Val Myers worked with the BBC's engineers, designing 22 soundproofed studios in the centre of the building, insulated by the offices towards the outside. Despite the huge shifts in the organisation's gravity with the establishment of the World Service at Bush House and the Television Centre at Shepherd's Bush, Broadcasting House remains a pre-eminent symbol of the Corporation. During the war it was painted battleship grey in an attempt to camouflage it, but the *Luftwaffe* found it anyway and a bomb exploded inside the building in October 1940 killing seven people during the broadcast of the *Nine O'Clock News* – which continued without interruption. [NMR 24416/023]

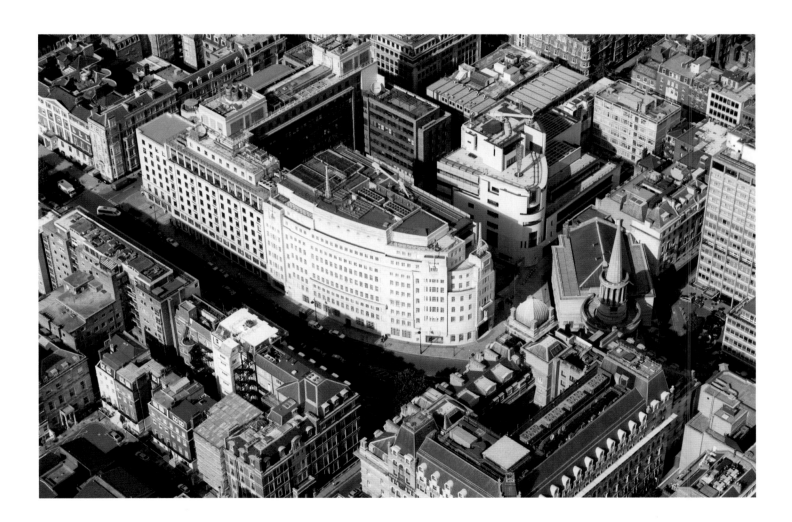

Holford House, Regent's Park, c 1918

When Regent's Park was first envisaged, there were going to be about 50 grand villas dotted around it, to help pay for the whole ambitious development. In the event only a handful of these grand houses went up, mostly opening off the Inner Circle. Holford House, seen here, was something of an outlier on the northern edge of the park. It was designed by Decimus Burton, 10th son of the builder-developer James Burton – James had been responsible for building many of the park's terraces (and lived at The Holme, one of the villas on the Inner Circle, also designed by son Decimus). The splendid private palace seen here was built in 1832 for James Holford, merchant and wine importer. After his death in 1853 it became Regent's Park College, where Baptist clergy were trained. Badly damaged by bombing, the house was demolished shortly after the Second World War. [RaeS Library; NMR TQ 2783/1]

Regent's Park with Winfield House and the Regent's Park Mosque, August 2006

The site of Holford House is empty, but a short distance to the west are two witnesses to the shifts in wealth and influence in 20th-century London. Winfield House (Wimperis, Simpson & Guthrie, 1936–7), built for the Woolworths heiress Barbara Hutton and now the American ambassador's residence, occupies the site of St Dunstan's Lodge (another of Decimus Burton's grand villas, this time built for the 3rd Marquess of Hertford) – transatlantic money and power have taken the place of aristocratic culture and debauchery. The gilded dome of the Regent's Park Mosque (Sir Frederick Gibberd & Partners, 1969–77), to the left, conveys something of the size and wealth of London's Islamic community. [NMR 24418/011]

London Zoo, Regent's Park, c 1930s

The Zoological Society of London was founded in 1824, the first society dedicated to the study of animals in the world. In 1826 the society rented a large triangular plot on the north-east side of the park and in 1827 this was laid out by the architect Decimus Burton; the zoo opened to the public the following year. By the middle of the century, zoos planned along similar lines had opened all around the world. The buildings were repeatedly remodelled as the collection grew and ideas about the presentation of animals changed; by about 1930 little remained of Burton's original buildings. The Bird House of 1883 (the low-roofed building in the lower right corner of the site) and the Parrot House of 1896 (the picturesque gabled building in the upper right-hand corner) still survive from the late Victorian expansion. Early in the 20th century, the wish to present animals in something more like their natural habitat found expression in the construction of the reinforced-concrete hills of the Mappin Terraces (1914), seen in the upper left-hand corner. The zoo seems closed and empty in this view, but at this date it was still one of the essential sights of London, a zoological portrait of the British Empire. [R H Windsor Collection, TQ 2883/1]

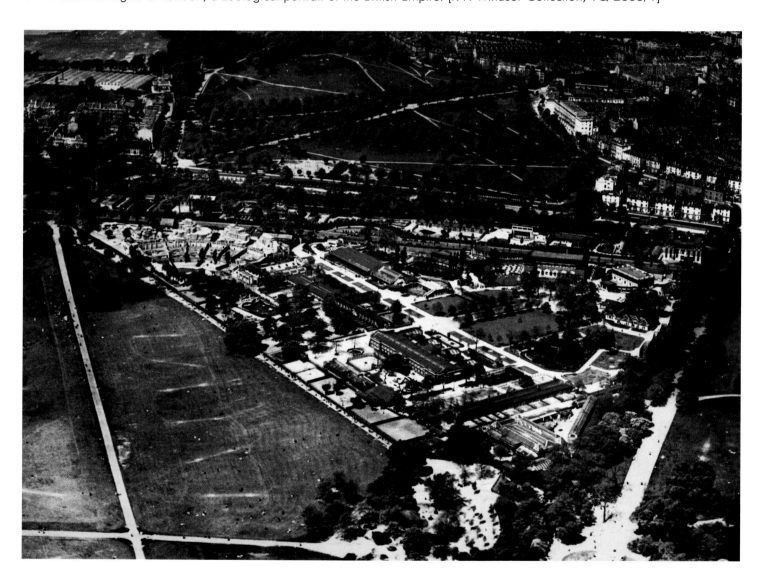

London Zoo: the Elephant House and the Penguin Pool, August 2006

In the 20th century, as the zoo has striven to update itself, it has received the attentions of numerous eminent architects. One of the distinguishing points about designing for animals is that they are unable to voice their own preferences – the one thing we can be fairly certain of is that their preference would not be to live in a zoo. Zoo architecture, at its best, is the closest that 20th-century architecture came to the follies built by the Georgian aristocracy in their parks. Here, on the left is the Elephant House by Sir Hugh Casson (1962–5) – the critic J M Richards referred to its 'massive curves, wrinkled hide and its curious silhouette' echoing the form of its tenants; it still remains in service. The white oval to the right is the Penguin Pool by the celebrated modernist Berthold Lubetkin (1934); Hugh Casson described it as a 'brilliant outdoor theatre set for the penguins', though one has to wonder whether anyone, even penguins, would wish to live in a theatre set. [NMR 24431/022]

Hyde Park with parts of Belgravia and Bayswater (north at top right-hand corner), 7 August 1944

London's lost rivers make a subject in themselves: here we are looking at part of the valley of the Westbourne, dammed c 1730 at the suggestion of Queen Caroline of Ansbach to form the Serpentine. Further south it runs in a sewer under Knightsbridge and Belgravia and is carried in a great iron pipe across Sloane Square Station, before joining the Thames close to the Royal Hospital, Chelsea. An anti-aircraft battery – the small network of roadways – can just be made out above the dark patch of grass in the largest open area of the park. The marks of war are also to be seen in what appears to be a small military encampment close by and in the allotments along Rotten Row below the Serpentine. The regular pattern of dots in part of the park is probably earlier anti-glider defences. [RAF/106G/LA/29/3182]

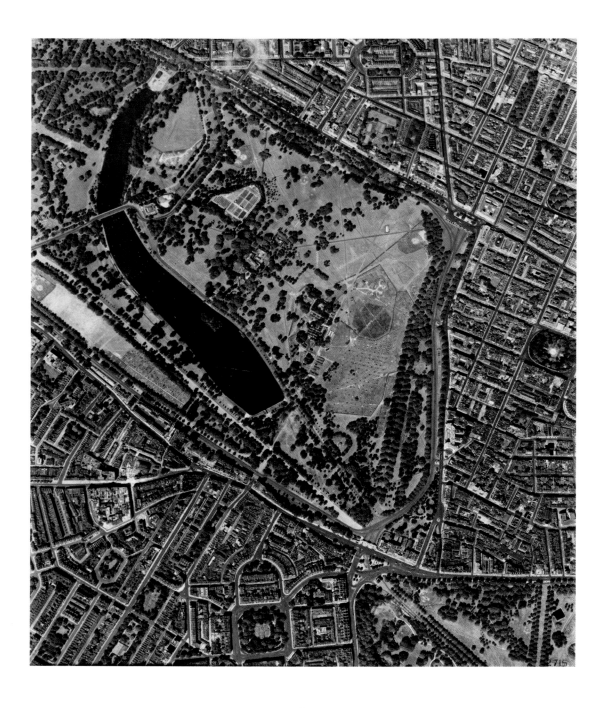

Looking west over Hyde Park, September 2006

Hyde Park's 340 acres extend from Bayswater to Knightsbridge. In the 18th century this formed the boundary of the West End, and Hyde Park Corner (at the lower left corner of this view), where the Kensington Turnpike reached the houses of Mayfair, was considered the western entrance to London. This was part of an estate given to Westminster Abbey after the Norman conquest – at this time it was the haunt of deer, wild boar and bulls. The Hyde was taken back into Crown ownership by Henry VIII as a hunting ground. Deer were still hunted here in the 18th century, though by this time the park had become a resort for all society ranging from the royal family all the way down to highwaymen and thieves, for which the park was notorious. In 1749, when Horace Walpole was returning from an engagement in Kensington, two highwaymen armed with a blunderbuss stopped him and took his watch and eight guineas. The park was also London's duelling ground of choice – Lord Mohun and the Duke of Hamilton managed to kill each other here in a particularly vicious engagement in 1712. [NMR 24444/002]

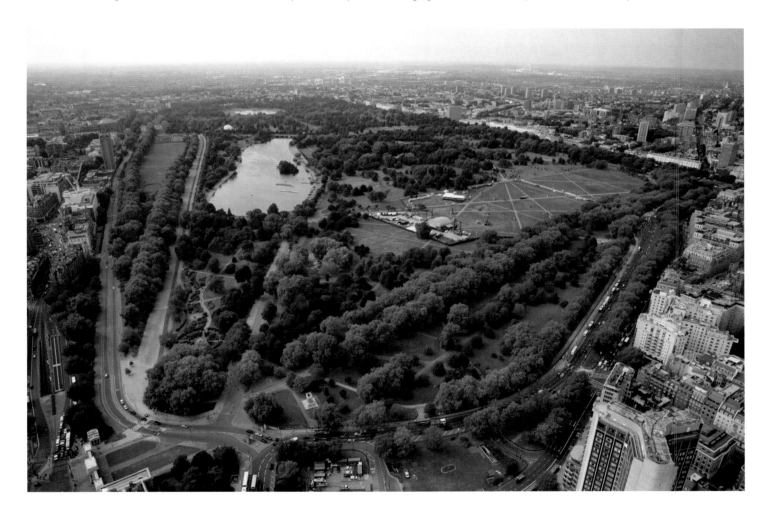

Dorchester Hotel and Park Lane, c 1930s

The Dorchester Hotel and Park Lane, in a view which expresses the changes coming over the aristocratic West End in the 1920s. Mayfair was developed in the 18th century on the property of the Grosvenor family, later earls and dukes of Westminster – they were transformed from being modest Cheshire landowners into the richest family in Britain on the profits from this estate and Belgravia to the south-west. The grandest residences were Dorchester House and Grosvenor House, the Westminsters' own London mansion, but by the time this view was taken they, like many others, had fallen victim to soaring property values. Just in front of the Dorchester is the Cambridge Gate (Decimus Burton, c 1824–5) into Hyde Park and just visible between the two gateways is the Cavalry Memorial (Burnet, Tait & Lorne, with sculpture by Adrian Jones, 1924). One puzzle about this picture is the even rows of objects seen in the park: what can they be? Deckchairs, perhaps? [R H Windsor Collection, TQ 2880/1]

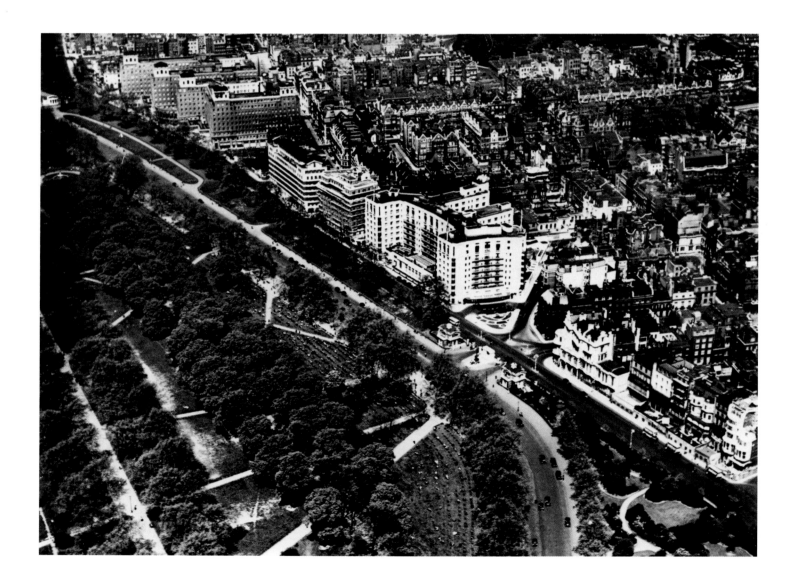

The Dorchester Hotel, Park Lane and western Mayfair, September 2006

The Dorchester Hotel occupies the site of Dorchester House, the most magnificent private house in London, a Victorian interpretation of a Roman Renaissance palace built for Robert Stayner Holford, whose family had made a fortune from their shares in the New River Company. In 1905 the company was nationalised with the rest of London's water industry, by the 1920s the great houses of the West End had had their day and Dorchester House came down in 1928. At least the hotel is a decent piece of Art Deco design (William Curtis Green with the engineer Sir Owen Williams, 1929–31), which is more than can be said for the towered brick bulk of the Grosvenor House Hotel (Sir Edwin Lutyens, c 1927–8) further up to the left. The high proportion of red brick in this view reflects the fact that a lot of 100-year leases on the Grosvenor estate expired in the late 19th century and, as new leases were issued, the original terraced houses tended to be replaced with larger blocks of smart flats faced in this material. Another such generational round of rebuilding took place in the 1930s, most notably in Grosvenor Square. [NMR 24444/013]

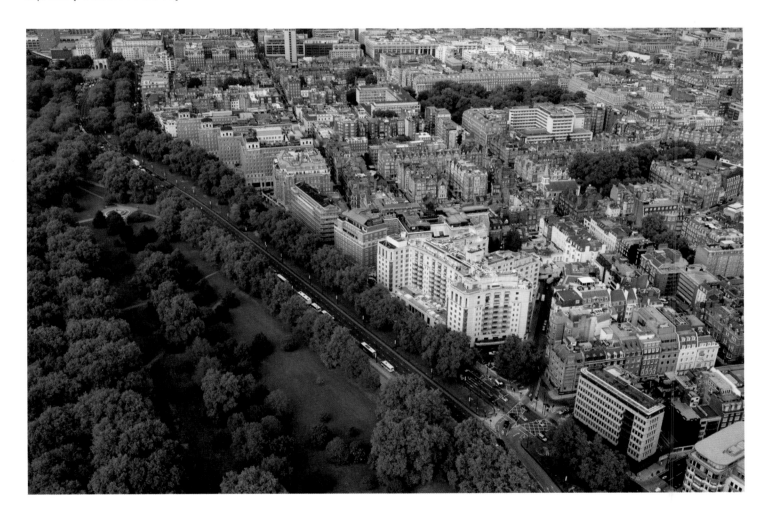

Bayswater and Marble Arch, c 1930s

A view over the area the Victorians called Tyburnia, now more usually called Bayswater. This was part of the Bishop of London's Paddington estate, shading in the distance into the estate of the Portman family. It was laid out in streets in the 1820s; in the 1830s it developed as a fashionable residential district of leafy streets and squares surrounded by tall stuccoed houses. The early 19th century was the great age of the London square and the area boasts Oxford, Cambridge, Hyde Park and Gloucester squares, amongst others. Paddington Station occupies the bottom left of this view, quite hard to recognise at first: look for the building which seems to have vertical black and white stripes on its façade, which is part of the famous terminus. Oxford Street appears clearly, heading off into the far distance from the corner of Hyde Park. [R H Windsor Collection, TQ 2781/1]

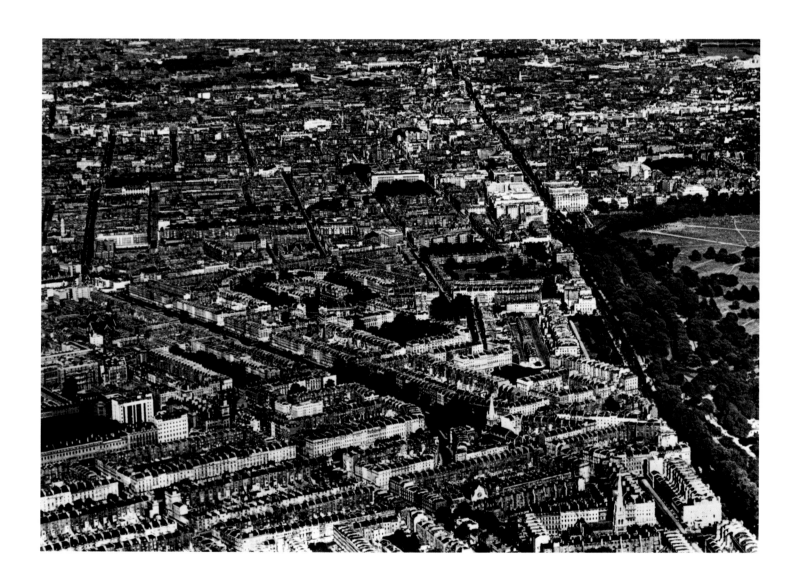

Marble Arch and Oxford Street, August 2006

This view looks over Marble Arch and down Oxford Street, with a splendid line up of those familiar icons of London: red double-decker buses. From above the streetscape has changed little since the 1930s, with only the odd 1960s newcomer apparent, and Oxford Street has retained its place as one of the city's premier shopping locations. The Marble Arch (seen poking out of the trees in the foreground) was only moved here in 1851, having been removed from its original position as the ceremonial entrance to Buckingham Palace. Before that this corner was called Tyburn and it was notorious throughout the country as London's principal place of public execution from 1388 until 1783, when the site was moved to Newgate Prison in the City. Hanging days were public holidays, regularly drawing huge crowds – the execution of the highwayman Jack Sheppard in 1714 was said to have drawn an audience of 200,000. A hanged man's body was believed to have magical curative properties and women flocked to press a hanged man's hands against their cheeks. It was all a very long way from red buses and shoe shops: the past is another country. [NMR 24420/007]

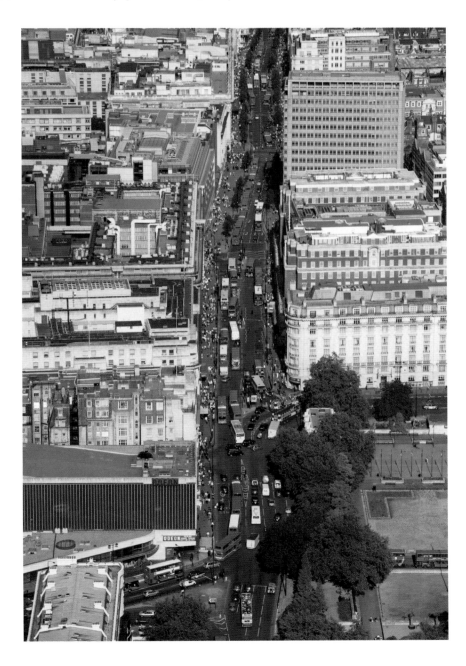

Bayswater and Paddington (north is at the top right-hand corner), 7 August 1944

The regular street grid in the lower right of this photograph represents the Bishop of London's estate, laid out by the architect Samuel Pepys Cockerell in the 1820s and developed between then and the 1850s. Westbourne Grove, the broad boulevard running north-west to south-east and lined with trees and stuccoed mansions, was intended as the grand boulevard of the area, the culmination of a quarter which Cockerell conceived as a northern equivalent to Belgravia. As it turned out, the area was tainted from an early stage by the noise, dirt and traffic generated by the Great Western Railway, whose tracks were carved through the cityscape in 1836–8. The strange, mottled appearance of the station roof reflects several direct hits by bombing: almost all of the glass has been blown out. [RAF/106G/LA/29/3131]

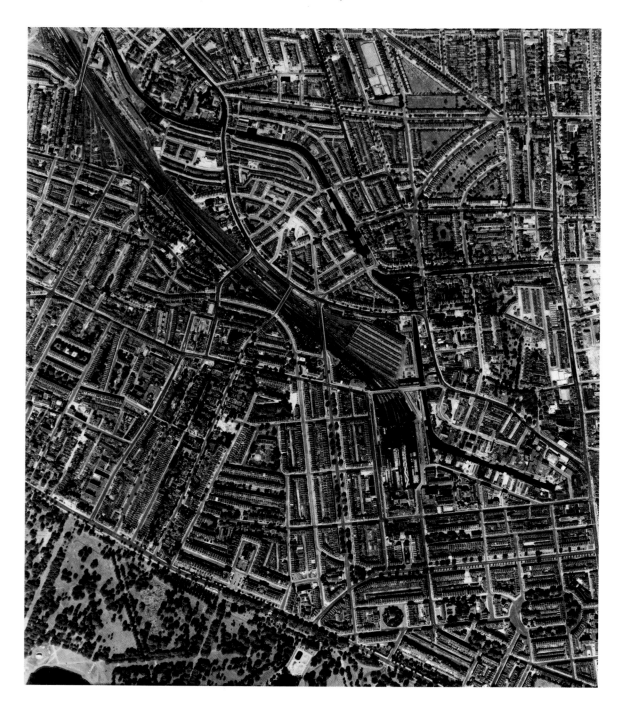

Paddington Station, August 2002

Brunel found a shallow depression at Paddington that suited the intended level of his railway and where land was available from the bishop's estate. By 1850 the GWR had far outgrown its original temporary station and Brunel designed its replacement with the magnificent three-span roof that still stands today. The fourth span, on the left, is part of a major extension of the station of c 1906–14. The large building at the top of the station is the hotel (1851–4), one of the first hotels in Britain to make a major architectural statement; it was designed by the architect P C Hardwick rather than Brunel. [NMR 21764/07]

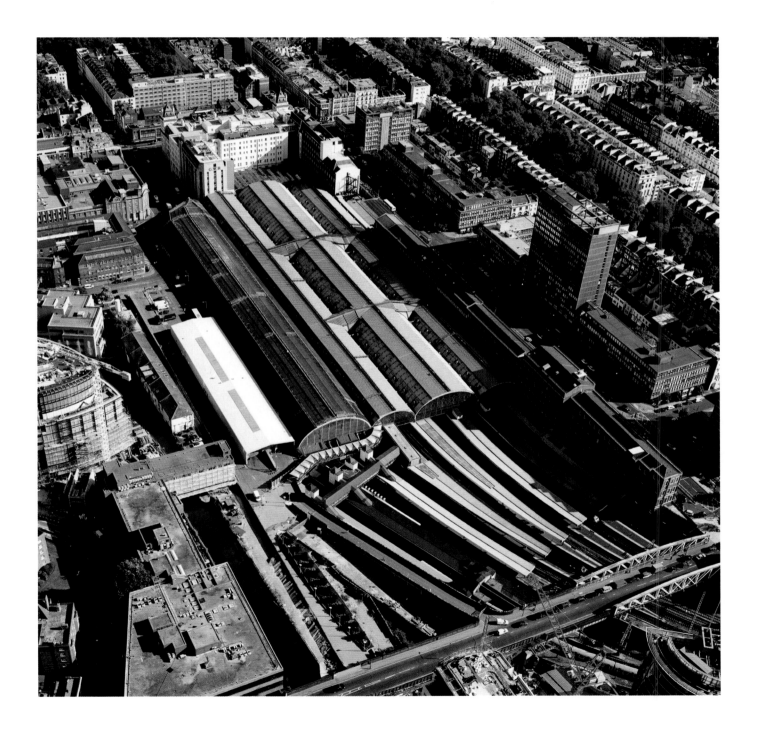

Marylebone Goods Station, 1908

This photograph of Marylebone Goods Station was taken from the balloon *Britannia*. Until the Second World War most of London's food, fuel and post, as well as myriad other goods deliveries, came by train and all of the railway termini had goods stations, an aspect of the city's life and work which has completely disappeared, as have almost all of their related buildings. [RAeS Library APh 339]

Marylebone Station, August 2006

The Great Central Railway, last of the great national trunk railway routes, had a difficult and expensive time securing a route into central London and when they got there the line was not a success – only five lines were ever laid running into the station, though room was left for another ten. So there wasn't very much money to spare for their terminus and Marylebone Station (H W Braddock, 1897–9) is modest in scale and has a pleasant, low-key character as if it was in a medium-sized county town. The Grand Central Hotel (Robert Edis, 1897–9), facing onto Marylebone Road, is a lot more grandiloquent and has been successfully restored to hotel use. The site of the goods yard and those extra tracks has been redeveloped with housing and the large building with its striking circular roof, now the London headquarters of BNP Paribas, the French investment bank. [NMR 24419/005]

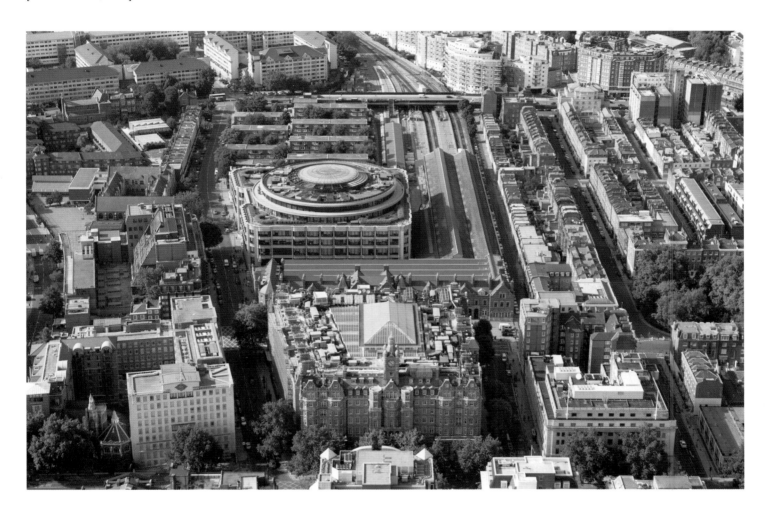

Kensington Gardens looking east to Hyde Park, c 1930s

Until the 19th century, Kensington was a distinct village, separated from the metropolis by Hyde Park and open fields. In the 17th century it became favoured as an area for smart out-of-town residences. One of these, a Jacobean house built by Sir George Coppin, was bought by the earl of Nottingham; in 1689 he sold it on to William III and Queen Mary, who disliked living at the old palaces of Whitehall and St James. Nottingham House had extensive grounds and, after it had become a royal palace, these were transformed in stages by the royal gardeners George London and Henry Wise. In the 1690s they laid out the area to the south of the palace (immediately to its right in this picture) as a formal parterre for Queen Mary. After 1703 London and Wise planned a great expansion of the grounds eastwards for Queen Anne, with avenues radiating from the Great Basin (now known as the Round Pond) – their layout still exists in outline, as seen in this view. [R H Windsor Collection, TQ 2680/1]

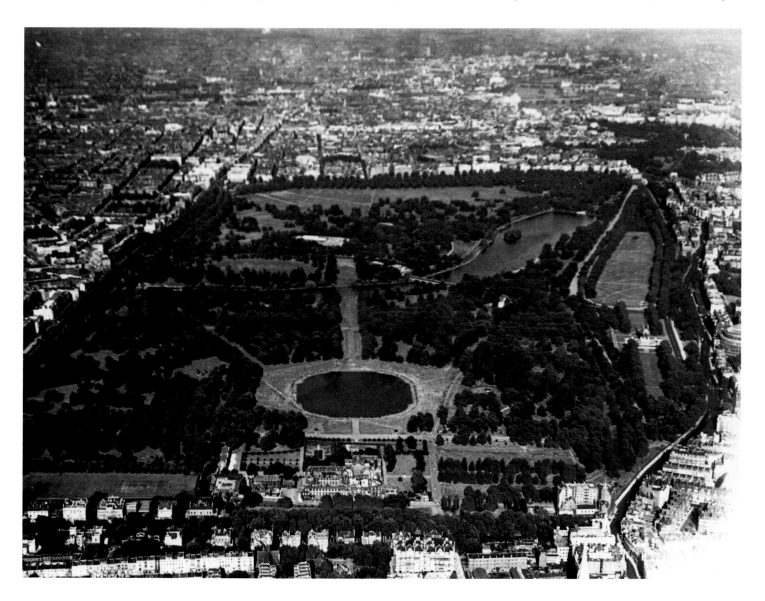

Kensington Palace, September 2006

After its purchase by William and Mary in 1689, Kensington Palace developed from a compact house to a sprawling complex of buildings. The royal requirements increased and Sir Christopher Wren (as architect) was never able to impose a coherent master plan on the house. The King's Gallery, to the right, remained the show façade, though it was never the main entrance. The first Hanoverian king, George I, liked it as it reminded him of his home at Herrenhausen and in 1718–21 three more state rooms were added to enable the palace to house formal courts better. Queen Victoria was born here on 24 May 1819. The state apartments have been opened to the public since 1889 (from 1912 to 1914 as the London Museum). The other areas of the palace continue to house suites of apartments for members of the royal family, who in recent times have included Princess Margaret and Diana, Princess of Wales. [NMR 24443/007]

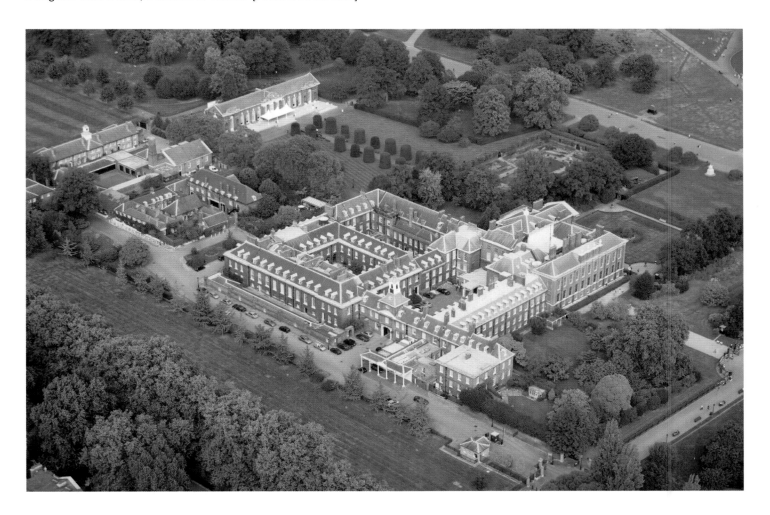

Royal Albert Hall looking north, c 1930s

Of the various grand institutions on the 1851 Commissioners' estate, the first to be built was the Royal Albert Hall of 1867–71, named for the Prince Consort. The huge domed building was the brainchild of Sir Henry Cole, one of the prince's great allies and Secretary to the Great Exhibition of 1851. It was paid for by selling seats to subscribers and the Hall is still owned by seat-owning shareholders. One might have thought that Prince Albert was sufficiently commemorated already, but he is represented again, to the south of the Hall (in the foreground here), on the Memorial to the Great Exhibition of 1851. [R H Windsor Collection, TQ 2679/1]

The Albert Memorial, September 2003

The Albert Memorial was built in 1872–6 as the nation's tribute to 'our blameless prince' after his premature death from typhoid fever in 1861. Covered in every kind of Gothic ornament and bearing 175 statues, the memorial is replete with symbolism and a particularly Victorian kind of moral earnestness. Sir George Gilbert Scott modelled his design on medieval church furnishings more than on historic buildings and the memorial's jewel-like character has to a large extent been restored by the recent refurbishment – the statue of the prince by J H Foley, which is nearly 14ft (4.2m) high, is once more covered in 24-carat gold leaf. The huge figure is shown reading a copy of the catalogue to the Great Exhibition of 1851. [NMR 23252/11]

The Royal Albert Hall and Albertopolis looking south, 11 July 1909

This balloon photograph shows the remarkable concentration of cultural institutions in the area. They provide a fitting commemoration for the Prince Consort, arguably the most intelligent and creative individual to (almost) sit on the English throne since Alfred the Great. It also commemorates the Great Exhibition of 1851, held in the Crystal Palace nearby in Hyde Park. The exhibition made a huge profit which was vested in a charitable Commission and used to buy a substantial area of land here in South Kensington. The 1851 Commissioners, over time, managed to fill their estate with such worthy institutions as the Natural History Museum (whose twin towers are just visible in the distance) and the Imperial Institute (T E Collcutt, 1887–93), a museum and educational institution dedicated to the British Empire – its tall tower commands the centre of the scene, with the façade of the Royal School of Chemistry (Sir Aston Webb, 1900–4) immediately beyond. [RAeS Library APh 318]

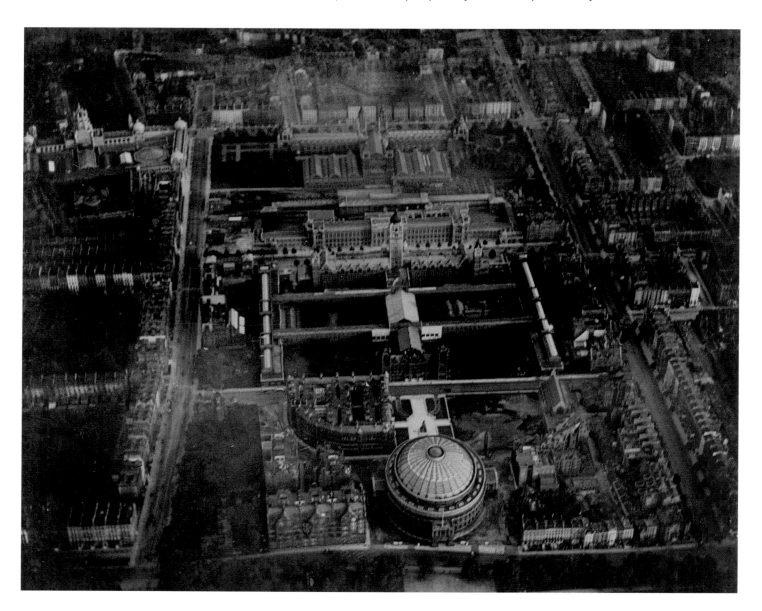

Albertopolis, September 2006

The Imperial Institute and most of the Royal School of Chemistry were demolished in the 1950s, to be replaced by new buildings for Imperial College. Even at the time it was a controversial decision and the replacement buildings (Norman & Dawbarn with Lord Holford, 1957–71) are the kind of dreary institutional boxes that give the architecture of the 1960s a bad name. Collcutt's noble central tower was left standing as a sop to history, though today it seems uncomfortably isolated rather than triumphant. Architecturally, South Kensington has gone downhill, but at least it remains a place of civilisation, dedicated to the ideals of high culture, public education and scientific advance fostered by its Victorian founders. Moreover, the 1851 Commissioners still own the estate and are still giving educational awards and scholarships from the proceeds. [NMR 24443/027]

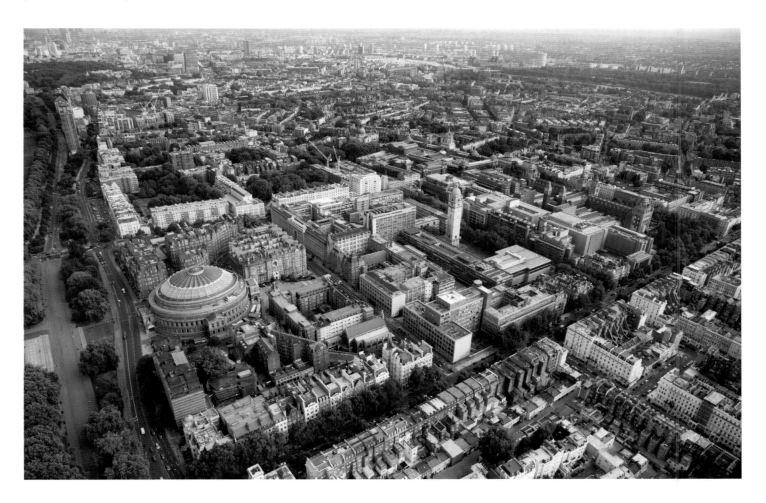

The Natural History Museum, 11 July 1909

The success of the Great Exhibition of 1851 inspired a second one in 1861, for which a huge brick building was built facing onto the Cromwell Road – the building had none of the grace of the original Crystal Palace and the exhibition was not nearly such a success. Gladstone's Liberal government cast around for a use for the vast, redundant building. Their suggestion that it be used to house an enlarged National Gallery was greeted with gales of contempt and instead the site was filled with Alfred Waterhouse's magnificent terracotta cathedral, which originally housed the Natural History department of the British Museum, opened in 1881. [RAeS Library APh 329]

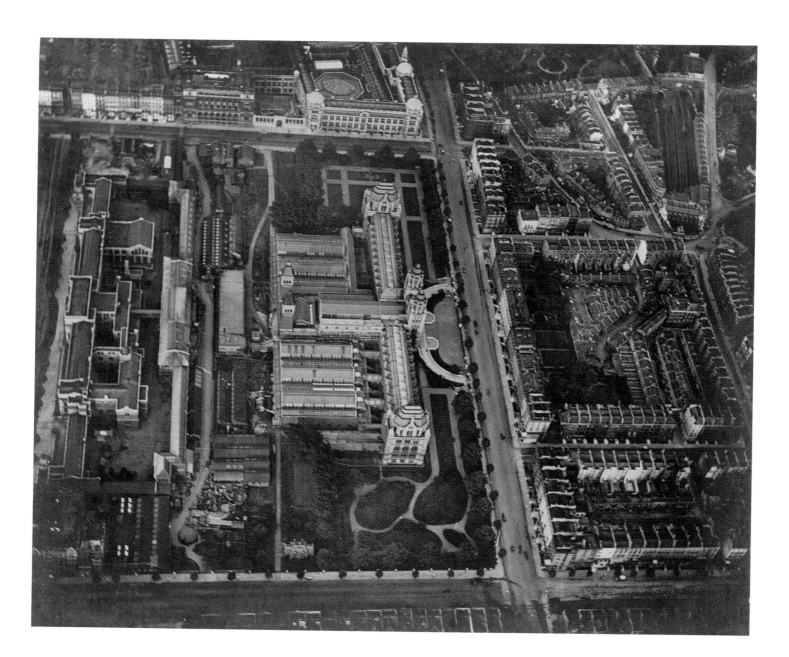

The Natural History Museum, August 2001

The Natural History Museum had the benefit of a singularly powerful and intelligent client in Richard Owen, its first superintendent, whose clear and bold plan for the museum allowed its architect, Alfred Waterhouse, to respond with a similarly clear and bold design. Living species were to be represented in the galleries to the left of the centre, geology and extinct species in the galleries to the right. The top-lit halls behind allowed for large displays: birds, fish and shells to the left, their fossilised equivalents to the right. Waterhouse's great terracotta façade is based on the Romanesque architecture of the 12th century, but in true Victorian spirit he designed sculptural decoration for it, representing living species to the left and extinct species to the right. [NMR 21451/07]

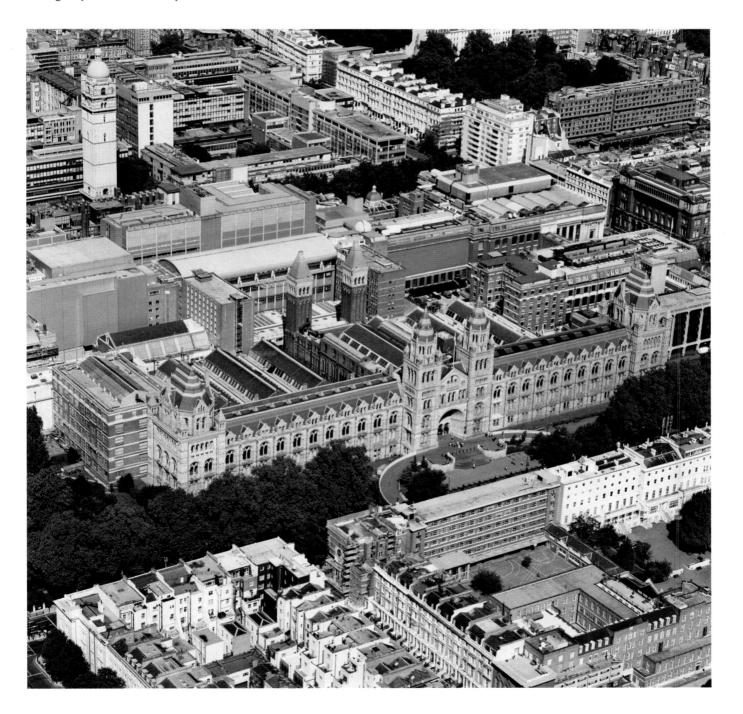

The Natural History Museum and Albertopolis from the south, c 1930s

The great cultural citadels of Albertpolis are here flanked by the long axes of Queen's Gate to the left and Exhibition Road to the right. The Commisioners for the Great Exhibition of 1851 made most of their money from the ground rents for the rows of huge terraced houses covered in white stucco along these and neighbouring streets. When this view was taken, most were still occupied by upper middle-class families of the kind typified by the Forsytes in John Galsworthy's *Forsyte Saga*. Today the great majority of them are now divided into flats, or used as hotels or for institutional use of one kind or another. However, a walk around South Kensington still gives a potent impression of the confidence, numbers and sheer wealth of the Victorian rich, if one reflects that every single house probably required upwards of 10 servants to run, plus horses, a carriage and a coachman in some neighbouring mews. [R H Windsor Collection, TQ 2679/2]

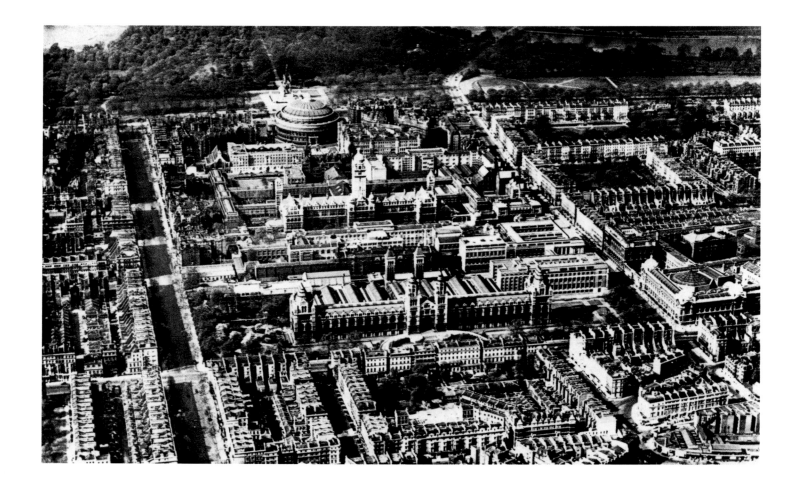

The Victoria and Albert Museum, August 2001

The Victoria and Albert Museum was another of the great institutions to arise on the South Kensington estate in the aftermath of the Great Exhibition of 1851. A School of Design and a Museum of Ornamental Art were brought together on this site in 1857 and grew in many stages. The immense front range was added by Sir Aston Webb in 1899–1909 to give unity to what had become a fairly confusing group of buildings. The vast collections have grown to embrace every material area, including sculpture in stone and marble, furniture, any kind of decorative metalwork, ceramics and glass, costume and textiles, and works on paper and canvas. The museum has never quite resolved the initial ambiguity as to whether it was meant primarily to be an educational institution for promoting good design or a museum of masterpieces in the fine and decorative arts. Not that this really matters: this is one of the great museums of the world and it can rise above petty questions of definition.
[NMR 21453/03]

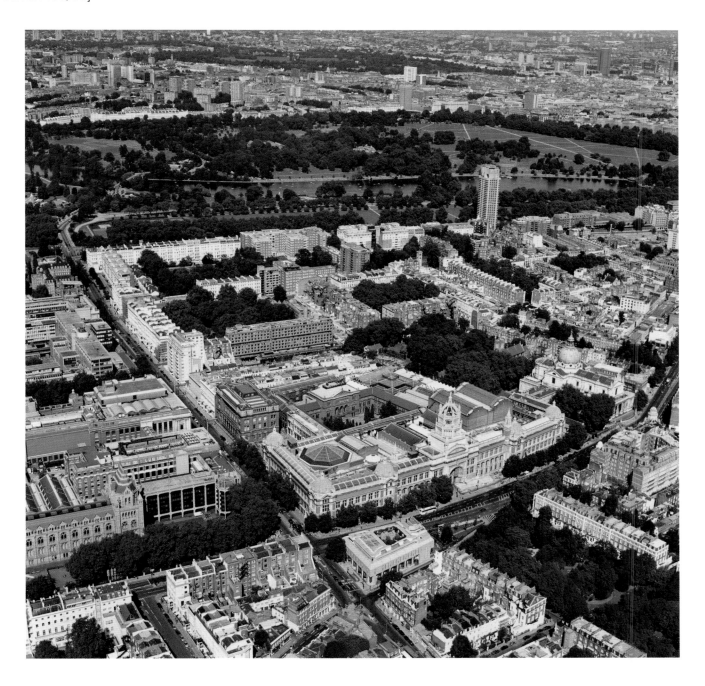

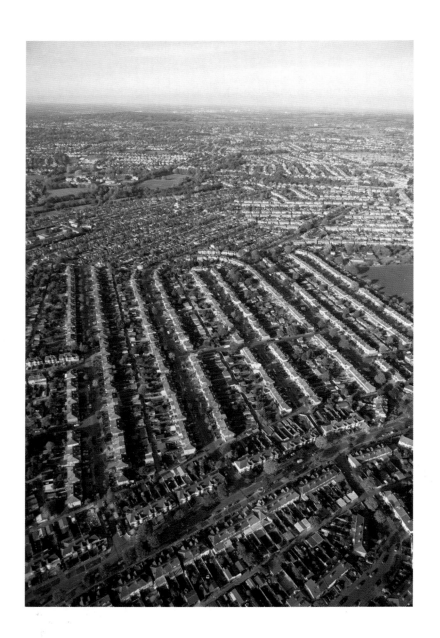

③

< THE WESTERN SUBURBS >

The Thames at Battersea with the Royal Hospital, Chelsea, 7 August 1944

The formal layout of the Royal Hospital at Chelsea and its grounds dominate the middle of this view. Wartime allotments fill part of the lawn to the north and a good deal of Battersea Park to the south of the river. The bulk of Battersea Power Station (S L Pearce and H N Allot, engineers, with J T Halliday and Sir Giles Gilbert Scott, architects) can also be seen south of the river (to the right of the railway lines). The power station's western half went up in 1929–35 with the eastern half following in 1944–53; the eastern half was incomplete at the time this photograph was taken. Look closely and you can see the shadows of both northern chimneys, but only one of the southern chimneys – the lower right-hand part of the building isn't there yet. [RAF/106G/LA/29/3237]

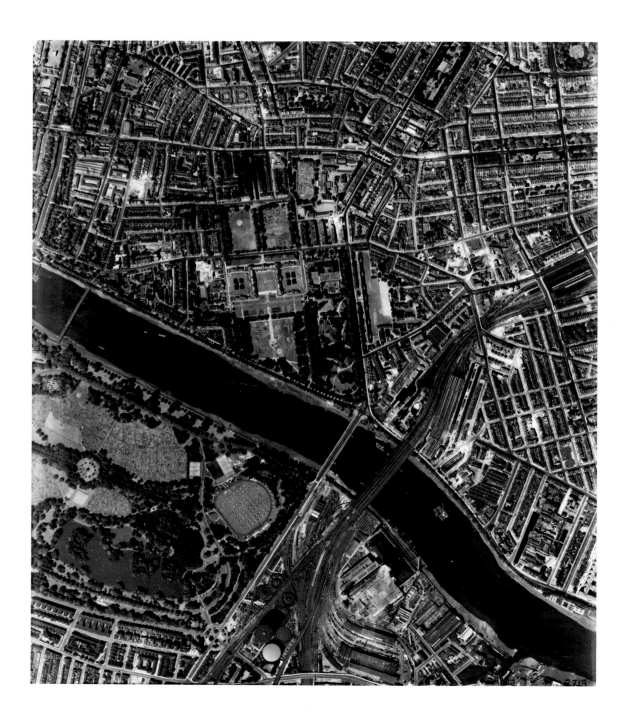

The Royal Hospital, Chelsea, from the south, August 2006

Up to the time of the Commonwealth, England had never had a standing army. Once it did, the problem of how to care for retired soldiers who were seriously wounded or invalided arose; to address this problem Charles II founded the Royal Hospital in 1682 on the model of the Hôpital des Invalides in Paris. This was Sir Christopher Wren's first major secular public building – his dignified, restrained brick architecture and the clear layout seem profoundly well suited to the building's role. The tree-covered area to the right has a markedly contrasting history: this is the site of Ranelagh Gardens, one of the pre-eminent pleasure-grounds of mid-Georgian London, centred on a great rotunda 150ft (45.7m) in diameter used for dancing, concerts and banqueting. Soon after Ranelagh opened in 1743, Horace Walpole wrote: 'It has totally beat Vauxhall ... you can't set your foot without treading on a Prince, or Duke of Cumberland.' [NMR 24411/004]

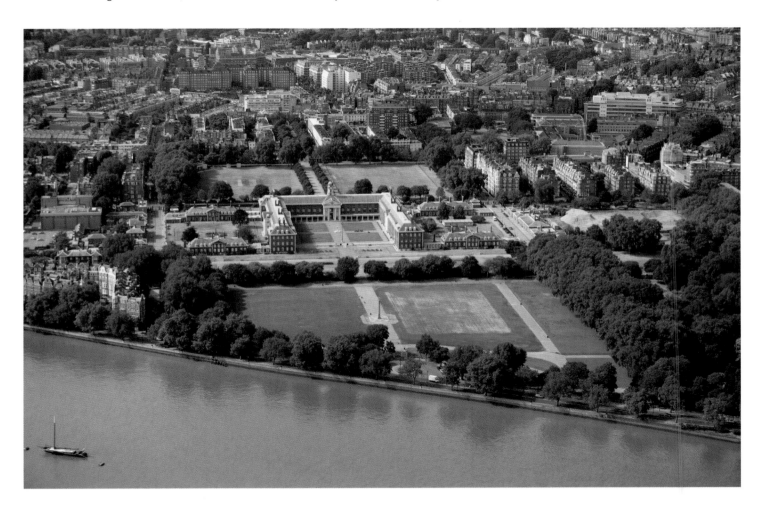

Victoria Railway Bridge and Chelsea Bridge under construction, c 1935

Thomas Page's original suspension bridge of 1851–4 has gone and is being replaced with the neat, rather plain-looking modern bridge of 1934–7 (by the engineers Rendel, Palmer & Tritton with the architectural treatment by G Topham Forrest of the London County Council). It is of technical interest as a self-anchored suspension bridge – the pull on the cables is resisted, not by conventional anchorage points, but through the stiffening girders in the bridge deck. To the right is the Grosvenor or Victoria Railway Bridge, Sir John Fowler's original two-track bridge of 1859–60, which was widened on the east (right) side in 1865–6 for the London, Chatham & Dover Railway Company and on the west side in 1901–5 by the London, Brighton & South Coast Railway. Note the basin with barges opening off the river between the two bridges. [R H Windsor Collection, TQ 2877/1]

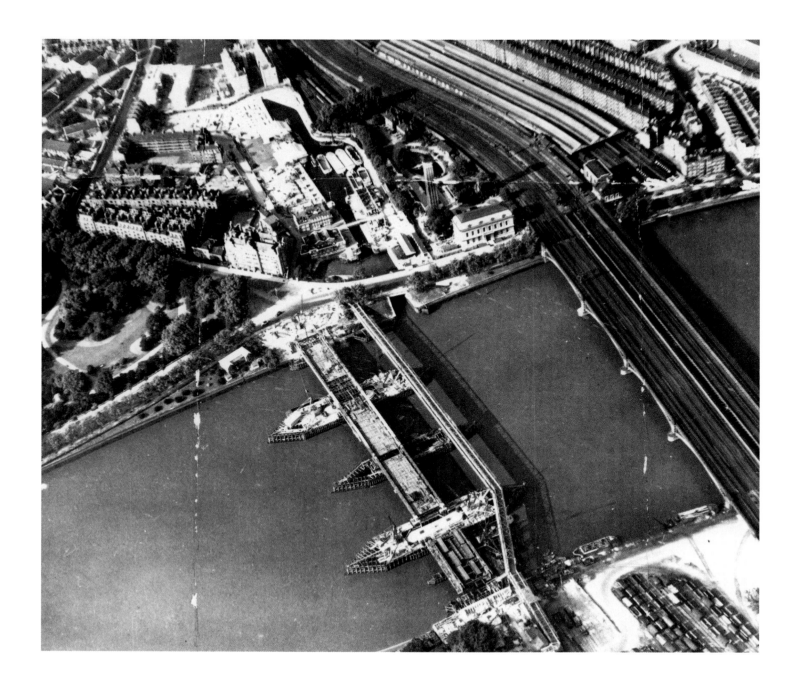

Victoria Railway Bridge and Chelsea Bridge from the south, August 2006

The railway bridge was rebuilt in 1963–7 (Freeman Fox & Partners, engineers), the broad segmental arches retaining something of the Victorian character. The trees to the left on the river bank preserve the memory of Ranelagh Gardens, the Georgian pleasure-ground that occupied this site until c 1803. In 1820 part of the site was bought by the Grand Junction Waterworks Company, which had been founded to bring water to west London using the Grand Union Canal (originally called the Grand Junction); however, it soon found this impossible. The company bought this Thames-side site in order to supply their customers from the river instead, ignoring the fact that their intake was just below the outfall of the 'Ranelagh Sewer', a grossly polluted brook. Eventually a storm of adverse publicity forced them to remove their intake to Kew Bridge in 1835 (see p 141). The Western Pumping Station, just to the left of the railway bridge, represents a later stage in the long Victorian campaign to clean up London – it was built in 1872–5 as part of Sir Joseph Bazalgette's great main drainage system to pump sewage into the main low-level sewer, and still performs that essential function. [NMR 24428/018]

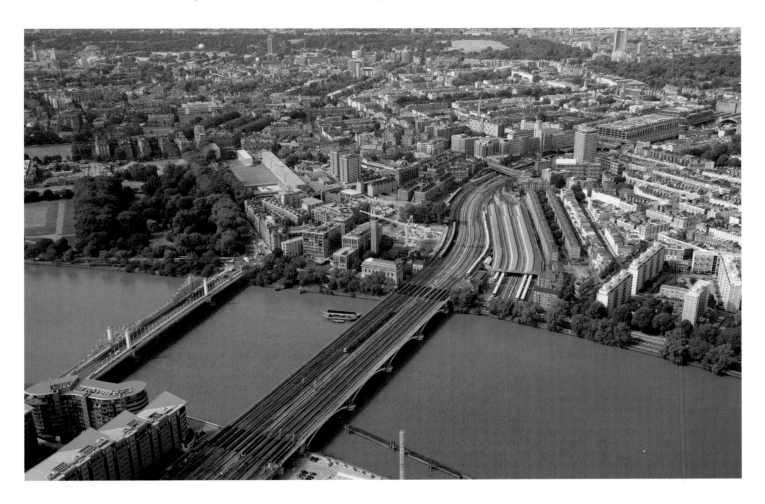

Chelsea Football Club, Stamford Bridge, with West Brompton Cemetery in the background, 7 November 1909

An athletics ground was opened here in April 1877; in 1904 it was bought, with adjacent property, by the Mears brothers. They offered the ground to Fulham FC, were turned down and resolved to found their own club. Chelsea FC was founded in a meeting at the Rising Sun pub, just over the road, on 14 March 1905. The ground was redesigned by the engineer Archibald Leitch, doyen of football ground design in Britain; he gave it his 'trademark', the little gable in the middle of the main stand roof, so it was still very new when this view was taken. In those days, when most of the crowd were expected to stand, Stamford Bridge's capacity was around 100,000. The club, despite its name, is actually in Hammersmith & Fulham; in the background is the geometrical layout of West Brompton Cemetery, just over the border in the Royal Borough of Kensington and Chelsea. [RAeS Library Aph 373]

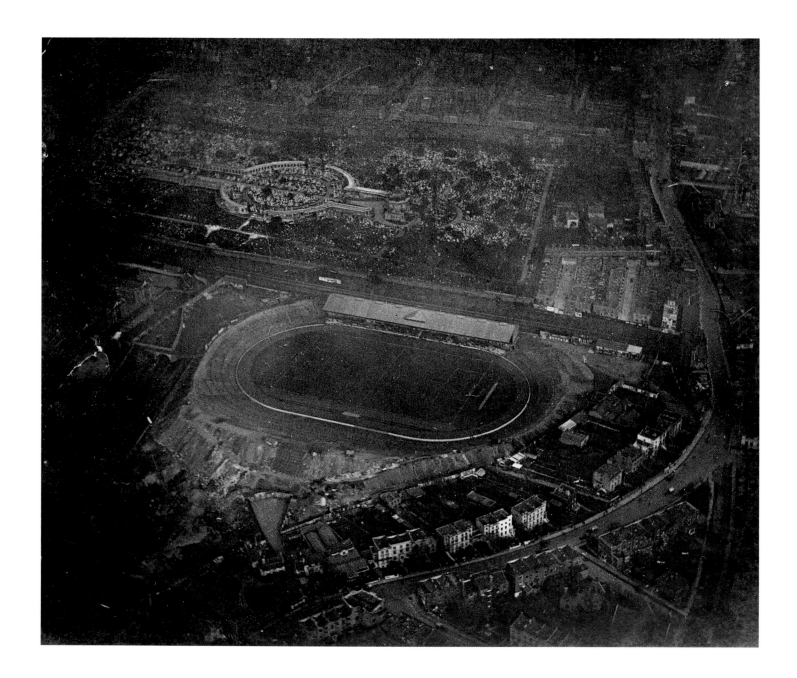

Chelsea Football Club, August 2001

It took a long time for Chelsea FC to make its mark – its first great period did not come until the 1960s, under Tommy Docherty's management. Grand ambitions – notably the construction of the East Stand with its impressive cantilevered roof in 1972–4 (engineers Darbourne & Darke) – brought the club close to bankruptcy and the ground was sold to property developers. The 1980s and 1990s saw a major revival in Chelsea's fortunes. The reconstruction of the ground, completed in 2001, was paralleled by a remarkable run of successes including three FA cups, three League Cups and two UEFA Cup Winners' Cups. The club's Edwardian founders would be gratified, but would doubtless be surprised by a great many things: the all-seater stadium with its capacity reduced to 42,055; the purchase of the club in 2003 by a reclusive Russian billionaire; the charismatic Dutch and Portuguese managers; and the fact that the 27 players in the first squad represent 15 different nationalities and that only 7 of them are English. Chelsea, at the time of writing one of the most successful football clubs in Britain, is a mirror of modern football, and of contemporary London. [NMR 21447/021]

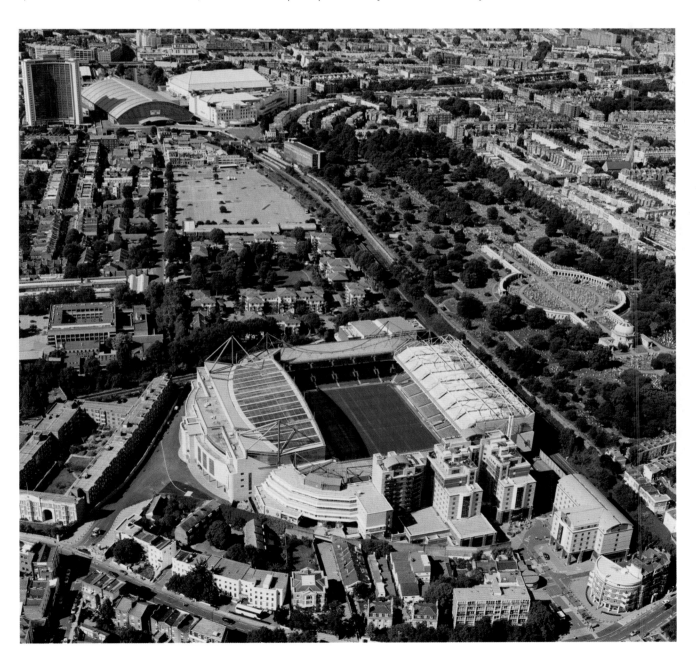

Earls Court Exhibition Centre under construction, 1936

London's first permanent centre for commercial exhibitions, designed by the engineer C Howard Crane and the architect Gordon Jeeves, sits over the District Line tracks just west of Earls Court Station. At the time, this was the largest reinforced concrete building in Europe, its main hall having a clear span of 250ft (76.2m). Public entertainment on the site dated back to 1887, when J R Whitley opened recreation grounds here – the most famous attraction was a 'Great Wheel'. Whitley's main hall, where he staged spectacles such as Buffalo Bill's Wild West Show, is visible in the background beyond the District Line. The new centre opened with the Chocolate and Confectionery Exhibition in September 1937. [R H Windsor Collection, TQ 2578/2]

Earls Court Exhibition Centre, August 2006

The original exhibition centre, Earls Court One, was doubled in size in 1989–91 with the addition of Earls Court Two, whose vast curved roof spanning 276ft (84m) appears at the back (architects RMJM). Earls Court plays host to such mammoth annual events as the Ideal Home Show, the Brit Awards and the MPH motor show. It is also one of the most important venues for rock concerts. Selling out at Earls Court – as did Pink Floyd on their *Dark Side of the Moon Tour* in May 1973, the Rolling Stones on their *Black & Blue Tour* in May 1976 and Coldplay in December 2005 – is considered one of the measures of a globally successful group. [NMR 24410/024]

White City: the stadium and part of the 1908 exhibition buildings, 18 June 1941

White City: the remains of the great Franco-British exhibition of 1908, a remarkable but largely forgotten episode in London's history when 140 acres of derelict land were laid out with gleaming classical buildings covered in white stucco (hence the name), centred on a huge court of honour and lake. It was the largest exhibition held in Britain to date, with 8 million visitors, and in the same summer the 4th Olympic Games were held here. At the time this photograph was taken, the stadium and half the exhibition buildings survived, but the northern half had already been cleared and replaced by the London County Council's White City housing estate (1938–9). The triangular open space at the foot of the image is Shepherd's Bush Green. [RAF/241/ACI/70]

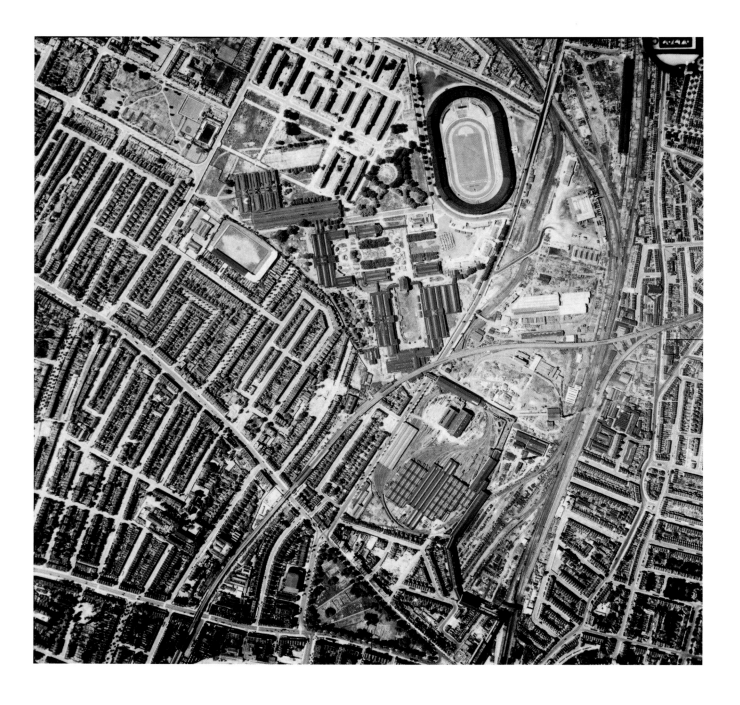

White City with the BBC Television Centre from the south, September 2006

The transformation of White City has been drastically complete – the BBC Television Centre on Wood Lane now stands where the 1908 exhibition's south court once stood. To the left is the blue end wall of the Loftus Road stadium, home to Queens Park Rangers and the Wasps Rugby Union Football Club: this appears at upper left of centre of the historic view and may help to relate one view to the other. BBC Television Centre, planned in 1950 by the architects Norman & Dawbarn, was built in stages into the 1960s. Ingeniously planned, it has offices around a circular central courtyard with studios radiating outwards in the lower buildings around it. Further north is the grey bulk of the BBC's corporate headquarters (Scott, Brownrigg & Turner and Renton Howard Wood Levine, 1989–91), moved here after the rejection of a proposal by the Corporation to redevelop the Langham Hotel site in Portland Place. These huge establishments have turned this odd corner of west London into one of the commanding heights of contemporary culture. [NMR 24442/035]

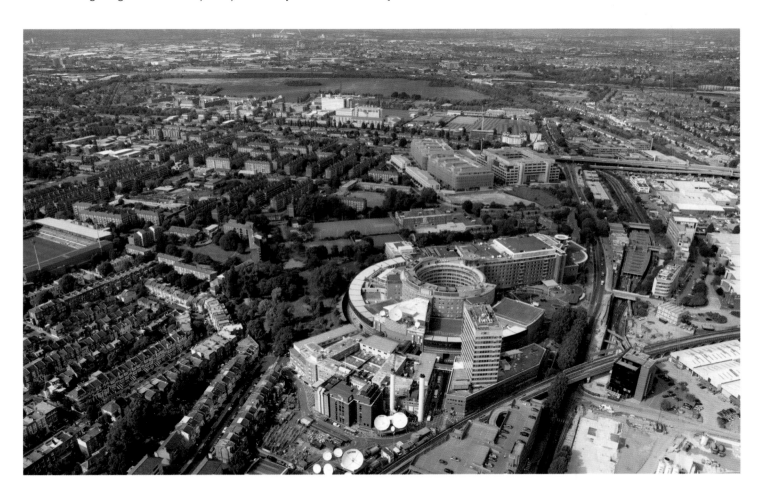

Chiswick House and grounds, 15 May 1948

Chiswick House is the most famous 18th-century villa in Britain and one of many fine suburban residences constructed by the elite of Georgian society to the west of London. It was built by Richard Boyle, 3rd Earl of Burlington, in 1727–9. Lord Burlington had inherited a serviceable Jacobean house, which stood just to the east of the villa (below and to the left in this view), so Chiswick House was intended more as a place of entertainment and in which to display his collections of paintings and ancient sculpture than as a residence. In this view, the square form of the original villa is obscured by the wings added to either side c 1788–94 by the architect John White for the 5th Duke and Duchess of Devonshire, who had inherited the house and wished to use it as an occasional residence. When this view was taken, the house had endured the indignity of use as a private lunatic asylum (1892–1929). House and grounds were purchased from the 9th Duke of Devonshire by Middlesex County Council to prevent their development for housing in 1929; as the borough had little use for the house, it was passed to the Ministry of Works to look after. The 17th-century stable block was casually demolished soon after. [RAF/58/28/5277]

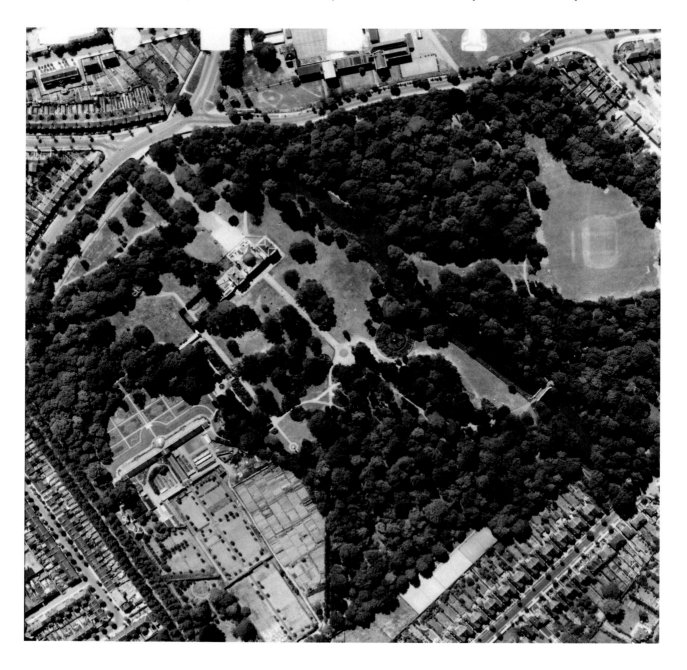

Chiswick House: an event in the grounds on Bank Holiday Monday, 27 August 2001

London's suburbs and surrounding villages once boasted many dozens of grand Georgian and Victorian houses like Chiswick. Today only a handful remain in private ownership; many have been demolished and most of those that survive are in public or institutional ownership of one kind or another. Chiswick's history has been complicated by its outstanding architectural importance – the Ministry of Works decided that the villa's original design was more important than the White wings, so they demolished them in 1956–7 and restored the side façades of the villa in facsimile. The Link Building, seen just to the side of the villa in this view, built by Lord Burlington to link the villa to the original 17th-century Jacobean house, was left as a kind of architectural appendix. The demolitions restored Lord Burlington's original design but left the villa in a near-isolated state that had never existed previously. The villa is quite small and, effectively lacking outbuildings, it has proved difficult to manage ever since. [NMR 21452/010]

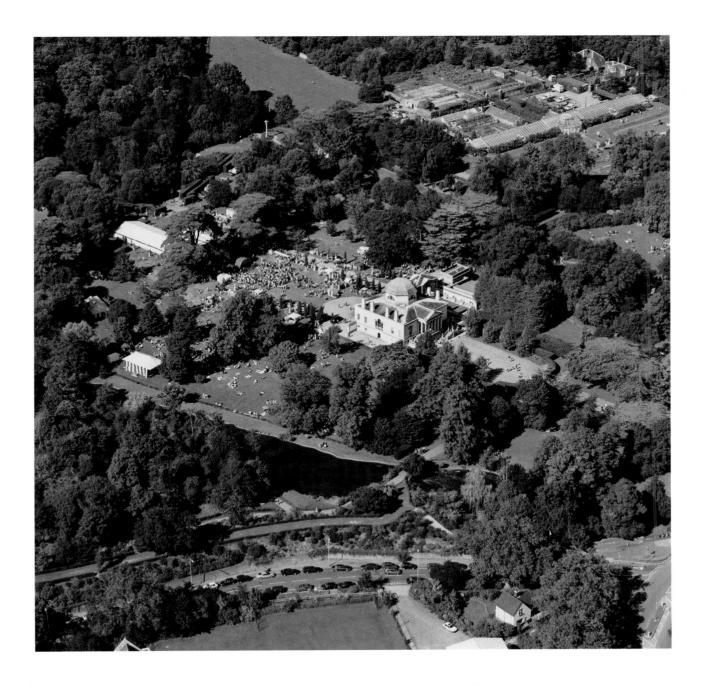

North end of the Royal Botanic Gardens, Kew, looking towards Kew Bridge Pumping Station, 7 May 1948

This view shows Sir William Chambers' Orangery and the allotments on Kew Green. Over the Thames are the filter ponds with the distinctive buildings of the Kew Bridge Pumping Station (to the right), established here by the Grand Junction Waterworks Company in 1835–7 when they were obliged by outraged public opinion to move their water intake from its previous, grossly polluted position on the Thames near the Royal Hospital, Chelsea. Legislation in 1852 forced the water companies to move their intakes further upstream above Teddington Lock. The Grand Junction Waterworks Company did so in 1855 and from this date the Kew Bridge site was used primarily for filtering water in the beds seen here. [RAF, TQ 1877/9]

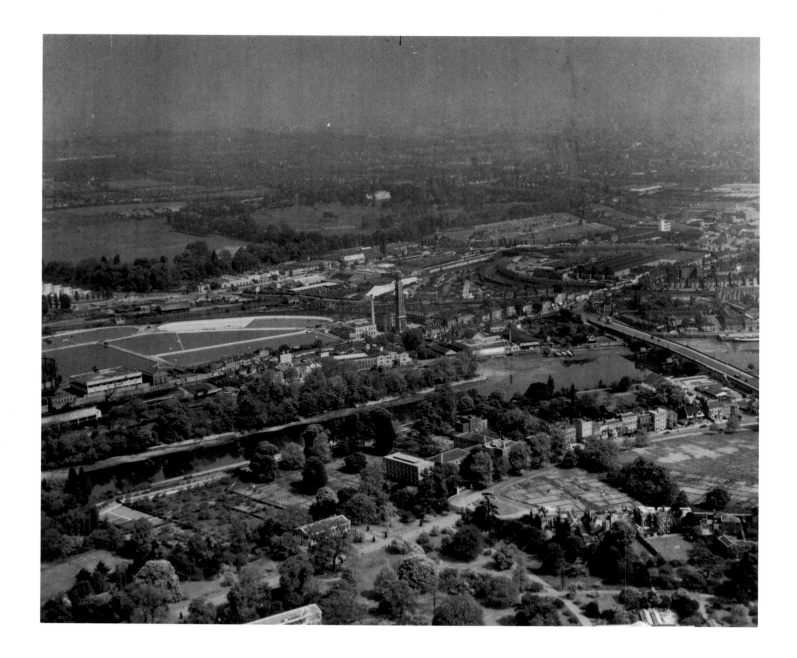

Looking south-east over Kew Bridge and the Kew reach of the Thames, August 2002

In the foreground are the handsome Italianate buildings of the Kew Bridge Steam Museum (seen around the tall tower), established by an energetic group of volunteers in the old pumping station. To the right facing onto the road is the original engine house of 1837, with a splendid Boulton & Watt engine of 1820, which was brought from the company's previous site at Ranelagh and was thus guilty of having supplied some of the foulest water in London's history (see p 131). The museum houses several other steam engines brought from other sites and the taller building to the left (1845, extended 1869) still houses the two great Cornish beam engines for which it was built. The 197ft (60m)-high tower houses standpipes, which provided a body of water for the great beam engines to pump against and a head of water to maintain the pressure in the mains. In the middle distance is the very handsome Kew Bridge (1903, Sir John Wolfe Barry & Cuthbert Bereton). Further in the distance, just to the right of Kew Railway Bridge, is the massive block of the Public Record Office (Property Services Agency, 1973–7).
[NMR 21757/003]

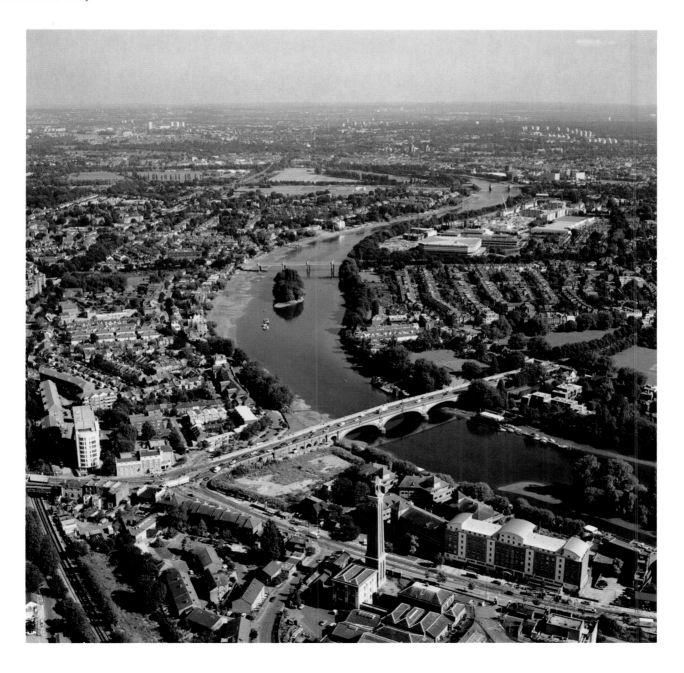

Windmill Bridge, Windmill Lane, Hanwell, c 1930s

The Windmill Bridge was a late work by Isambard Kingdom Brunel of 1858–9 for the Great Western & Brentford Railway, a branch line heading down to Brentford Dock on the Thames. Brunel had to sink his line in a deep cutting, carrying the Grand Union Canal (originally the Grand Junction) above it in a cast-iron aqueduct and carrying the lane above that on a wrought-iron bridge. [R H Windsor Collection, TQ 1479/1]

The Windmill Bridge in its setting, August 2006

The view conveys how much the modern suburban landscape is a 19th-century creation. First came the Grand Union Canal (originally the Grand Junction), whose London end opened in stages in 1801 and 1805; then the turnpike road to Uxbridge, now the A4020 (this is the main road running straight up the picture near the right-hand edge); then the Great Western Railway's main line (1838), which crosses the road at a diagonal from right to left; and finally the branch line to Brentford (1859), running through the cutting lined with trees on the left side of the picture. The Windmill Bridge crosses the canal in the middle distance. In the centre foreground are the roofs of Ealing Hospital, originally built as the Middlesex County Lunatic Asylum (1829–31); under its first superintendent, John Connolly, it was a progressive place, pioneering industry as therapy and notable for its avoidance of the use of restraint, a rarity at the time. [NMR 24409/011]

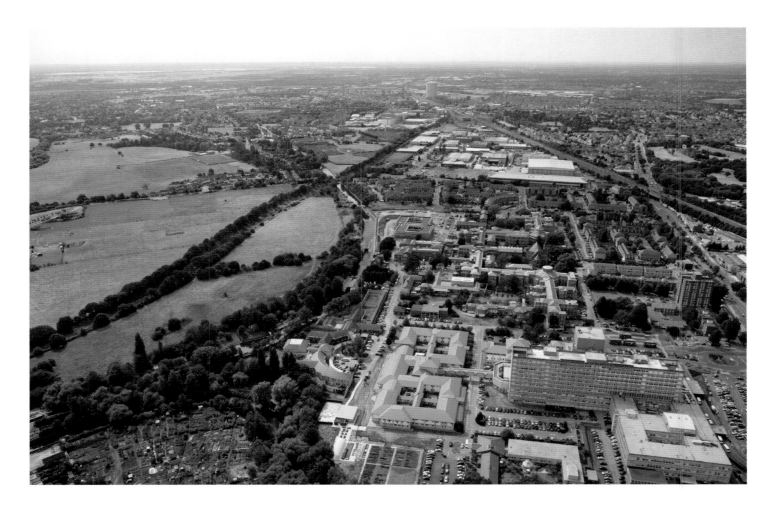

Camouflaged factory at Harlington, 20 July 1941

This view shows the sprawling roofs of the Fairey aircraft factory at Harlington, rather effectively painted with camouflage during wartime. The old Great Western main railway line is immediately to the north and the equally large but uncamouflaged gramophone and record factory of EMI (Electro-Musical Industries) is north of the railway; Hayes and Harlington Station is just out of the picture to the right. The Fairey Aviation Company was founded in 1916 in a shed on this site off North Hyde Road; it later opened a test-flying ground at nearby Harmondsworth (see p 154). Fairey was an innovative manufacturer of both civilian and military aircraft, and in 1941 would have been manufacturing Barracuda bombers and Firefly fighter aircraft (among other things) on this site. At its post-war height in 1959, the factory was employing 4,000 people. The following year the firm was taken over by Westland Ltd. [RAF, TQ 0979/1]

Harlington looking west, August 2006

This view shows the site of Fairey Aviation with the Great Western main line to the right. The manors of Hayes and Harlington were mentioned in Domesday Book and remained simple rural villages until the cutting through of the Grand Union Canal (originally the Grand Junction), after which brick-making and market gardening began on a commercial scale. Though the railway opened in 1838, the GWR were not much interested in suburban traffic and did not open a station here until 1864. Even then, development was slow. In the inter-war period the fields began to fill up with the rows of semi-detatched houses and factories seen here; the two neighbouring villages were merged as an Urban District in 1930. [NMR 24408/006]

Hampton Court Palace, c 1930s

Cardinal Wolsey bought the lease of the manor of Hampton in 1514 and transformed it into the most splendid and up-to-date palace in England, incautiously arousing the envy of King Henry VIII. Wolsey's decision to offer Hampton Court as a present to the king in 1525 came too late to avert his dismissal and disgrace. It became one of Henry's favourite residences and he spent more money here than at any other palace. The palace fell out of use as a royal residence in the reign of George III, who had unhappy childhood memories of it, and for more than a century it slumbered, divided into 'grace and favour' apartments. Though there was a degree of Victorian renovation, this was nothing like the sweeping refurbishment which Hampton Court would almost certainly have endured had it remained in full royal use – it is to this neglect that we owe its wonderful historic atmosphere today. [R H Windsor Collection, TQ 1569/1]

Hampton Court Palace from the south, September 2006

In the foreground is the western, Tudor part of Hampton Court: the Base Court surrounded by lodgings for the household and the Clock Court with the high roof of Henry VIII's Great Hall on its north side. Beyond is the Fountain Court surrounded by the King's and Queen's Apartments, rebuilt in the 1690s for William and Mary by Sir Christopher Wren – these replaced Henry VIII's apartments. To the left are the immense Tudor kitchens and service courts. Hampton Court remains more closely associated in the public mind with Henry VIII than with anyone else, but its genial character probably owes more to Wolsey, his master mason Henry Redman, William and Mary, and Wren than to the sadistic, deeply unattractive personality of 'Bluff King Hal'. [NMR 24438/050]

Hampton Court Palace and Parks, 7 August 1944

Wolsey is thought to have enclosed about 2,000 acres of parkland around Hampton Court and most of this is still open space. This RAF vertical photograph conveys the magnificent scale of the Baroque landscape at Hampton Court, the one place in Britain which still stands comparison with the great formal landscapes of Bourbon France. The great semicircular parterre east of the palace and the Long Water, extending through the Home Park (towards the foot of the photograph), were laid out for Charles II soon after his restoration in 1660. The Bushy Park was laid out by the royal gardeners George London and Henry Wise for William III – its huge avenue is aligned on the Tudor Great Hall, though this is hardly apparent on the ground. In 1944 the great circular pond of the Diana Fountain seems to have been drained and given over to allotments. [RAF/106G/LA/29/3216]

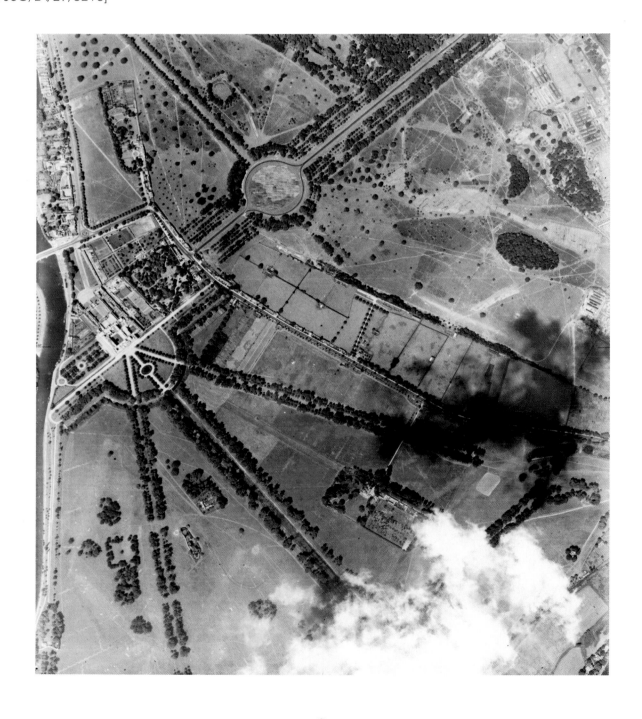

Hampton Court Palace, September 2006

Wren's South and East fronts: the former (to the left) housing the King's Apartments, the latter housing the Queen's. Hampton Court under William III was the headquarters of the grand alliance opposing Louis XIV and his ambitions to dominate Europe. The contrast with the overpowering magnificence of Louis' Versailles could not be more marked – Hampton Court's cheerful red-and-white façades in their verdant setting are positively homely in comparison. In his first scheme for Hampton Court, Wren proposed to sweep away the whole of the Tudor palace except for the Great Hall, rebuilding the place on something like the scale of its French rival. William and Mary's financial and political situation would not allow this, so Wren designed this scaled-down version leaving half the Tudor palace intact. Hampton Court is a supremely satisfying architectural compromise, intensely expressive of England's culture, history and national character. [NMR 24438/036]

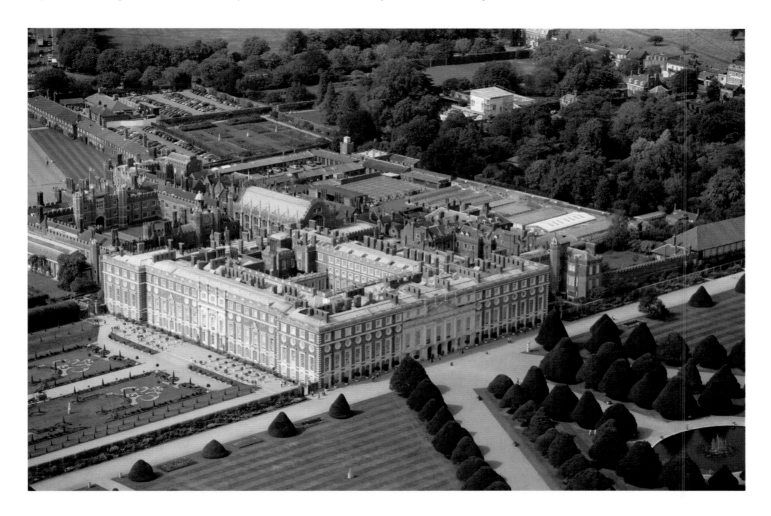

Hampton Waterworks, Lower Sunbury Road, August 1944

Hampton Wick, just west of Hampton Court, displays the distinctive landscape of a major waterworks. The Metropolis Water Act of 1852 obliged London's water companies to remove their intakes above Teddington Lock (that is, above the tidal reach of the river) to find a supply fit for human consumption. Three companies – the Grand Junction, the Southwark & Vauxhall and the West Middlesex – bought adjacent sites to either side of Lower Sunbury Road and moved here in 1853–5. The London water companies were nationalised and the Metropolitan Water Board formed in 1906, but Hampton remains a key part of London's water system. This image dates from 1944, hence the great number of allotments visible. [RAF/106G/LA/29/4107]

Thames Water's Hampton works today, September 2006

Running diagonally across the background are the yellow brick Victorian engine houses built by the Grand Junction, the Southwark & Vauxhall and the West Middlesex companies. Seen from Upper Sunbury Road, these form one of the most impressive set pieces of water industry architecture in Britain, though today they are all redundant and consigned to workshop and storage use. The heart of the working site today is the pair of fine Art Deco buildings put up by the Metropolitan Water Board between 1934 and 1947: the Davidson Rapid Filter House flanked by its small filter ponds in the foreground and the Stilgoe Engine House beyond it (which lost its chimneys and boiler house on its conversion to electric pumps). A large part of London's water supply is purified here, run first through the rapid filters and then much more slowly through the big filter-beds around the site. At any one time a number of the beds will be emptied out so that their sand can be changed and washed, as seen here. [NMR 24437/015]

Kempton Park Racecourse and Waterworks, August 1944

Kempton Park Racecourse was closed for the duration of the war and the area around its main stand (upper left of the course) was filled with a prisoner-of-war camp; the straight line of the shadow of its surrounding wall can be seen in this photograph. The white broken lines in the centre of the course are the remains of anti-glider defences, which would have been abandoned by 1944. The reservoirs and filter ponds of the Kempton Waterworks are situated at the upper right. The waterworks were established by the New River Company under an Act of Parliament of 1897 and completed and opened by the Metropolitan Water Board in 1908. A tramway – branching off from the main railway line – was built to bring coal to the engine house (to the left of the two rows of small filter ponds) from a wharf on the Thames at Hampton. [RAF/106G/LA/29/4102]

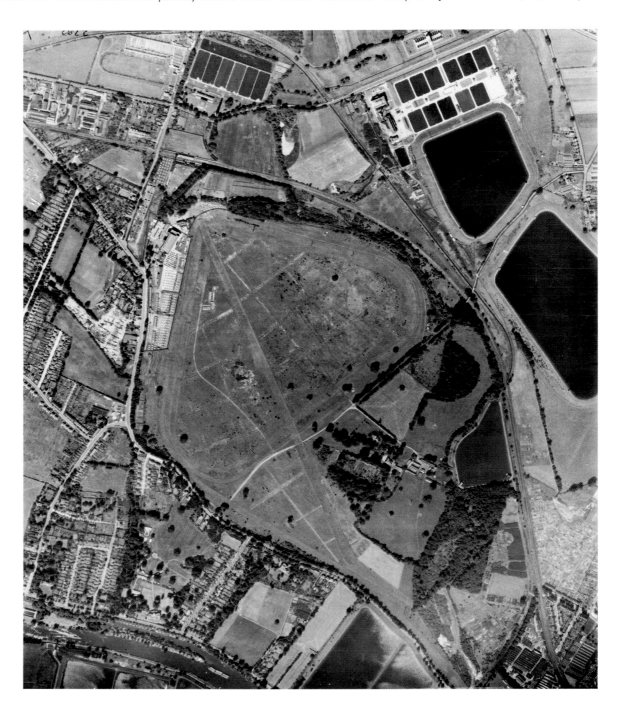

Kempton Park Racecourse, September 2006

A Victorian businessman, S H Hyde, leased the 210-acre Kempton Manor estate in 1872 and opened the racecourse here in 1878. Since then, it has developed as a famous venue for both flat racing and National Hunt racing (that is, with jumps). The course closed for refurbishment in 2005–6, which included the re-laying of the all-weather flat track seen here – the course is 8 or 10 furlongs, depending on which of the two loops is used. There are flat-racing events all year round and National Hunt fixtures from October to March on the triangular turf track of 1 mile and 5 furlongs. Kempton Park's best-known fixture is probably the King George VI Chase, a National Hunt event held annually on Boxing Day. The tall floodlights for evening fixtures can just be seen, laid flat on the ground. [NMR 24436/024]

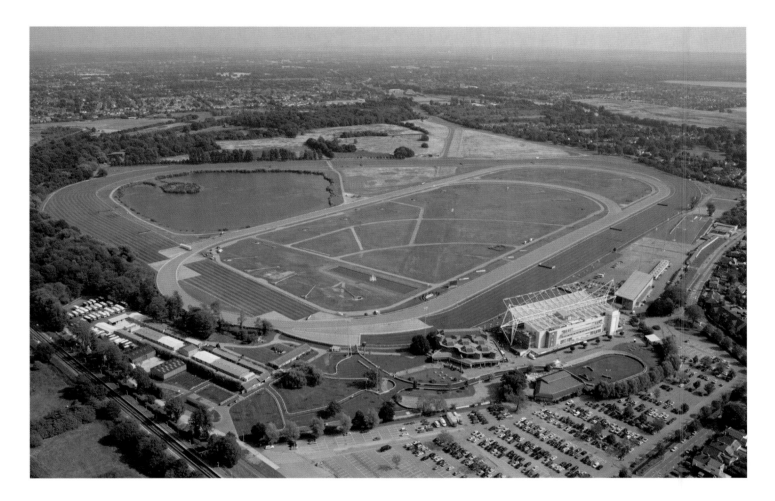

Air show at Heathrow, c 1930s

Few readers would recognise this as Heathrow Airport (or at any rate its 1930s predecessor). The Fairey Aviation Company, whose main factory was in nearby Harlington (see p 144), bought a 150-acre site here and opened Harmondsworth Aerodrome as an airfield for test flights in 1929. It was later renamed the Great West Aerodrome, but with its well-drained gravel soil, it didn't need a hard runway. We do not know the exact date of this photograph, but Fairey is evidently hosting some kind of air show, with marquees and parked cars in the centre of this view. At this date civilian flights took off from the nearby airfields at Heston and Hanworth Park. In 1944 the site was appropriated by the Air Ministry, supposedly for a new bomber airfield to serve the war in the Far East, and work began; however, the RAF was never to occupy the site. Lord Balfour, the Under-Secretary of State for Air at the time, said in his memoirs that the claim that Harmondsworth was needed for the war effort was a smokescreen – the government intended to use the site for a great new civilian airport all along and by citing military necessity saved itself the need for a long public inquiry. [R H Windsor Collection, TQ 0876/2]

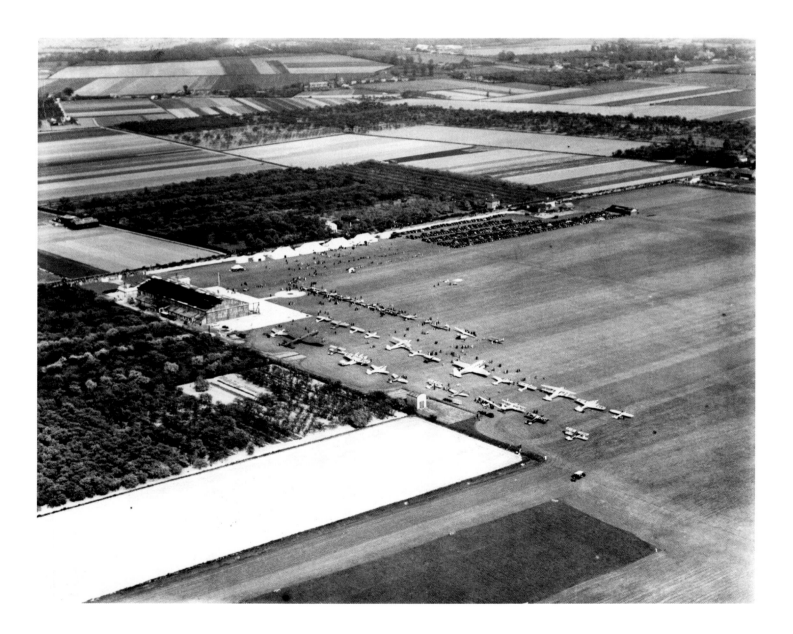

Heathrow Airport, September 2006

Pity the poor neighbours: Heathrow is today the busiest airport in Europe and the third busiest in the world (after Atlanta and Chicago O'Hare), with 67 million passengers in 2005. It also receives more international passengers than any other destination and can thus claim to be the world's leading international airport. Heathrow's history embodies planning politics at its most difficult and contentious – its position on the west side of London renders it relatively easy to access for large parts of the British population, but also means that for much of the year incoming aircraft have to fly over central London because of the prevailing westerly winds. Its relatively low elevation (about 80ft (24.4m) above sea level) also makes it prone to fog. It is one of the greatest generators of wealth in the south-east of England, sustaining huge numbers of jobs, but the noise, traffic and pollution it creates blight a vast area. The decision to group the original terminals – 1, 2 and 3 – in the middle of the runways (to the right and in the distance), seemed like efficient planning in the 1950s, but has proved a serious constraint on the airport's growth ever since. Terminal 4, opened in 1986 on the south side of the airport, to the left in this view, represented a response to this problem. [NMR 24435/009]

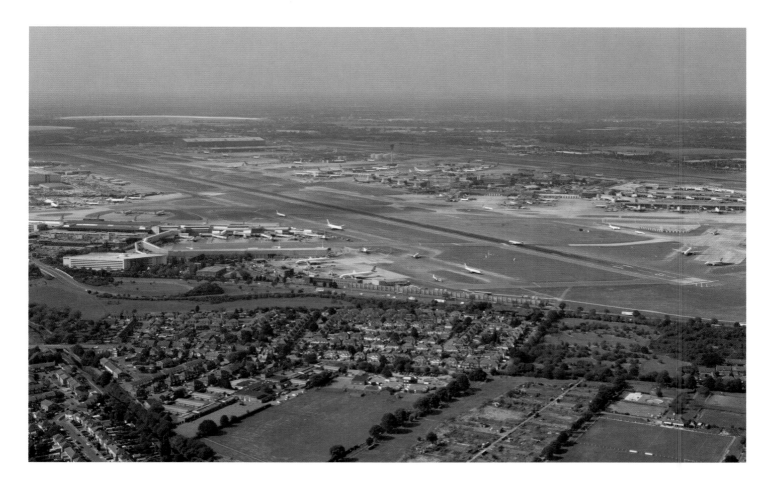

Heathrow Airport under construction, 5 June 1946

Heathrow was handed over to the Ministry of Civil Aviation and opened as a civilian airport in 1946, without any proper public consultation at all. The original six runways were being laid out when this view was taken and the new airport opened shortly after with tents to house its first passenger terminal and facilities. The original runways, designed for piston-engined aircraft, were relatively short by later standards and in the 1950s the airport was redesigned with two much longer runways (of 4,266yd (3,901m) and 4,003yd (3,660m)); it has got by using these ever since, but they are a major constraint on capacity. In 2003 a government White Paper proposed that the airport should receive a third east–west runway; with a sixth terminal this would raise its capacity to 115 million passengers a year, but this would probably involve destroying the neighbouring villages of Harmondsworth and Sipson. [RAF, TQ 0676/1]

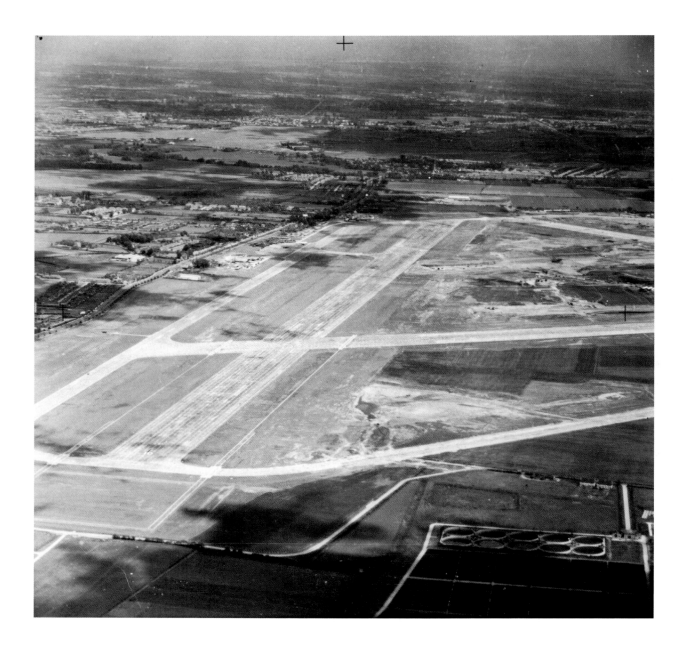

The service area at the east end of Heathrow, September 2006

Several Boeing 747s from different airlines are drawn up on the asphalt, while just below them is a Concorde: the beautiful, supersonic would-be rival aircraft, marginalised and defeated, and presumably parked here as a museum piece. Heathrow's new Terminal 5, under construction at the other end of the airport and due to open in March 2008, will have the capacity to serve Europe's revenge – Airbus Industrie's giant A-380, the would-be rival and successor to the 747. In the middle distance, with its immensely wide glazed doors open on the left side, is the BOAC (British Overseas Aircraft Corporation) hangar, a magnificent piece of reinforced concrete construction of 1950–2 by the engineer Sir Owen Williams. A pity that passengers don't see this, Heathrow's one outstanding building (pending the opening of Terminal 5, that is). Heathrow has been voted the worst airport in the world in at least one mass survey, but it works, and on a spectacular scale. Here is modernity, here is our culture, summarised in the contrasts between the extraordinary personal freedom of movement (unimaginable in any previous age), the ugliness and banality of the terminals and the magnificent daily feats of technology and organisation – the real beauty of the place – which are almost completely taken for granted. The people of any previous century would be awestruck. [NMR 24435/002]

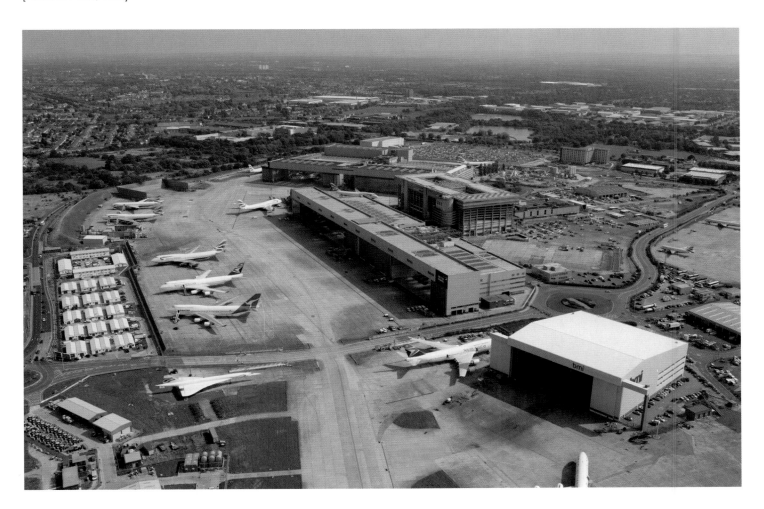

West Drayton Station, 7 May 1948

The Great Western Railway opened their line from Paddington to Maidenhead, with their first station here, at the beginning of June 1838. It was some way north of the old village centre and remained more or less a country halt until late in the 19th century, when the semi-detached houses here began to spring up. [RAF, TQ 0679/2]

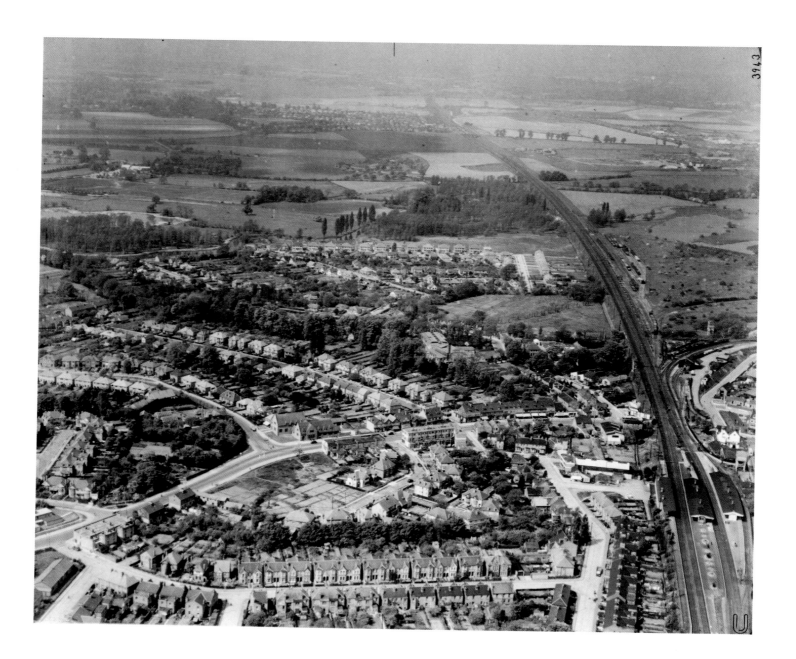

West Drayton, August 2006

The Great Western main line with West Drayton to the left and Yiewsley to the right. The Grand Union Canal (originally the Grand Junction) flanks the railway in the foreground of the view. Owing to its proximity to his railway, Brunel had the GWR's locomotives delivered by barge, craned onto the line and trialled here. West Drayton is of Saxon origin and was a substantial place in medieval times: something of its original village character survives in the streets around the church and the site of the old manor, left of the prominent pair of Y-junctions in the road. [NMR 24407/018]

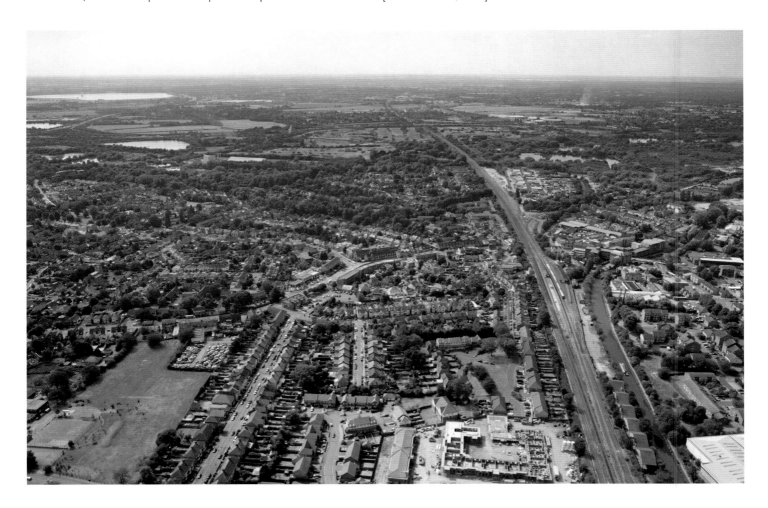

RAF Northolt, 5 November 1947

This view shows the main group of buildings at RAF Northolt; Western Avenue (the A40) is situated to its left. The Royal Flying Corps laid out an airfield here in 1915 from which to fly defensive patrols against Zeppelin raids. It was developed as a fighter airfield in the 1920s and became the first airfield to receive the Hawker Hurricane. Northolt was one of 11 Group's Sector Stations during the Battle of Britain (like Biggin Hill and Hornchurch) and was home to 303 'Kosciusko' squadron, the first Polish squadron to be formed within the RAF. [RAF, TQ 0984/8]

RAF Northolt from the east, October 2006

From 1946 to 1952 Northolt served as London's principal civilian aerodrome while Heathrow was under construction. After that it reverted to military use, in which it remains. The apron, runways and perimeter road survive very much as they were during the Second World War, though most of the buildings have been lost. It now serves as the RAF's principal base for royal and VIP transport. [NMR 24389/014]

Uxbridge town centre, 15 August 1948

Uxbridge's character is still that of a Middlesex market town, with the gentle Buckinghamshire countryside extending beyond. The Great Western Railway's branch line, leading to a terminus at Cowley Road, is clearly visible in the lower left-hand corner. The Piccadilly Line arrived in 1938: its terminus by Adams, Holden & Pearson appears to the right of centre with its crescent-shaped façade. Just to the left, the town's fine 18th-century Market House and (left of that) the little church of St Margaret represent the historic core. Beyond, the town's limits are formed by the Grand Union Canal (originally the Grand Junction, marked by the line of sheds left of centre) and just beyond this the River Colne, mostly visible as a line of trees. The High Street leads into the Oxford Road (A4020), which winds into the distance, intersecting with the A40 at the Denham Roundabout (see pp 164).
[RAF, TQ 0584/6]

Uxbridge town centre, August 2006

Uxbridge became the focus of the new borough of Hillingdon in 1965. This view shows how comprehensively the old market town has been reshaped since then: more change in 40 years than in the previous 400. The ring road, carved through the lower part of the picture, defines the town centre at the cost of cutting it off from everything to the south. The town's new municipal status is signalled by the Civic Centre at lower left, making some amends for its bulk by its friendly, vernacular-inspired architecture and its brick cladding. All that really remains recognisable from the past is the line of the High Street winding up the middle of the picture. To either side of this, office developments from the 1980s have taken the place of the little streets lined with simple terraces, turning Uxbridge into north-west London's answer to Croydon – a Faustian architectural bargain for the little town, which has retained some importance as a centre of employment and wealth creation but lost nine-tenths of its character in the process. [NMR 24407/011]

The A40 (now M40) under construction, 5 November 1947

The edge of London and a portent of the future. This view shows Western Avenue or the A40 being extended westwards from the ridge just north of Uxbridge, over the Grand Union Canal (originally the Grand Junction) and the River Colne, to end, for the time being, at Denham Roundabout; the quiet wooded countryside of Buckinghamshire lies ahead. Petrol is still rationed and the half-built road is very quiet. The rise of the private motor car has only just begun. [RAF, TQ 0585/3]

The same view today, August 2006

Denham Roundabout has become Junction 1 of the M40, while immediately beyond lies Junction 16 of the M25. Traffic engineering and the private car have changed the way in which we perceive landscape and distance, and have become major elements in both landscape and cityscape in their own right – this has been the most important and pervasive change in our relationship with our surroundings in the last 50 years. The River Colne, in the foreground, is the boundary between the county of London and Buckinghamshire: beyond lies the protected landscape of the Green Belt. The M40 at this point is one of the few places where one has a palpable sense of transition on entering the metropolis. This is the new western gateway of London. [NMR 24407/003]

④

< NORTH LONDON >

Charterhouse, c 1930s

This picturesque backwater is on the fringe of the Square Mile, a reminder that London was once circled by buildings such as these. Sir Walter Manny, one of Edward III's knights, founded a Charterhouse – that is, a monastery for the contemplative Carthusian order of monks – here in 1370 and was buried before its high altar in 1372. Charterhouse Green, the square expanse of lawn in the middle of the picture, represents the area of the great cloister, around which the monks had their cells, each with an individual enclosed garden. The church and the other buildings were ranged along the south, or lower, side of this. The monks suffered dreadful persecutions at the hands of Henry VIII and Thomas Cromwell in the 1530s – several of them were hanged or died in prison. [R H Windsor Collection, TQ 3182/1]

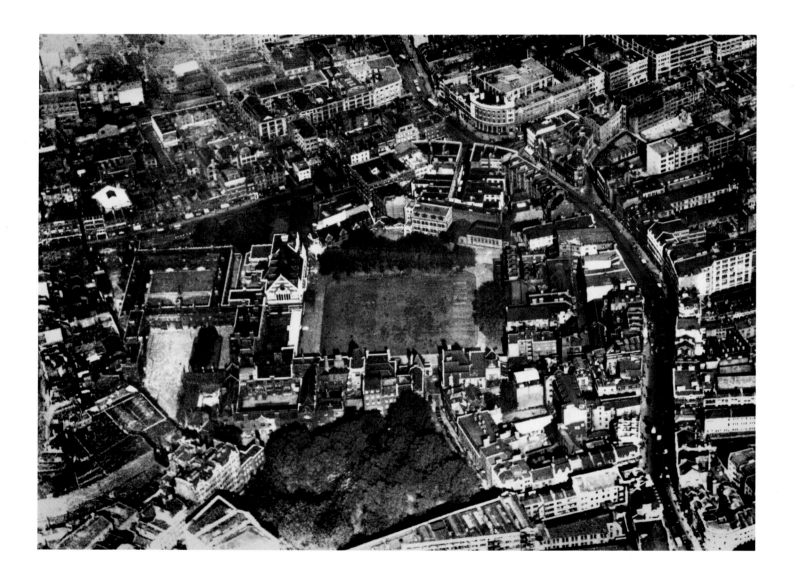

Charterhouse and Charterhouse Green from the south, August 2006

Like many monastic houses in the country, the London Charterhouse was rebuilt as a nobleman's residence, belonging successively to the North family, the 4th Duke of Norfolk and the 3rd Earl of Cumberland. In the early 17th century a rich merchant, Thomas Sutton, converted the buildings into a school for 40 boys and an almshouse for 80 pensioners. The Charterhouse School remained here until 1872, when it moved to its present site at Godalming, at which point the buildings were taken over by the Merchant Taylors' School. The school carried out major additions, including the Great Hall seen to the left of Charterhouse Green. They moved out in 1933 and the Charterhouse was devastated by bomb damage in 1941. The ancient buildings were sensitively repaired by the architects Seely & Paget (1950–9) and are still occupied by the Charterhouse pensioners. The various school buildings around the green were partly replaced in the 1950s for their present occupants, St Bartholomew's and the Royal London School of Medicine and Dentistry. [NMR 24423/030]

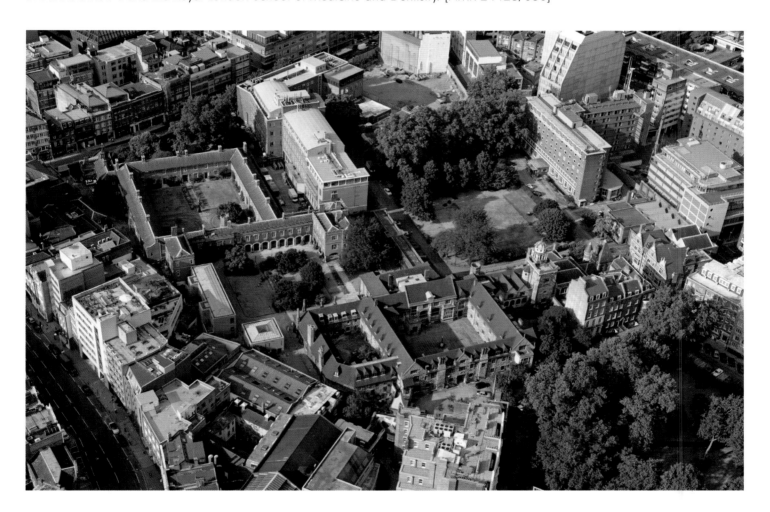

Euston and St Pancras stations from the north, c 1930s

The impact of the railways on Victorian London is vividly conveyed in this view over Euston (left of centre), St Pancras (the building with the arched roof towards the right-hand edge) and the Midland Railway's huge goods station (immediately to the left of St Pancras). When the London & Birmingham Railway arrived looking for a terminus a hundred years previously, the city had already spread north of the New Road, now the Euston Road (running from left to right in the foreground). The company built Euston Station (engineer Robert Stephenson and architect Philip Hardwick, 1833–7), with the celebrated Euston Arch – more properly a portico or propylaea – whose pediment is just visible below and to the left of the curved station roofs. As the London & Birmingham developed into the London & North Western Railway, the station had to grow and the original master plan was abandoned: by the time this view was taken, Euston had a layout of bewildering complexity. The view of the Euston Arch from the south was closed off in order to provide a site for a later extension to their railway hotel. [R H Windsor Collection, TQ 2982/1]

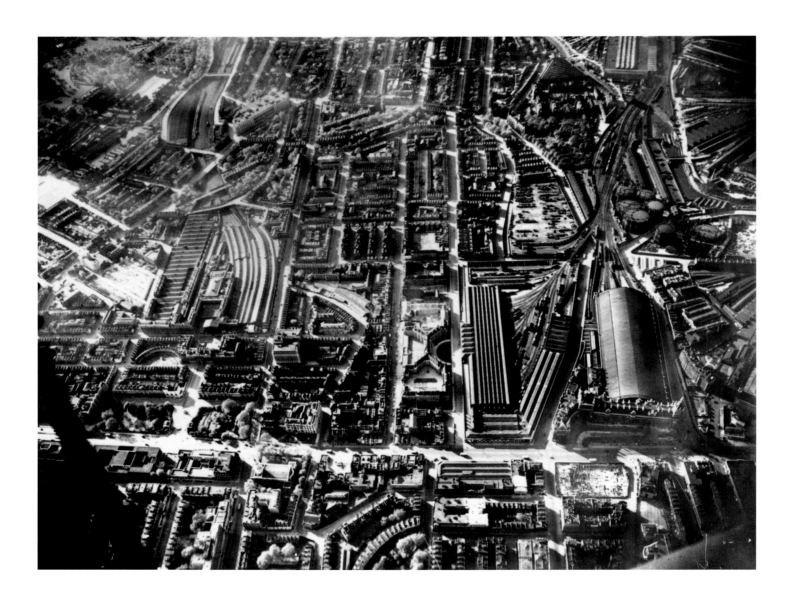

Euston Station from the south, September 2006

The redevelopment of Euston in the 1960s became one of the great causes célèbres of the conservation movement – every trace of old Euston, one of the first and most historically important railway stations in the world, was destroyed. The demolition contractor offered to number and save the stones of the Euston Arch for reconstruction at the front of the new station; the decision went all the way to the Prime Minister, Harold Macmillan, who rejected the idea in the name of progress. The new Euston (R L Moorcroft of the British Rail Architects' Department, 1962–8) arguably appears at its best seen in a bird's-eye view as here, from where the huge roof has something of a diagrammatic quality. From a human visitor's point of view, however, the station is almost characterless, its architecture entirely failing to express the drama of travel or its importance in our national life. Inside, the concourse is principally notable for its almost total lack of anywhere to sit down without having paid for catering. Instead of proclaiming itself as the gateway to the north, the new Euston hides (as well it might) behind a plaza surrounded by squat, shiny black offices (R L Seifert & Partners, 1974–8). This was one of the worse architectural bargains of the last century. At the time of writing, the total redevelopment of the station is under consideration. [NMR 24447/003]

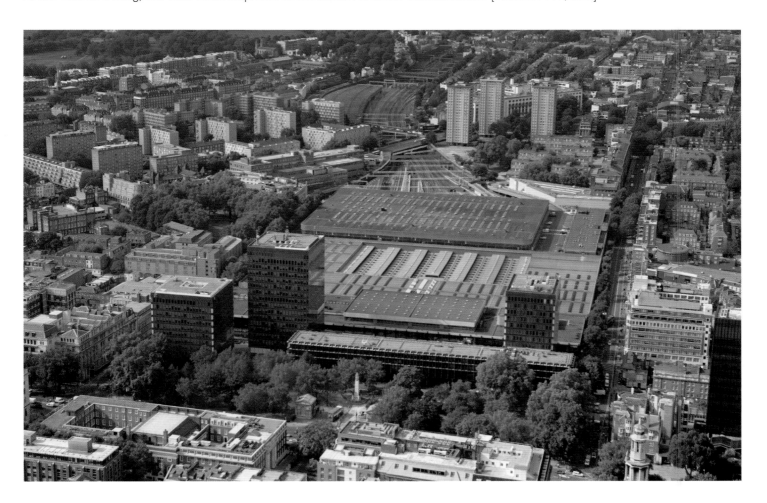

St Pancras and King's Cross stations from the south, c 1930s

This view shows the scale and extent of the neighbouring King's Cross and St Pancras stations. The London & North Western at Euston had the advantage of being first on the scene; by the time the Great Northern Railway arrived to build King's Cross in 1851–2 the area was filling up and their station was fitted into a relatively narrow site. Lewis Cubitt's twin train sheds, seen at an angle to the right of centre, simply express the station's functional division between the Departure Side (to the left) and the Arrival Side. The Midland Railway arrived in London late and was obliged to pay a heavy price, demolishing a whole quarter of poor terraced houses in Somers Town in the process – despite this St Pancras Station was one of the wonders of the age. The engineer William Barlow designed the huge train shed, at 245ft (74.7m) the widest clear-span roof in the world when it was built. Sir George Gilbert Scott provided the architecture, including the Midland Grand Hotel which forms the station's main façade, and made St Pancras one of the great triumphs of the Gothic Revival. When this view was taken, the King's Cross Goods Yard (directly above King's Cross) and the Midland Goods Station (immediately to the left of St Pancras) were still in service. [R H Windsor Collection, TQ 3083/1]

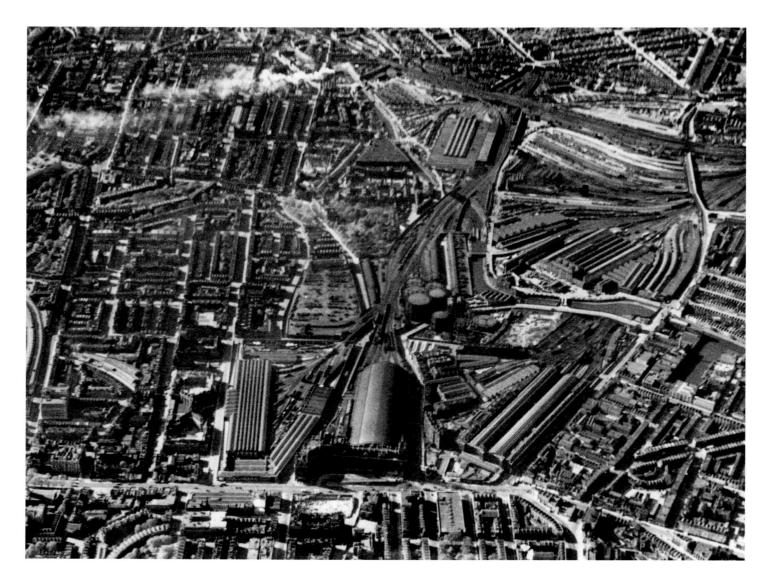

The British Library, St Pancras Station and King's Cross Station from the south-west, September 2006

After 70 years of change, this remains one of the most architecturally dramatic and rewarding areas of London. Most obviously, the Midland Goods Station has been replaced by the huge red-brick ranges of the British Library (Colin St John Wilson, 1978–97), more or less the only major public building to be built in Britain in the last decades of the 20th century, a late triumph of the humane modernism represented by Alvar Aalto and Hans Scharoun. Building the library was a very fraught process, bedevilled by budget cuts and changes of mind, and it is perhaps surprising that the library came out as impressive, architecturally coherent and functionally successful as it is. St Pancras, its towering neighbour, was cleaned and repaired in the 1990s and the two great buildings now form one of the strongest architectural pairings in London. [NMR 24447/004]

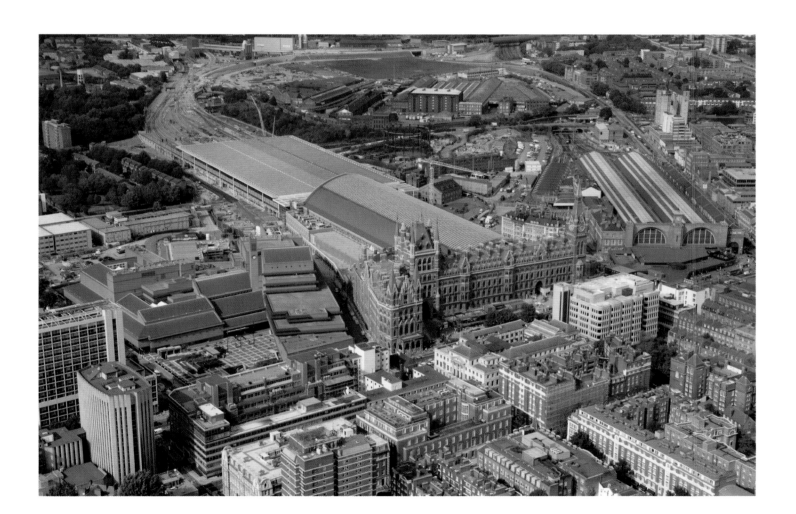

Euston Station from the north, with St Pancras and King's Cross to the left, c 1930s

When the London & Birmingham Railway were building their extension into Euston in 1836–7, this area of Camden was already filling up with houses and they were obliged to purchase and demolish great tracts of houses, carving a route through the regular grid of the streets. Later, the Great Northern and Midland Railways did the same. Ever since, the area has been notable for the abruptness with which its social tone and character changes, from the leafy respectability of Oakley Square in the foreground, to the public housing of Somers Town between the two railway stations, to the untamed and dirty industry of the King's Cross Goods Yard area at the upper left. [R H Windsor Collection, TQ 2982/2]

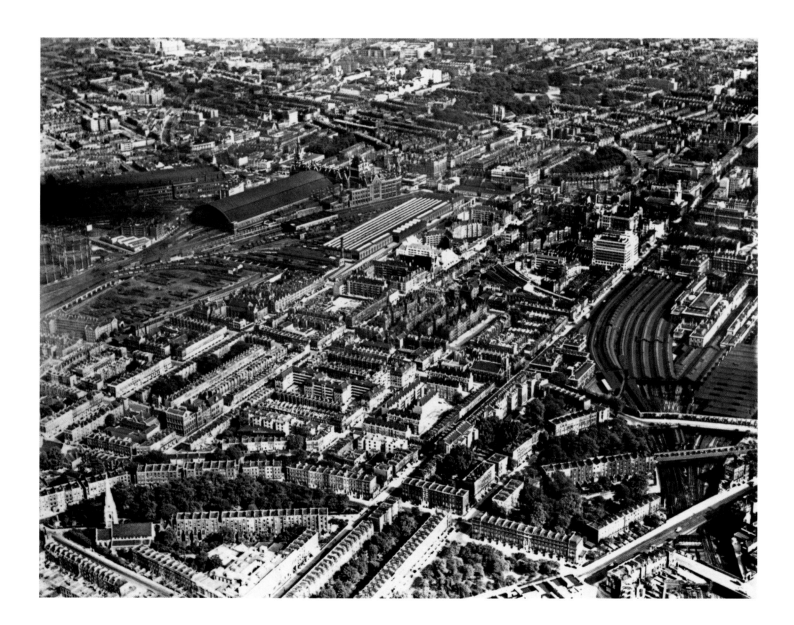

St Pancras Station from the north, September 2006

One of the most potent images of regeneration and renewal in London: the great extension for the new Channel Tunnel Rail Link terminus (Alastair Lansley and the CTRL Design Team, 1997–2007) at St Pancras, seen nearing completion. The great new roof extends 'like a flying carpet' (in the words of its architect) to the north of Barlow's arched train shed. The station, superbly refurbished and extended, will be Britain's gateway to the continent. What with the magnificent Victorian buildings, the legacy of railway history, the new link to the continent, the scale and quality of the new buildings, the impending regeneration of the immense goods yard area and the nearby presence of one of the world's great libraries, King's Cross and St Pancras are acquiring an impressive cargo of symbolic (as well as practical) value. This will surely be one of the great focal points of the city in the next century. [NMR 24447/025]

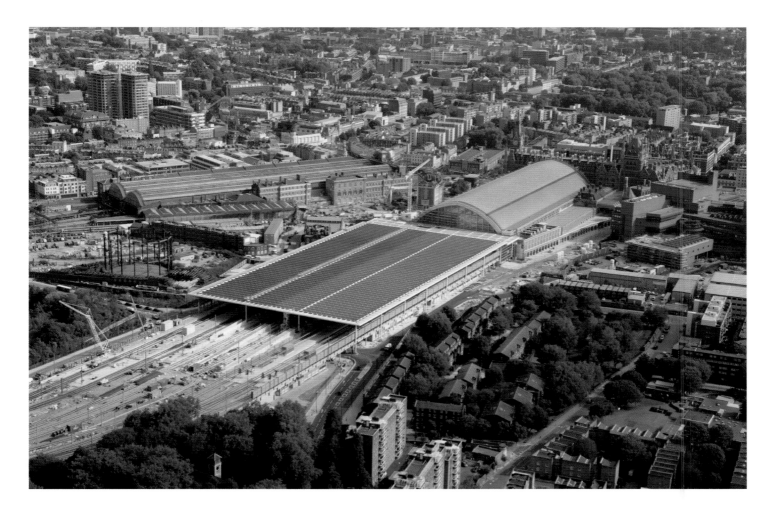

Caledonian Market, Islington, c 1930s

Caledonian Market is located north of King's Cross off York Way and Market Road. The Corporation of London moved their live cattle market here from Smithfield in 1852. At the time the site was still open fields and their architect, J B Bunning, laid out the great square market with its magnificent central clock tower; the 12-sided structure around its base housed a telegraph office and banking offices. The two large blocks on the left were hostels for drovers, the broad shed roofs were the meat market and the four smaller rectangular buildings at the corners were pubs, to keep the whole busy establishment suitably lubricated. This view dates from the 1930s, shortly before the cattle market closed in 1939; the meat market followed suit in 1963.
[R H Windsor Collection, TQ 3084/1]

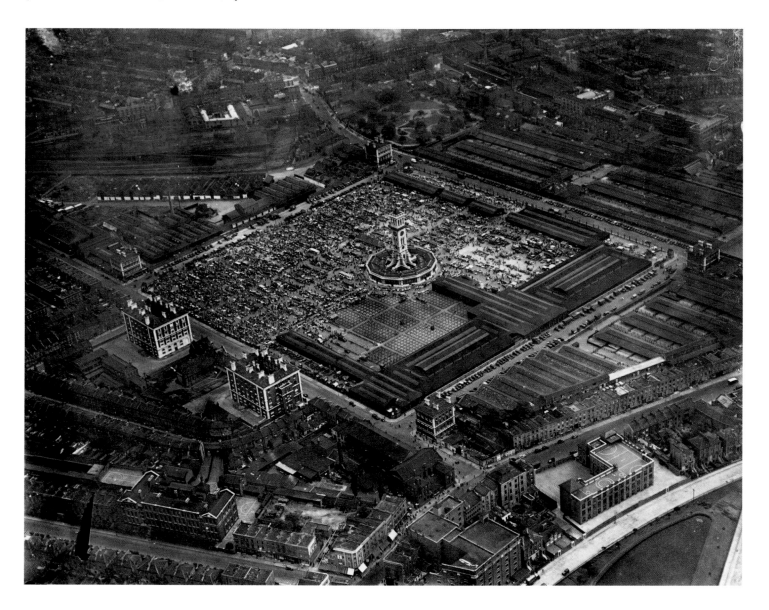

Market Estate, Islington, September 2006

The site of the Caledonian Market is now half-landscaped as open space and half-filled with public housing built by Islington Borough Council in the late 1960s. Refurbishment works in the late 1980s included taking down the access decks that originally linked the red-brick blocks, reflecting a realisation that 'streets in the sky' do not work. Three of the four pubs that anchored the corners of the market survive and can be made out in this view, while the clock tower remains as an isolated monument. [NMR 24458/027]

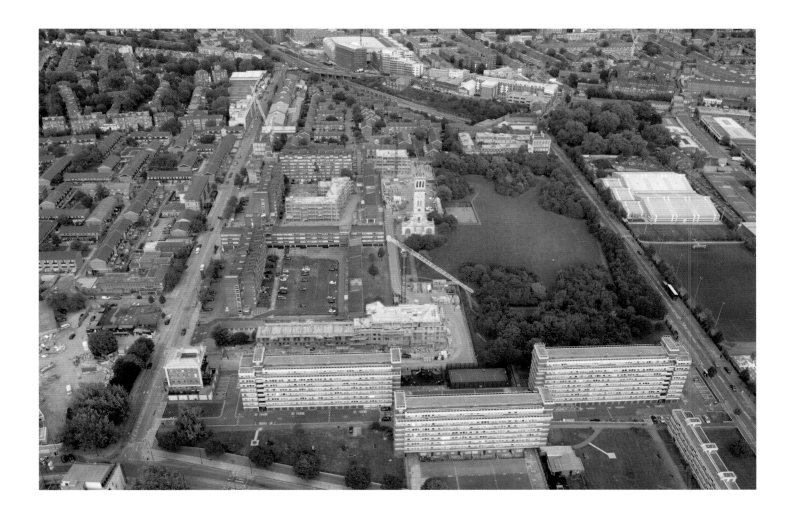

Hampstead Heath from high above, 7 August 1944

North, roughly speaking, is at the top in this view, with the village of Hampstead on the left and Kenwood House at upper right; Spaniards Road cuts diagonally across the top and the terraces of Belsize Park and Gospel Oak are seen at the foot of the page. The Heath – 800 acres of public open space on the first sizeable hill north of the Thames – has been common land since time immemorial. All over England, in the late 18th and early 19th centuries, vast areas of common land were enclosed by private landlords under Enclosure Acts; Hampstead Heath saw a notable case of local opinion fighting back. In 1829 Sir Thomas Maryon Wilson, lord of the manor, petitioned Parliament for the right to enclose and develop the Heath. The villagers of Hampstead fought him in the courts and the case was still unresolved at his death 40 years later. In 1871 John Maryon Wilson sold his manorial rights to the Metropolitan Board of Works and Hampstead Heath has been safeguarded as public property ever since. [RAF/106G/LA/29/3027]

Kenwood and Hampstead Heath looking south, August 2001

Cover the top quarter of this view with your hand and it might be a scene in any English county: a grand Georgian country house set in a wooded park, with a village at the park gates, lakes in the valley below and open countryside stretching into the distance — this was more or less the truth of the situation until the 19th century. William Murray, Lord Chief Justice and 1st Earl of Mansfield, bought the small estate of Kenwood with a medium-sized country house in 1754. Between 1766 and 1774 the house was remodelled and enlarged for him by Robert and James Adam, and in the 1790s the 2nd and 3rd earls had the park landscaped to designs by Humphrey Repton. In the next century the 220-acre estate was enveloped by the growing suburbs and by 1914 the Murrays had decided to sell up. A local group was formed to campaign for the house and grounds to be saved from development and, after protracted negotiations and fund-raising, the bulk of the estate was acquired by the London County Council in 1922–4. The house and the last 74 acres were bought from Lord Mansfield by Edward Cecil Guinness, 1st Earl of Iveagh, in 1925. Lord Iveagh, then 78, furnished the house and filled it with his great collection of paintings. His bequest of the house, land and contents to the nation in 1927 was one of the most generous benefactions ever made to the people of London. Kenwood is today managed by English Heritage and attracts over a million visitors a year. [NMR 21454/10]

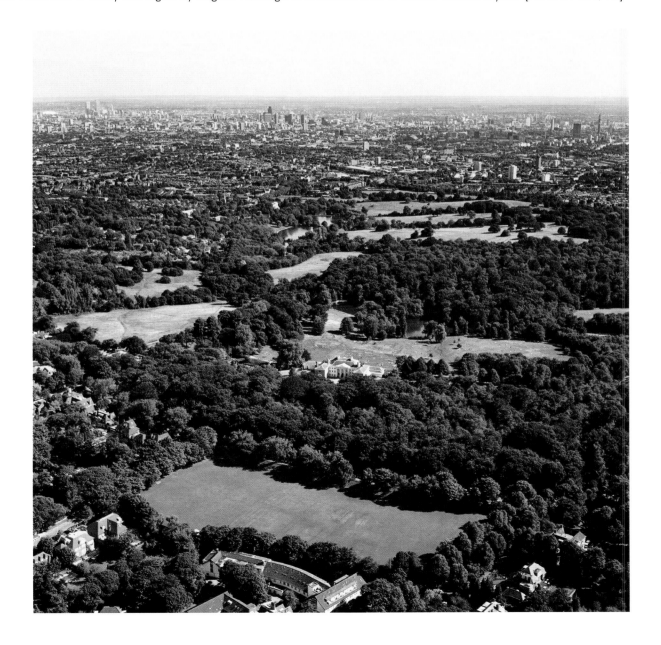

Hampstead Heath, pre-1914

This undated glass slide is from before the First World War. It shows Hampstead, looking south across the Vale of Health Pond with the village and the spire of Christ Church, Hampstead Square (Samuel Daukes, 1851–2), to the right. The Vale of Health is an isolated group of houses on the edge of the Heath seen on the left in the picture. Its name, given in the early 19th century, is possibly a little ironic, for in the 18th century there were tanneries and other noxious trades here. Suburban villas appeared in the 1860s and the area became all the more desirable when development on the rest of the Heath was blocked. [RAeS Library, Lantern slide 1948]

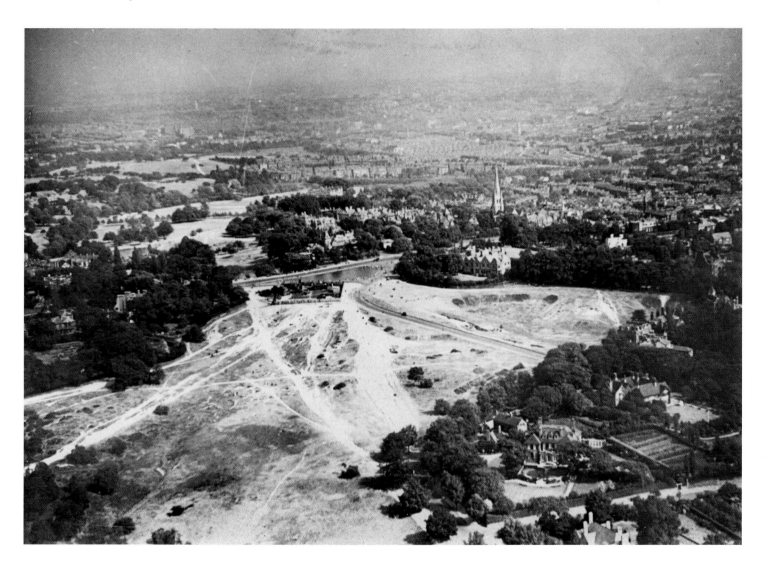

Hampstead Village looking east over the Heath, September 2006

The reasons for Hampstead's enduring popularity and fashionableness can be understood clearly enough from this view — its hilly site, its intricate street pattern and small scale, its greenness and the fine heritage of Georgian and Victorian houses make it the most instantly appealing of north London's villages. The spire of Christ Church, Hampstead Square, makes a fitting visual focus. Below, more or less in the centre of the view, is the hipped roof of Fenton House (c 1693), Hampstead's finest domestic building, now owned by the National Trust. At the lower right is Mount Vernon (T Roger Smith, 1880 with later wings), built as a hospital for consumptives: a fine building but out of scale with its surroundings. [NMR 24460/006]

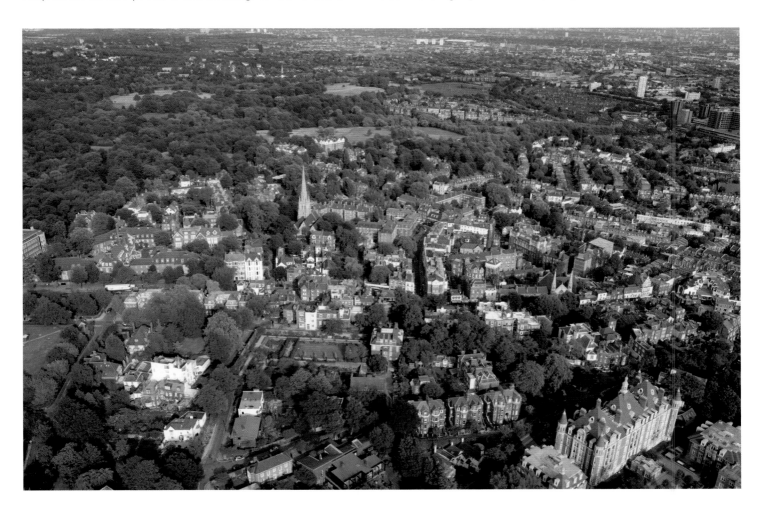

Highgate with the flank of Hampstead Heath to the left, 7 August 1944

The complex street plan reflects the up-and-down topography of the area. On the left-hand side are the Hampstead Heath ponds, with the bathing pond marked by its twin jetties; Kenwood is just off the top left-hand corner. Highgate Road runs up the photograph on the left, roughly parallel to the ponds, then becomes West Hill as it bends round to the right. Highgate Hill is the emphatic diagonal running from the right to left up the right-hand half of the view. The large open area covered with a speckling of white dots at the centre of the picture is Highgate Cemetery. Highgate Village on its hilltop, immediately above this, remains one of London's most appealing village centres (despite rather oddly being divided between three boroughs), offering Hampstead a serious run for its money. [RAF/106G/LA/29/3029]

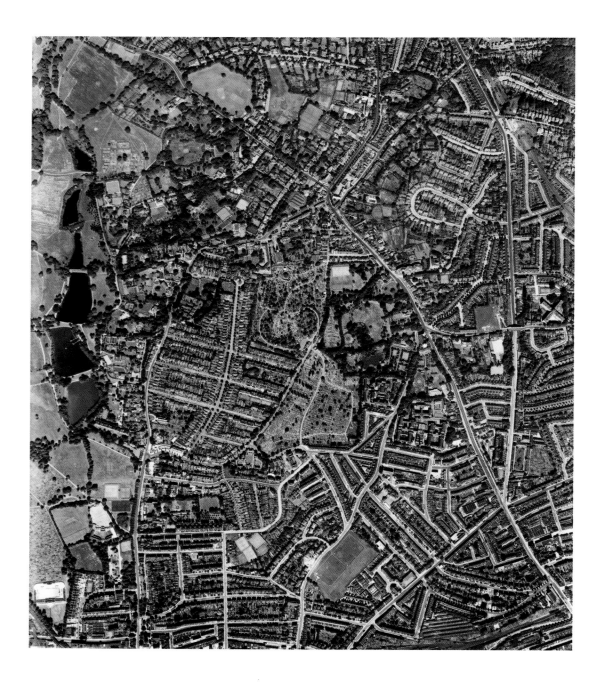

Looking south over Highgate Village towards the City, September 2006

This view, from somewhere above the top of the photograph on the opposite page, looks southwards down the hill towards the City. A village grew up on Highgate Hill in the late medieval period on the edge of the Bishop of London's Middlesex estate. A new tollroad was built ascending the hill and the toll gate at the top is said to have given the village its name. By the end of the 16th century it was becoming a popular resort for Londoners, being, as the cartographer John Norden put it, 'a most pleasant dwelling, yet not so pleasant as healthful'. In the 16th and 17th centuries substantial houses grew up along Highgate Hill – Cromwell House and Lauderdale House still remain. The famous cemetery was established in 1839, swiftly becoming a tourist attraction for its fine architecture, as well as a fashionable place to be buried! Highgate remains one of north London's most desirable addresses. On the right-hand edge of the view is the red-brick bulk of Witanhurst (George Hubbard, 1913), the huge house built for soap magnate Sir Arthur Crosfield, said to be the largest private house in London. [NMR 24459/020]

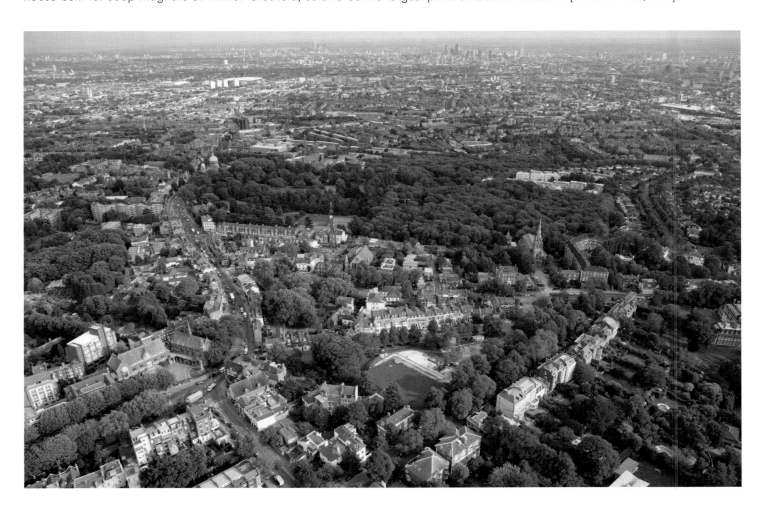

Alexandra Palace and Park, 7 August 1944

Alexandra Palace, envisaged as a 'People's Palace' for north London, was based on the Crystal Palace as it had been reconstructed at Sydenham (opened in 1854). A first initiative in 1858 stalled, but in 1860 the Great Northern Palace Company was founded; it soon raised the necessary money and started work. In 1863 the park was opened and in 1865–6 the buildings took shape – they were built by the contractor Sir John Kelk and the architect John Johnson, reusing materials from the 1861 Exhibition building at South Kensington, which had itself been built by Kelk (thus reinforcing the analogy with the Crystal Palace). The building burnt down 16 days after it was opened and was rebuilt to Johnson's designs. There was a theatre, huge exhibition halls and a concert hall seating 12,000 with the world's largest organ. Despite a varied programme of musical, cultural and educational events, the palace was never a financial success and was taken into public ownership in 1901. In the First World War it was used as a barracks and housed first Belgian refugees and then German prisoners of war. [RAF/106G/LA/29/3084]

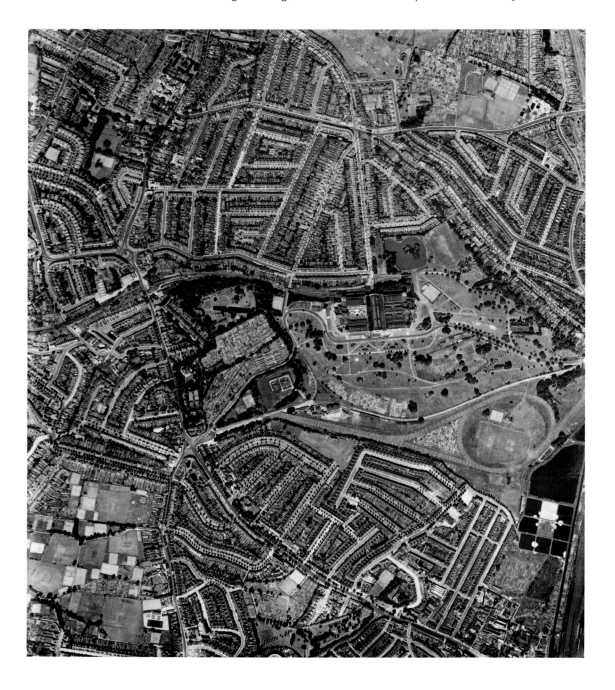

Alexandra Palace from the south, August 2006

In 1934 part of Alexandra Palace was leased by the BBC, attracted by the high site. They constructed the television mast that still adorns the south-east tower and regular television broadcasts began in 1936 – the first broadcast, on 26 August, was a variety show called *Here's Looking at You*. The BBC moved to Shepherd's Bush in 1956 (*see* p 137), but Alexandra Palace still has an important place in the history of broadcasting. Park and palace were taken over by the Greater London Council in 1966 and by the borough of Haringey in 1980; in the latter year the palace was ravaged by another great fire. A campaign of rebuilding took most of the 1980s and is not yet complete (1981–8, architects Peter Smith and the Alexandra Palace Development Team, with Pell Frischmann, engineers). This view conveys Johnson and Kelk's rather hefty Italianate architecture: the left-hand half with its arcades substantially intact, the right-hand half rather marred by their being infilled to make television studios. [NMR 24398/032]

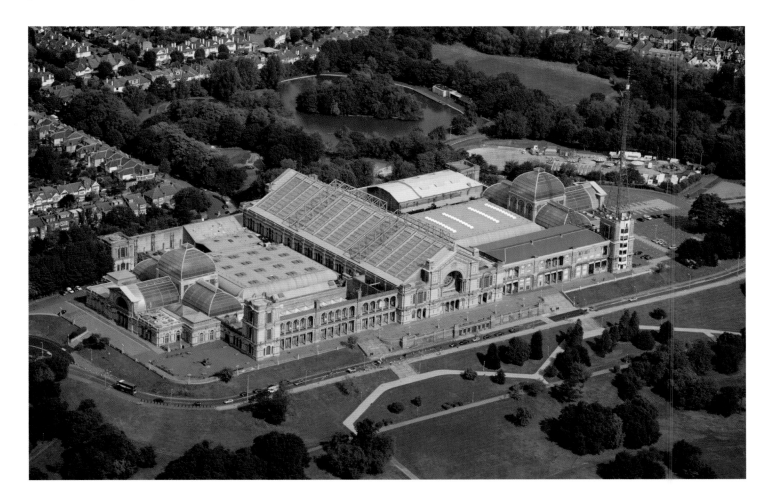

Hampstead Garden Suburb, 20 April 1946

Sir Nikolaus Pevsner wrote that this was 'the aesthetically most satisfactory and socially most successful of all 20th-century garden suburbs'. Indeed Hampstead Garden Suburb is one of the most remarkable achievements of humane, integrated town planning and architecture in Europe. Its founder, Dame Henrietta Barnett, had laboured to help the poor in the slums of Whitechapel as the wife of a clergyman, Canon Samuel Barnett. She had a vision of an ideal planned community and when the extension of the Northern Line threatened this area with speculative development, she saw her chance and founded the Hampstead Garden Suburb Trust in 1906. Funds were raised and an initial 243 acres bought – it was always part of Dame Henrietta's scheme to reserve the southern part of the site as an extension to Hampstead Heath. Raymond Unwin, the brains behind the garden city of Letchworth in Hertfordshire, was appointed as architect-planner and work began in 1907. A major extension of another 112 acres was acquired and laid out in 1911. A further extension of over 300 acres to the east, laid out by the Trust's partner companies, was added after 1919. [RAF/TUD/UK/161/5100]

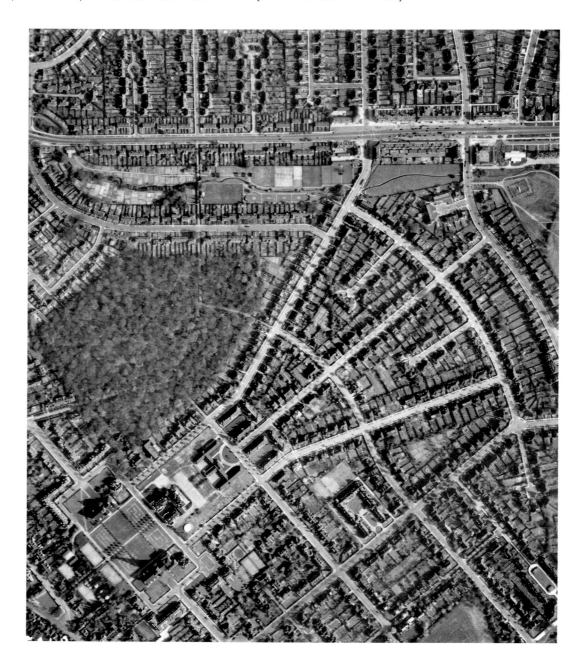

Hampstead Garden Suburb: the central axis from the south, September 2003

Hampstead Garden Suburb's Central Square is at the highest point of the development. The square was laid out by Sir Edwin Lutyens, who also designed the twin churches: the Anglican St Jude with its spire and the domed Free Church beyond. The Garden Suburb displays a subtle balance between the formal layout and architecture of the Central Square and adjacent areas, and the more winding roads and picturesque values adhered to elsewhere. Britain's building industry was then at an all-time peak in terms of quality of materials and construction, and the Arts and Crafts movement had generated a wealth of talent in domestic architecture in figures like M H Baillie-Scott, Charles Wade, Barry Parker, Lutyens and many others. It is sad but perhaps inevitable that Dame Henrietta's vision of a community of middle- and working-class people living together should have been overtaken by its own sheer attractiveness (and by its cost, both in land and construction) – today the Garden Suburb has become almost entirely a middle-class preserve. It has, nevertheless, been a powerful and wholly beneficent influence in the history of 20th-century architecture. [NMR 23258/08]

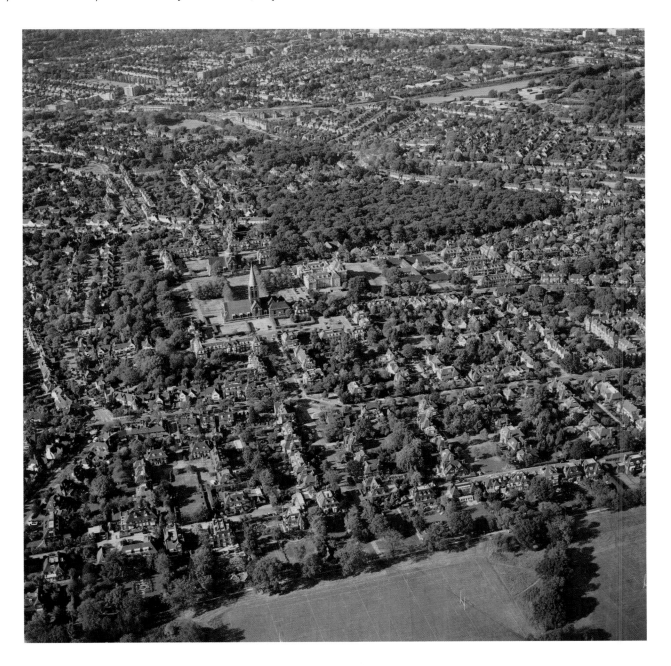

Suburban housing, Queensbury, c 1930s

This view is of Queensbury in the modern borough of Brent, looking north up Honeypot Lane (now the A4140). After the refinement of Hampstead Garden Suburb, Queensbury displays the standard suburban housing of the 1930s as provided by a host of small builder-developers. They were encouraged by the opening of a branch of the Metropolitan Railway to Stanmore in 1932, on which a new station at Queensbury opened in 1934: it is just visible at the lower right-hand corner. The branch was taken over by the Bakerloo Line in 1939 and then merged into the new Jubilee Line in 1979. In south London it was the opening of commuter rail lines which tended to drive the pace of suburban development; in north London it was the expansion of the Underground. Around the existing features – the railway and the main road – this newly invented cityscape had sprung up out of the fields in a matter of months. A few hedgerows survive in the open fields at top left. The presence of the small factories at the lower right-hand corner is a reminder of how few formal planning controls there were during the inter-war expansion of London. [R H Windsor Collection, TQ 1889/1]

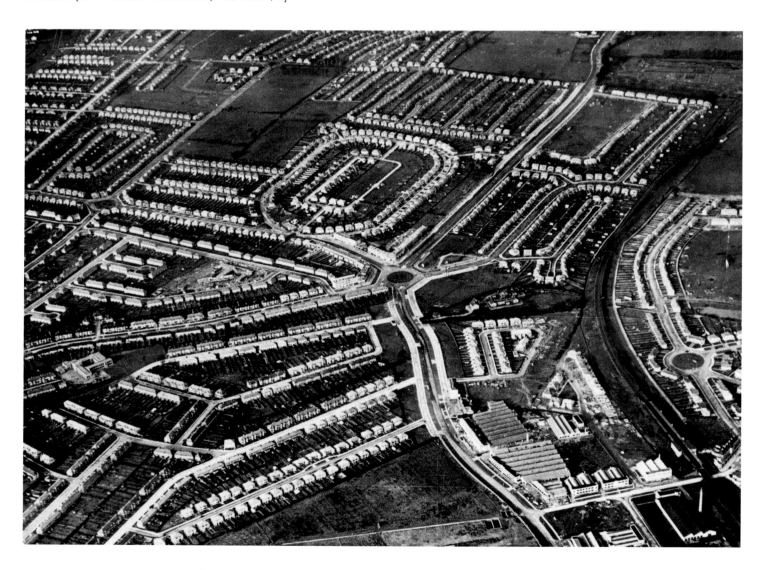

Queensbury: the same view today, October 2006

Queensbury's architecture is standardised and generic, the 1930s equivalent of Georgian pattern-book terraces. Even so, the broad streets, the air of spaciousness, the universal provision of gardens and the possibility of real independence made places like this a haven for people fleeing the Victorian inner city. Quiet suburbs like this – too frequently derided by smart critics – belong in any study of London because they represent such a major part of its fabric and, by and large, they work.
[NMR 24390/055]

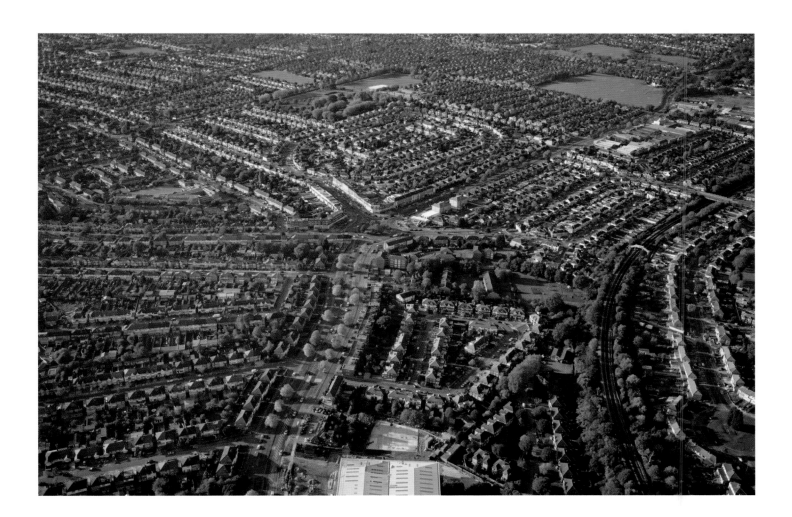

Railway lines at Stonebridge Park just south of Wembley, with waiting goods trains and a camouflaged power station, 31 August 1943

The broad expanse of the railway lands seems to cut abruptly through the quiet suburban streets, but in fact it was the railway that came first – this is the London & Birmingham Railway's original main line into Euston, opened in 1837. The L&BR was merged into the London & North Western Railway in 1845. In the early 1900s, with their commuter traffic growing strongly, they planned a new line, alongside their main line, from Euston out to Watford. The first short stretch of it opened with steam traction in 1912, but the LNWR always intended that the line should be electrified and in 1913 they built the power station, seen here, to serve it. The original timber cooling towers can be seen just behind the single concrete cooling tower. Wembley Stadium is just out of the picture to the left. [RAF, TQ 1884/1]

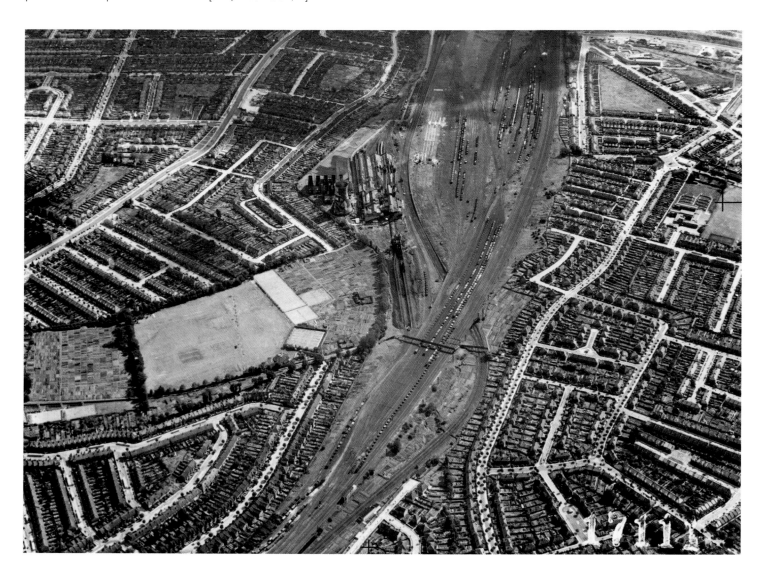

Railway lines at Harlesden, October 2006

The same view today: this is now the West Coast Main Line. The power station has disappeared, replaced by a depot and carriage sheds, but electrification has been applied to all the lines. The North Circular Road crosses the railway and Stonebridge Park Station is just short of it and to the left. [NMR 24392/001]

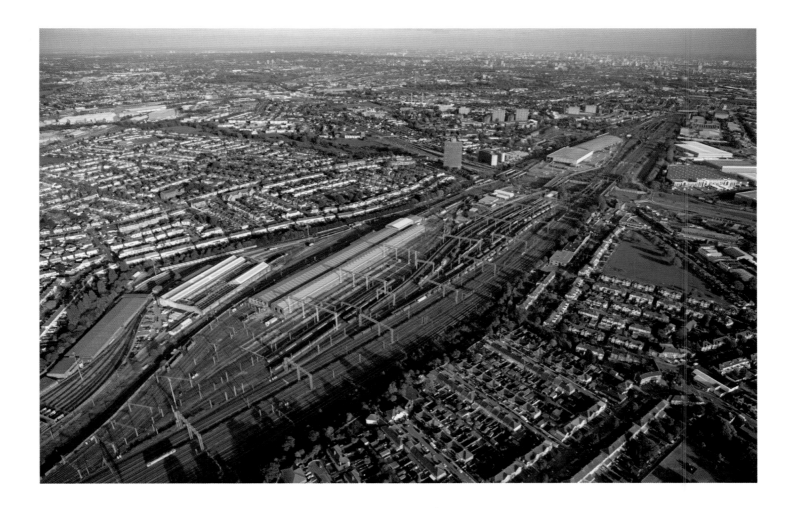

Wembley Stadium, 20 April 1946

Wembley Stadium is seen here with the site of the British Empire Exhibition of 1924–5 above it. In the 1880s there was a park and a sports ground here. In 1889 Sir Edward Watkin, Chairman of the Metropolitan Railway, sought to make Wembley a tourist attraction by building a 1,050ft (320m) rival to the Eiffel Tower here. However, when it had reached 200ft (61m) the money ran out; the incomplete stump of 'Watkin's Folly' stood until 1907. In 1918 the government began plans for the British Empire Exhibition on the 219-acre site – it was to be the last of the old-style grand public exhibitions of the kind that started with the Crystal Palace in 1851. North of the stadium there extended a grand avenue, with the huge twin palaces of Industry and Engineering, seen at the very top of this view. There were many other halls and pavilions representing territories of the British Empire, but by 1946 most of them had been taken down; Canada and Australia occupied the open areas immediately above the stadium in this view. The exhibition was visited by 27 million people, making it the last and greatest public display of British imperial power. [RAF/3G/TUD/UK/161/5069]

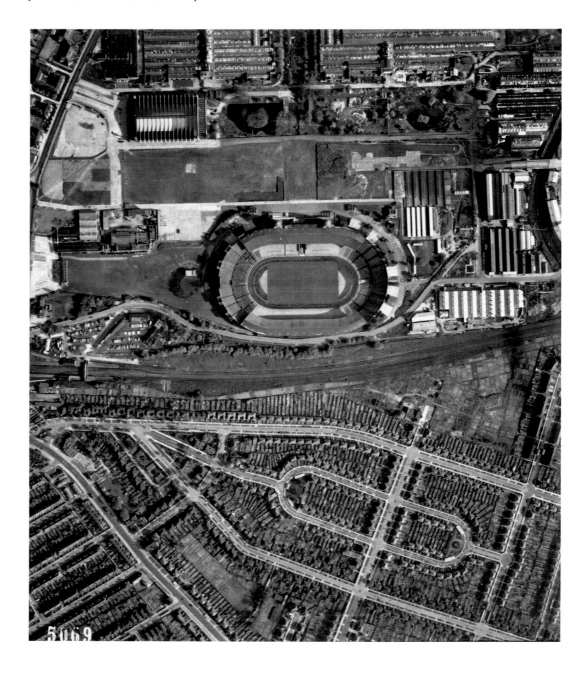

Wembley Stadium, 23 March 1999

Old Wembley Stadium with the famous 'twin towers' is part of the history of Association Football and now a thing of legend. The vast reinforced concrete stadium, originally seating 120,000, was designed by John Simpson and Maxwell Ayrton with the engineer Sir Owen Williams and opened in time for the FA cup final of 1923. Remarkably, the huge building went up in only 300 days at a cost of £750,000. By the time this view was taken, the surviving British Empire Exhibition buildings had been consigned to use as warehouses and were in a neglected state, but the stadium remained one of the great meeting places of British sporting life, its finest moment coming when it hosted the Olympic Games of 1948. [NMR 18308/03]

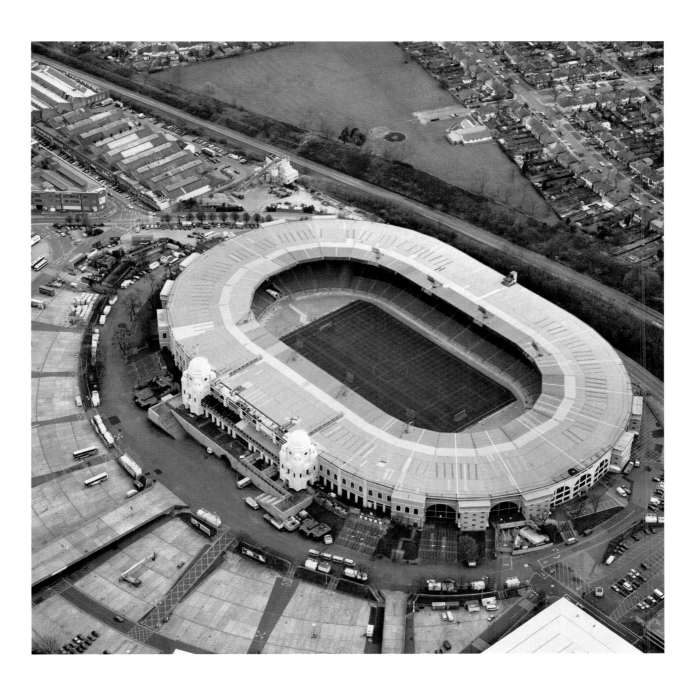

Wembley Stadium under construction, 16 September 2003

The old stadium had an iconic importance – above all for generations of football fans – and was listed at Grade II, but by the 1990s it seemed tired and inadequate. Consideration was given to refurbishment and to redevelopment while retaining the familiar 'twin towers'; however, in the end the Football Association and Brent Council resolved to make a fresh start and demolish it completely, partly on the grounds that retaining the twin towers would have kept the new stadium to more or less the dimensions and site of the old building, given the immovable line of the railway on the other side. The last match was held in the old stadium in October 2000. The start of the new building was delayed by political and financial problems, and work only began in October 2002. As this picture shows, the first year of construction was taken up with the groundworks and the giant concrete service cores. [NMR 23260/08]

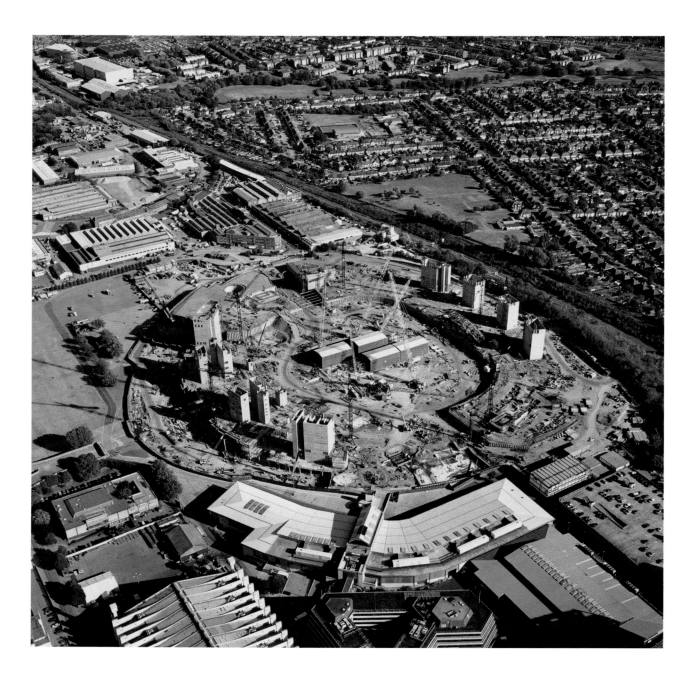

Wembley Stadium, October 2006

The new Wembley Stadium was designed by Foster Associates and HOK Sport as architects with Connell Mott McDonald as engineers. This is one of the largest buildings in Britain, with an enclosed volume of 4 million cubic metres. The seating capacity of 90,000 is a good deal smaller than the old stadium, but still makes this the second largest in Europe (to the Nou Camp in Barcelona). The giant arch, 436ft (133m) high and 1,033ft (315m) in span, is the pre-eminent symbol of the new stadium; it is not just decorative, but carries a good part of the weight of the 11 acres of roof (4 acres of which are retractable), allowing the building to do without columns and freeing up the sightlines. Its construction has been difficult and controversial, involving long delays, huge cost overruns and a much-publicised lawsuit between the main contractor and the steelwork contractor, all in marked contrast to the swift construction of its predecessor. Had those responsible for the initial decision known how fraught and expensive it would be, it would almost certainly not have been built (like many other magnificent and valuable projects). [NMR 24391/007]

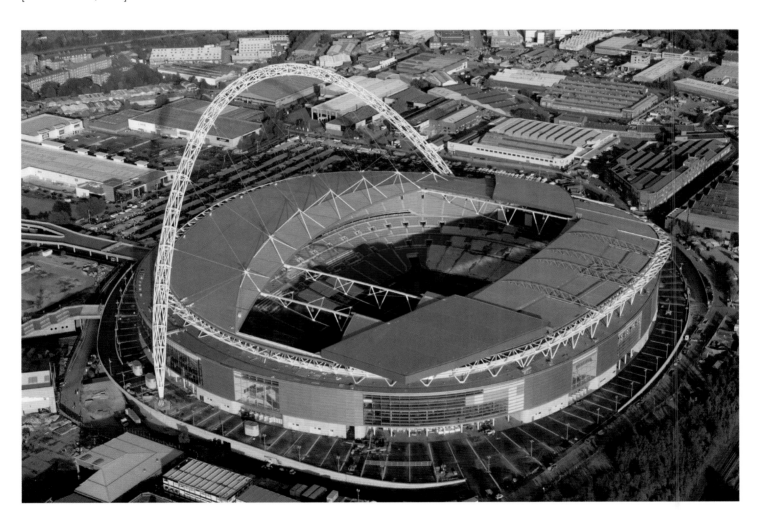

Harrow-on-the-Hill, c 1930s

London is not a very hilly place, so Harrow stands out among the seas of quiet suburbs, the tall spire of St Mary's forming one of north London's best landmarks. The biggest event in the village's history was the foundation of Harrow School by a benevolent yeoman farmer, John Lyon, in 1572. The school's buildings don't form the usual inward-looking quadrangle, but make a wonderfully composed group around the hilltop, with Victorian and early 20th-century buildings by Sir George Gilbert Scott, William Burges and Sir Herbert Baker. Below this group, the large building spreading down the hill on the right-hand side is the Biology Schools (Basil Champneys, 1886); the Music School (Edward Schroder Prior, 1891) is seen below this and surrounded by gardens near the foot of the picture. [R H Windsor Collection, TQ 1587/1]

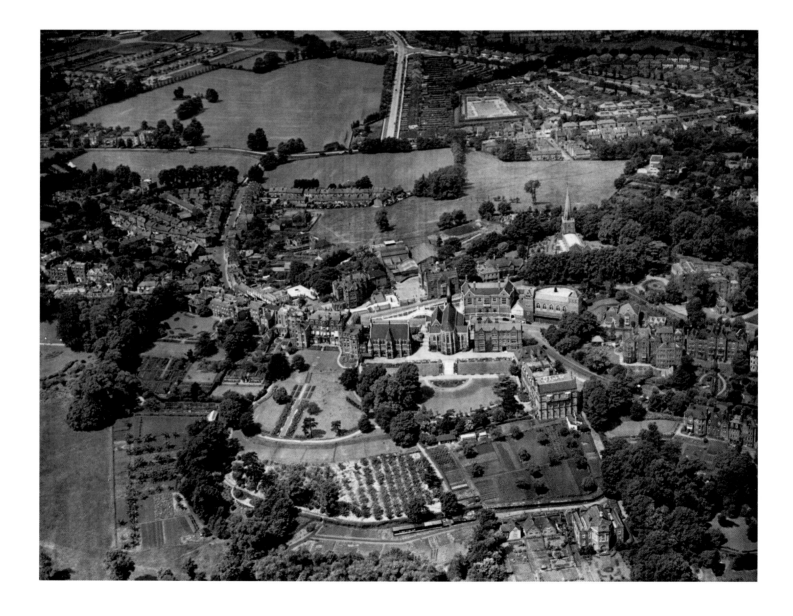

Harrow-on-the-Hill, October 2006

This view shows the parish church, with its spire rising out of the trees, and the school buildings grouped to its right with the long curve of West Street rising from the lower left to meet the High Street, coming in from the right. Sir John Betjeman imagined the steep hill here surrounded by the sea in his poem *Harrow-on-the-Hill* (1954):

> Then Harrow-on-the-Hill's a rocky island
> And Harrow churchyard full of sailors' graves
> And the constant click and kissing of the trolley busses hissing
> Is the level of the Wealdstone turned to waves
> And the rumble of the railway
> Is the thunder of the rollers
> As they gather up for the plunging
> Into caves.

[NMR 24390/027]

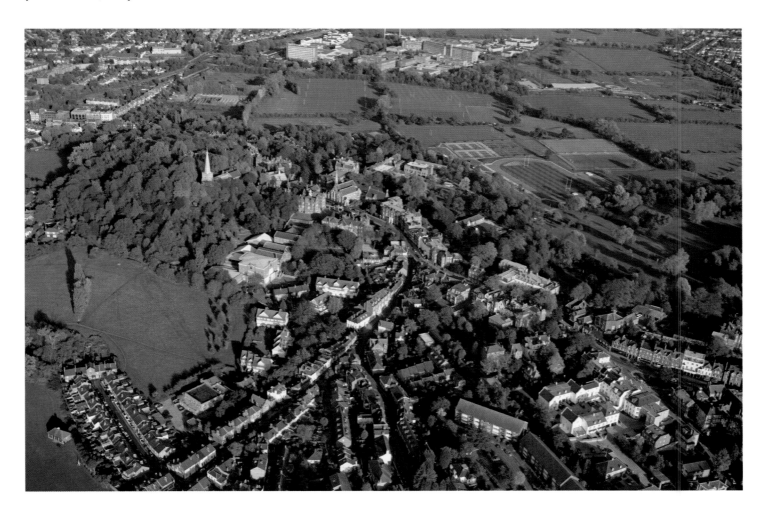

RAF Hendon, c 1930s

Aviation activity at Hendon started in 1909 with aircraft manufacture by Everett & Edgcombe, followed by the setting up of a flying school by Louis Bleriot in 1910. In 1911 Claude Grahame-White bought the land with winnings from air races, including the Gordon Bennett cup, in the United States. He developed the site as the London Aerodrome, built aircraft and also ran air displays and the Aerial Derby, a race around London first held in 1912. At the beginning of the war Graham-White became a flight commander in the Royal Naval Air Service (RNAS) and made the first night patrol in search of a Zeppelin, but in 1915 he resigned his commission and concentrated on building aircraft for the war effort. During the war Hendon was an important training base for the RNAS and the Royal Flying Corps. In 1922 the Government took possession of Hendon and between the wars it was famous as the location of the RAF's annual air displays. In this view, north is to the right and Aerodrome Road is seen skirting the lower left side of the airfield. The Grahame-White Company's premises and hangars are generally to the right of the road, while the RAF's officers' mess and premises are to the left. At this time it is still an airfield with no paved runway, but the large circle in the middle (known as a Smoke Wind Detector) defines an area where a smoke grenade was placed so that returning pilots could check wind direction. [R H Windsor Collection, TQ 2190/1]

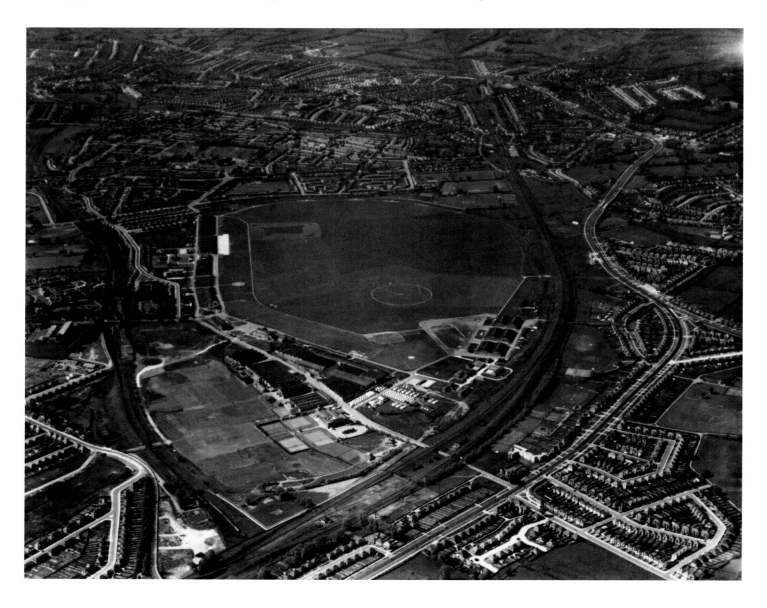

The RAF Museum, Hendon, September 2006

Hendon Airfield is unrecognisable in this view from more or less the same viewpoint – the M1 now snakes alongside the railway and the airfield is gone. The massive concrete blocks of the Metropolitan Police Training College rise in the middle distance on the southern part of the aerodrome estate. The one link with the glorious aeronautical past is the RAF Museum, whose shed-like roofs are at upper right, just left of the railway. [NMR 24460/025]

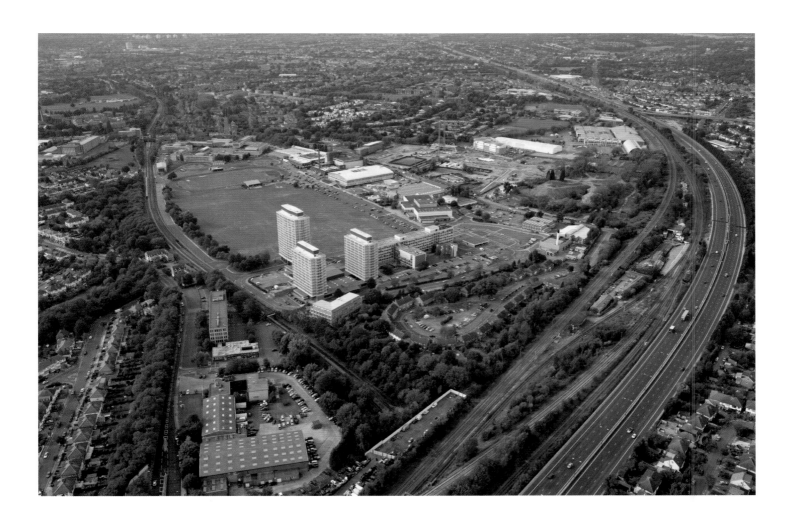

King George V Reservoir and Pumping Station, and the Royal Ordnance Factory, Enfield Lock, 19 October 1948

Since the 12th century there have been several campaigns to control the River Lea (or Lee) and make it navigable – so many additional channels have been dug as to give the valley an intricate, small-scale new geography. In this view the Lea Navigation appears to the left of the King George V Reservoir, with the flood relief channel or diversion branching off around the right-hand edge of the reservoir. A small-arms factory was opened here at Enfield Lock in 1816, using water power from the river, and remained the principal source of rifles for the British army throughout the 19th century. It remained modest in scale until the crisis generated by the Board of Ordnance's dismal performance in the Crimean War. A fact-finding mission went to visit the United States and a new factory was built in 1854–6 based on American models and equipped with American machinery. The workforce rose to over 1,000 and by 1860 they were turning out 1,744 rifles a week. Another expansion was carried out in 1886–7, when water power gave way to steam power, and the workforce rose to 2,400. The famous Lee-Enfield rifle, designed by James Lee, was manufactured here from 1895. The Royal Ordnance Factory is the large, irregular group of roofs at centre left; the rows of roofs in the fields to the right of the view are probably greenhouses or covers over crops. [RAF/541/183/3032]

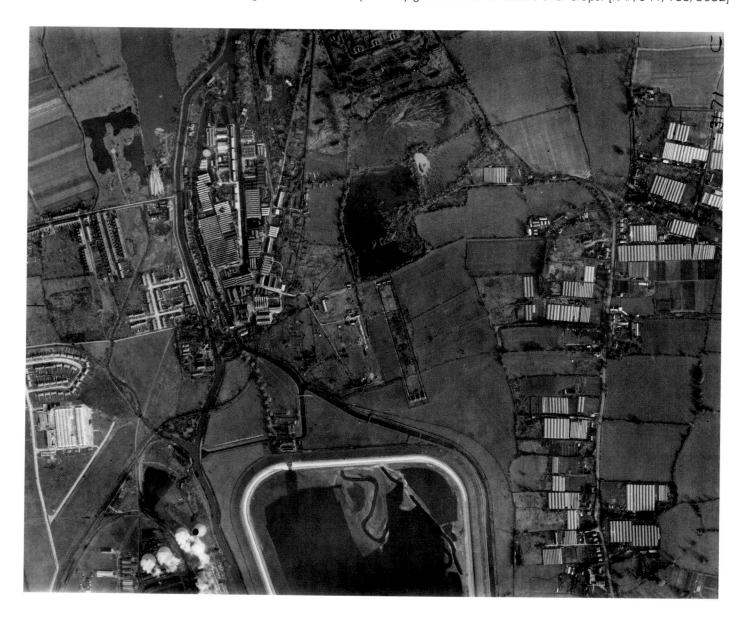

The King George V Pumping Station and the former Royal Ordnance Factory, Enfield Lock, September 2006

The Royal Ordnance Factory went into a slow decline after the Second World War, but did not finally close until 1987. The site has been redeveloped as housing, though a few of the 19th-century buildings survive, including the façade of the main factory building of 1854–6. Immediately to the south is the huge King George V Reservoir – one of a series running down the Lea Valley – which covers 420 acres and was inaugurated in 1913. The reservoir is above the level of the river and enclosed by earth banks. Water was raised into it by a remarkable device, the 'Humphrey Pumps' – invented by H A Humphrey, the pumps have no piston and worked by igniting a mixture of gas and air directly in a column of water on a four-stroke cycle. The technology was absolutely new when it was installed here by the Metropolitan Board of Works, but was overtaken by the First World War and the subsequent development of diesel, turbine and electric pumps. The handsome engine house (W B Bryan, c 1910–13) can be seen beside the reservoir. [NMR 24383/005]

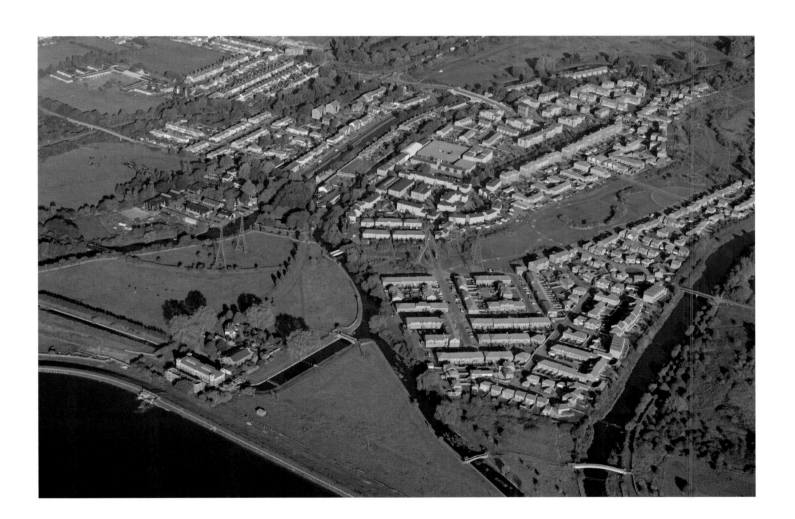

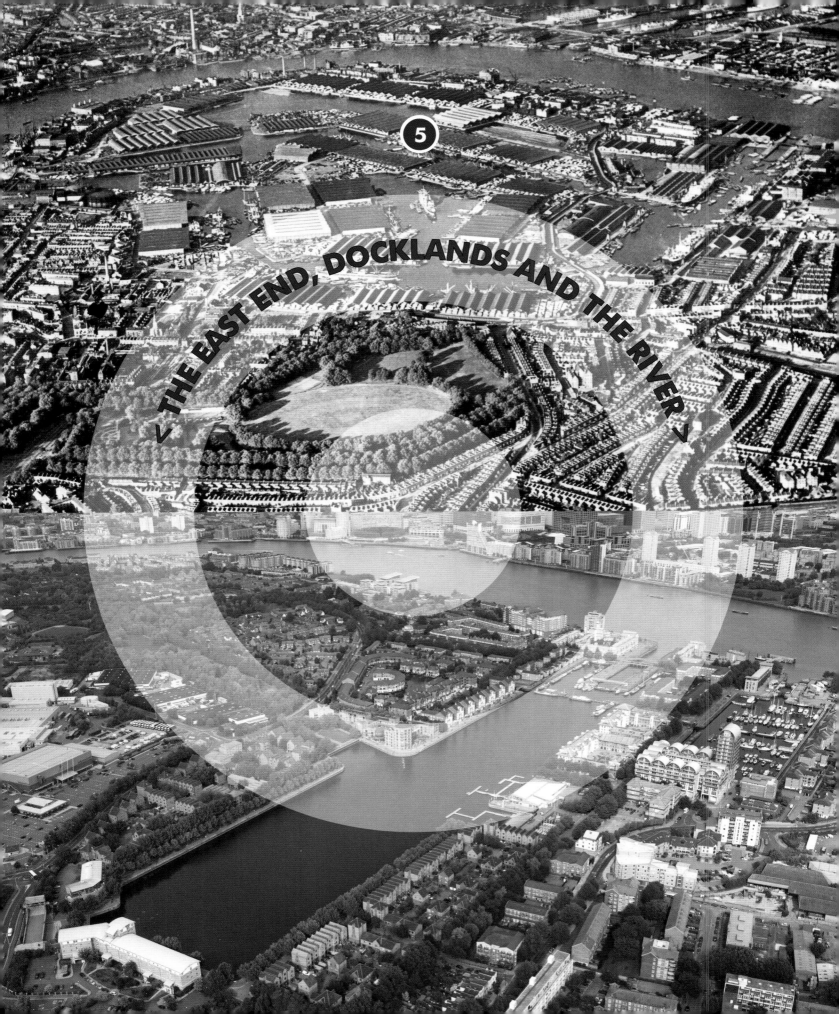

< THE EAST END, DOCKLANDS AND THE RIVER >

High above the Tower of London, St Katharine's Dock and London Docks (north is towards the upper right-hand corner), 7 August 1944

This vertical image gives a spectacular indication of the City and East End's sufferings during the preceding four years. Great tracts of the Eastern City are empty sites, the roof of Cannon Street Station (in the top left-hand corner) is a skeleton and the east end of the Custom House (David Laing, 1812–17, rebuilt by Sir Robert Smirke in 1825–8), the long building on the river halfway between Cannon Street Station and the Tower, is in ruins. The three basins of St Katharine's Dock, just east of the Tower, have lost half their warehouses and the dock office, at the northern apex of the site, is visibly in ruins. There are gaps around the oblong basin of London Docks, just to the right, though the five North Stack warehouses on its northern flank seem to be intact. A barrage balloon, part of the city's air defences, is moored in the western arm of the Tower moat.
[RAF/106G/LA/29/3297]

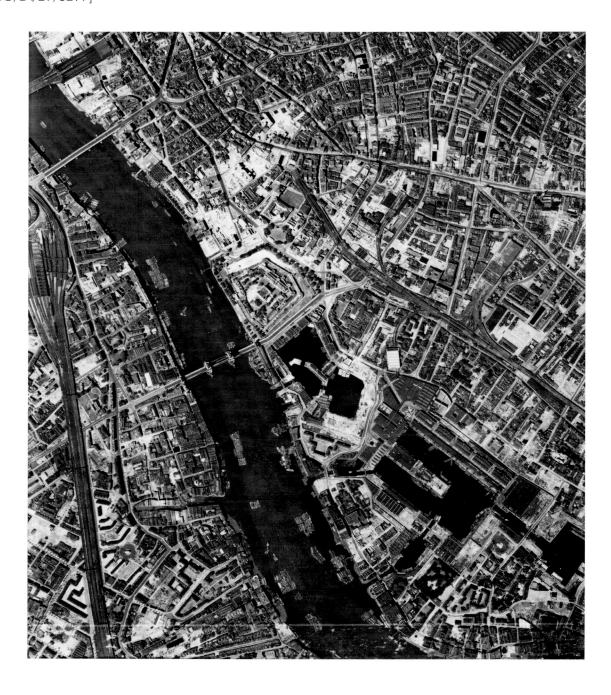

Tower Bridge and St Katharine's Dock looking east, September 2006

Wartime destruction was followed by several rounds of reconstruction, to the point that the old East End, for better or worse, is no more. The buildings of St Katharine's Dock, to the left of Tower Bridge, are almost all replaced. Beyond, one side of the oblong basin of London Docks has been left as an ornamental canal; the rest of the basin, a unique and irreplaceable asset, was filled in for housing. The North Stacks were demolished in the 1970s and 1980s, and replaced by the News International newspaper plant. The destruction of most of these historic dock buildings, the majority of which had survived the Blitz, was one of the worst architectural losses that London endured in the 20th century and was entirely avoidable. [NMR 24450/008]

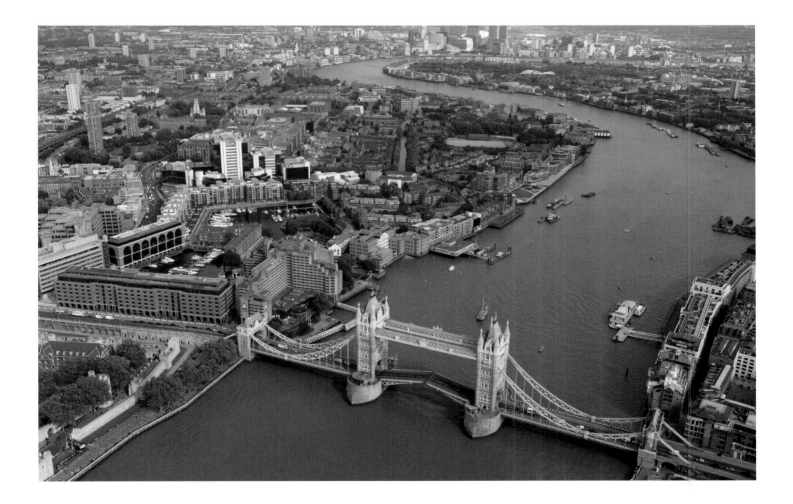

The Tower of London and St Katharine's Dock taken from the balloon *Corona*, 6 July 1908

The Tower's concentric plan reads very clearly, reflecting its historic development from the 11th-century White Tower in the middle, to the development of the inner curtain walls mostly from the reign of Henry III in the mid-13th century, to the addition of the outer curtain for Edward I in the late 13th century. For most of its history the Tower housed a great variety of functions, including the principal Mint of the English Crown until the construction of new buildings for the Mint, seen at upper left, in 1807–12. This was the principal centre for production of British coinage until the 1960s, while banknotes were printed at Debden in Essex. [RAes Library APh 342]

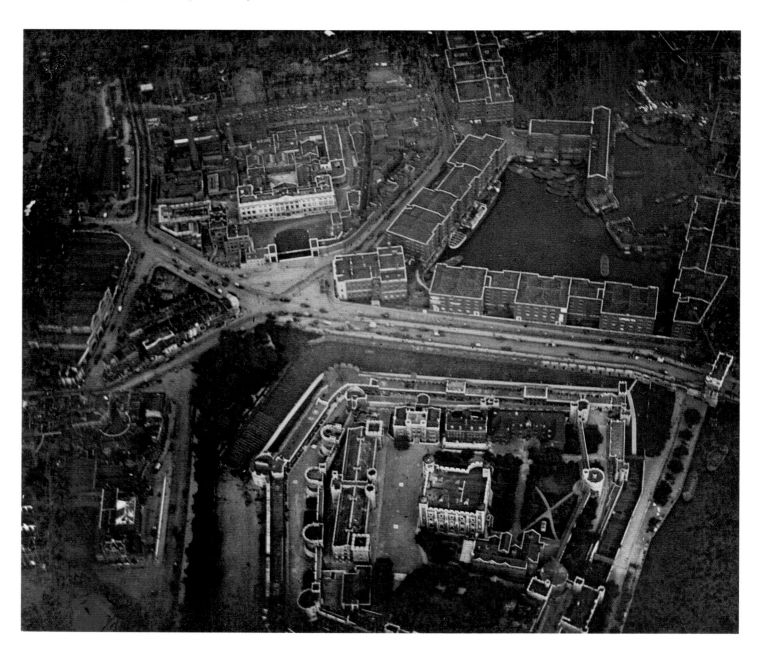

The Tower of London from the south-west, September 2006

The Tower has been progressively hemmed in since the construction of St Katharine's Dock in the 1820s and Tower Bridge in the 1880s and 1890s. The blighting of its setting was taken a stage further with the construction of the A101 dual carriageway in the early 1960s, a vital link in London's arterial road network, but one which transformed Tower Hill from a quiet destination into a canyon of roaring traffic. This might have been redeemed to some extent by the quality of the new buildings flanking it, but unfortunately wasn't. A stretch of the Roman city wall remains visible to the left of the picture, between the road and the 1960s buildings. [NMR 24467/007]

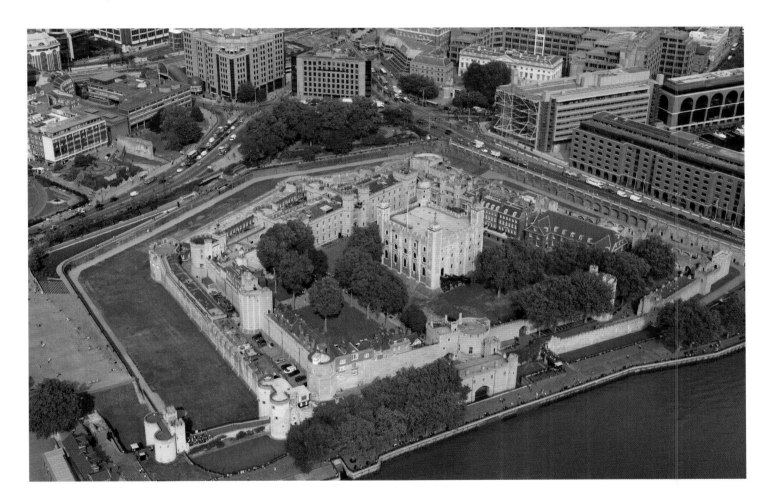

Tower Bridge, c 1900

A much-loved landmark, seen in a hand-coloured glass slide in the O E Simmonds Collection, now owned by the Royal Aeronautical Society. Tower Bridge was built by the Corporation of London's Bridge House Estate Trustees in 1885–94. The Pool of London was still intensively used by shipping and the new bridge had to provide a clear passage 200ft (61m) wide and of 135ft (41.2m) headroom for two hours at each high tide. Practically, the only way this could be provided was with a bascule bridge with lifting arms. The need to provide a route for pedestrian traffic while the bascules were raised generated the need for the high towers (which house passenger lifts) and the walkway between them. This produced an interesting hybrid design, the side-spans being suspended from curved trusses, which are tied through the walkway over the centre span. The Gothic style was stipulated by Parliament to harmonise with the Tower of London. The completed bridge was opened in 1894 by a flotilla led by the Prince of Wales in the royal yacht. [RAeS Library, Lantern slide 6911]

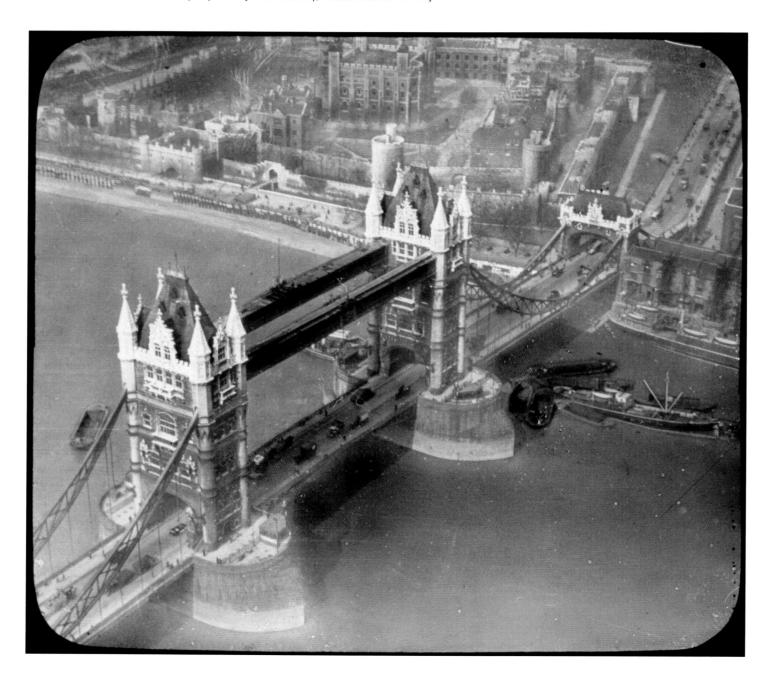

Tower Bridge, August 2002

The Bridge House Estate Trustees engaged Sir John Wolfe Barry as the engineer for the new bridge, but the main designer of its frame was his junior partner, Henry Marc Brunel, younger son of the famous Isambard Kingdom. Sir Horace Jones, chief architect to the Corporation, provided the elaborate late Gothic cladding. The bascules were powered by hydraulic machinery driven by tandem cross-compound steam engines, provided by Armstrong Mitchell & Company on the River Tyne. The bascules were converted to electric power in 1976, but some of the magnificent machinery survives under the south approach viaduct. [NMR 21766/11]

The London Hospital, c 1930s

The London Hospital on the Whitechapel Road – renamed the Royal London in 1990 in honour of the Queen's visit to commemorate its 250th anniversary – is one of London's great institutions. A group of doctors led by John Harrison, a 22-year-old surgeon, founded the London Infirmary to care for the poor of the City in 1740. Funds were raised from City men, the present site was leased in 1744 and the name was changed to the London Hospital in 1748. Work began on new buildings to designs by the surveyor Boulton Mainwaring in 1753; they were then standing among open fields. The growing population of the East End meant that the hospital could not stand still and repeated extensions in the 1770s, 1830s, 1860s, 1870s and 1890s have transformed the simple Georgian buildings beyond recognition. In the late 19th century the London Hospital was the largest in Britain with 790 beds; a medical college and nurses' home were opened in 1877.
[R H Windsor Collection, TQ 3481/1]

The Royal London Hospital, September 2006

A helicopter comes in to land on the Alexandra Wing (T P Bennett Partnership, 1978–82) of the Royal London Hospital. In 1896 Sydney Holland, later Lord Knutsford, became chairman of the hospital – he raised funds for it on a heroic scale and presided over a major expansion in partnership with the remarkable matron, Miss Eva Luckes, a country gentleman's daughter appointed to the role at the age of 26, who gave the rest of her life to the hospital. Major rebuilding was carried out by the architect Rowland Plumbe, who added the yellow-brick centrepiece over the middle of Mainwaring's original façade. The hospital survived serious bomb damage in the war and proposals for a total rebuilding in the 1960s. The first stages of a major redevelopment of the hospital can be seen in this view, which will preserve the 18th-century buildings towards the Whitechapel Road, but redevelop the rear of the site with a series of glass tower blocks (architects HOK International and contractors Skanska/Innisfree). [NMR 24451/008]

Poplar and Limehouse looking west towards the City, 1 May 1949

This is the heart of the East End. St Anne's Limehouse (Nicholas Hawksmoor, 1714–19) appears prominently left of centre and the line of Commercial Road is clearly visibly, snaking diagonally across the view from centre left to upper right. Workshops and warehouses back onto the Regent's Canal (1812–20), still a working waterway, which leads down to Limehouse Basin and the river. This view conveys the degree to which the East End had been devastated by the Blitz and the great swathes which had been cleared – and also the neat rows of terraced houses which had survived, punctuated by the prefabs laid out on some of the bombed sites, representing post-war hope and reconstruction. [RAF, TQ 3781/36]

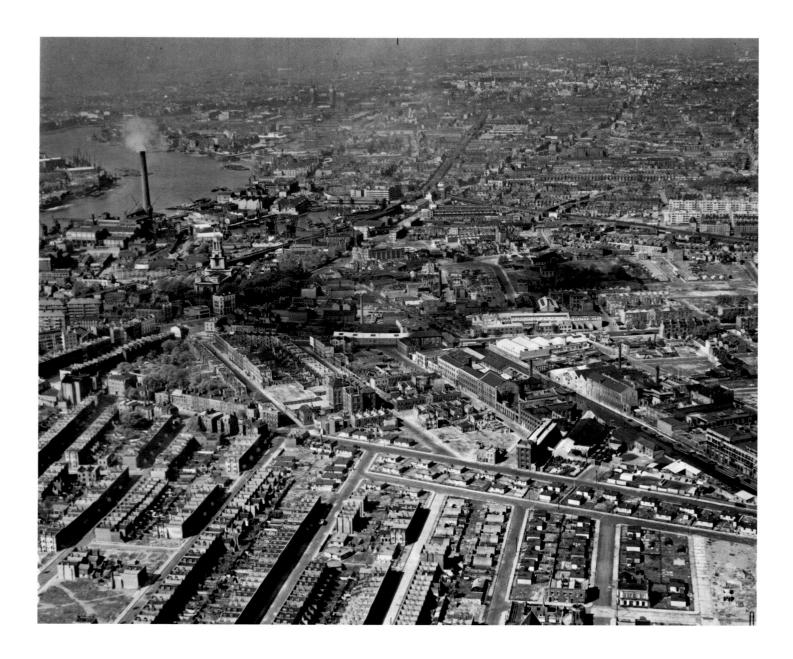

Poplar and Limehouse looking west, September 2006

In the early 20th century Poplar Borough had been one of the poorest in Britain and had also gained fame as a centre of municipal socialism and the Labour movement. After the catastrophic destruction of the war, the borough became the scene of a remarkable experiment in public housing with the Lansbury Estate, named for George Lansbury, pre-war Labour leader and MP for the area. This was planned by the London County Council and conceived as the live 'architecture exhibit' for the Festival of Britain in 1951. It was meant to demonstrate the principles of Forshaw & Abercrombie's *County of London Plan* of 1943: lower housing densities, more open space and communities planned away from traffic around school catchment areas. In those days, brick construction and relatively low heights (two to four storey) were the norm. The Lansbury Estate is roughly speaking in the lower right quarter of the picture, running up to the Commercial Road (A13), which bisects the view and then bears to the right. In the left foreground, in the green open space, is the former church of St Matthias, built as the company chapel of the East India Company in 1652–4. [NMR 24454/009]

Rotherhithe, the Surrey Docks and the Thames (north is approximately at the upper right-hand corner), 7 August 1944

Until the 18th century Rotherhithe, or Redriff as it was also known, was a linear village with a single street running for over a mile along the south bank of the Thames – Rotherhithe Street can clearly be read here, running just inside the bend in the river. The land enclosed by the bend was marshy and unusable, until the development of the Surrey Docks. At the south (lower) end are the Greenland and South Docks. The Canada Dock (on the left-hand side), the Albion Dock, Surrey Basin and the Stave Dock (towards the top, opening off the entrance lock), the Russia and Norway Docks (diagonally across the centre of the picture) and the Lavender and Acorn Ponds (to the right, though harder to see as they are full of floating timber) were all added in the 19th century. The group as a whole was dominated by trade with the Baltic and Canada, above all in softwood. The dockers had their own slang and distinctive protective hats for carrying timber. [RAF/106G/LA/29/4299]

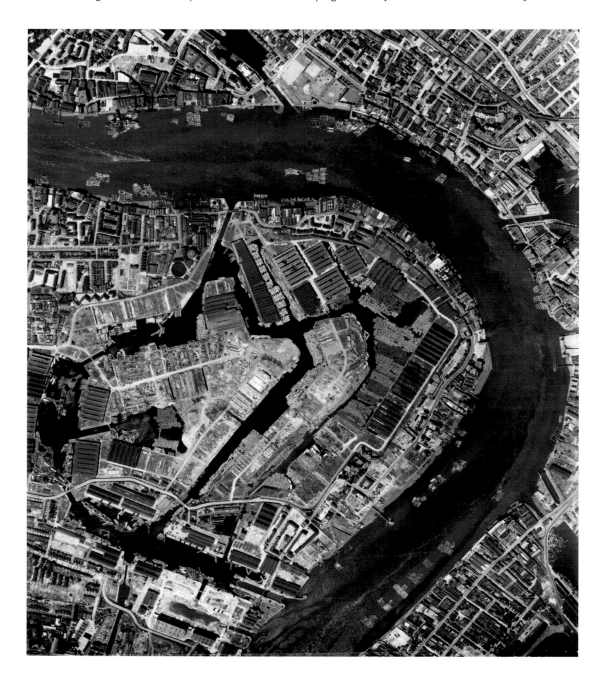

Surrey Quays from the west, September 2006

The Surrey Docks were closed in 1969–70 and a distinctive quarter of London and a whole way of life came to an end almost overnight. The 300-acre site was taken over by the GLC and Southwark Council, and most of the dock basins were filled in – only the Greenland Dock remained complete. In this view, an ornamental pond created out of the north end of the Canada Dock is in the foreground with the Surrey Quays Shopping Centre off to the right. The triangular pond to the left is the Surrey Basin, just inside the original north entrance lock. The wood running from left to right across the centre of the picture represents the site of the Russia Dock. Cul-de-sacs lined with houses occupy the site of the great basins. [NMR 24451/013]

Surrey Docks looking north-east, c 1930s

The more northerly basins of the Surrey Docks were developed gradually from 1804 under three different companies – they were principally concerned with the Baltic and northern trade, as the names Canada, Norway and Russia implied. As this view shows, there were hardly any warehouses at the Surrey Docks; the basins were instead surrounded by extensive one-storey sheds for bulk cargoes, principally timber. [R H Windsor Collection, TQ 3579/1]

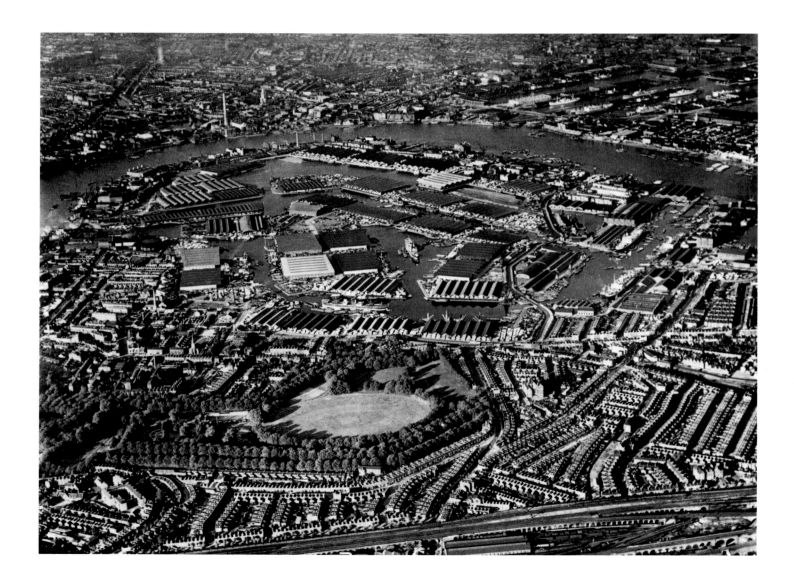

Greenland Dock and South Dock, September 2006

The first section of the Surrey Docks to be excavated was the Howland Wet Dock – a fitting-out basin on this site covering 10 acres – in 1697–9. This was redeveloped as the Greenland Dock in 1802 and used by the whaling trade. It was doubled in size in 1894–1904 by the engineer Sir John Wolfe Barry, designer of Tower Bridge. The South Dock, remodelled in 1851–5, opens off it to the right. These are the only parts of the Surrey Docks to have been left intact: we can ask whether more should have been left and a different approach taken? A fine swing bridge, which formerly carried Redriff Road over the passage between Greenland Dock and Canada Dock, is visible to the bottom left of the view (painted red and seen alongside the modern road). [NMR 24451/019]

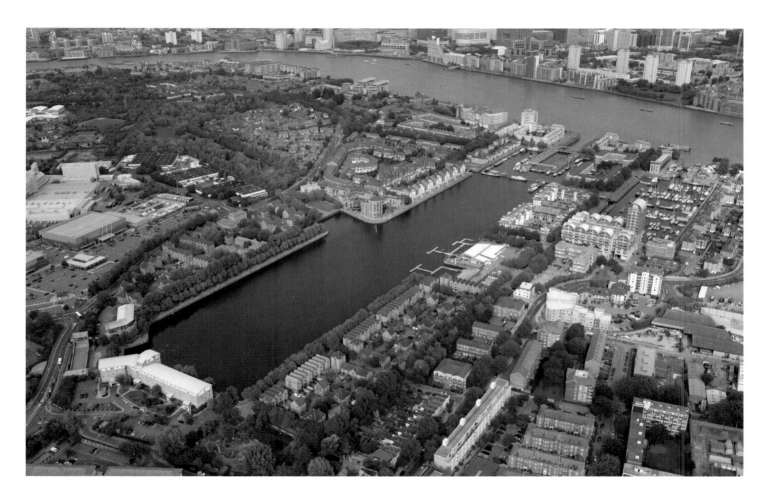

Greenwich Park (north is approximately at the top), 7 August 1944

In this view allotments fill the northern slopes of Greenwich Park and a barrage balloon is tethered in its upper left-hand corner. There had been an enclosed hunting preserve here since the late Middle Ages, with a royal palace – rebuilt by Henry VII and much loved by Henry VIII and Elizabeth I – down by the river. The impressive axial layout of avenues, laid out for Charles II to designs by the French designer André le Nôtre in the 1660s, reads very clearly from the air. Remains of extensive earthworks from earlier in the war, probably anti-glider defences, seam the surface of Blackheath at lower left. The industrial landscape of Deptford Creek, at upper left, is in marked contrast to the greenness of the park; the Deptford Power Station, identifiable by its coaling wharf, is on the site of Sebastian Ziani de Ferranti's generating station of 1887–9, the first large generating station in Britain built to transmit electricity at high voltages over long distances. Ferranti's ambitious vision was not a commercial success and his building was replaced with the one seen here from 1929. [RAF/106G/LA/29/3342]

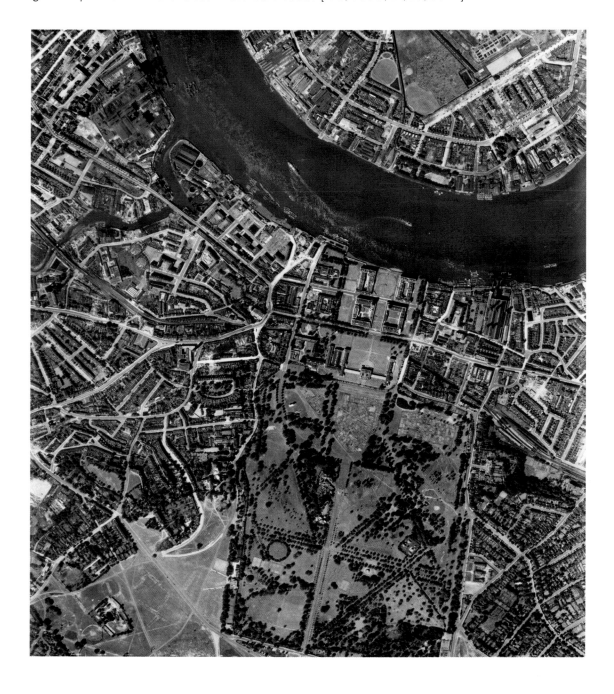

Greenwich Park, September 2006

This view looks north up the 'grand axis' at Greenwich with the towers of Canary Wharf in the distance. The park, much loved and intensively used, shows few changes. This picture was taken on a good day for cropmarks: the lattice-grid of the allotments, shown in the wartime vertical picture, appears quite clearly in the broad areas of grass below the paths crossing in an X. The somewhat more emphatic oblong cropmark to the right of the X and below the National Maritime Museum is a backfilled air-raid shelter from the Second World War. [NMR 24452/007]

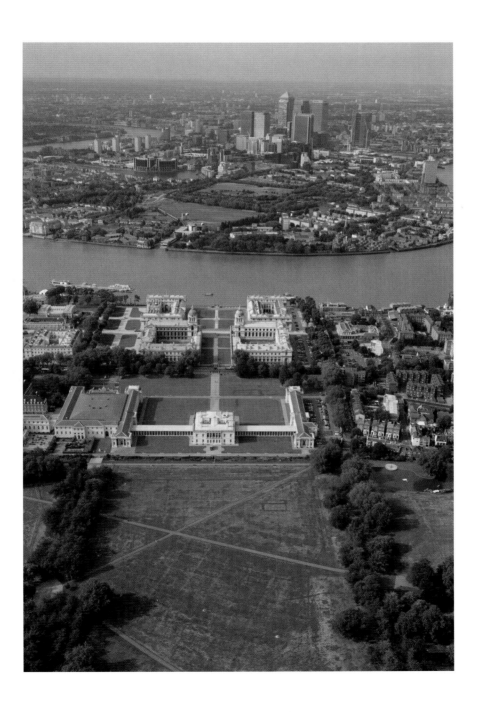

Greenwich Park looking north-east towards the Greenwich peninsula, c 1930s

The Royal Observatory's buildings cluster on the heights of Greenwich Park in this view. The observatory was established here by the first Astronomer Royal, John Flamsteed, on Sir Christopher Wren's recommendation. Charles II provided £500 and a supply of bricks, Wren designed it and Flamsteed went on to make over 30,000 observations from here, compiling his great atlas of the stars, the *Historia Coelestis*. The observatory's unique contributions to astronomy and navigation were recognised by an international convention in 1884, which fixed the internationally agreed lines of longitude with their prime meridian running through the observatory site (specifically, through Sir George Airy's Transit Circle). The irregular marks in the foreground, to either side of the path, are a Saxon barrow cemetery, still quite visible on the ground. [R H Windsor Collection, TQ 3877/1]

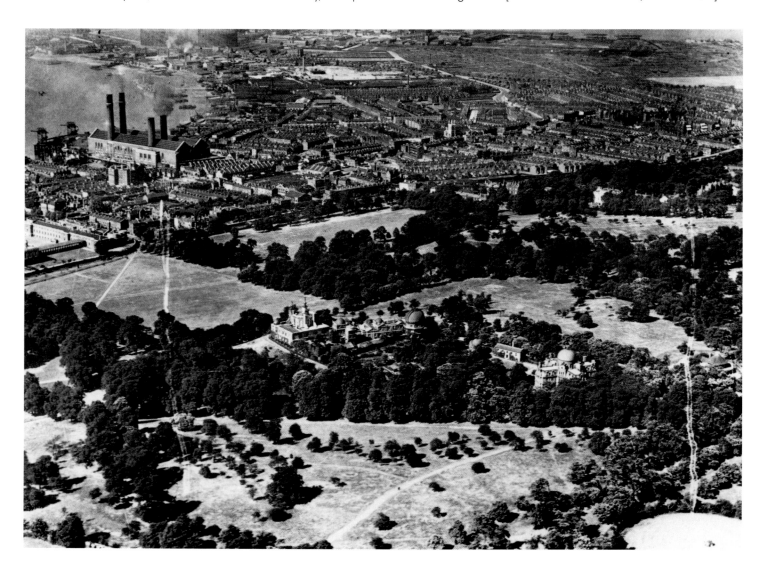

Greenwich Generating Station, September 2006

One of the landmarks of the Thames, the Greenwich Generating Station is an industrial counterpart to the magnificent Baroque buildings of the Royal Hospital. Greenwich's huge power station was built in 1902–10 by the London County Council Architects' Department to power the capital's tramways, now providing the reserve supply for London Underground. The distinguished architect Emmanuel Vincent Harris (architect of the Ministry of Defence Main Building, see p 73) cut his teeth on this building as a student. The chimneys were originally much taller: in the historic view you can see two full height and two shortened chimneys. [NMR 24452/013]

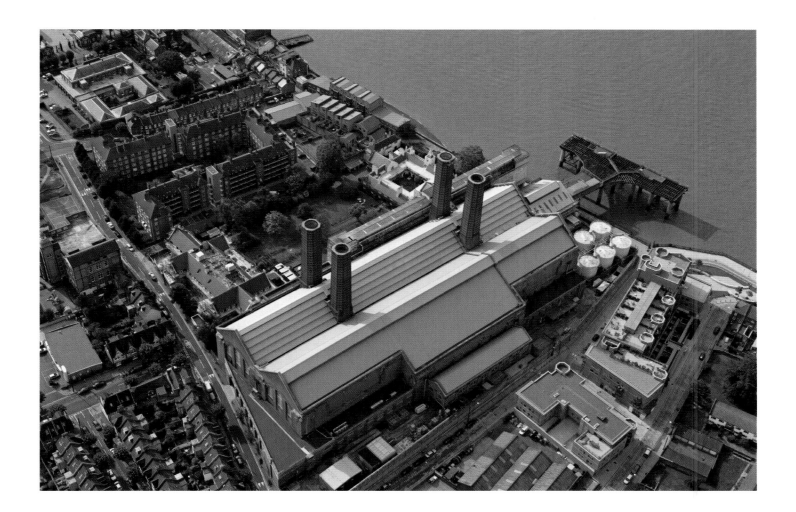

The Royal Naval College at Greenwich looking east, c 1930s

Charles II demolished the derelict Tudor palace at Greenwich and built the first wing of an intended new palace (representing half of the nearest quadrangle) in 1662–9. The scheme was abandoned and the site was given by William and Mary to their newly established Royal Hospital for Seamen in 1692. Sir Christopher Wren's buildings, developed out of the Charles II wing, are one of the glories of English architecture, framing the view from the river up to Inigo Jones' Queen's House (1616–37), seen to the right. In the 19th century the Queen's House was transferred to the Royal Naval College's new school (for orphaned sons of sailors), for which the wings and colonnades were added. When this picture was taken, the school had recently moved to Holbrook in Suffolk and its buildings transferred to the new National Maritime Museum. The 'footprint' of the school's dummy ship, used for sail-training, is clearly visible on the lawn in front. [R H Windsor Collection, TQ 3878/1]

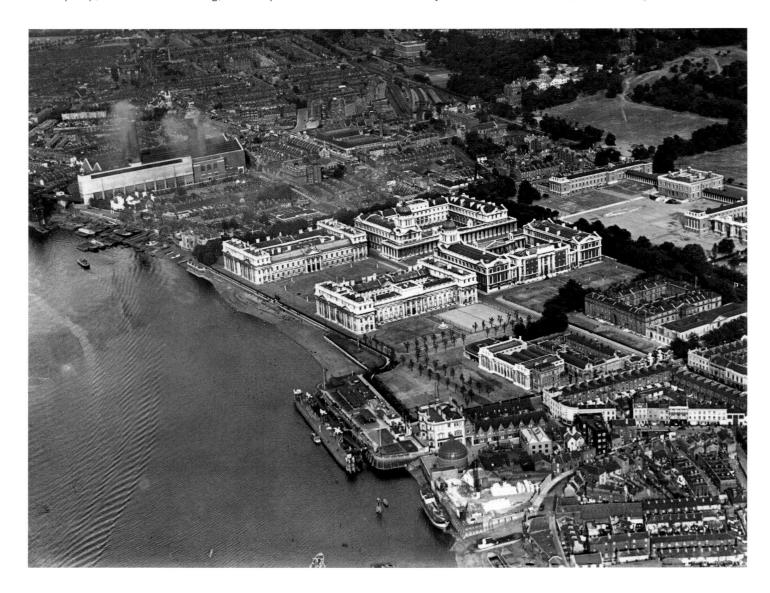

The former Royal Naval College, Greenwich, September 2006

There is something very appealing about the thought of these magnificent buildings – grander than any of the royal palaces, even Hampton Court – being built as a retirement home for injured sailors; at its height in the early 19th century there were over 2,710 of them. Unfortunately, the sailors, however invalid and retired, had a tendency to become rowdy, and in the 19th century the Royal Hospital got something of a bad name and the foundation began to support its beneficiaries in other ways, as 'out-pensioners'. In 1869 the Royal Hospital was closed and the Royal Naval College was moved here from Portsmouth. The Royal Naval College merged with the college at Devonport and moved out in 1999, and the Greenwich buildings were transferred to a charitable foundation. They have been superbly adapted to house the new Greenwich University and Trinity College of Music, and the whole campus is beautifully maintained and open to the public. [NMR 24452/022]

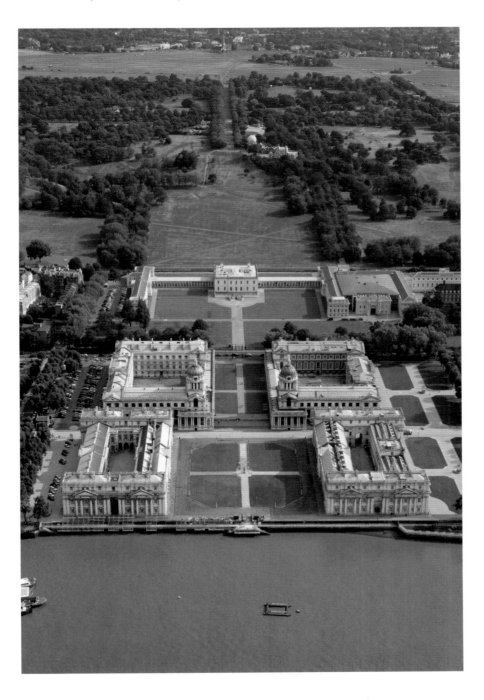

Isle of Dogs (north is to the top right-hand corner), 7 August 1944

The Isle of Dogs is in the heart of Docklands. The river frontage is lined with wharves, shipyards and workshops. Within these, the emphatic line of Westferry Road (to the left and top) and Manchester Road (to the bottom right), mirrors the line of the riverfront and rings the island. Towards the top of the picture are the three parallel bars of the West India Docks of 1797–1806, linked to the L-shaped Millwall Docks of 1863–9. Look closely and the effects of heavy bombing in 1940–1 are visible in the many missing houses and in the burnt-out West India Quay Warehouses (the right-hand half of the long row, just north of the uppermost dock basin, are roofless). Mudchute Park, the open space in the lower part of this photograph, has allotments and an anti-aircraft battery – the four spots within white circles are the guns, while the dark feature in the middle is the firing control bunker. Note also the regular cluster of sheds to house the battery's crew. [RAF/106G/LA/29/4341]

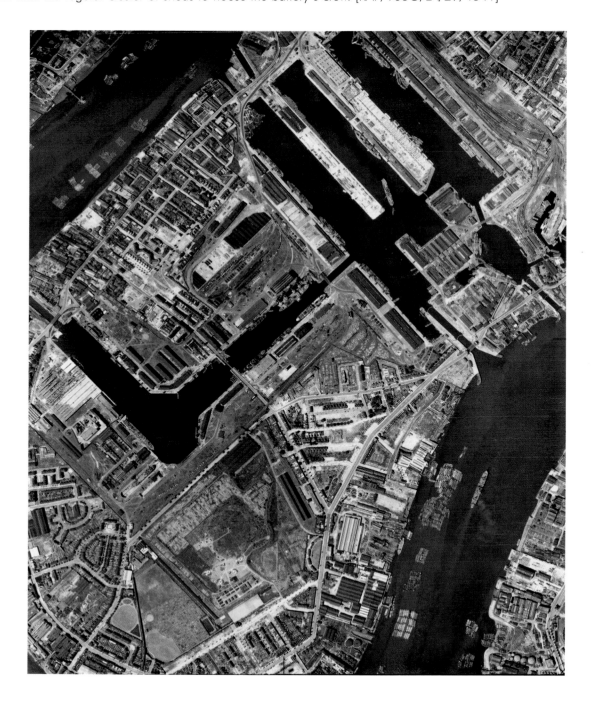

The Isle of Dogs with Canary Wharf from the south, September 2006

London's docks were visibly in decline in the 1970s and those on the Isle of Dogs finally closed in 1980. Transformation began with the establishment of the London Docklands Development Corporation the following year. The interior of the island, bounded by Westferry Road and Manchester Road, is filled by the houses of Millwall to the left and the open space of Mudchute Park to the right, a mixture of 19th-century fabric, post-war public housing and new development. The riverfront sites have almost all been redeveloped with smart flats and houses taking the place of industry. Few of the historic buildings have survived the transformation. A rare exception is Burrell's Wharf, the large brown building with black window frames at mid-left – this was the smithy and workshop of the yard where John Scott-Russell & Company built Brunel's *Great Eastern*, for 40 years the largest ship in the world. [NMR 24453/004]

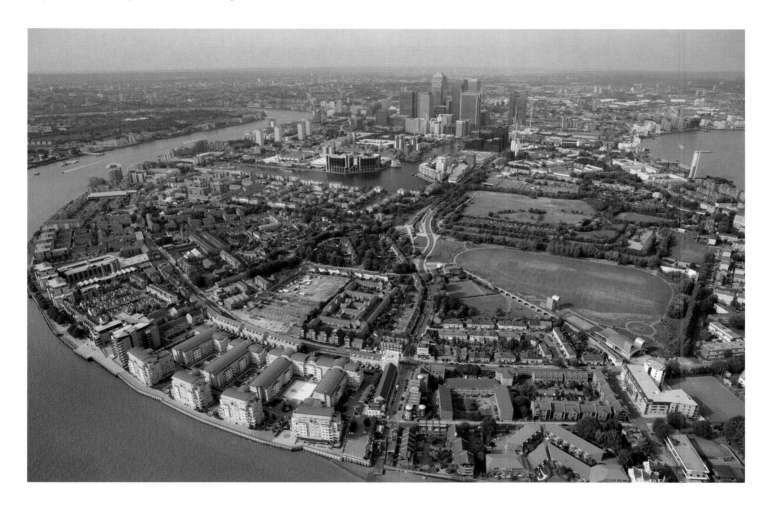

East end of the West India Docks looking north, 1 May 1949

Almost a whole quarter of Cubitt Town has been bombed, cleared and replaced with neat rows of prefabs; St Paul's Church, the dignified Public Library on Strattondale Street and a number of pubs have survived the general clearing. Note the movable bridges of various types and the generous allocation of space given to dock railways and sidings. There is also a neat little hydraulic accumulator tower, with its engine house and chimney, for powering cranes just below the second ship from the left in the near basin. Poplar is in the background and the East India Dock at the upper right-hand corner. [RAF, TQ 3879/7]

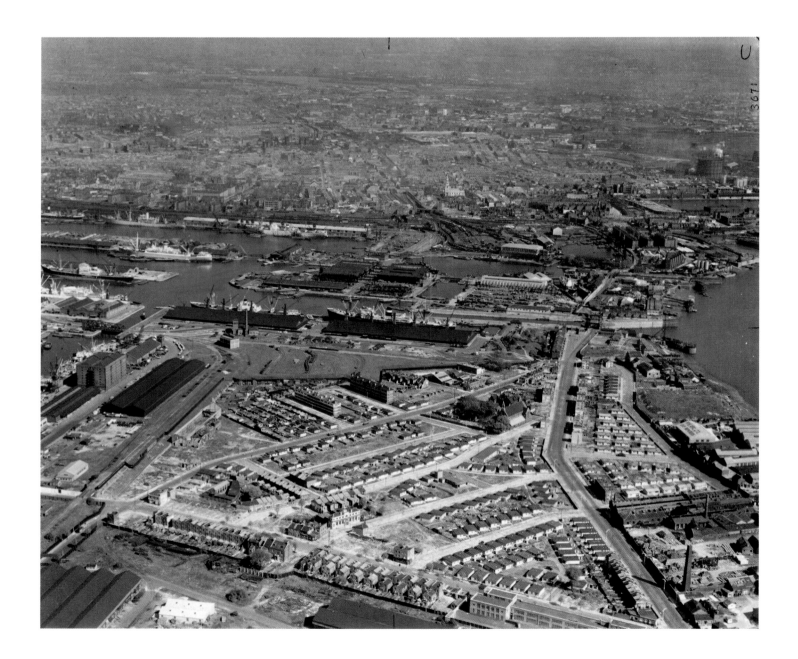

The eastern side of the Isle of Dogs looking north, September 2006

The government and the London Docklands Development Corporation set up an Enterprise Zone on the Isle of Dogs in 1982, with relaxed planning controls and incentives for development. The Docklands Light Railway, which opened in 1987 reusing the line of the dock railway, is seen running down the middle of the lower half of the picture. The scale of development really took off with the birth of the Canary Wharf scheme, the original initiative coming in 1985 from an American developer, G Ware Travelstead, with the backing of a number of banks. The site and the project were purchased by the Canadian firm of Olympia & York, highly successful developers in Toronto and New York, and the first phase went up in 1987–91 to a master plan by Skidmore, Owings & Merrill. The central tower (Cesar Pelli Associates), 800ft (243.8m) tall to its pyramid-shaped cap, is still Britain's tallest building at the time of writing. Unfortunately, as the first phase neared completion the economy dipped into recession and the development went into receivership in 1992–5. [NMR 24453/018]

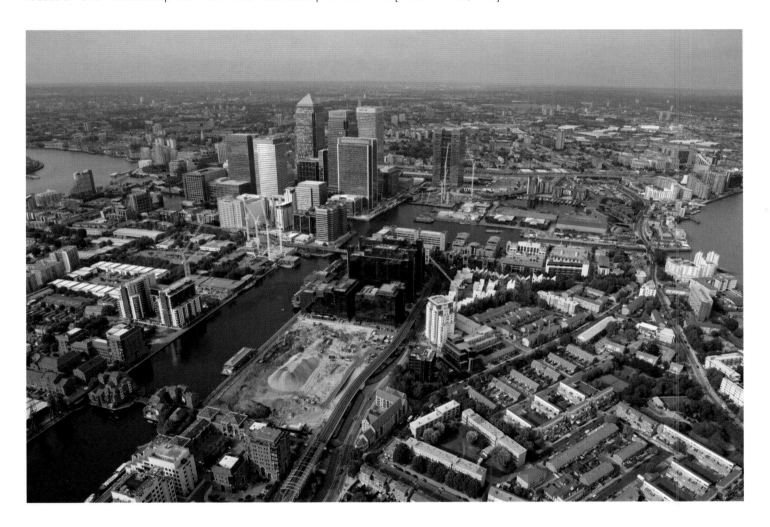

Isle of Dogs and West India Docks looking north, 1 May 1949

This view homes in on the western side of the West India Docks. To judge by the shadows it is mid-morning on a bright day, but the streets seem empty. The devastation wrought by the Luftwaffe reads more clearly in the whole rows of missing houses. The right-hand two-thirds of the West India Quay Warehouses (on the far side of the far basin), bombed in 1941 and seen in the vertical view from 1944 on p 224, have been cleared. [RAF, TQ 3779/64]

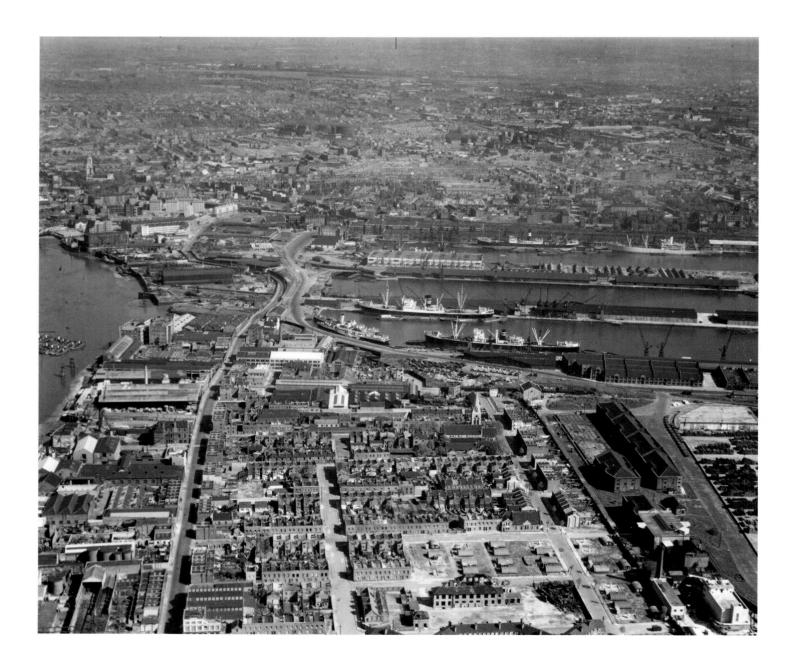

Canary Wharf looking east, August 2002

No part of London in living memory has been more radically or completely transformed than the West India Docks. The estate was bought in 1995 by a new consortium, Canary Wharf Limited; it has prospered ever since and development is now largely complete. The main tower has been joined by twin 700ft (213.4m) towers just to its east housing the European headquarters of Citigroup (Cesar Pelli Associates and Adamson Associates, 2000–2) and the world headquarters of HSBC (Foster Associates, 1999–2002). The adjacent site of Heron Quays has been developed, with its slightly lower blocks, and there is more to come. One of the beauties of the watery site was that it presented an opportunity to create a totally new layout and build to a completely different scale without clashing with the urban context. The dramatic group of towers sits comfortably here (arguably, a good deal more so than their equivalents in the old City, which tend to look randomly squeezed in by comparison). The place has matured as a financial and business centre to equal the City and the vehement initial opposition to it, which even at the time looked short-sighted, has now died away. If Canary Wharf did not exist it would now be essential, for London's well-being, to invent it. [NMR 21763/14]

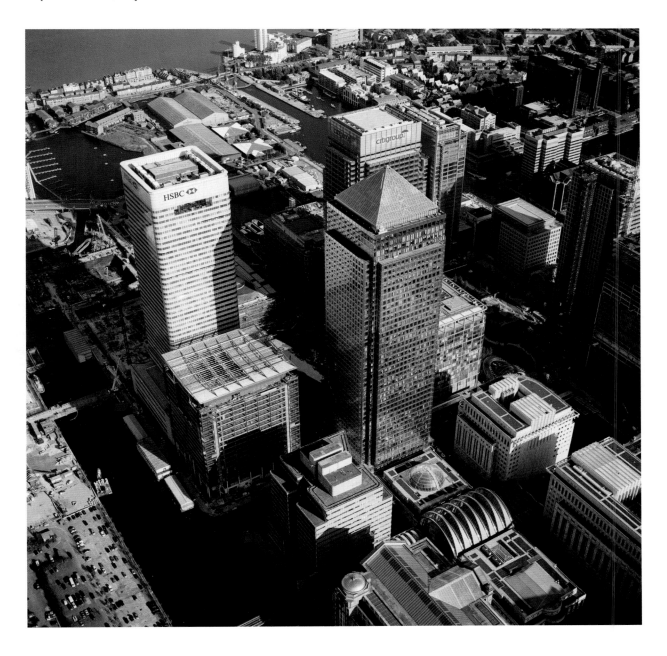

Looking north over Poplar, 1 May 1949

Poplar grew up after the East India Company established its shipyard (c 1614) at Blackwall just to the east. A hamlet developed along the high street, seen running from left to right in the middle of this view. Its focus was the company's chapel, later the parish church of St Matthias, seen in the little park left of centre. Built as a plain brick building, this was refaced by the architect W M Teulon in Kentish ragstone in 1870–6. The park looks neat and well-tended, but whole swathes and blocks of the 19th-century terraces have been bombed and cleared. Viewed closely, many more houses seem to be in ruins. Another sign of the change in times: two buses are heading west up Poplar High Street, but hardly a single private car is visible anywhere in the picture (a number of lorries and what might be a car can be seen in one of the works yards in the foreground).
[RAF, TQ 3780/173]

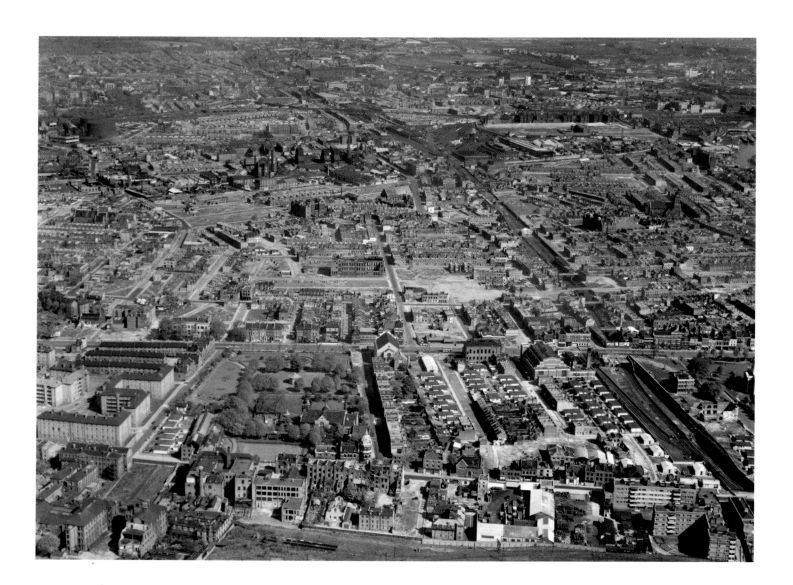

Poplar looking north, September 2006

Poplar High Street ought by rights to have turned into one of the East End's Victorian town centres; it was on its way to doing so when, in 1899, the metropolitan borough of Poplar was merged with Bromley and Bow, and the combined town hall moved to Bow Road. The post-war development of the Lansbury Estate (*see* p 213) represented a major attempt to rebuild the neighbourhood, but somehow Poplar did not recover to become the town that it might have been. However, several of the elements are there: two important historic churches (All Saints, 1820–3 by Charles Hollis, is to the right) and good public buildings such as the old Baths with the remarkable stepped roof carried on elliptical concrete arches right at the centre of the picture (1931–4 by Harley Heckford). It also has spacious green spaces and the Chrisp Street Market. The Docklands Light Railway runs north towards Stratford; All Saints Station is seen here between the church it is named for and Poplar Baths. [NMR 24454/003]

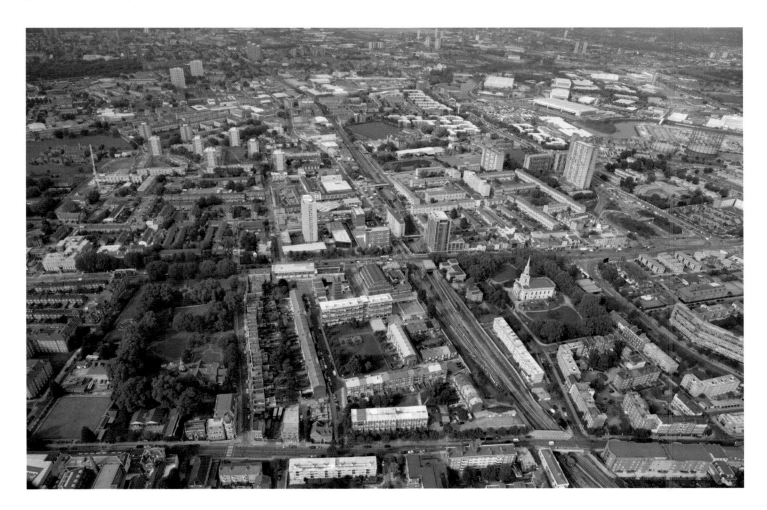

Lower Lea Valley and East India Dock looking east, 1 May 1949

Air-raid shelters survive on many otherwise cleared house sites in this view. Beyond is the river, with the East India Dock basins to the right. Beyond the dock, the sharp bend with the glassworks and the Thames Ironworks site is lost in the morning haze. The view must have been taken very early for the streets are eerily empty. The misty quality of this view is probably more to do with the deterioration of the original print than with the weather. This hazy appearance, together with the sharp shadows and the missing buildings, adds to the surreal atmosphere, as if of a ghost city. Indeed, almost every building in this picture is doomed and has since disappeared. [RAF, TQ 8781/13]

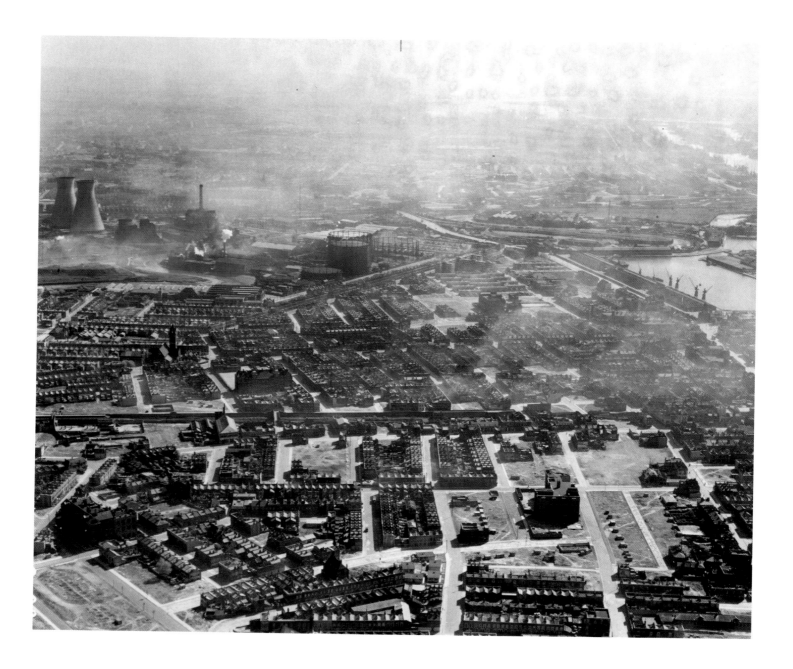

The Lower Lea Valley looking east, September 2006

The latter half of the 20th century has dealt drastically with the Lower Lea Valley, first by removing almost all of the 19th-century fabric seen in the previous picture and replacing it with mostly public housing, led by the spectacular Balfron Tower in the centre of this view (Erno Goldfinger, 1965–7 – this was the precursor of the better known Trellick Tower). Highway engineering has also dealt brutally with the area: the A13, seen heading into the distance here, is one of East London's vital arteries, but it places a heavy traffic burden on poor Poplar. The Blackwall Tunnel approach, running from left to right behind Balfron Tower, severs Poplar from Blackwall and the Lea. Of the East India Company's shipyard at Blackwall, on the right of this picture, very little remains visible: the site is now filled with grey modern blocks. There is something faintly paradoxical about the fact that, of all the structures seen in the previous picture, the only ones which are still there 60 years later are the gasholders – huge boxes of flammable gas. [NMR 24454/018]

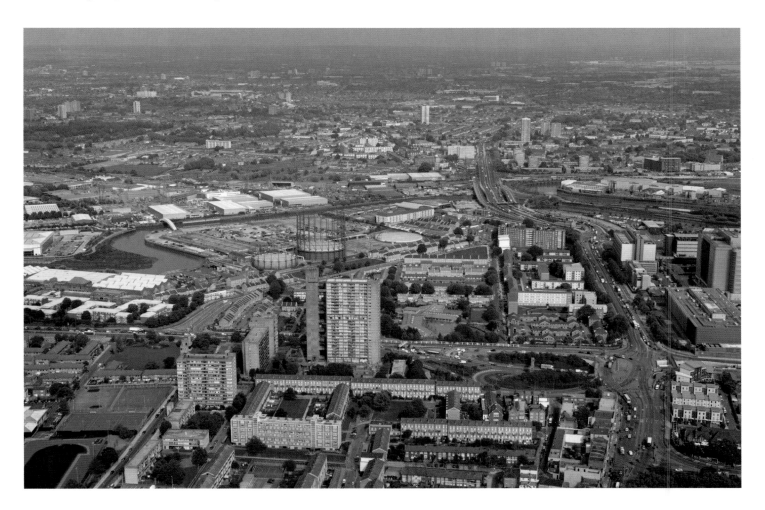

Power station in the Lower Lea Valley, 1 May 1949

Looking back over the same area from the east, the character of the Lower Lea Valley as London's industrial heartland becomes clearer. The Edwardian generating station on Border Street with its old-style timber cooling-towers is being replaced by a new concrete-framed structure. Over the river, the Poplar Gasworks (1876) looks appropriately grimy, its mounds of coal a reminder that, in the days before North Sea exploration, the production of 'town gas' involved heating coal in ovens to produce coal-gas, coke and any amount of unpleasant by-products. The left-hand of the two gasholders seems to have been hit by a bomb and blown up (which must have made quite a bang). Note the Nissen-hut style temporary houses appearing among the Victorian terraced houses in the foreground. [RAF, TQ 3981/5]

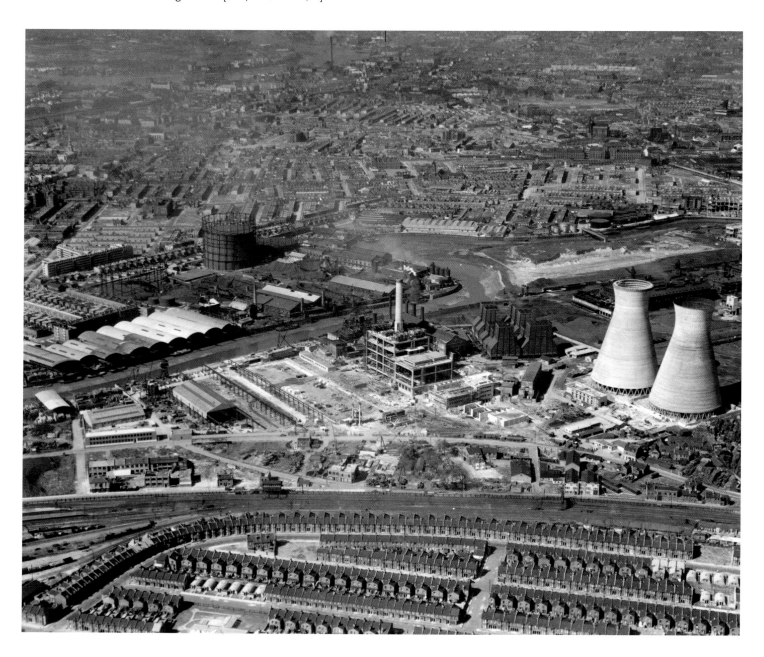

The mouth of the River Lea looking south, September 2006

The Lea meanders spectacularly just before it runs into the Thames at Blackwall Reach. Until the mid-20th century the river was lined with industry and a surprising amount survives today. The site of the East India Dock, the shipyards established by the East India Company (familiarly known as 'John Company') after 1614, is just off to the right: the dock basins have gone, as has the short-lived Blackwall Generating Station. [NMR 24454/019]

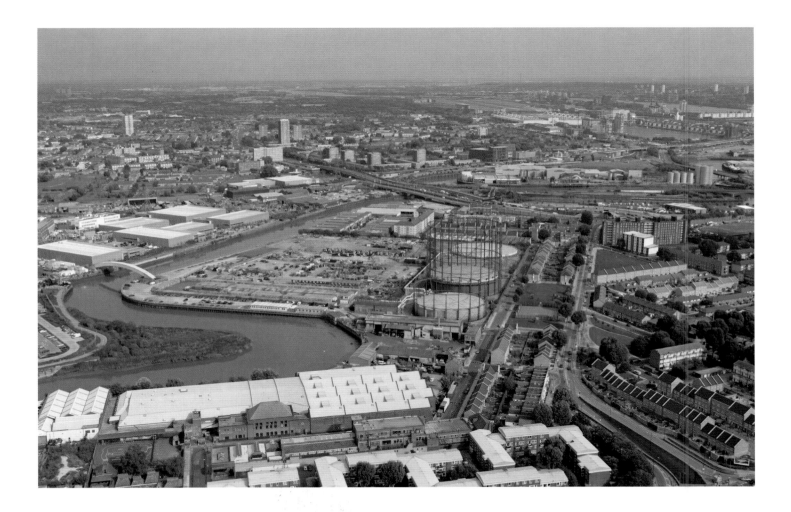

Woolwich Common with the Royal Artillery Barracks and Royal Dockyard (north is approximately at the top right-hand corner), 7 August 1944

Woolwich is one of the most martial places in the British Isles. The open space at lower left is Woolwich Common and the regular rectangular group of buildings in the approximate centre of the photograph are the famous Royal Artillery Barracks. The complex roofs of the Royal Military Academy (James Wyatt, 1805–8) are partly visible at the lower left-hand corner: note the shadow of its turreted central block. Two more complexes – the Red Barracks and the Cambridge Barracks – are adjacent to each other off Frances Street, immediately above the Royal Artillery Barracks. To judge by the multiple scars on the Common, the Royal Artillery would seem to have been practising digging trenches: note the elaborate ones fringing the area just south of the Barracks, which are also clearly visible as parchmarks on the right-hand side of the grassy area in the modern view. The distinctive pattern of an anti-aircraft battery (four spots surrounded by white circles) can be seen just above the lower left corner. At the top of the picture, on the riverside, are the buildings and dry docks of Woolwich's former Royal Dockyard.
[RAF/106G/LA/30/4014]

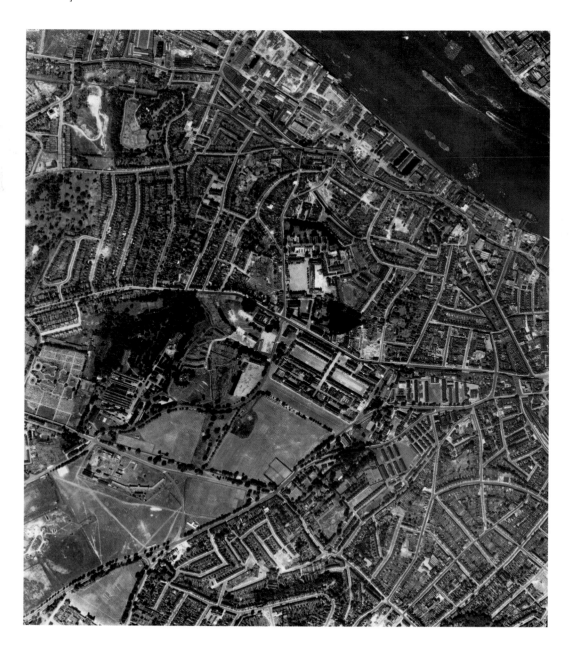

The Royal Artillery Barracks, Woolwich Common, September 2006

The Royal Regiment of Artillery was established in 1716 and based at the Arsenal, down by the river and just out of this view to the right. By 1772 their barracks there were overcrowded and James Wyatt, Surveyor-General to the Office of Works, was commissioned to design new buildings on Woolwich Common. The result was a great rectangular group with the tremendous 1,000ft (305m) façade seen here – the eastern (right-hand) half was built in 1775–82 and the western half wasn't finished until 1802. Most of the original buildings behind the façade were rebuilt in the 1960s and the site still has capacity to house 4,000 men. At the time of writing, the Royal Artillery is due to move out. Their place is to be taken by the Public Duties battalion of the Foot Guards, who are moving from Chelsea Barracks and the Cavalry Barracks. The Royal Artillery Barracks are to be the venue for the shooting events at the 2012 Olympics. [NMR 24457/029]

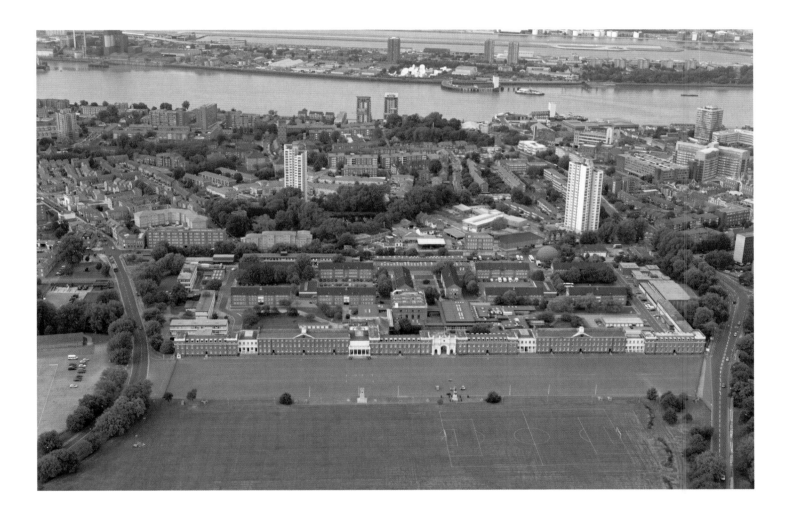

The Royal Docks: Albert Dock and Victoria Dock (north is approximately at the top right-hand corner), 7 August 1944

This view is over the Royal Docks with the Thames to the south. These vast expanses of water, among the largest excavated docks that have ever been created, began with the Royal Victoria Dock to the left, which was 1¼ miles long and covered 94 acres. It was built in 1850–5 at the initiative of the engineer George Parker Bidder and the railway contractors Samuel Morton Peto, Edward Ladd Betts and Thomas Brassey, and bought in 1864 by the London & St Katharine's Dock Company. To the north are allotments and an anti-aircraft battery towards the upper right corner. The Thames-side is lined with industry: after the Metropolis Building Act of 1844 banned 'noxious trades' from the city, industry settled here on a large scale, including S W Silver & Company's rubber and telegraph cable works (after which Silvertown was named) and Alexander Keiller & Sons' jam factory at Tay Wharf. Abram Lyle's sugar refinery at Plaistow Wharf made golden syrup, while Henry Tate & Sons made white sugar cubes, patented by them in 1878; the two companies subsequently merged, but both plants remain in operation. The serried terraces of Silvertown housed one of the poorest communities in Victorian and early 20th-century London. [RAF/106G/LA/29/3336]

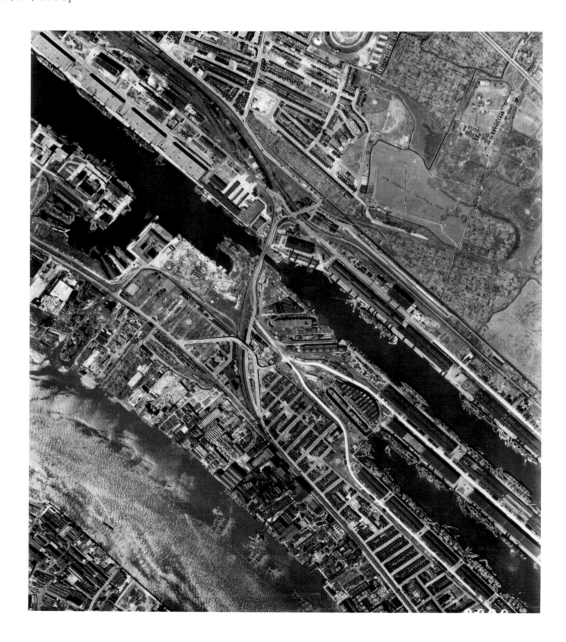

The Thames Barrier and Silvertown, September 2006

The Thames Barrier is arguably the most important building in London. The low-lying areas of the city have been prone to flooding from the earliest recorded times. The Victorians began to embank the river systematically, but this could not prevent the serious floods of 1928 and 1953. Other factors make the threat of flooding quite real: ocean levels are rising due to the melting of polar ice; Britain is tilting, the south-east sinking at a rate of about a foot a century; and London's geology is predominantly soft. Indeed, mean tide levels in the Thames estuary have been rising since the last ice age and appear to be rising at around 2ft (61cm) per century. A flood defence across the river was first advocated in the 1850s. An Act of Parliament was passed in 1972 and work began in 1975 to designs by the engineers Rendel, Palmer & Tritton. The barrier is a huge machine spanning 1,673ft (510m) across the river with a row of movable gates, including four main ones for the navigation channels, 200ft (61m) wide, the same width as the opening of Tower Bridge. [NMR 24455/021]

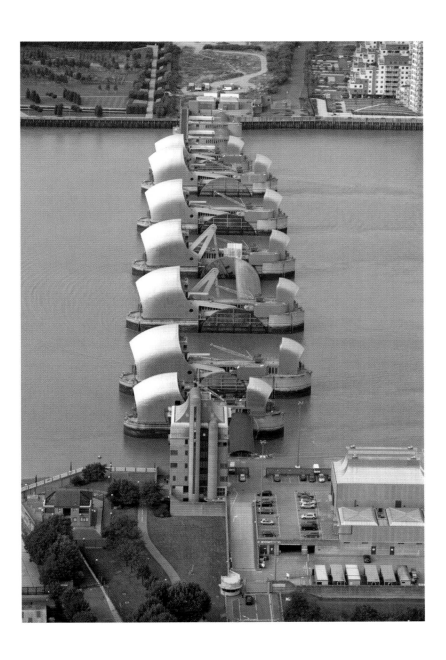

Millennium Mills, Royal Victoria Dock, c 1930s

In its original form the Royal Victoria Dock was wider, with a series of finger quays on its north side, seen in the foreground here; these disappeared when the whole north side was rebuilt c 1937 (as seen in the previous views). As a late addition to the Royal Victoria Dock scheme, the engineer George Parker Bidder proposed the Pontoon Dock opening off it to the south, seen here in the approximate centre of the view. It was fitted with huge hydraulically operated pontoons for lifting ships out of the water and into eight finger docks for repair. From 1896 the area was adapted for the bulk grain trade and in the 1930s the immense reinforced-concrete Millennium Mills, seen here, were built by Messrs Spiller. The chimneys of the riverside factories loom beyond. [R H Windsor Collection, TQ 4080/13]

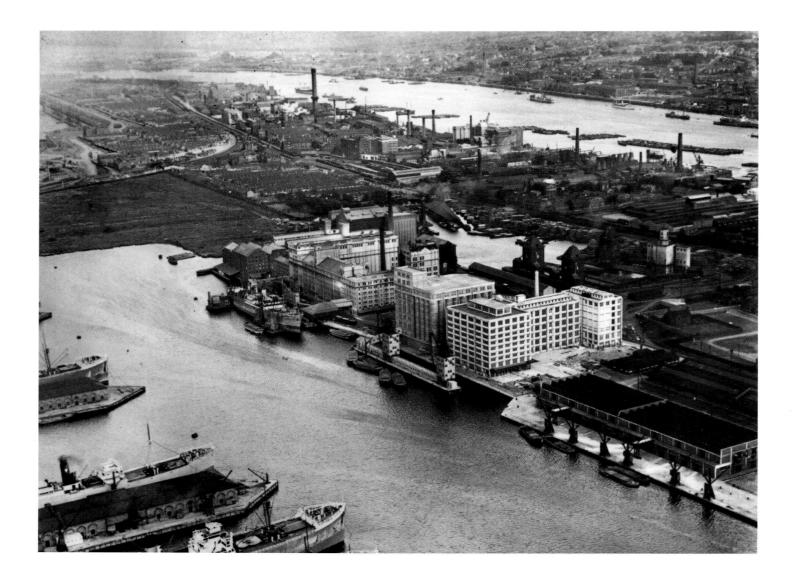

The Royal Docks, with the Royal Victoria Dock in the foreground, looking east, September 2006

The vast basins of the Royal Docks are one of the great visual thrills of East London and a development opportunity that few cities of London's size and age can match. The scale of the Royal Docks is such that, over 25 years after the establishment of the London Docklands Development Corporation, there are still large empty sites. So far, little of the new architecture quite lives up to the setting, but the regeneration impresses by its sheer scale. For instance there is the immense white ExCel exhibition centre (Moxley Architects, 1999–2000) – the cantilevered supports which form its skyline carry the roof, freeing it from the need for columns and enabling this to be the widest clear span roof in Britain at 285ft (87m). The long, dazzlingly white Barrier Point Wharf development (Goddart Manton for Barratt Homes, 2000) can be seen on the right-hand side of the photograph. Behind it and facing onto the Thames is the green space of the Thames Barrier Park, designed by the French landscape architect Alain Provost (1998–2000), while in front of it is the empty area of Crescent Wharf, the site of the Brunner Mond chemical works where the terrible Silvertown Explosion of 1917 happened. Brunner Mond had opened the factory in 1894 for the innocent purpose of making soda crystals. During the First World War, the Ministry of Munitions pressurised them against their will to manufacture TNT there, in the midst of a heavily built-up area. On 19 January 1917 a fire broke out and 50 tons of TNT exploded, devastating a vast area and killing 73 people. [NMR 24455/005]

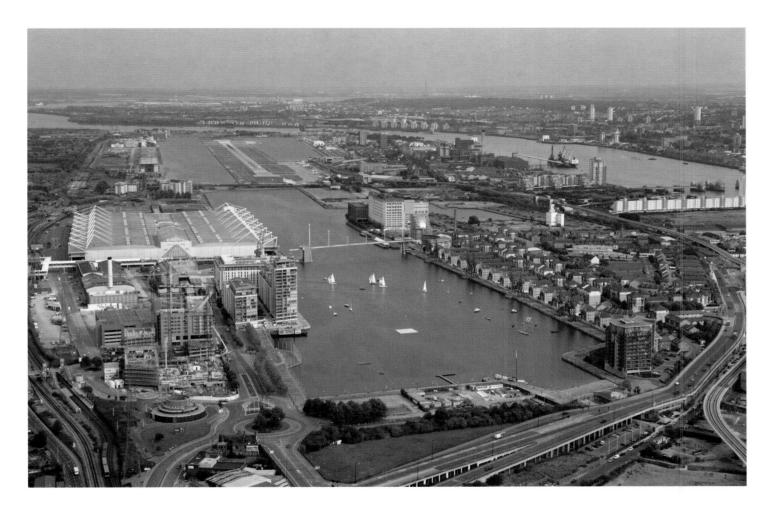

Royal Albert and George V Docks looking east, c 1930s

The Royal Albert Dock, seen on the left, is over a mile long and covers 85 acres with its locks. It was built by the London & St Katharine's Dock Company in 1875–80 to link the existing Royal Victoria Dock (behind the viewer) to the Thames at Gallions Reach, seen in the distance. This rather grainy view of the 1930s doesn't allow one to see much detail, but the large size of the ships is apparent. The immensely long range of single-storey transit sheds on the left-hand (north) side can be made out, evidence of a move away from large-scale warehousing towards swifter transport of goods by rail. In the 20th century the Royal Albert Dock became a major centre of the frozen meat trade and large cold stores were added. [R H Windsor Collection, TQ 4280/1]

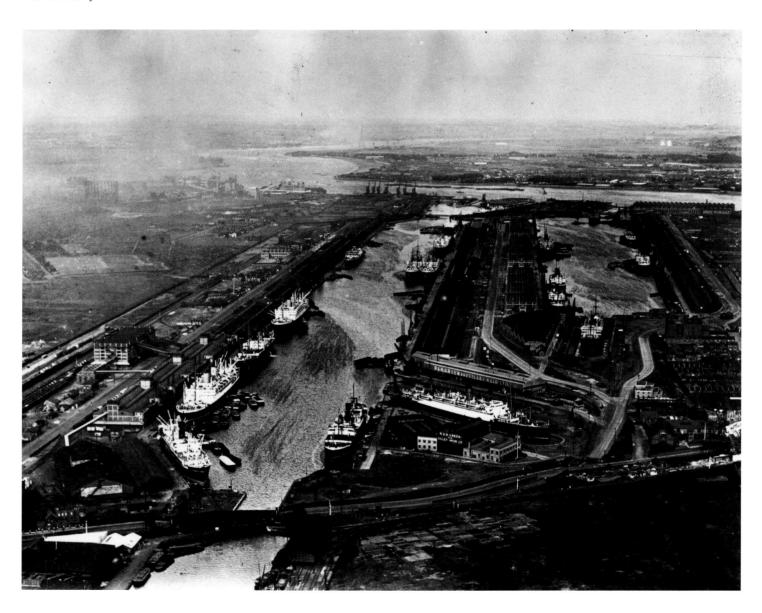

The University of East London, Royal Albert Dock, August 2006

These colourful buildings make up the new University of East London on the north side of the Royal Albert Dock. The university was founded in 1992 by the merger of three colleges and has campuses here and in Stratford. The wonderful site was exploited to the full by the excellent buildings of the university's first phase (Edward Cullinan Architects, project architect John Romer, 1998–9). The drum towers of the halls of residence, with their butterfly-wing roofs, made the new university into an immediate landmark and local icon; it is a pity that the same architects were not chosen for the subsequent phase. The university opened its new Business School here in 2006. [NMR 24399/045]

The Royal Docks from the east, c 1930s

In 1908 London's numerous dock companies were abolished and merged into the Port of London Authority by an Act of Parliament. The new Authority added the George V Dock in 1912–21, seen here to the left opening off the Royal Albert Dock in the background. It was given the exceptionally large entrance lock and gates seen here – big enough to accommodate the 35,000-ton liner, the SS *Mauretania* – in the 1930s. This completed the Royal Docks, which were by then the largest area of impounded (as opposed to dammed) water in the world. Immediately to the south of the entrance lock was the London works of Harland & Wolff, famous Belfast engineers and shipbuilders, whose north-light roofs appear prominently in the foreground of this view. [R H Windsor Collection, TQ 4380/1]

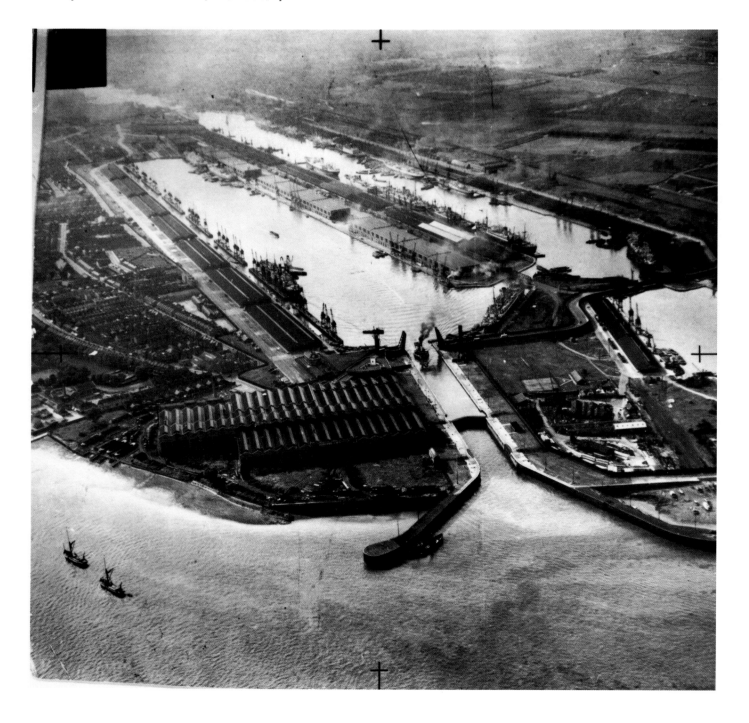

The Royal Docks with the City Airport from the east, September 2006

With the closure of the Royal Docks, the idea of having a regional airport close to the heart of London rapidly took hold. The City Airport (c 1982–7) – built and operated by the contractors John Mowlem & Company – was created on the immensely long quay between the Royal Albert and George V Docks for short-haul flights to the continent. The spectacular scale of the docks, and the wide-open spaces still available for development, are manifest. [NMR 24456/024]

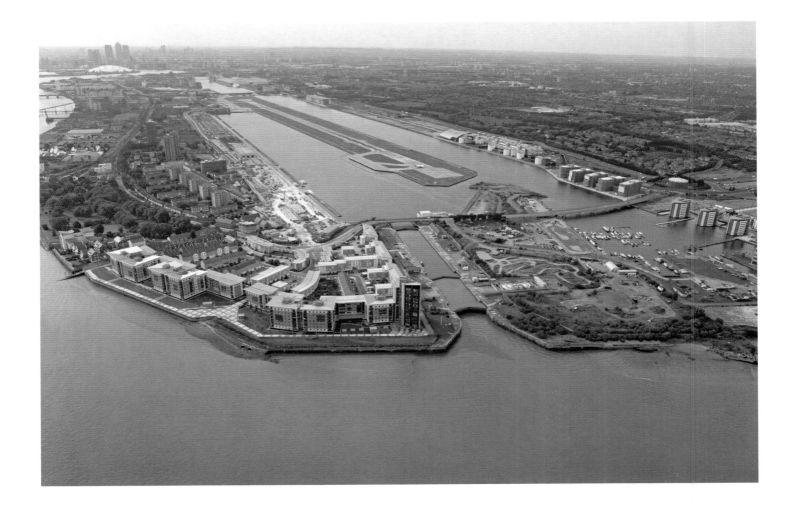

Royal Arsenal, Woolwich, with the Thames and entrance to the Royal Docks (north is at the top of the image), 7 August 1944

This view spans the river to include both North Woolwich at the top and Woolwich proper below. The Woolwich Ferry is to be seen, generating a lot of wash, docking at the jetty on the north side. In this view, the Woolwich (south, or lower) side of the river is dominated by the Royal Arsenal, with its huge areas of factory roofs. In the Victorian age this was Britain's largest armaments factory and during the First World War its workforce peaked at over 70,000. During the Second World War, arms production was dispersed to many other sites around the country, though the Arsenal remained important. Rather oddly, a single circular roof (covering gun-shrinking pits) seems to have been singled out for camouflage treatment. Immediately above and below it are the buildings of the Armstrong Gun Factory. Immediately to its left is the square block of the Rifled Shell Foundry. North of this, and aligned on the big jetty, are the symmetrical blocks of the Grand Storehouse. At its height, the Arsenal estate stretched for two miles down the river, enclosing over 1,200 acres of factories, storehouses and firing ranges (see p 248). [RAF/106G/LA/30/4012]

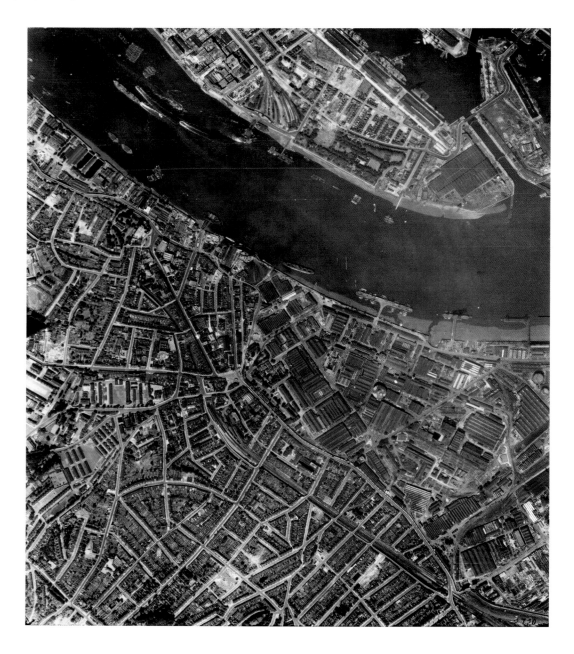

The Royal Arsenal, Woolwich, September 2006

Arms production at Woolwich ceased in the 1960s and much of the estate was sold to the Greater London Council, which developed Thamesmead on it. The historic heart of the site, the area seen here, ceased to be the property of the Ministry of Defence in 1994, by which time many of the buildings had gone. Ten years on, the Arsenal's regeneration is still in progress. For 200 years, this was the pre-eminent source of the British Empire's firepower. Bronze cannon for the Georgian army and navy's guns were made in the Brass Gun Foundry (the scaffolded building at the top of the tree-lined avenue), iron cannon in the Dial Square building (the largely open site to the left of it). Gunpowder and shot were made in the Royal Laboratory (the two isolated buildings in the area of derelict land to the right of the avenue) and later in New Laboratory Square (the irregular square of buildings below this). The Victorian army's paper rifle cartridges were made in the irregular group of buildings left of the avenue. Gun carriages were made in the Carriage Department, the huge gable-roofed building to centre left. There was, of course, very much more of it. The site's past is effectively commemorated by 'Firepower', the Royal Artillery Regiment's museum, recently established in the Paper Cartridge Factory and New Laboratory Square. [NMR 24469/034]

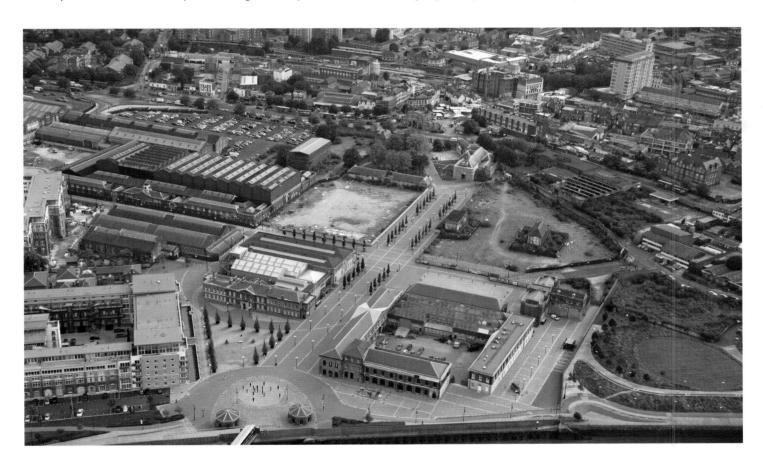

Beckton with the east end of the Royal Victoria and George V Docks (north is approximately at the top right-hand corner), 7 August 1944

In this view the vast expanse of the Beckton Gasworks – established by the East London Gas Light and Coke Company, which bought 540 acres here in 1868 – is seen to the top right. The works and their attendant settlement were named after Simon Adams Beck, governor of the company; it became the largest gasworks in the world, serving 4.5 million customers at their peak. The original coaling jetty is the middle one at upper right – coal from the north, landed here, was taken by railway to the six symmetrically arranged rectangular retort houses immediately above, where it was heated to produce gas and coke. Other by-products such as tar and dyes were also manufactured on the huge site. The area to the south of the river visible here is entirely filled by the complex, secret landscape of the Royal Arsenal's hinterland – the mouth of the Arsenal Canal and the extensive network of roads and narrow-gauge railways can be made out. The numerous white dots surrounded by banks at the foot of the image are probably magazines. [RAF/106G/LA/30/4009]

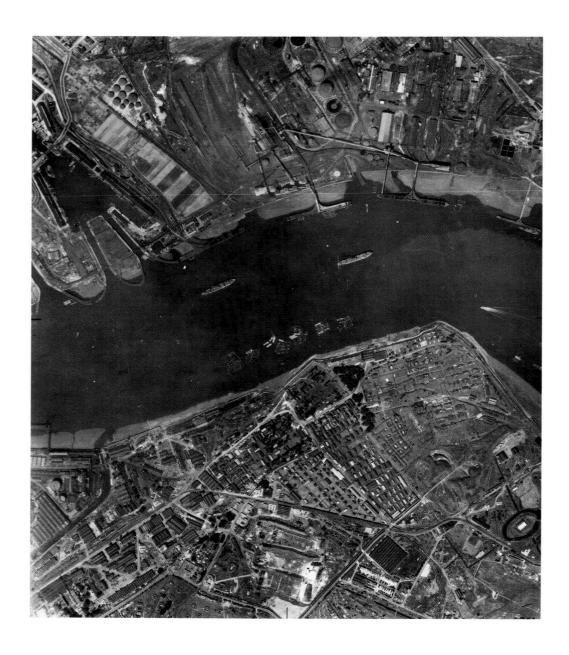

Gallions Reach and Beckton, August 2006

The Beckton Gasworks site today. The manufacture of coal-gas ceased in 1969 and until quite recently large tracts of the site were derelict – many East Londoners will remember the dramatic landscape of ruined buildings and coke ovens rising amongst heaps of rubble and forests of buddleia and weeds, all quite freely accessible. Today, regeneration is going forward. The gasholders, visible at top centre of the historic view, are still there and in use. The gasworks had 42 miles of private railway; today part of the site is occupied by one of the main depots for the Docklands Light Railway, seen here in the foreground. The columns for the coaling jetty of the original gasworks of 1868–70 are the ones in the middle; the original retort houses opened off a railway which was aligned with this. Today half the site is empty and half is now covered with the consumer paradise of the Gallions Reach Shopping Centre. Beyond is the Beckton Sewage Works, where Joseph Bazalgette's main Northern Outfall Sewer (1859–64) discharges into the Thames. Until the works were begun in 1889, millions of gallons of raw sewage were pumped into the river here, to be swept out to sea on the ebb tide (still a vast improvement on the previous situation). Today – save for when storm water overloads the system – it is at least treated. In the distance is Barking Creek, where the Roding flows into the Thames. [NMR 24399/037]

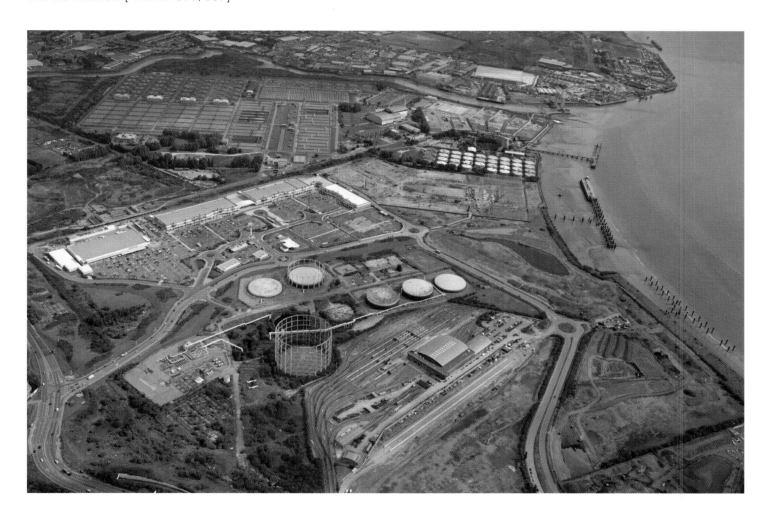

Barking Power Station, c 1930s

Barking Power Station, one of the largest in Europe, stood on the east side of the mouth of Barking Creek. Its first phase, Barking 'A', opened in 1925 – this is the brick-clad building to the right. The long turbine hall with its pitched roof is backed by the two boiler houses with their ranks of five chimneys each. A later and more utilitarian extension – Barking 'B' to the left – opened in 1933; it observed the same overall scheme, with the turbine hall in front backed by a single boiler house with four massive chimneys. Coal is piled up in neat lines on the quayside, ready to be fed by conveyor into the giant complex. The huge station closed in 1981 and was replaced with a new combined-cycle power station to the east in Dagenham in the 1990s. [R H Windsor Collection, TQ 4681/1]

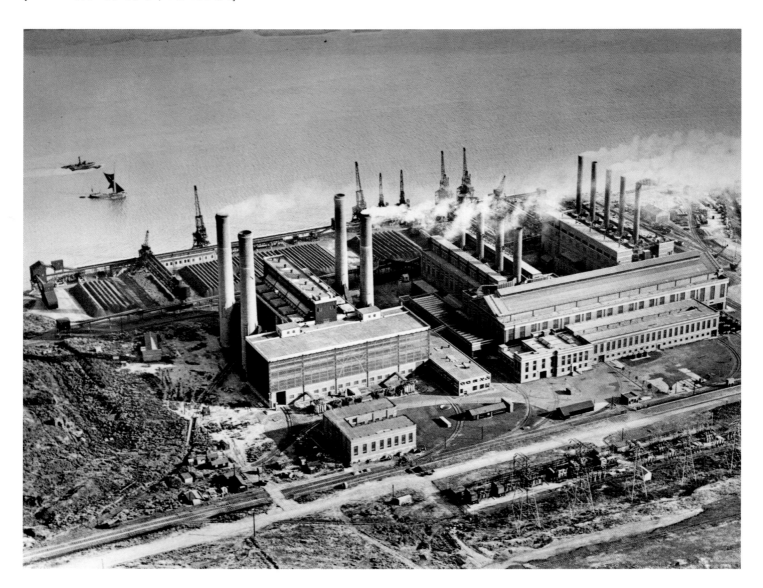

Barking Creek and the Flood Defence Barrier, August 2006

This view is of Barking Creek, where the River Roding enters the Thames. The Flood Defence Barrier is part of the same grand initiative as the Thames Barrier but designed on a different principle: the huge gate, about 125ft (38m) wide, drops like a portcullis from above, within an immense gate-frame 192ft (58.5m) high (Binnie & Partners, 1979–83). The edge of the Beckton Sewage Works is in the foreground and the power station site lies beyond. [NMR 24399/002]

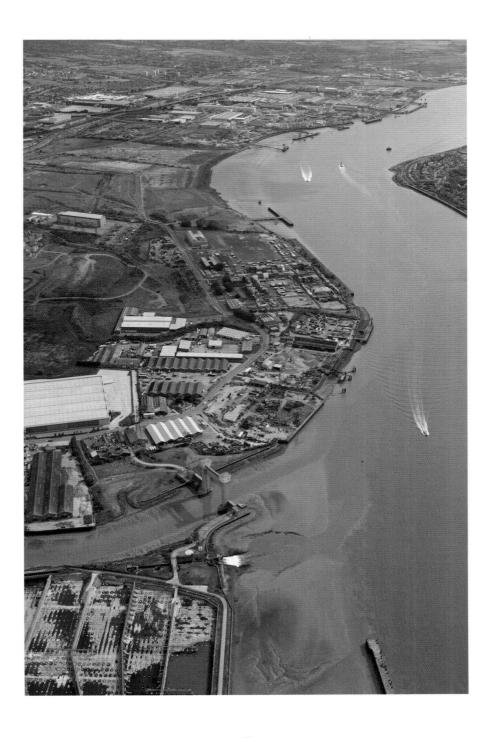

Ford Motor Factory, Dagenham, 7 August 1944

In the late 1920s the Ford company decided to relocate their main British manufacturing base from Trafford Park in Manchester; Dagenham eventually won out over Southampton and the gigantic factory was laid out to designs by Charles Heathcote & Sons of Manchester in 1929–31. To support the huge main assembly building (over 1,000ft (305m) square), 22,000 concrete piles were sunk into the marshy ground. It was a fully integrated plant, planned along the same lines as the company's original works at Dearborn, Michigan, USA. Coal and iron ore were landed at the great jetty on the longest privately owned waterfront in London. Coal was fed into the power station towards the top in this picture and into a coking plant, identifiable by its gasholder (look for the circular shape). Coke and iron were fed into the iron foundry – the largest in the south of England – on the upper (eastern) flank of the building and finished vehicles emerged from the other end. In the 1930s it was reputed to be the largest works in Europe and in the 1950s over 40,000 people worked here, making it the private, north-of-the-river equivalent to the Arsenal at Woolwich. [RAF/106G/LA/30/3132]

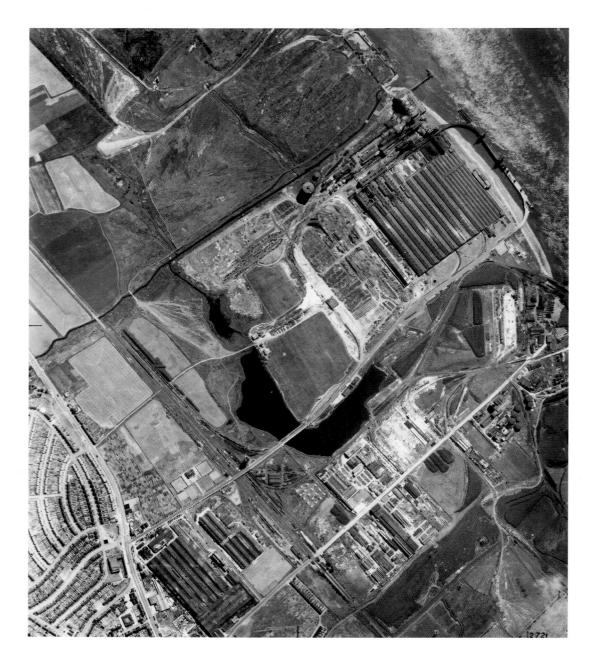

Ford Motor Factory, Dagenham, August 2006

Car production ceased at Dagenham in 2002: today the heart of the manufacturing site is the new Diesel Engine Assembly Plant (Austin-Smith & Lord), the gleaming white roofs in the foreground. The water features are known as Dagenham Breach, the remaining part of an enormous area first flooded by the little River Beam in the 14th century. There were repeated attempts to drain the area, until in 1716–20 the harbour engineer Captain John Perry succeeded in embanking the Beam and draining much of the site. A substantial lake remained, though it was further reduced by the spread of industry – this has been retained as a fine landscape feature. In the foreground is the elevated A13. To the right is the new Barking Power Station (Balfour Beatty Projects, 1992–5), the replacement for the one shown on p 250 and an eco-friendly installation running on combined-cycle gas turbines. [NMR 24400/004]

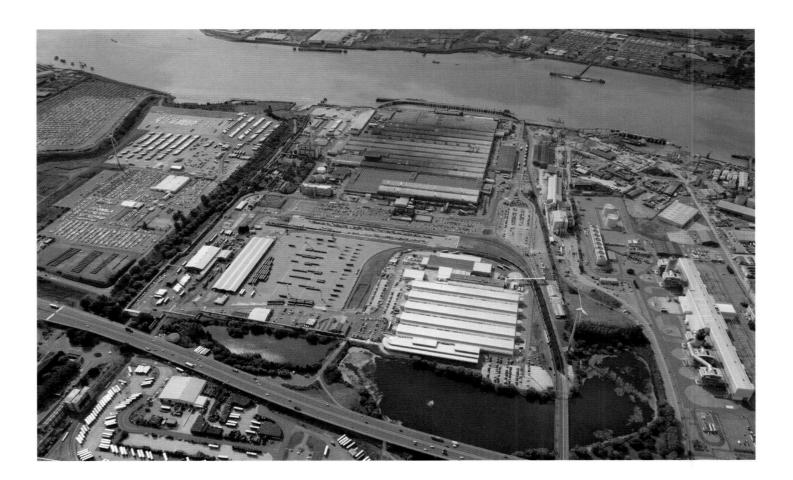

RAF Hornchurch, 25 April 1941

In this view RAF Hornchurch is still bearing the visible scars of the 14 bombing raids made by the Luftwaffe in the previous year – the first raid alone left 85 bomb craters. The Royal Flying Corps opened an airfield here at Sutton's Farm in 1915; it was upgraded in 1928 and renamed RAF Hornchurch in 1929. In 1940 Hornchurch was one of 11 Group's Sector Stations, in the front line during the Dunkirk evacuation and the Battle of Britain; by August, 10 fighter squadrons were based here and by the end of September they had claimed over 411 enemy aircraft destroyed, with another 235 'probable victories'. As the view makes clear, Hornchurch was still an airfield in the true sense, without hard runways. The perimeter road can clearly be made out and the main group of hangars and support buildings on the left. The straight lines visible on the airfield are probably the remains of attempts to camouflage it with mock field boundaries. [RAF, TQ 5384/1]

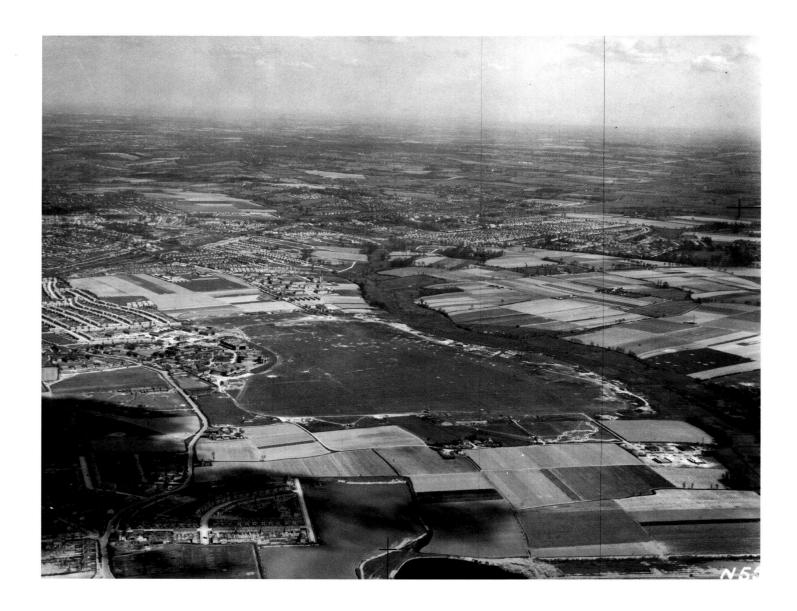

Hornchurch Country Park, August 2006

It is quite difficult to orient oneself in relation to the historic picture: the one reliable common feature is the River Ingrebourne running down the right hand side of both. The airfield closed in 1962 and the site was sold, with the western edge of the site going for housing. The Officers' Mess and a number of residential buildings from the airfield survive, with new housing built around them – this is, in general terms, the area of housing to upper left of the open green area. The main part of the site was sold for gravel extraction and most of the structures demolished. Subsequently the borough of Havering acquired the site, created Hornchurch Country Park in 1980 and carried out a great deal of landscape restoration and tree planting. The open wooded area in the centre of this picture represents the middle of the airfield. The history of RAF Hornchurch continues to attract great interest and pride from local residents and it is a pity that, other than the Officers' Mess and the other buildings on Astra Close, only a few features from the airfield remain visible. [NMR 24401/004]

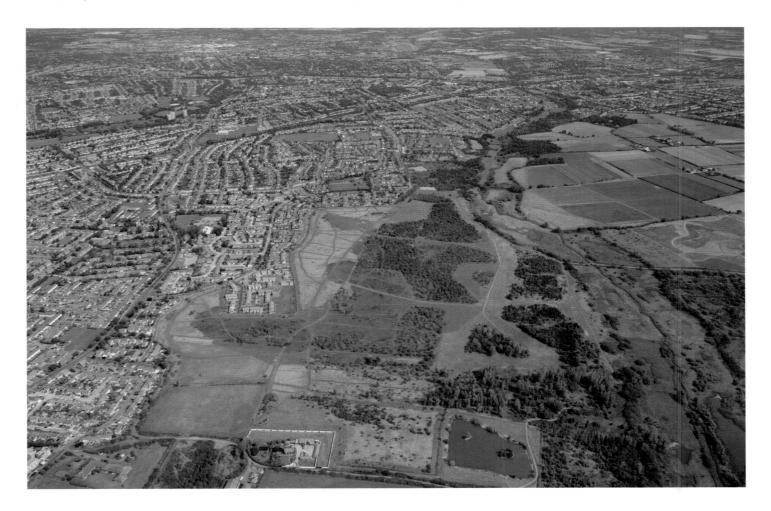

Erith, 6 May 1949

This was a Saxon settlement in origin and Henry VIII established a naval dockyard here where ships built at Woolwich were fitted out. There was a brief period in the 1840s when Erith developed a pier and pleasure gardens, and was turned into a pleasant resort, something like a south-of-the-river equivalent of Southend. However, when the North Kent Railway arrived in 1849, the town developed into another industrial centre, served by the prominent coaling jetty seen here. Unfortunately there are no traces of the town's ancient past to be seen in this photograph. [RAF, TQ 5178/3]

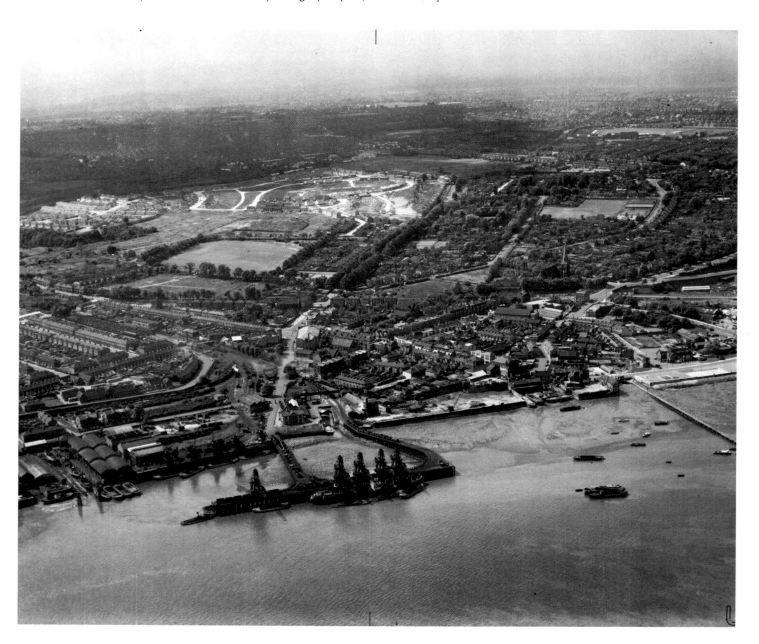

Erith town centre, August 2006

The remains of the old jetty can be seen in the two columns in front of the new jetty, but little else survives in this view of Erith town centre. In an extreme version of the fate that has overcome so many English towns, the old high street has been entirely redeveloped with a shopping centre, whose twin blocks now line it to either side. They, and the supermarket that appears above the jetty, have taken over more or less the whole of the functions of the town centre. They have probably saved the town economically, but at what a price! [NMR 24404/029]

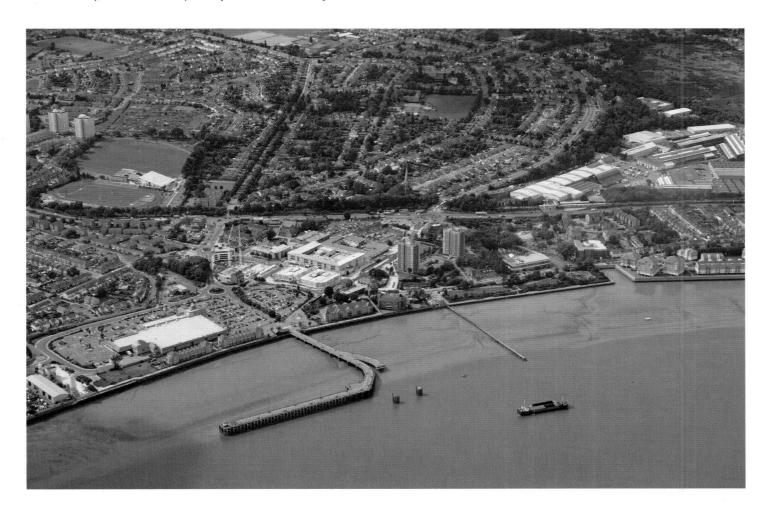

Prefabs, Erith, 6 May 1949

Erith is seen here from the landward side. The town had been the target for heavy bombing during the war because of its industries – post-war reconstruction is represented here by the neat and attractive rows of prefabs along Betsham Road and Reddy Road. The industrial waterfront shades off into the distance, towards Plumstead Marshes, with the chimney of the Crossness Sewage Pumping Station in the far distance. The fine spire of All Saints, Victoria Road, left of centre, signals the way up to the leafier suburb of Belvedere. [RAF, TQ 5177/14]

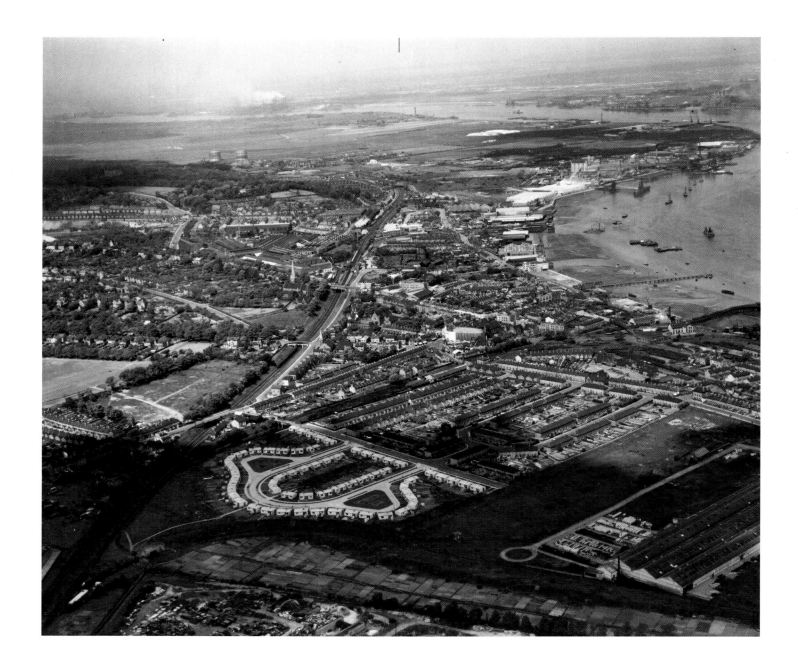

Erith and Slade Green from the south-east, August 2006

A large part of what is now called the Thames Gateway – an area that takes in some of the poorest areas in the south-east of England – is spread out in this view. Here Erith and the neighbouring village of Slade Green (in the foreground) meet the marshy fields of the Cray Valley at the edge of the metropolis. The group of buildings surrounded by fields at lower left is Howbury Grange – the square feature is a medieval moated site, a platform surrounded by stone walls rising from a still-flooded moat, though the house that it once sheltered has long gone. Nearby is a fine 17th-century brick barn. The grey marks in the large field at lower right are the remains of a well-preserved anti-aircraft battery from the Second World War. Every part of London has a history and has something to be proud of. [NMR 24402/009]

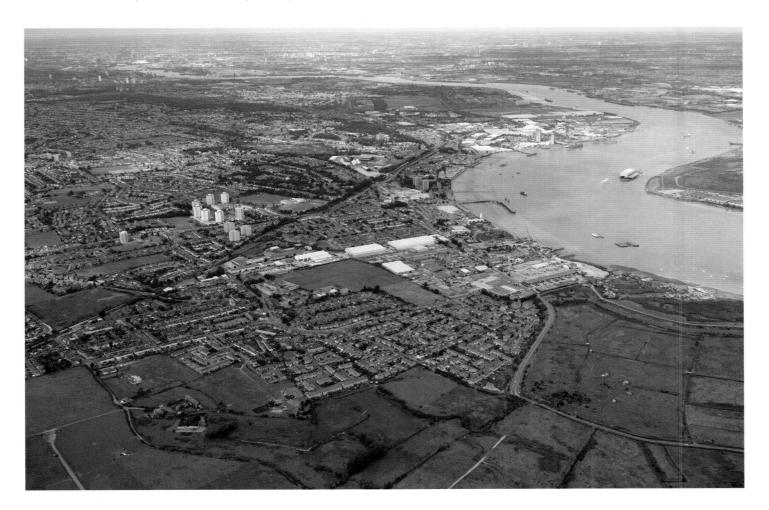

Flooding on the Thames marshes, 5 February 1953

London, like many other great maritime cities, has long had an ambiguous relationship with the sea – at once the reason for its existence, the original cause of its prosperity and the most relentless threat that faces it. The earliest record of floods in the city is from 1099 and great floods have struck it in every century since. In 1953 a great tidal surge inundated huge areas of the Thames estuary, drowning 300 people. This photograph shows fields between Crossness and Erith, with the river in the distance, at the height of the flood. It was this disaster that initiated the campaign which ultimately led to the construction of the Thames Barrier. [RAF, TQ 4979/6]

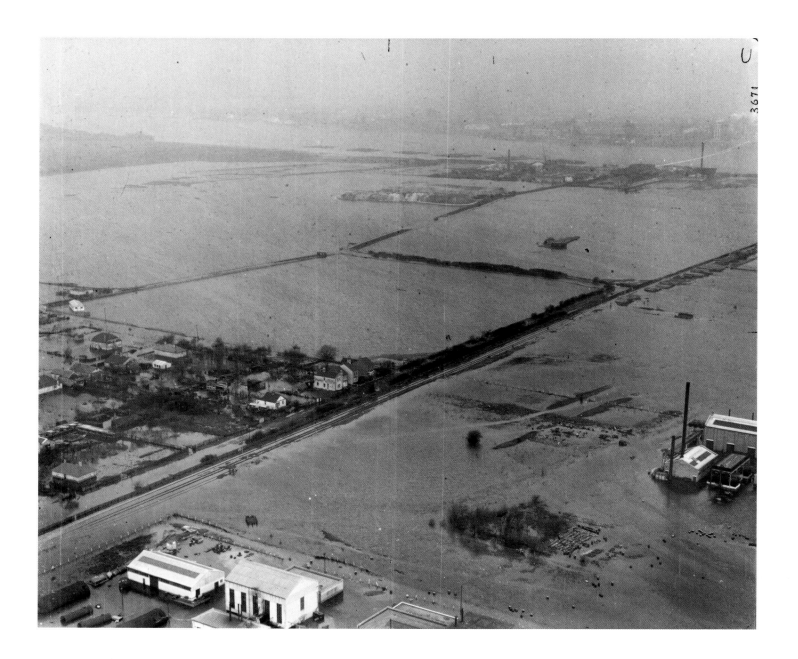

Thames foreshore at Crayford Ness, Erith, August 2006

Erith is not obviously one of London's great historic sites, but the Thames foreshore just to the east is one of the most remarkable archaeological sites in southern England. In the Neolithic era sea level was much lower and dense primeval forests of oak and yew grew along the banks of the tidal Thames. As sea level rose, the trees' roots became waterlogged and they died, to be covered by dense thickets of alder, which thrives in wet conditions. The sea level rose higher, the alder died off and by Roman times the area was probably covered by salt marshes. Sea level continued to rise and a broad tract of the salt marsh disappeared beneath the water at high tide. Today a slice of this ancient landscape is revealed by very low tides: stumps and trunks of trees up to 4,000 years old dot the grey mudflats for several hundred metres, as seen here. The Thames has become an 'erosional' rather than a 'depositional' environment and the ancient forest is being steadily eroded by the tide. The sea level continues to rise: London's future can only be guaranteed by engineering and by continual vigilance. [NMR 24402/023]

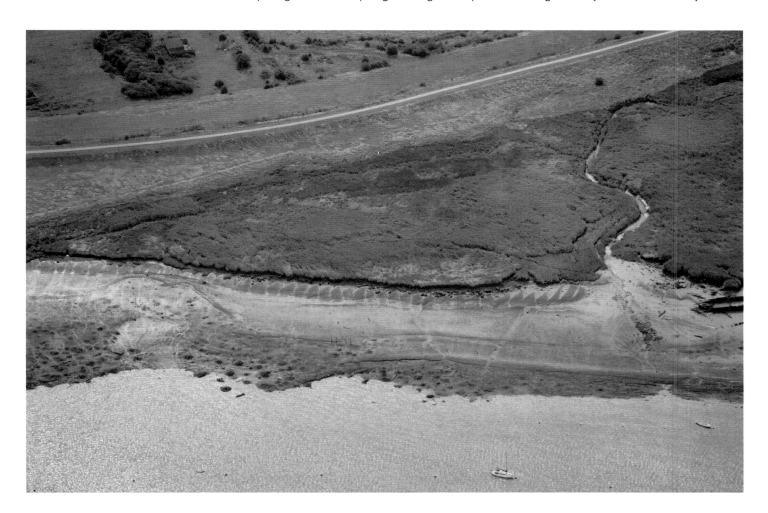

6

< SOUTH LONDON >

Waterloo Road and Waterloo Station, 1936

This view looks north up Waterloo Road to where John Rennie's magnificent Waterloo Bridge of 1811–17 is being demolished, with a temporary bridge alongside it to the east. Rennie's bridge was architecturally the finest in London, its nine elliptical arches, each of 120ft (36.6m) span, all executed in perfect granite masonry; however, its piled foundations were undermined by the river and the tides, and two of the piers settled severely in 1923, leading to the controversial decision to demolish and replace it. To the left are the broad roofs of Waterloo Station, home of the London & South Western Railway, who gradually made this the capital's pre-eminent station for suburban commuter services. The station grew piecemeal and by 1900 over 700 services a day were coming into or going out of it. The company decided to rebuild completely and this was done between 1901 and 1922 to designs by the engineer J W Jacomb Hood. Their new terminus had architectural ambitions, but unfortunately, the grand Baroque façade faces right onto the rival South Eastern Railway's viaduct (leading into Charing Cross). [R H Windsor Collection, TQ 3179/1]

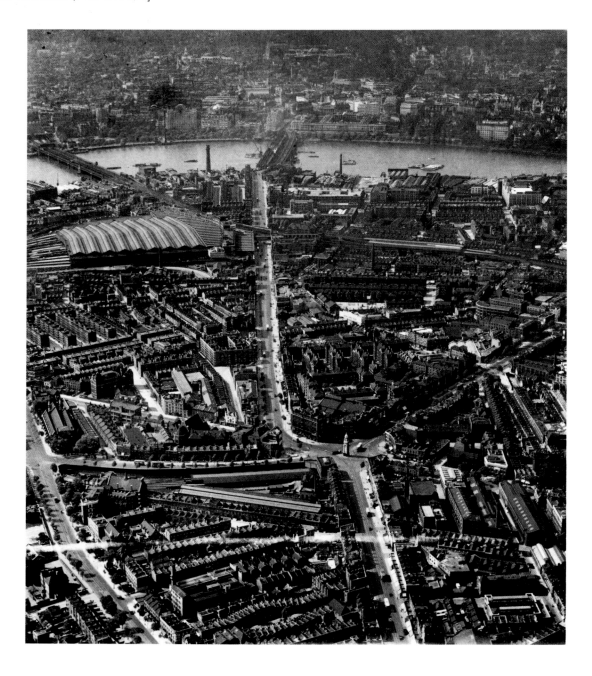

St George's Circus and Waterloo Road looking north, August 2006

The chaotic diversity of south London, where Lambeth meets Southwark, is apparent in this view. In the 18th century this area was still St George's Fields, a large area of open space with the rows of terraced houses just beginning to encroach. Here the mass meetings to support the radical John Wilkes with the cry 'Wilkes and Liberty' were held and here the anti-Catholic Gordon Rioters assembled prior to their three-day rampage of destruction. Here the popular Methodist preachers addressed huge crowds. The opening of the first Blackfriars Bridge in 1769 was the catalyst for change. The bridge's designer, Robert Mylne, laid out Blackfriars Road, which meets Waterloo Road at a circular space – St George's Circus – seen here. Waterloo Road is the one leading directly ahead and Blackfriars Road diverts off to the right at the Circus. An obelisk was built to mark the new circus in 1771 – it was moved, but recently restored to its original site. Mylne and the City's architect, George Dance, harboured grandiose notions of lining the new roads with grand terraced houses, but it was not until the 1820s that the area was fully developed and then at a much more modest level. This has never been a smart part of London. [NMR 24412/015]

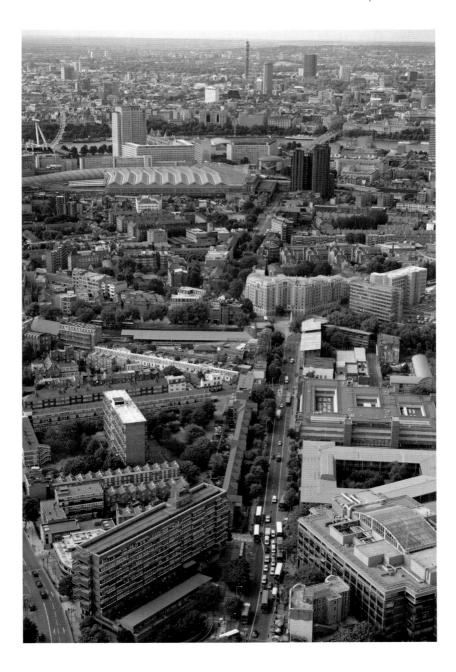

The Oval, Kennington (north is at the top), 17 May 1948

This oval shape appears on maps of London from around 1800, part of an ambitious piece of street planning that was never properly developed. The site remained empty until the Montpelier Cricket Club obtained a lease of it from the Duchy of Cornwall in 1845 and laid out a cricket ground here; shortly after, Surrey County Cricket Club was formed and moved in. Surrey was one of the nine counties which competed in the first County Championship in 1873. They have since won 18 times, more than any other county except Yorkshire. The Oval, however, was also used to stage rugby and association football matches in the 19th century and the Football Association's semi-finals and most of its finals were held here between 1870 and 1892. In this view, taken on the last day of a match between Surrey and Kent's second XI, the players can be seen coming out of the main pavilion (1895–7, seen at the lower short side of the Oval) with its famous Long Room. The Oval was set up to house prisoners during the Second World War, but it was never actually used in this capacity and was restored to use shortly after. [RAF/58/28/5075]

The Oval, Kennington, 27 August 2001

England versus Australia: the final afternoon of the 5th Test Match of 2001. England's second innings is underway – they are trying to save the game after being forced to follow on, chasing Australia's first innings total of 641. Australia went on to win by an innings and 25 runs. The Oval is one of the great cricketing venues of the world and the last match of a full Test series in England is by tradition played here. The first Test Match between England and Australia was played at the Oval on 6–8 September 1880, being won by England by five wickets. Many cricketing records have been set here: for example the highest innings in Test cricket (903 for 7, England against Australia, 20–3 August 1938), during which Len Hutton scored the highest individual score in a Test between the two countries (364 runs). The Hobbs Gates at the entrance are named for another cricketing legend, Sir John Berry ('Jack') Hobbs. The ground has a capacity of around 15,000. [NMR 21453/10]

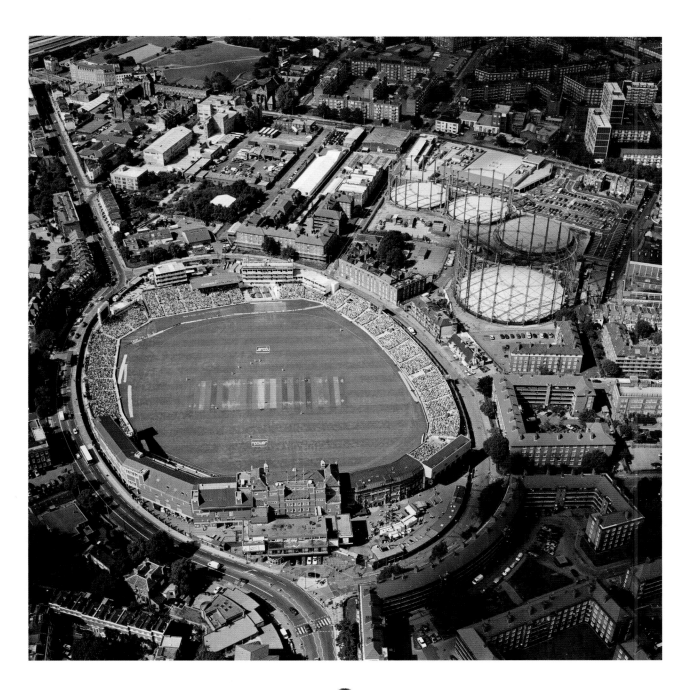

Battersea Park Station from the balloon *Corona*, 1909

The railway lines are those of the London, Brighton & South Coast Railway running into Victoria Station (c 1860). Battersea Park Station appears sandwiched between the viaducts (1864–5). The Park Town estate was developed in the 1860s to designs by the architect James Knowles; Queenstown Road and Queen's Circus, seen here, were to be its centrepieces. Unfortunately, the arrival of the gasworks and multiple railway lines blighted the area and hindered its progress, with the effect that the circus, as can be seen here, was never properly developed. Battersea became a centre of the fashionable Edwardian craze for ballooning, as the balloons were filled from the adjacent gasworks. [RAeS Library APh 344]

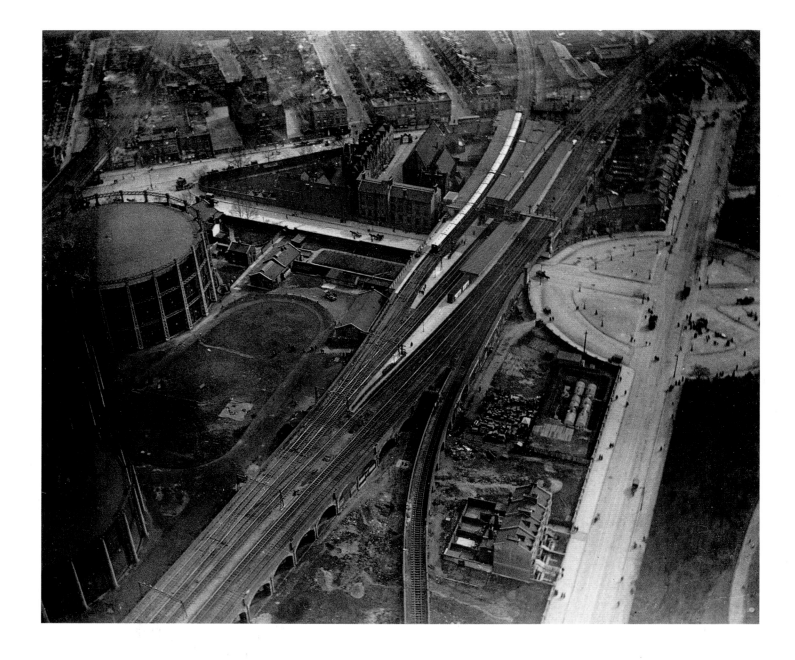

Battersea Power Station and Gasworks looking north, August 2006

In this view Queenstown Road heads towards Chelsea Bridge, while the railway lines head towards the Grosvenor Bridge (*see* p 130). Battersea Power Station, to the right, was begun in 1929, the western (left-hand) side coming first (1929–35, S L Pearce and H N Allot engineers with J T Halliday and Sir Giles Gilbert Scott as architects). Halliday designed the remarkably grand interior, with faience pilasters, marble linings and bronze doors, but Scott was brought in as architectural consultant for the exterior and contributed the distinctive 'moderne' styling, in particular the vertical fluting of the brickwork and the detailing of the chimneys. The eastern half, allowed for in the original design, was added in 1944–53 – rather surprisingly, given the austere circumstances of the time, Scott's design was followed exactly. The power station eventually closed – the western half in 1974 and the eastern half in 1982 – and since then its history has been a melancholy saga of failed hopes. The entrepreneur John Broome was allowed to gut the building, removing the roofs in 1988–9 as the first stage of a planned conversion to an entertainment complex. The venture failed and a number of different schemes have been mooted since, but none has succeeded and the power station remains an empty shell. [NMR 24411/018]

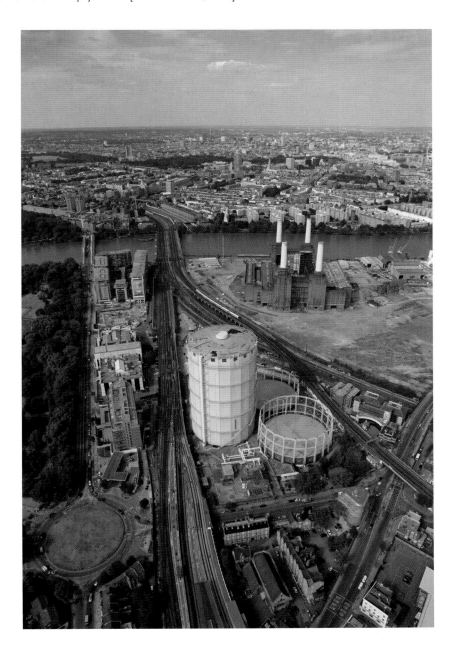

Clapham Common (north is approximately at the top right-hand corner), 14 December 1941

In this view Clapham Common is marked by the concerns and perils of a city at war, with allotments filling the left-hand side, an anti-aircraft battery with its supporting sheds and roads just right of centre and a regular peppering of bomb craters; its indigenous wildlife suffered heavily from all this. In the 18th century Clapham became a fashionable suburb, its common surrounded by fine villas and terraces, inspiring William Makepeace Thackeray to write in *The Newcomes* that 'of all the pretty suburbs that still adorn our Metropolis there are few that exceed in charm Clapham Common'. The highwaymen who had once plagued the area had been banished and the common itself was landscaped in the later 18th century. Holy Trinity Church (Kenton Couse, 1774–6, with the chancel by Beresford Pite, 1903), on the north side of the common, became the focal point of a devout community who campaigned against slavery and child labour, including William Wilberforce, Henry Thornton and Zachary Macaulay. [RAF/70/241/AC3]

Clapham Common from the south-west, August 2006

In the 1820s the developer Thomas Cubitt laid out Clapham Park to the east of the common. In the 1860s the architect James Knowles laid out the Cedars estate, centred on Cedars Road, flanked by the big terraces called The Cedars (the twin blocks at centre right on the far side of the drought-ridden Common) and linked to his slightly less classy Park Town estate down the hill in Battersea (see p 268). In the mid-19th century Clapham was a preserve of the upper-middle classes, akin to a southern Kensington. By the 1890s the area was gently sliding down the social scale, the Georgian villas with their spacious grounds being replaced with rows of more modest brick terraces. Amidst these development pressures, Clapham Common survived as an open space because of the concerted efforts of local residents, forming a committee to preserve it in 1836 and campaigning to prevent a railway from crossing it in 1864. [NMR 24411/028]

Wimbledon, All England Lawn Tennis Club (north is at the top), 7 July 1948

The club premises are on Church Road, the tree-lined road running north–south. At its southern end this road runs into the irregular crossroads where it meets the High Street (continuing southwards) and Arthur Road (off to the right). St Mary's Church with its churchyard, just off Arthur Road, represents the historic heart of the village. Just to the north of the church, straddling Home Park Road, was the splendid Jacobean mansion built c 1590 by the Cecil family. This was replaced by a second grand house built for Sarah, Duchess of Marlborough, c 1732 and a third grand house built for Earl Spencer c 1799–1802. Sadly, all three have vanished: traces of their parkland remain in the areas now filled by the Wimbledon Park Golf Club and the Tennis Club, seen here. It is the week after Wimbledon fortnight and the characteristic wear patterns can clearly be made out on the tennis courts and also on the fields used for car parking. [RAF/106G/UK/1624/5255]

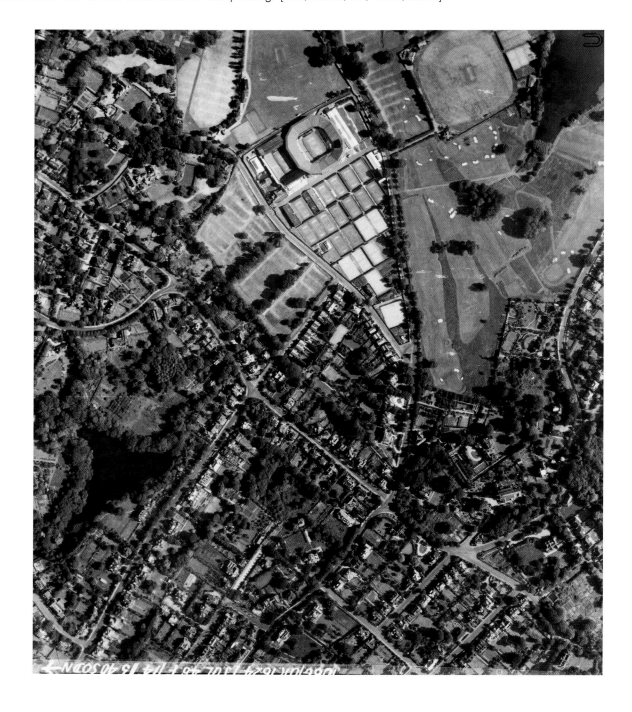

Wimbledon looking north towards the All England Lawn Tennis Club, September 2006

The grey tower of St Mary's Church, at the extreme right-hand side, marks the old village centre. Wimbledon Park House stood just beyond, with its park extending northwards into the area now occupied by Wimbledon Park Golf Club (seen to the right) and the All England Lawn Tennis Club (with the construction cranes). In the foreground are the desirable Edwardian residences of the leafy area between the High Street and Church Road. Look carefully, though, and you can see how rising property values have subverted the upper-middle-class Edwardian idyll, with the rows of town houses and individual houses on plots carved out of the big gardens. [NMR 24463/014]

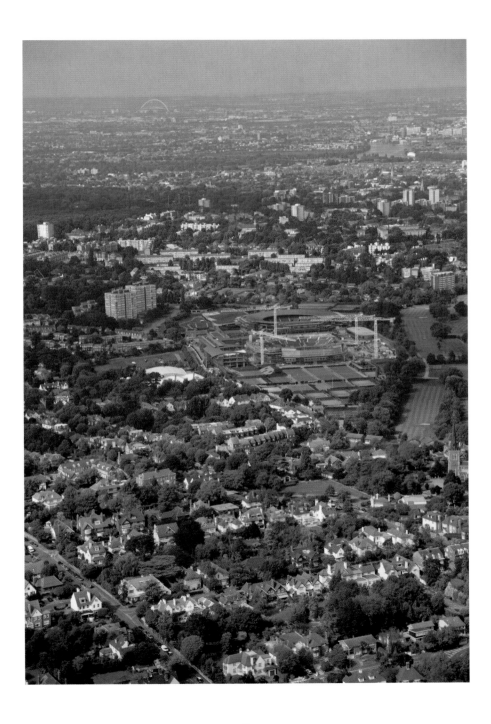

Centre Court, The All England Lawn Tennis Club, Wimbledon, c 1935

The All England Croquet Club was founded in 1869; in 1877 it became the All England Croquet and Lawn Tennis Club and in 1882, in recognition of the game's rising popularity, the All England Lawn Tennis and Croquet Club, which remains the official title. The original grounds were at Worple Road, Wimbledon; the club moved to its present, more spacious premises on Church Road in 1922. Centre Court is seen here during the championship c 1935–6; an expectant crowd fills the stands, but the court has been covered. Rain stops play? [R H Windsor Collection, TQ 2472/1]

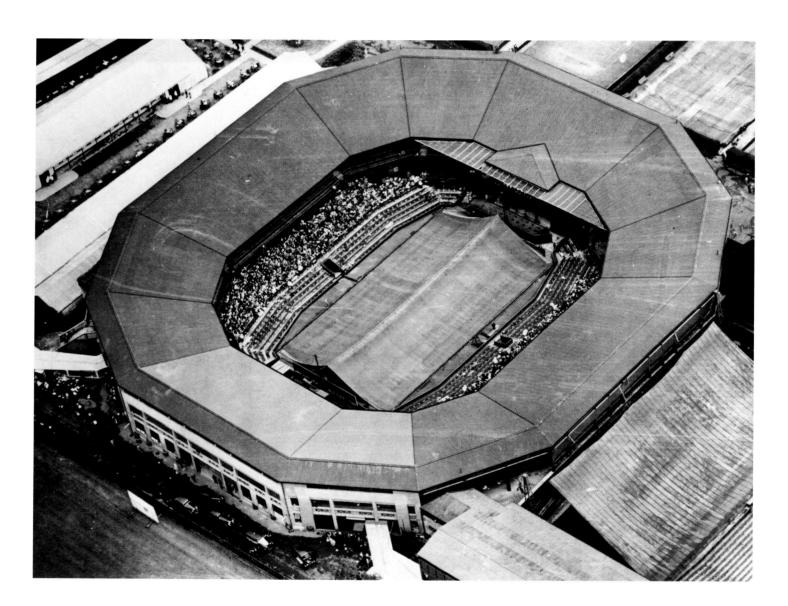

The All England Lawn Tennis Club, Wimbledon, September 2006

Wimbledon's two-week long annual open tournament has long been the most famous tennis event in the world, attracting attendances of around 500,000. Its success has obliged it to engage in major remodelling. The new Number 1 Court, seen to the right, was opened in 1997 and has a capacity of 11,500. The famous Centre Court, dating from 1922, is seen in the early stages of remodelling, which will add six new tiers of seats, raising its capacity from around 14,000 to 15,000. A sliding roof will be added in a later phase, in time for the 2009 championships, and 'rain stops play' will be a thing of the past. [NMR 24441/001]

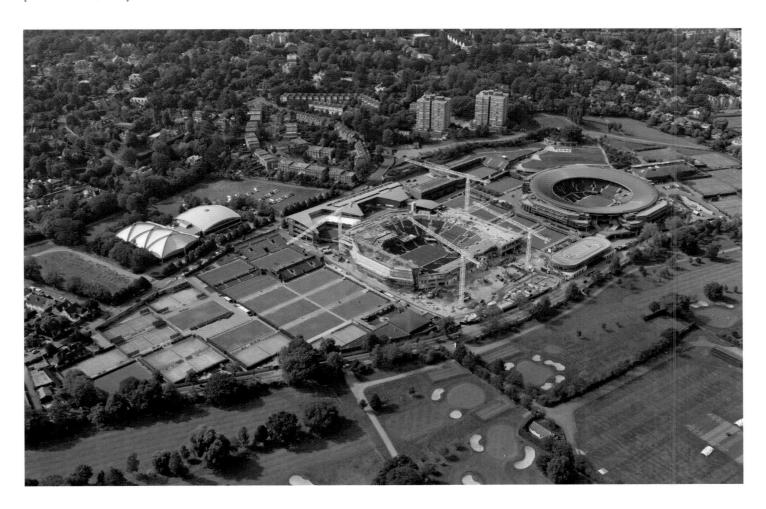

Wimbledon Common with Caesar's Camp (north is towards the top right-hand corner), 7 August 1944

Most of the Common's 1,100 acres are seen here, with the fairways of the Royal Wimbledon Golf Club in the lower left-hand half of the picture. The Wimbledon and London Scottish Golf Club's course, to the north of this and seen set amongst the paths below the wooded area, is less insistently landscaped, but can be recognised from the lighter tone of its small circular greens. The Common, in its origins a medieval heathland, shades off into thickly wooded areas on its northern fringes, terminated by the formal layout of Putney Vale cemetery. Allotments and the dotted lines of anti-glider defences mark the open spaces to the north and south of Cannizaro Road, at lower right. The ancient past is registered here by the ghostly presence of Caesar's Camp, a large Iron Age hillfort or enclosure, whose banks and ditches appear as a faint circle spanning three fairways in the northern half of the Royal Wimbledon Golf Club's course (seen halfway up the picture at centre-left). [RAF/106G/LA/29/3277]

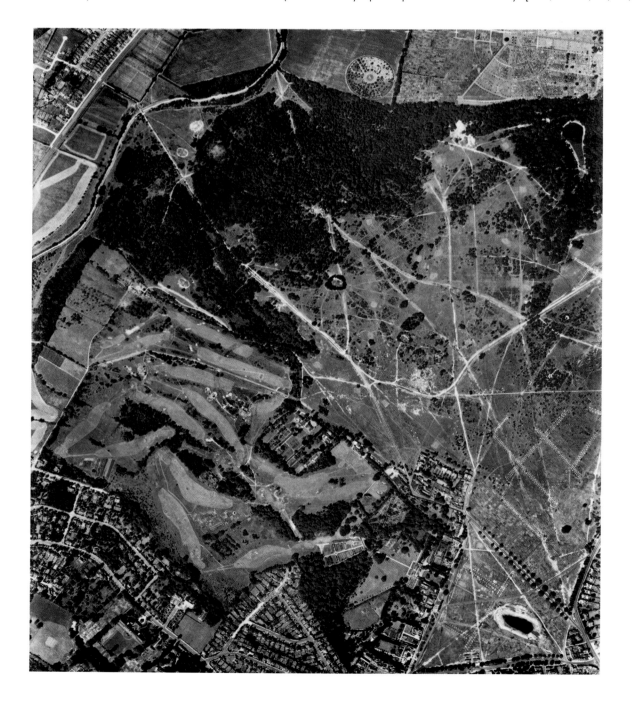

Wimbledon Common looking south towards New Malden, May 2006

Few cities of London's size can have nearly so much green space within their boundaries, partly thanks to the royal parks, but also due to the traditional English love of nature and landscape, and of Londoners' determination to protect their ancient common lands which in most parts of the country were enclosed and taken into private ownership by the neighbouring landowners in the late 18th and early 19th centuries. Wimbledon and Putney Commons were protected by the more public-spirited attitude of the Spencer family, the lords of the manor, and were given formal protection by an Act of Parliament in 1871. They are still administered by eight conservators, five of whom are appointed by residents who live within three-quarters of a mile of the area. The Royal Wimbledon Golf Club occupies a sizeable tract of the centre of the Common and Caesar's Camp appears clearly in the middle of this view. [NMR 24440/013]

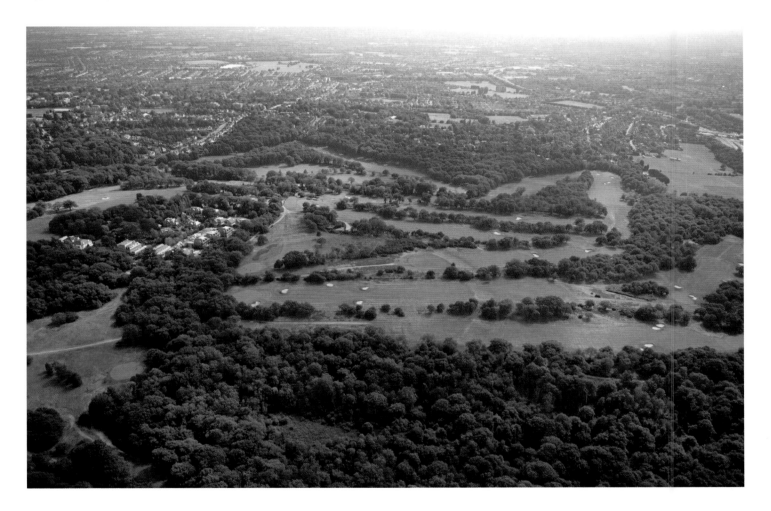

White Lodge, Richmond Great Park, c 1930s

White Lodge, a fine Georgian villa set in the huge open spaces of Richmond Great Park, was built by the architect Roger Morris for George II shortly after his accession in 1727. Subsequently it became a favourite retreat for Queen Caroline, for whom the wings were added by the architect Stephen Wright in 1751–2. The house was leased by George III to his prime minister Henry Addington, Lord Sidmouth, c 1800. White Lodge reverted to the Crown and was a royal residence for most of the 19th century; this was the home of Queen Mary's parents, the Duke and Duchess of Teck, and the Queen (then the Duchess of York) gave birth to her son, the future Edward VIII, here in 1894. Edward VIII's younger brother, the Duke of York (the future George VI) lived here for a few years after his marriage to Lady Elizabeth Bowes-Lyon. White Lodge now houses the Royal Ballet School. [R H Windsor Collection, TQ 2073/1]

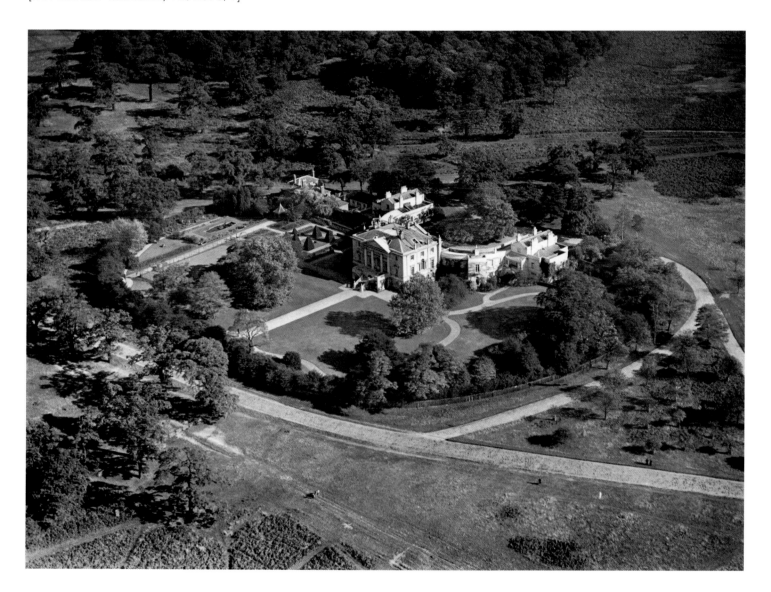

Richmond Great Park with White Lodge, September 2006

Richmond Great Park, over 2,000 acres in area, was enclosed as late as 1637 by Charles I to provide another hunting preserve for Richmond Palace and Hampton Court – a huge area of what had been open common land was surrounded with high brick walls. This symbol of royal prerogative was given by the Commonwealth government to the Corporation of London, in thanks for their support in the Civil War. In 1660 the Corporation deemed it judicious to give the park back to Charles II, but like the other royal parks it has been open to the public ever since. Large herds of red and fallow deer continue to live in this vast oasis. In the distance are the white towers of the Alton Estates at Roehampton (London County Council Architect's Department, 1951–8). [NMR 24439/016]

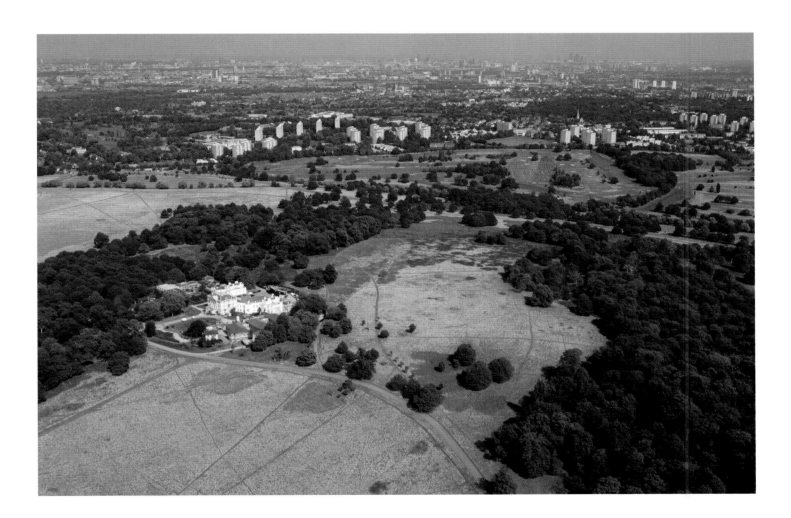

Richmond, 28 September 1948

This view looks north-west over Richmond from the direction of the Great Park. In the 14th century the village of Sheen, as it then was, became the site of one of Edward III's favourite residences. The palace was rebuilt by Henry V and again for Henry VII, who renamed the palace in honour of his northern earldom of Richmond. Richmond's beautiful Green is the square open space fringed by trees in the middle distance – the Tudor palace occupied the area between it and the river. Sadly, this second Hampton Court was largely demolished in the later 17th century and its site is now occupied by a number of particularly agreeable private houses. Richmond became a popular resort in the 18th century and has been a smart suburb ever since, as is testified by the comfortable Victorian villas in the streets off Queen's Road, seen in the foreground here. The impressive church of St Matthias with its 192ft (58.5m) spire, a fine work by Sir George Gilbert Scott of 1857–8, provides a focus for this handsome Victorian neighbourhood. [RAF, TQ 1874/1]

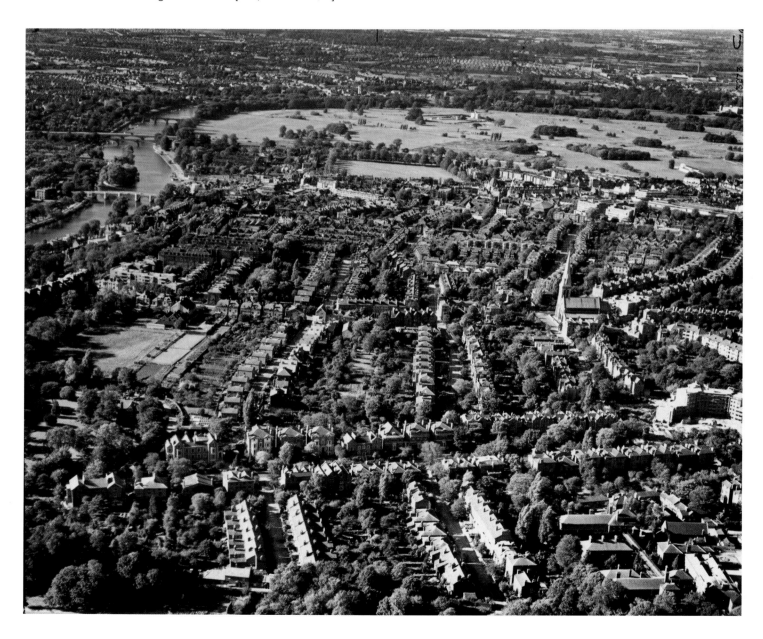

Looking south-west over the Old Deer Park at Richmond, 28 September 1948

Richmond, rising towards Richmond Hill (seen in the upper left corner of this view), is so leafy that at first the houses hardly register. To the right of Richmond is the flatter, but still spacious, topography of Twickenham. In the centre of the photograph are the wide open spaces of the Old Deer Park, enclosed by James I as an adjunct to Richmond Palace, which stood in the tree-girt area immediately beyond the road and the railway that cut across the view at the top of the open park. In the early 18th century there were ambitious plans for a new royal palace here, but nothing came of them and instead there is the compact and villa-like Old Observatory, prominent in its isolation. It was designed by the architect Sir William Chambers for that cultivated monarch George III and finished in time for him to observe the Transit of Venus from there in 1769. The idyllic impression is completed by the trees of the Duke of Northumberland's estate at Syon in the foreground, with the shell of All Saints, Isleworth, burnt out in 1943, close by. [RAF, TQ 1676/8]

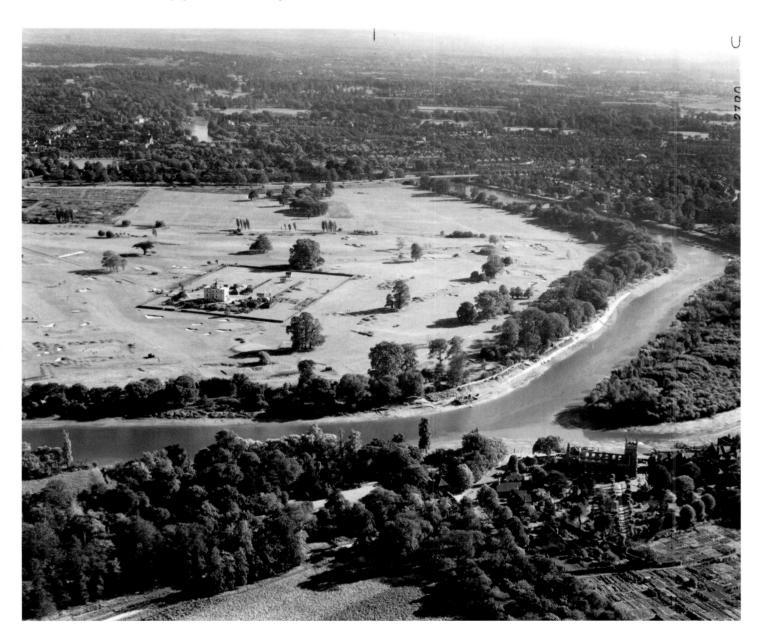

The Royal Botanic Gardens, Kew, looking north, 7 May 1948

The gardens originated as the grounds of three grand suburban residences: Ormonde Lodge (to the south, on the edge of what is now the Old Deer Park, demolished in 1771), White Lodge (close by the Orangery seen in the distance in this view, demolished in 1822) and Kew Palace or the Dutch House (still standing, and lost in the trees in the distance). The three houses became private royal residences in the 18th century and Queen Caroline (wife to George II) and Princess Augusta (wife to his son, Frederick, Prince of Wales) bear much of the credit for first laying out fine gardens around them. Kew became a favourite retreat for George III and his family, and in 1761 they commissioned Sir William Chambers to build the magnificent Pagoda, 163ft (49.7m) high, representing Georgian Britain's global reach and the king's own wide-ranging interests. [RAF, TQ 1876/2]

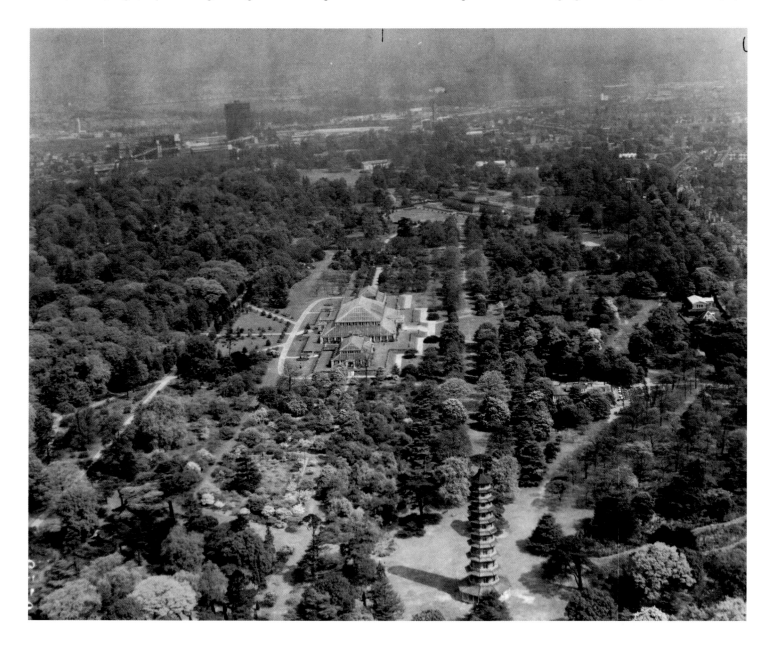

The Royal Botanic Gardens, Kew, looking north, August 2002

In 1841 Queen Victoria gave part of the royal gardens at Kew to be the Royal Botanic Gardens, with Sir William Hooker as their first director. They grew from 11 acres to their present area of 300, becoming one of the world's primary places of botanical research in the process. In this view we can compare the Pagoda of 1761, which might also be said to represent Georgian hedonism and love of the exotic for aesthetic reasons, with Decimus Burton's Palm House of 1845 (in the distance) and Temperate House of 1859–62 (in the centre), which represent Victorian seriousness and study of exotic places for the advancement of science. [NMR 21757/10]

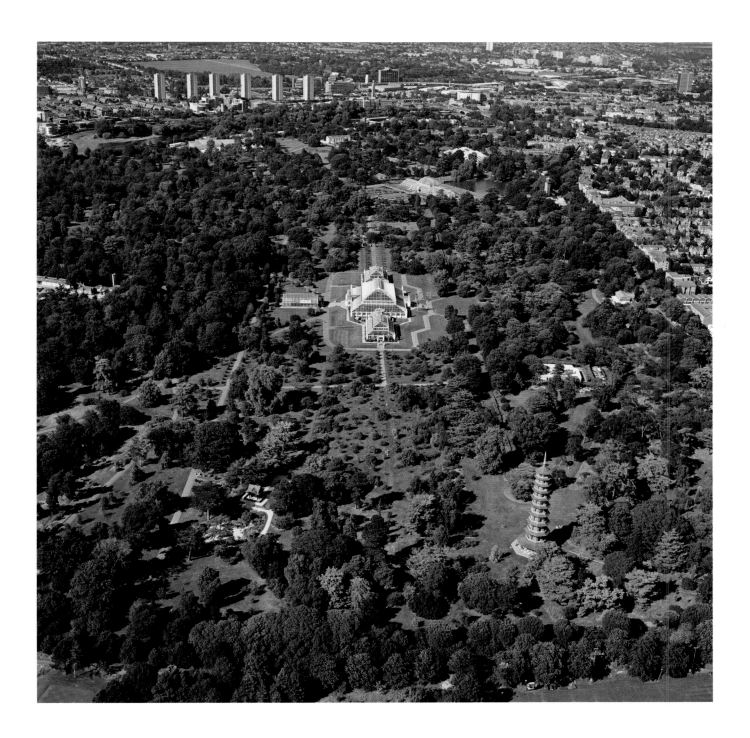

RAF Kenley, 7 November 1941

North is approximately at the bottom right in this view, with the wooded valley of Whyteleafe to the left. The Royal Flying Corps enclosed part of Kenley Common as an airfield in 1917 and in 1939 it was enlarged by taking in farmland and further common land. Kenley was one of RAF Fighter Command's Sector Stations in the Battle of Britain, playing a major role in the conflict. In March 1939 the Air Ministry had agreed to Sir Hugh Dowding's request that airfields prone to waterlogging should have hard-paved runways. The two hard-paved 800yd (731.5m) runways and the perimeter road seen here were only completed in December 1939. Dowding was also behind the construction of the 12 fighter pens with their distinctive 'E' shape, distributed around the perimeter road, each with two bays to shelter aircraft from lateral blast and impact; fighters may be seen sitting in almost every pen. Traces of camouflage treatments are clearly visible on both runways and the surrounding field. Kenley was subjected to particularly heavy attacks by the Luftwaffe on 18, 30 and 31 August 1940, in which 42 personnel were killed. The scars of these raids can be seen here in the ravaged sites of three bombed hangars in the upper left-hand corner of the airfield. [RAF/S653/H9/140/46]

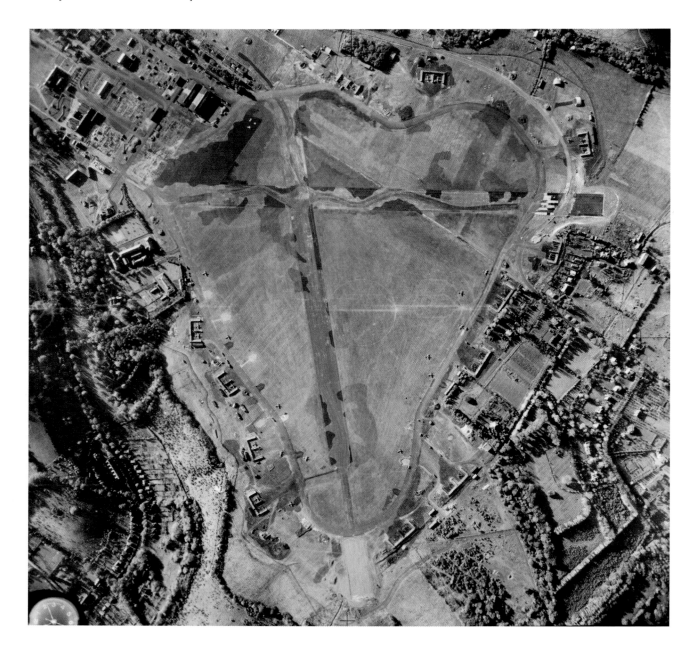

Kenley Airfield and Common (north is approximately to the right), June 2003

The RAF closed Kenley as an active fighter base in 1959 and left the base in 1966. The land around the site, up to the perimeter road, was then mostly handed back to the Corporation of London, as managers of the public open spaces in Coulsdon and West Wickham, while the Ministry of Defence retained ownership of the area inside the perimeter road, which the RAF continues to use for training with gliders. Thanks to this gentle running-down, Kenley has retained its original layout and 10 out of the original 12 fighter pens are preserved to some extent, though some have been mutilated or reduced in size. The original hangars, which would have been at the left-hand end, have gone, but the officers' mess and the headquarters buildings survive. The circular feature (a Smoke Wind Indicator, see p 198), just visible near the exact centre of the archive image, can still be seen as a parchmark in the grass in this view. Despite the losses, this is the best-preserved Second World War airfield in the country, a unique survival with a direct historical link to the Battle of Britain. [NMR 23072/20]

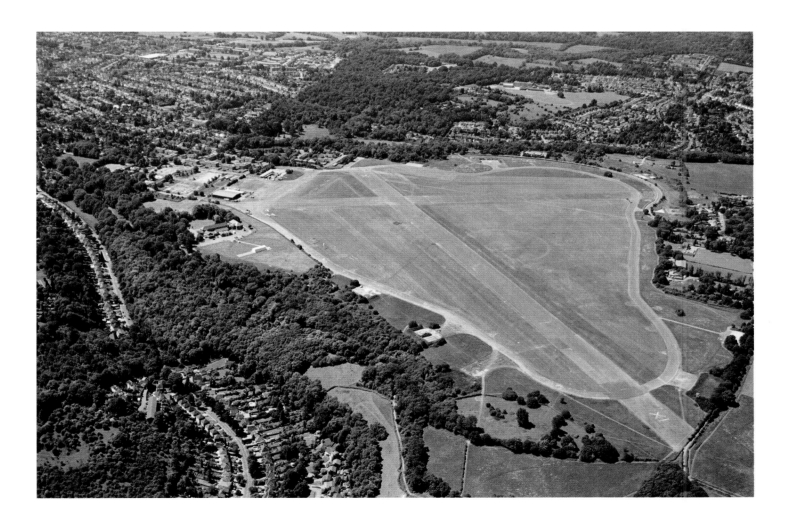

RAF Biggin Hill, 27 June 1941

Biggin Hill is of unique importance in the history of the Royal Air Force. A military airfield was established here in 1917 and work began on a permanent rebuilding in 1929. Biggin Hill was the location of pioneering experiments in air-to-air and ground-to-air radio communication and the development of the integrated system of fighter defence based on radio and radar that proved crucial during the Battle of Britain. Like nearby Kenley, the airfield was rebuilt with hard-paved runways and a perimeter road according with a series of the protective fighter pens developed by Sir Hugh Dowding; this work was only completed in the spring of 1940. Biggin Hill shared the distinction of being the most bombed of Fighter Command's aerodromes with RAF Hornchurch (see p 254) and the effects are clearly to be seen in these views. The aerodrome was attacked 12 times between August 1940 and January 1941; its worst day was 30 August 1940, at the height of the Battle of Britain, when a small force of German bombers came in at low level with 1,000lb bombs and 39 personnel were killed. In all, 453 RAF aircrew were killed while operating from here. [RAF/241/AC9/72 and 73 mosaiced together]

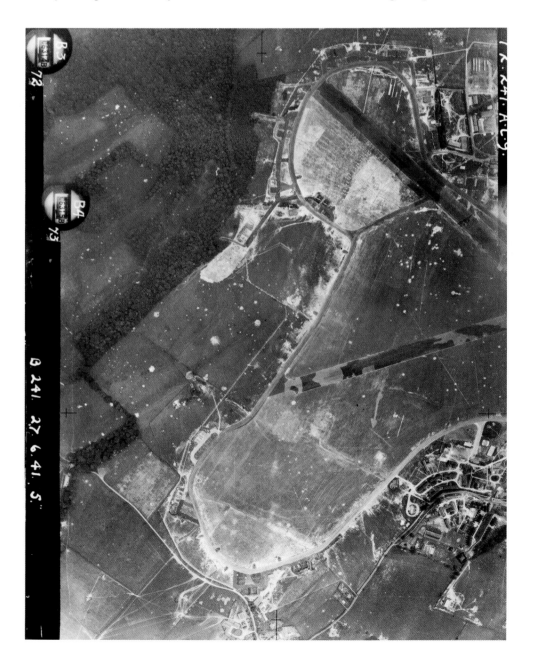

RAF Biggin Hill, 11 October 1948

Grass has grown over the bomb craters and a whole new runway has been added for jet aircraft since the 1941 view reproduced opposite. Despite this development in its capacity, Biggin Hill went into decline as a military airfield in the late 1950s. Civilian traffic, transferred here from Croydon, began to share the runway with the RAF base in 1956. The base became used primarily as the Officer and Aircrew Selection Centre, until this function was moved to RAF Cranwell in 1992. Today Biggin Hill is London's sixth civil airport, with significant commercial and private business. [RAF/CPE/UK/1789/4409]

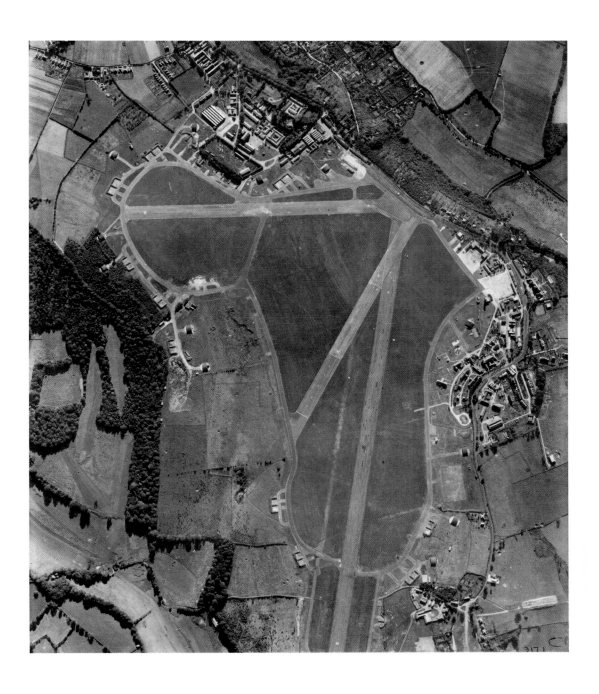

Danson House and Park with Bexleyheath (north is to the top right-hand corner), 4 August 1944

Danson House and Park are here surrounded by the suburban streets of Bexleyheath. The road which makes a long straight diagonal cutting off the upper right-hand quarter of the picture is the A207, the old Dover Road, on the line of the Roman road known as Watling Street. In the open ground at upper left is the distinctive outline of an anti-aircraft battery – the four dark spots in light circles linked by a road are the guns, while the regularly spaced rectangular blocks immediately below them are the associated encampment. Danson House is not a big country house, but a villa built to the designs of Sir Robert Taylor in 1762–6, one of the perfect, compactly planned houses for which he was renowned. The park was landscaped and its lake created by the famous landscape designer Lancelot 'Capability' Brown around the same time. [RAF/LA/33/3058]

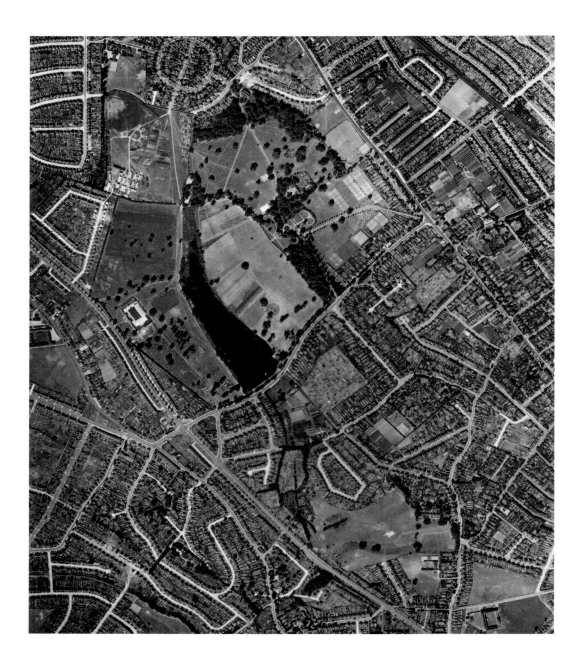

Danson House, August 2006

Danson embodies some of the dominant themes of Georgian culture. Its builder, John Boyd, had an office in the City and a town house in Westminster; Danson was his suburban retreat, an easy drive from the City along the Dover Road. Boyd's father, Augustus, had made the family fortune between 1700 and his death in 1765 in the slave trade and through sugar plantations in the West Indies based on slave labour. His son John was nominally a merchant, but inherited a large income from such sources and so could live the kind of leisured, cultured life that Georgian society regarded as the ideal. Danson, with its broad park, its precise, perfect architecture and its exquisitely decorated interior, was conceived as the perfect setting for this. The family fortune, however, had shallow roots and his son, John Boyd II, was obliged to sell up in 1805 to another merchant with West Indian interests – that is, whose fortune was probably also based on slavery. The house and park were bought by the borough of Bexley in 1923. The park has long been valued by surrounding communities, but the house fell into serious disrepair in the 1980s and 1990s. English Heritage funded and ran a major rescue project to restore the house, which is today one of the jewels of south-east London. [NMR 24405/004]

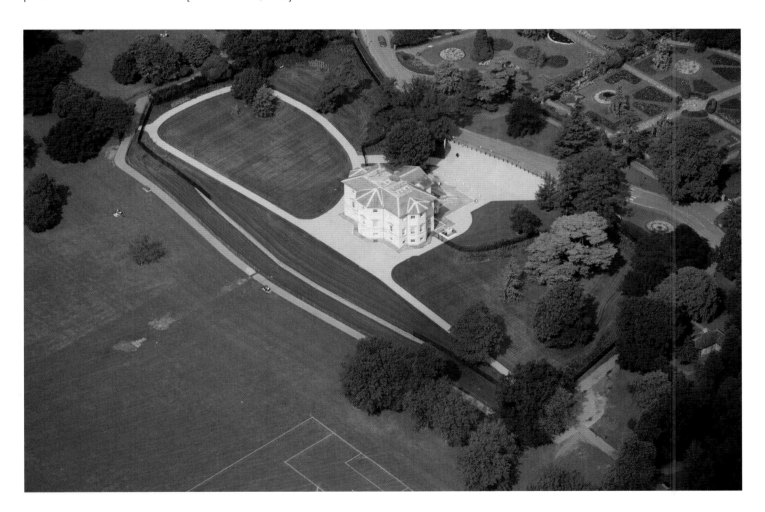

Hall Place looking east towards Crayford, 21 June 1949

This view of the valley of the River Cray vividly conveys what was happening on the edges of London up till the Second World War and the advent of real planning controls. The lower half of the view remains a Kentish idyll centred on Hall Place, a singularly atmospheric and beautiful manor house. In the upper half of the view is Crayford, which developed in the late 19th and early 20th centuries from a modest village on the Cray into an industrial suburb, with rows of terrace and semi-detached houses spreading out into the countryside to the east. In the far distance is the Thames between Erith and Dartford.
[RAF, TQ 5074/6]

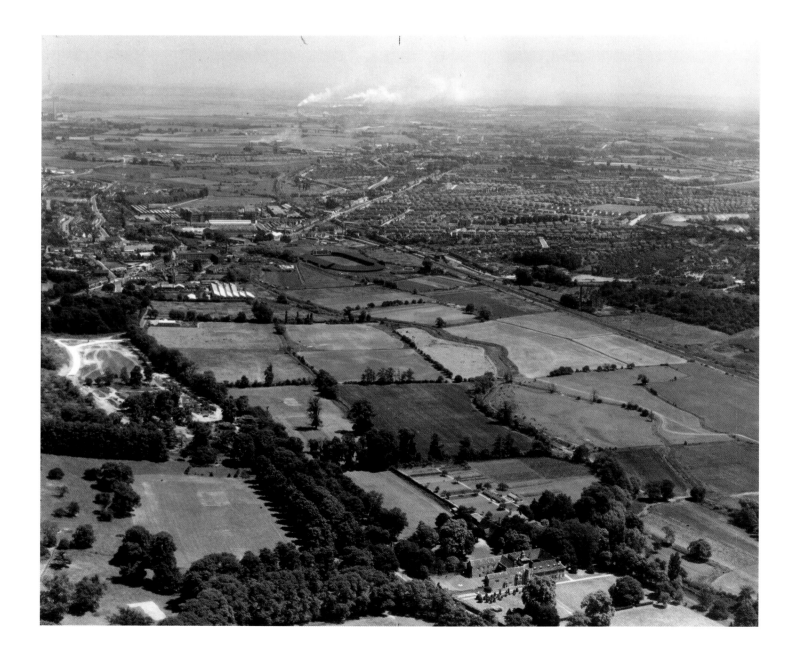

Hall Place from the north-west, August 2006

Hall Place stands on an ancient site. In 1537 it was bought by a City merchant, Sir John Champneis, who built a new house represented by the three stone-built wings, using materials brought from an (unknown) demolished monastery. Today it seems the essence of ancient Englishness; then it would have seemed very different, a new house built by a new man to advertise his wealth, with stone gained by the destruction of an old and sacred place. Tudor England was not a gentle society. In the 17th century the house was bought by the Austens, another family of City merchants, who added the red-brick wings with their hipped roofs that enclose the square courtyard. The combination of Tudor and 17th-century architecture makes Hall Place a sort of rustic version of Hampton Court. In the 18th century the estate was inherited by the Dashwoods of West Wycombe in Buckinghamshire, who rarely lived here; they let the house to a variety of tenants ending with the Countess of Limerick, who lived here from 1917 to 1943. The Dashwoods' ownership preserved the house and grounds until both were purchased by the borough of Bexley in 1935; Hall Place opened to the public as a library and museum in 1969. [NMR 24403/016]

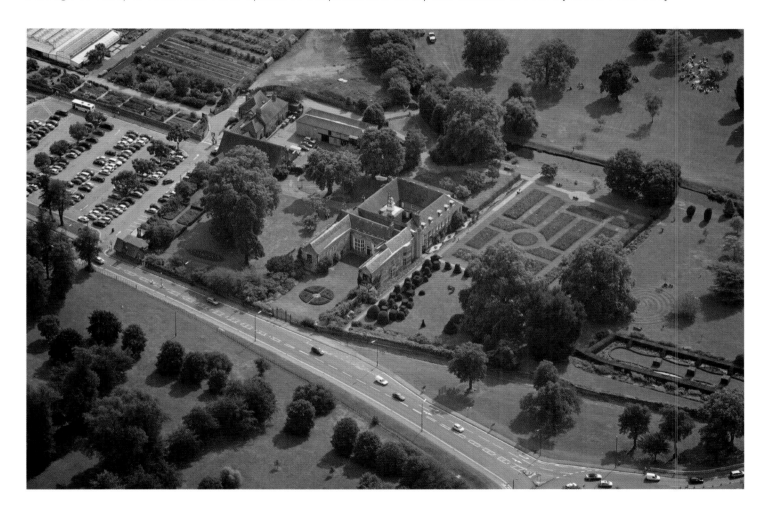

Crayford with the greyhound stadium in the foreground, 21 June 1949

It is difficult to interpret this view of the greyhound stadium – the buildings seem complete, but there is no race track and it seems disused. Perhaps dog racing had been suspended for the duration of hostilities and not restored? The River Cray is just perceptible, winding in the lower left-hand corner of this view. Far more evident is the emphatic diagonal of the A207/226 – this is the Roman Watling Street, the main road leading from Dover to London, and beyond as far as Chester. In Saxon times the ford over the river here was called Creganford and it is thought to have been the site of a major battle between the Romano-British and the invading Jutes in AD 457. At the time of Domesday Book, Crayford had a church and three mills.
[RAF, TQ 5174/3]

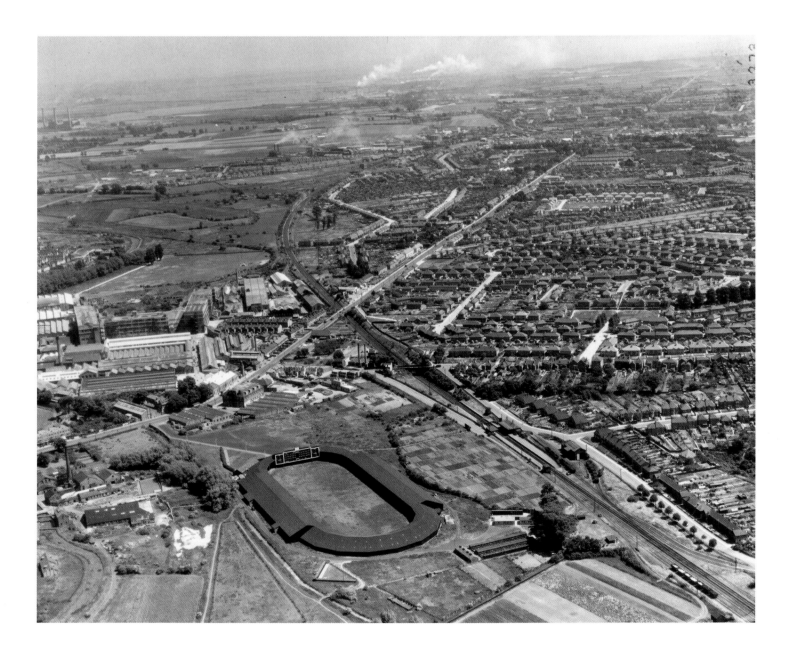

Crayford town centre from the south, August 2006

Here, the greyhound stadium has been rebuilt on a slightly different site. This was a sleepy Kent village until the late 19th century. In the 1880s an American-born inventor, Hiram Stevens Maxim, settled there. He was a brilliant engineer, registering 122 patents in the United States and 149 in Britain, and his inventions ranged from the standard mousetrap to the terrifying Maxim Gun, the world's first machine gun. Maxim, Nordenfeldt & Company was established in Crayford to manufacture his gun, which became one of the key weapons underpinning the final expansion of the British Empire in the late 19th century. In 1897 his company was bought by Vickers, the Sheffield-based steelmakers. During the First World War they expanded the factory in Crayford to the point where it employed over 14,000 people. The arms factory has gone, but Crayford Garden Suburb, built by Vickers & Company to house their workforce, remains. [NMR 24403/031]

The Crystal Palace from the west, early 20th century

The Crystal Palace is seen here high on its ridge at Sydenham. The vast iron and glass building was originally built in Hyde Park to house the Great Exhibition of 1851; its construction, in five months flat, was an astonishing achievement by its designer, Joseph Paxton, and builders, Fox, Henderson & Company. The Great Exhibition was a triumphant success, attracting over 6 million visitors. It closed on 15 October and a company was formed to purchase the materials of the building and reconstruct them in more permanent form as a place of culture and entertainment. Paxton was closely involved in the new company and Fox, Henderson & Company won the contract to build the new palace, which was shorter and more compact than the Hyde Park version, but higher and more elaborate in appearance. It opened in June 1854 at a cost of £1,300,000 – £800,000 over budget. [R H Windsor Collection, TQ 3470/2]

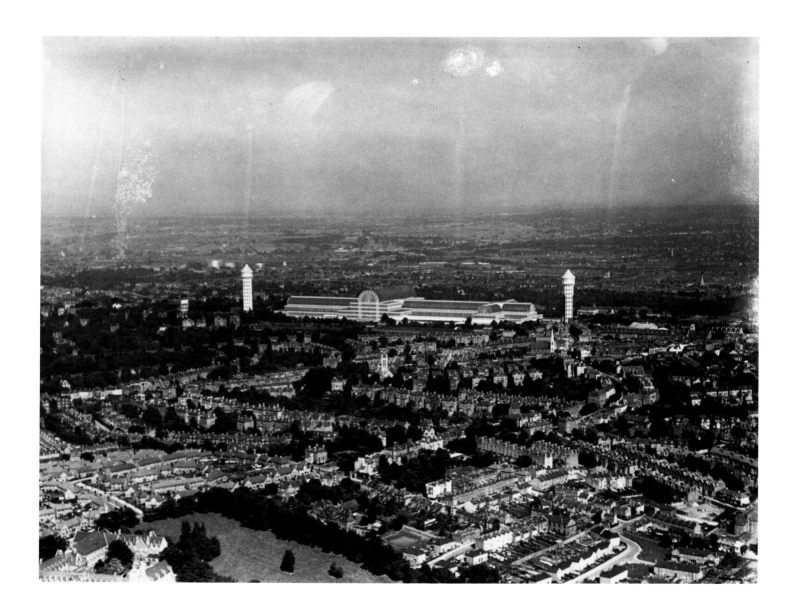

The Crystal Palace from the south-east, early 20th century

The rebuilt Crystal Palace was one of the great triumphs of Victorian culture. It housed art galleries and the extraordinary Fine Art Courts designed by Mattthew Digby Wyatt and Owen Jones, representing the art of various periods and cultures, including medieval, Roman, Egyptian, Chinese, Islamic and Assyrian. It also housed a concert hall seating 4,000, which hosted annual 'Handel Festivals'. Pageants and spectacular firework displays were put on. The magnificent gardens, designed by Edward Milner, had the most spectacular fountains in Britain, with 12,000 jets of water; a full display required 7 million gallons of water and could only be managed on rare occasions. The twin 282ft (86m) water towers, designed to supply the fountains and to provide chimneys for the palace's boiler room, were designed by Isambard Kingdom Brunel. The palace was phenomenally popular, attracting 2 million visitors a year from 1854 to 1884. Like its temporary predecessor in Hyde Park, the palace aimed to bring the world to London. [RH Windsor Collection, TQ 3470/3]

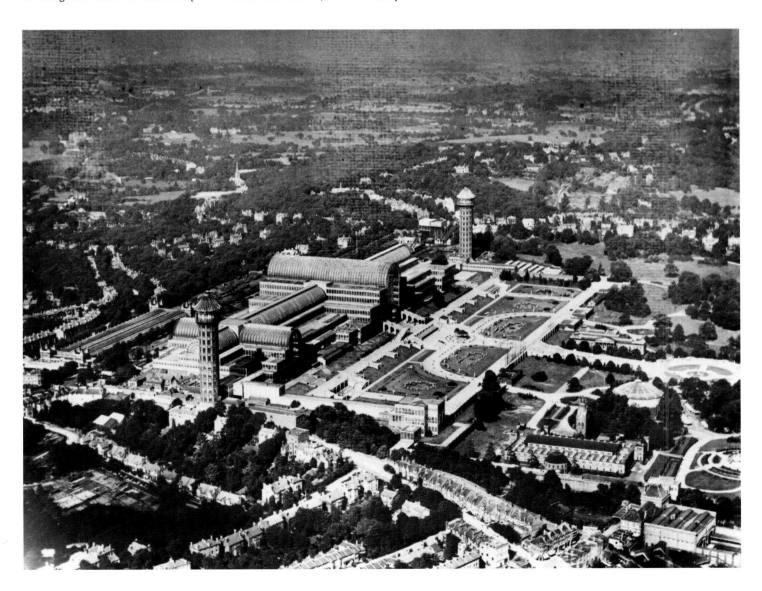

The Crystal Palace destroyed by fire, 1936

The tragic end of the Crystal Palace. The Crystal Palace company never quite got over the burden of its enormous initial cost and despite its popular success, it struggled to make a profit. By 1900 the competition generated by the increasing sophistication of Victorian mass culture was eating into the palace's visitor numbers. In 1911 the company went bankrupt. A popular campaign demonstrated that the Crystal Palace was still much loved and it was acquired for the nation in 1913. A new trust was set up to run it, but the building had become neglected, times were changing and it never quite regained its mid-Victorian lustre. The palace – the ultimate symbol of the Victorians' optimism, ingenuity, all-encompassing interests and belief in culture for everyone – was destroyed by an accidentally caused fire on the night of 30 November 1936.
[R H Windsor Collection, TQ 3470/9]

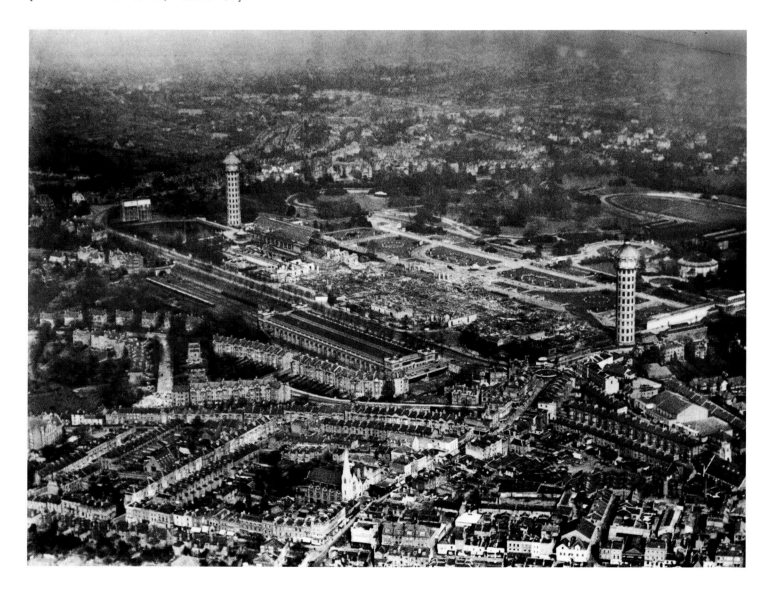

Crystal Palace Park, October 2006

In this view the partly wooded area with the famous television mast on the left is the site of the palace. To its right are Paxton's great terraces and steps. To the right of these, on the site of the gardens and fountains, is the National Recreation Centre (London County Council Architects' Department,1956–64) with its stadium and sports hall. All around are the comfortable south London suburbs, Victorian creations to a large extent. London is an ancient place and is today one of the greatest of 'world cities'. However, to a remarkable degree – in its topography, its broad character and its fine detail – it remains a Victorian city. The ghost of the Crystal Palace, greatest of Victorian fantasies, hangs over this empty hilltop, a south London landmark. [NMR 24384/020]

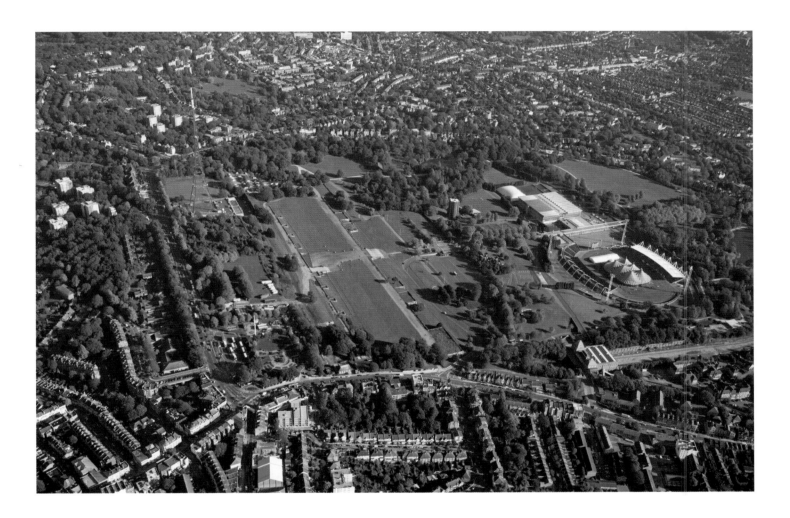

FURTHER READING

The following books have been especially useful in the preparation of this one:

Ackroyd, Peter 2000 London: *A biography*. London: Chatto & Windus

Glinert, Ed 2003 *The London Compendium: Exploring the hidden metropolis*. London: Allen Lane

Harwood, Elain and Saint, Andrew 1991 *London*. HMSO in association with English Heritage

Richardson, John 2000 *The Annals of London: A year-by-year record of a thousand years of history*. London: Cassell

Sinclair, Iain 1997 *Lights out for the Territory: Nine excursions in the secret history of London*. London: Granta Books

Weinreb, Ben and Hibbert, Christopher, eds 1983 *The London Encyclopaedia*. London: Macmillan

The Buildings of England series:

Bradley, Simon and Pevsner, Nikolaus 1997 *London 1: The City of London*. Harmondsworth: Penguin

Cherry, Bridget and Pevsner, Nikolaus 1983 *London 2: South*. Harmondsworth: Penguin

Cherry, Bridget and Pevsner, Nikolaus 1991 *London 3: North West*. Harmondsworth: Penguin

Cherry, Bridget and Pevsner, Nikolaus 1998 *London 4: North*. Harmondsworth: Penguin

Cherry, Bridget, O'Brien, Charles and Pevsner, Nikolaus 2005 *London 5: East*. London: Yale University Press

Bradley, Simon and Pevsner, Nikolaus 2003 *London 6: The City of Westminster*. London: Yale University Press

ACKNOWLEDGEMENTS

Warm thanks are due to English Heritage's Aerial Survey team for the superb new images used in this book. Luke Griffin took on the huge task of pulling thousands of photographs from the NMR's archive store; Rose Ogle, Katy Groves and Catherine Runciman catalogued the photographs; and Martyn Barber and Damon Spiers provided information about early balloon photography and the history of the RAF collection. The majority of the aerial photographs from 1999 onwards were taken by Damian Grady; Damian would like to also thank Peter Horne and Jane Stone for their help and photographs on the 2006 flights. Special thanks should also be given to the staff and pilots of Premiair Helicopters who helped us plan and execute the flights over central London and also Mick Webb for piloting our Cessna 172 around outer London. The author would like to thank our Publishing team for all their efforts and attention to detail in bringing the book to publication, especially René Rodgers, who edited and project-managed the book, Susan Kelleher for proofreading the text and Adèle Campbell and Rob Richardson for their support on the project. Damian Grady and Roger Thomas provided invaluable advice on several of the captions, and Andrew Saint kindly read and commented on the introduction. We would also like to thank Michael McMann for all of his hard work on the design of the book. Finally, we owe a special debt of thanks to the Royal Aeronautical Society and in particular to their librarian, Brian Riddle, for allowing us to use the early 'balloon' images from their collection.

INDEX